Major European Art Movements, 1900–1945

PATRICIA KAPLAN was born in New Jersey, received her B.A. from Goucher College, her M.A. from the New York University Institute of Fine Arts, and is completing her Ph.D. degree at the City University of New York. She has taught at Brooklyn, Queens, and Richmond colleges. She is currently an editorial associate of *Art News,* an art critic for *Art in America,* and a contributor to *Art Journal.*

SUSAN MANSO was born in New York City, received her B.A. from Antioch College, and did her doctoral studies at the University of California at Berkeley. She taught art and literature at Richmond College, CUNY, from 1968 to 1975. Ms. Manso has written in the fields of art and literature for, among others, *Review, The Journal of the Center for Inter-American Relations; New Boston Review; Women Artists Newsletter;* and *The Village Voice.*

Major European Art Movements, 1900–1945

A CRITICAL ANTHOLOGY

Edited by Patricia Kaplan
and Susan Manso

A Dutton Paperback

E. P. DUTTON · NEW YORK

Library of Congress Catalog Card Number: 77-71306

ISBN: 0–525–47462–5

Published simultaneously in Canada
by Clarke, Irwin & Company Limited, Toronto and Vancouver

10 9 8 7 6 5 4 3 2 1

FIRST EDITION

DESIGNED BY JEANETTE YOUNG

Grateful acknowledgment is made to the following for permission to quote from copyright material:

Dore Ashton: "Stripping Down to Cosmos." Reprinted from *A Reading of Modern Art,* Harper & Row, Icon Editions, New York, revised edition, 1971. Copyright © 1969, 1971, by The Press of Case Western Reserve University, by permission of The Press of Case Western Reserve University.

John Bowlt: "Artists of the World, Disunite!" Reprinted from the exhibition catalogue *Russian Avant-Garde, 1908–1922,* Leonard Hutton Galleries, New York, 1971, by permission of Leonard Hutton Galleries and the author.

John Elderfield: " 'Dada': A Code for Saints?" Reprinted from *Artforum,* 12, no. 6, February 1974, by permission of the editor and author.

Edward Fry: Introductory essay reprinted from *Cubism,* McGraw-Hill Book Company, New York, 1966, by permission of McGraw-Hill Book Company.

Robert Goldwater: "The Primitivism of the Fauves," "The Brücke," "The Primitivism of the Blaue Reiter." Reprinted from *Primitivism in Modern Art,* Random House, Inc., New York, 1938, revised edition, 1966. Copyright 1938, renewed 1966, by Robert Goldwater. Reprinted by permission of Random House, Inc.

Lawrence Gowing: "Matisse: The Harmony of Light." Reprinted from the exhibition catalogue *Henri Matisse: 64 Paintings,* The Museum of Modern Art, New York, 1966, by permission of The Museum of Modern Art. Copyright © 1966 The Museum of Modern Art. All rights reserved.

Clement Greenberg: "Collage." Reprinted from *Art and Culture,* Thames and Hudson, London, revised edition, 1973; and Beacon Press, Boston, 1961, by permission of Beacon Press, Boston. Copyright © 1961 by Clement Greenberg.

Hans L. C. Jaffé: Introductory essay reprinted from *De Stijl.* Harry N. Abrams, Inc., New York, n.d., by permission of Harry N. Abrams, Inc.

Lucy Lippard: Introductory essay reprinted from *Surrealists on Art.* Prentice-Hall, Inc., Englewood Cliffs, New Jersey. Copyright © 1970, by permission of Prentice-Hall, Inc.

Rose-Carol Washton Long: "Kandinsky and Abstraction: The Role of the Hidden Image." Reprinted from *Artforum,* 10, no. 10, June 1972, by permission of the editor and author.

Octavio Paz: *Marcel Duchamp, Or, the Castle of Purity.* Viking Press, New York, 1970, reprinted by permission of Grossman Publishers, a division of Viking Penguin, Inc. English translation copyright © 1970 by Jonathan Cape Ltd. Copyright © 1968, 1970, by Octavio Paz.

Robert Rosenblum: "Other Romantic Currents: Klee to Ernst." Reprinted from *Modern Painting and the Northern Romantic Tradition, Friedrich to Rothko,* Harper and Row, New York, 1975, by permission of Harper and Row, Publishers. Copyright © 1975 by Robert Rosenblum.

Leo Steinberg: "Drawing as if to Possess." *Other Criteria: Confrontations with Twentieth-Century Art,* copyright © 1972, by Oxford University Press, Inc., reprinted by permission of the publisher and the author.

Joshua C. Taylor: "The Futurist Goal, The Futurist Achievement." Reprinted from the exhibition catalogue *Futurism,* The Museum of Modern Art, New York, 1961, by permission of The Museum of Modern Art. All rights reserved.

Robert Welsh: "Mondrian and Theosophy." Reprinted from the exhibition catalogue *Piet Mondrian Centennial Exhibition,* The Solomon R. Guggenheim Museum, New York, 1971, by permission of the author.

Contents

Illustrations

Major European Art Movements, 1900–1945

Introduction

It is common to see the history of art and particularly the art of this century as a linear progression from one style or development to the next. This is understandable; however, it can be dangerous. The habit of seeing art as so many "wherefroms and wheretos" once led Dore Ashton to remark with exasperation: "Twentieth-century art is not a relay race in which one breathless runner holds out the torch to the next." The relay-race mentality, all too typical of the general survey, is absent here. Insight takes precedence over inclusiveness, and this is deliberate. Beginning about 1905 with the Fauves, these essays examine major styles and individual artists' careers through World War II. Our aim is not to "cover" twentieth-century art but to create an opportunity for its fresh apprehension.*

The art is considered first—not as parenthesis to what precedes or follows. It is also considered without being designated as either traditional or avant-garde. Acts of homage and radical gestures are often present in the same artist's body of work.

Each essay reflects that ours is an age of criticism. An enormous literature has grown up to explain modern art, sometimes standing in its way. Leo Steinberg warns: "familiar ideas about difficult things tend

* Russian Constructivism and its international manifestations—French Purism, the German Bauhaus, and abstract art of the 1930s—are unexplored here. Sculpture and architecture are beyond the limits of this volume.—Eds.

to hang on; they are economical and sharing them becomes a kind of companionship." This companionship, Steinberg and these other authors avoid. Instead, they illuminate the art and in the process refine and redefine accepted critical thought. A good example is Robert Rosenblum's fresh historical synthesis; by defining a Northern Romantic tradition that survives the transformations of twentieth-century art, Rosenblum challenges those who view the making of modern art through exclusively Parisian lenses. Elsewhere, Steinberg posits "other criteria" for the experience of modern art, asking, "who has not had the experience—especially with Picasso's Cubism—of seeing the work confound its interpreters?"

Some of these essays confront issues and problems of modern art history. In tracing the history of De Stijl, for example, Hans Jaffé questions the historian's objectivity. He asks how the art historian should "treat a subject that belongs by no means to the past, but is still a part of the present." His response is to recognize that art history can help to place the work but not necessarily to explain it. Other authors who study art movements keep in mind the distinction between the movement and the art itself. They continually test the definition of one before the evidence of the other. The very notion of movement is inappropriate for Dada, as John Elderfield shows. The logic and care he devotes to Dada, characterized by illogic and chance, is a paradox that befits his subject.

The writers included in this anthology are scholars, historians, critics, and poets. Often, categories overlap. And yet, a writer's orientation does provide an index to the way art is encountered. As opposed to the scholar's commitment to documentation, the critic remains vulnerable to the experience of the art and willing to make qualitative judgments. For example, critic Dore Ashton's approach to Joan Miró is evocative. Her reflection does not lead to new factual conclusions, rather it helps one to feel the paintings. By contrast, the scholar Robert Welsh traces the influence of Theosophic doctrine in Piet Mondrian's work and acknowledges the separateness of this endeavor from the experience of the art itself: "No one who seriously studies Mondrian's abstract work in the original will confuse his paintings—enlivened as they are by subtle tensions of line, color, implied movement, and generated space—with the theoretical preoccupations that inform his iconographic content." The poet Octavio Paz writes on Marcel Duchamp, while formalist critic Clement Greenberg scrutinizes Cubist collage. Greenberg dissects with surgical precision; Paz intuits in a Surrealist vein. In each

case, the writer's subject is congenial to his sensibility, enlivening the dialogue.

A theme common to many of the selections is the modern artist's drive to simplify and purify art. This drive is part of the artist's impulse toward the primitive and it often reflects a commitment to the spiritual. Artists as various as Henri Matisse and Mondrian and such groups as the German Blaue Reiter and the Dutch De Stijl all share this desire to strip art to its essences. To be sure, how each defines essence, and whether it relates to the natural or supernatural, distinguishes them. For Mondrian and Wassily Kandinsky, the search for purity led to a rejection of the empirical world, an art of complete abstraction. Abstraction was a means to purify the senses and reach spiritual truths. Paul Klee and Miró share a microscopic vision. Their fascination with biological and cosmological origins leads each to invent a private language of signs and symbols, metaphors for the form-giving principles inherent in things.

There is another kind of reductive process in twentieth-century painting that has little to do with spirit and cosmos. The Cubists created a language that both reduces and transforms the visual world. Their pictorial strategy—an organization of intersecting signs, notations, and flat planes in shallow space—gave to their paintings an abstract look, radically different from past art. And, despite the fact that most early writers claim Cubism is basically realistic, the context for this reality is bewildering. Its basic assumptions, whether scientific, philosophical, or psychological, preoccupy and confuse us still. As if to confound matters, the Cubists invented collage, thus extending the dialogue between art and reality by playing up fundamental premises of the creative act, disjunction and artifice. In the course of their discoveries, the Cubists exposed problems inherent in painting itself. Their revelations changed art; they had no program to change the world.

In contrast to Cubism, the history of modern European art movements is one of ambitious aims and noisy propaganda. The focus can be spiritual, political, or broadly cultural, but the end is the same—to use art to change man. The Italian Futurists wanted to hurl man forward into the brave new world of technology. As part of their aggressive contemporaneity, they rejected the past. The De Stijl group believed they were completing the past—part of a historical process of purification. The task of art—a radically reductive geometric abstraction—was to lead the way to universal and absolute harmony for mankind. Like

the Futurists, De Stijl proclaimed a new consciousness of the age. And the Surrealists examined consciousness itself. These agents of liberation wanted to sweep away traditional concepts of art and artist, to blur distinctions between inner and outer reality. Theirs was a new humanism aimed at the total emancipation of man.

The aesthetic nihilism of Futurism and Dada was more easily formulated than implemented. The social change they hoped to effect through art never came to pass. Moreover, their attempted raids on artistic tradition did not match the radicalism of a single figure, Marcel Duchamp. Whereas these groups sought to project the power of art into life, Duchamp's ironic stance admits of no distinction between the two. His entire life, perhaps unwittingly, turned into art and also legend. He drew the ordinary manufactured object, the "ready-made," into the domain of art, vastly extending its boundaries and those of criticism. Duchamp was a critic of criticism. His very presence challenged all accepted notions of art, art history, and its literature. In essence, this is the mission of all art writing.

P. K.
S. M.

Matisse: The Harmony of Light*

LAWRENCE GOWING

Matisse's entire career unfolds in Gowing's essay. He shows how Matisse's direction, seemingly opposite to that of the avant-garde, turns out to be very radical. The ebb and flow of vibrant color from the Fauve period through the late paper cutouts is central to this story. Themes and patterns recur—Matisse's need for a purity in his art, his relationship to the decorative, and his lifelong search for the light that would last. These tendencies come alive in Gowing's prose.

The most comprehensive study of the artist's life and work is Alfred Barr, Jr.'s, *Matisse: His Art and His Public* (New York: The Museum of Modern Art, 1951).**

Lawrence Gowing is Slade Professor, the Slade School of Fine Art, University College, London.

* Reprinted from the exhibition catalogue *Henri Matisse: 64 Paintings,* The Museum of Modern Art, New York, 1966.

** Additional readings are suggested when the author's text or footnotes do not include them, or where particular sources are relevant to a basic understanding of the material. There has been no attempt to offer complete bibliographical information to supplement these essays.—Eds.

Some painters seek out art as if by instinct and fall on it with fury; some of them receive it at birth and enter the inheritance with a kind of scorn. Matisse, by contrast, came to painting late and seriously. He accepted the styles of the nineteenth century, as he came to know them, without apparent reservations, and some of their essence remained with him always. In 1895, at the age of twenty-five, he was a capable student in a conventional (but nonetheless sensitive) academic style, which continued as if Manet had never lived. He was on the verge of a respectable success, with no disposition to overturn anything.

He was hardly aware of the existence of Impressionism until he was twenty-seven. Then he discovered it as well as some of the developments that had already succeeded it. Even so, he showed no particular facility. Gustave Moreau, his teacher, commended Toulouse-Lautrec, but all that Matisse learned at the Moulin de la Galette was the tune of the farandole—he found himself whistling it thirty-five years later while he painted Dr. Barnes's mural. It was the style of modern painting—the color and the touch—rather than its view of life that affected him.

The *Dinner Table* (1897), which he painted for exhibition at Moreau's suggestion, looks now like an unexceptional Impressionist picture. It is distinguished by a clear iridescence of color, but there is also a certain moderation that avoids disrupting the real solidity of things. The *Dinner Table* was nonetheless objectionable to Matisse's academic supporters, and in the pictures that followed, his response was altogether more personal and extreme. The pure colors of Impressionism, as he wrote later in a statement that has a good deal of autobiography in it, "proved to the next generation that these colors . . . contain within them, independent of the objects that they serve to represent, the power to affect the feelings. . . ."[23]*

Matisse's feelings were evidently and unexpectedly involved. The brightness of Impressionist color stimulated, in the next few years, a series of pictures that were increasingly impetuous and free. *Sideboard and Table* (1899) reflects the divisionist manner of the neo-Impressionists, but with none of their methodical system. The color is pursued for its own sake; it slides easily into arbitrary and enchanting lilac and turquoise. The application of the paint has evidently a fascination of its own; a spot is apt to land delicately in the middle of the touch before,

* Superior numbers in the text refer to books in the alphabetical list of references at the close of this essay.

gaining from it a complementary nimbus. Other pictures are less precise. Some of them are freely dappled with color, rather in the manner of Bonnard. The two men were moving in opposite directions: the way in which Matisse set green against orange or scarlet against violet was in comparison strangely impulsive, almost reckless. Painting from the window of his apartment on the Quai St. Michel, he made an impatient cascade of pink and green brushstrokes spell evening light on the towers of Notre Dame. Other pictures that he was painting at thirty, among them the *Male Model* (c. 1900), adopted the most forceful of the post-Impressionist ways with color. Yet the aspect of Cézanne they followed was not so much the basic analysis as the boldness, the quality of pictorial statement.

In style these pictures are various and discrepant, but they have in common a continual and deliberate audacity with color. They give the first glimpse of an element in Matisse's artistic constitution that reappears at the crucial points of his development. Though nothing in his art is uncalculated, the precipitate mood of these pictures already had more of the boldness of modern painting, more of its compulsive response, regardless of consequences, to requirements inherent in the picture, than almost anything in the art of the 1890s. Late in his life he described the frame of mind in which the impetus came to him: "Although I knew I had found my true path . . . I took fright, realizing that I could not turn back. So I charged head down . . . urged forward by I knew not what—a force that I see today is quite alien to my normal life as a man."[14]

Nevertheless Matisse's beginning left him with a sense that the chromatic substance of painting was real and credible, a sense that his juniors hardly shared. He never adopted the ironic detachment with which Picasso, for example, took up the styles of the 1890s. Pure color seems to have held for him a special value that debarred him from the kind of facility that was in the air. The prodigality of Derain and Vlaminck, his colleagues in the next few years, and the airy lightness of Braque's manner under their influence were both equally foreign to him. Matisse and Derain had studied together in 1899; two years later Derain introduced Matisse to Vlaminck, with whom he was working at Châtou. But while the younger men continued from the point Matisse had reached, Matisse himself hesitated. The hardship of his personal life with no patron or dealer to support him was a deterrent; by nature he was prey to obsessional anxiety, and he had good reason for it now. He

was married, with three children; in 1900 he was painting exhibition decorations by the yard at the Grand Palais for a living, and during the following years he was often unable to keep his family together.

Moreover, he regarded his apprenticeship as still unfinished. Matisse studied everything, always, and never without enormous labor; he worked from morning to dusk all his life to ensure that the apparent spontaneity of art should be thoroughly rehearsed. In 1900 he was rehearsing self-identification with the expression of an animallike passion. He would hurry from his hack work to night school to model a jaguar after Barye. The study itself was obsessionally rigorous. He devoted months to it and before he could finish it he had to borrow a dissected cat from a medical student to examine the articulation of the spine and the tail. He explained that his object was "to identify himself with the passion of the beast, expressed in the rhythm of the volumes."[15] He was evidently confident that the passion could be studied as objectively, and by the same methods, as other constituents of art had traditionally been studied. At first consideration the idea seems incongruous, yet it is characteristic. The animal quality, the natural force of impulse, had a special value to him, and he cultivated it. The nickname *les fauves,* the wild beasts, which his circle was given five years later when the full force of his originality burst on the public, was welcome to him.

For the time being, Matisse's paintings were far from ferocious. Paintings like *Carmelina* (1903; fig. 1) were relatively somber, rigorously studied from life and modeled in deep tone. Their force was wholly traditional. Technically, Matisse was consolidating his ground, but he was also pondering the implications of his earlier audacity. Unlike Vlaminck, who thought visiting the Louvre sapped one's strength, Matisse was well aware of what tonal modeling had to offer, and of the whole tradition of pictorial structure that went with it. Matisse possessed, as the counterpart of his recurrent boldness, an almost equally persistent streak of caution. It was a part of his strength; he never moved until the way ahead was clear. All his life his development proceeded by alternate forward steps and pauses. When the time came for each step, he was entirely convinced of its rightness and beauty, and ready to hold forth on the subject—almost too ready for some of his friends.

The special significance of Cézanne for Matisse was that he had sacrificed neither color nor structure, and when Matisse went to the South in 1904, he still had Cézanne in mind; Cézanne was always an

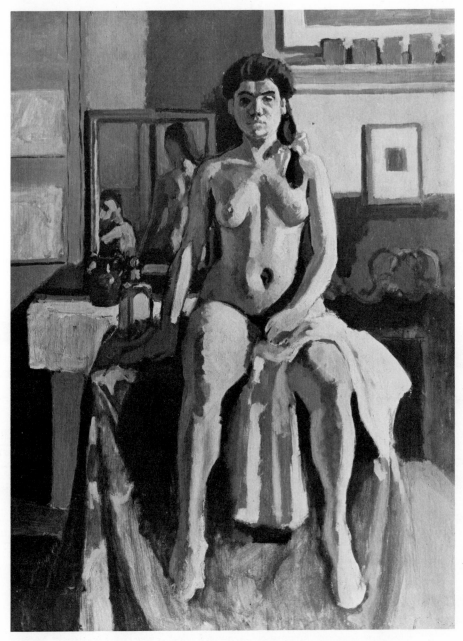

1. Henri Matisse: *Carmelina*. 1903. Oil on canvas. 31½″ × 25¼″. Courtesy Museum of Fine Arts, Boston, Tompkins Collection.

example of moral resolution to him, a talisman. But Signac, established nearby at St. Tropez, provided a more immediate and dominating influence. Neo-Impressionism was the fashion, and a deliberate, methodical system had a special virtue to "the anxious, the madly anxious Matisse," as Cross, who lived a little distance away and watched the process of conversion, described him. The unbridled force of color had run away with him once: the controlled neo-Impressionist style was welcome. Moreover, the wide-spaced lozenges of paint isolated elemental ingredients of painting—the effect of one pure color on another and the energy that is inherent in a brushstroke.

Matisse, as he said, "never avoided the influence of other artists. I should have thought it a form of cowardice and a lack of sincerity toward myself."[1] Yet the style of Signac and Cross became in his hands a curiously personal one. The sophisticated manner was followed as if naïvely for its own sake, so that the last traces of Impressionistic illusion dissolved and only the bare visual elements were left. His neo-Impressionist sketches, despite the busy brushstrokes, have a suggestion already of his later simplifications. In style the picture that he made out of them, with its complementary halos, followed Signac and Cross; in composition it had affinities with Symbolism and the bathers of Cézanne (see study for *Luxe, Calme et Volupté,* 1904; fig. 2). But it also contained something of Matisse's own that was independent of all of them. The couplet from Baudelaire's *L'Invitation au voyage,* from which he took his title, was like a motto:

> Là, tout n'est qu'ordre et beauté
> Luxe, calme et volupté.

Matisse had discovered within the post-Impressionist apparatus, which had been devised to deal directly with the world, the possibility of quite a different and opposite purpose. The pictorial means, with their richness and profusion, could hold a quality of tranquillity that offered an escape from all that oppressed him.

Signac was delighted with *Luxe, Calme et Volupté,* and bought it, but the Indian summer of neo-Impressionism was over. It had served its purpose for Matisse; the intrinsic qualities that he found in it were of more significance than the means by which he reached them. In the works that followed, the orderliness was by no means so apparent and the neo-Impressionist system was progressively transformed.

The stimulus of pure color provoked another headlong rush, apparently as impetuous as the first. The pictures exhibited in the fall of 1905,

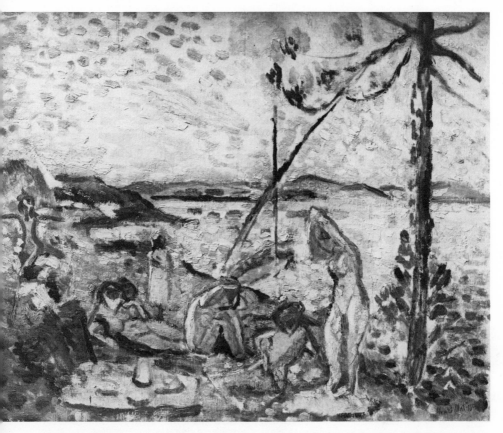

2. Henri Matisse: *Luxe, Calme et Volupté*. Study. 1904. Oil on canvas. 12¾″ ×
16″. Private collection.

which earned Matisse and his friends the name of wild beasts, had the
appearance of arbitrary fury both in the color and in the brush that
applied it. But Matisse's color was now directed by a very positive pur-
pose. Turning away from the full spectrum of neo-Impressionism, he
reduced his palette until it was dominated by the fiercest oppositions in
it. His new pictures revolved around the poles of red and green. The
harsh polarity in itself set them apart from the characteristic schemes of
all the painting under the sign of Impressionism, schemes that were
aligned with the poles of yellow and violet or orange and blue, the opposi-
tions that carry the illusion of light and shadow and the implication of
atmosphere and space. The combination of red and green offers precisely
the reverse. It denies depth; it insists on the painted surface. The pictures

of the latter part of 1905 were above all pictures of red and green, reflecting the elation of his escape from the naturalistic spectrum.

The light in these pictures is of another kind. Where red and green meet, something happens; there is a continuous, fluorescent palpitation as between no other colors. It may be that the eye detects the possibility, even the minute consummation, of the additive mixture that forms yellow, an effect more real and more surprising than anything in neo-Impressionist theory. At all events, the extremity of the contrast in hue between equivalent tones sets up a dazzling vibration. It is such vibrations that give light to pictures like the *Open Window* (1905; fig. 3). The brush responds with animation to the drama of the conjunction. The colors of Fauvism meet as equals; only their functions differ. Sometimes an intense red line is balanced against inert green masses. In a picture of Madame Matisse called *Woman with Hat* (1905), it is the green that passes around and between the patches of scarlet, orange, and violet that denote the model, as if exploring the medium of existence in which the colors float together, and exploring also a human quality— probing the meaning of the elegance and discovering a moroseness in the modish pose. Combining red with green and adding to them an intense dark blue, Matisse began to deal with the intrinsic properties of color. The whole of his subsequent practice was, in a sense, an extension of the discovery of 1905. When he came to teach, he distinguished two methods—"one considering color as warm and cool" in the Impressionist manner, "the other seeking light through the opposition of colors."[2] The latter was Matisse's way, and he pursued it almost without interruption for the rest of his life, placing color against color and revealing an inherent light in the interval and the interplay between them.

There is little in the preceding pictures to prepare one for the style of 1905. The examples of both Signac and Cézanne certainly pointed toward painting made solely out of color, and recollections of Gauguin may have done more than either to suggest the combination of red and green. But the precedent that Matisse studied most closely and the one that fortified him best was undoubtedly his own. "I found myself, or my artistic personality," he told Apollinaire, "by considering my early works. I discovered in them something constant which I took at first for monotonous repetition. It was the sign of my personality, which came out the same no matter what different moods I had passed through."[24] The self-regarding habit, indeed the engrossment in himself, that the words betray was characteristic; it was a vital part of his equipment. It led him to a frank acceptance of the painter as the single significant

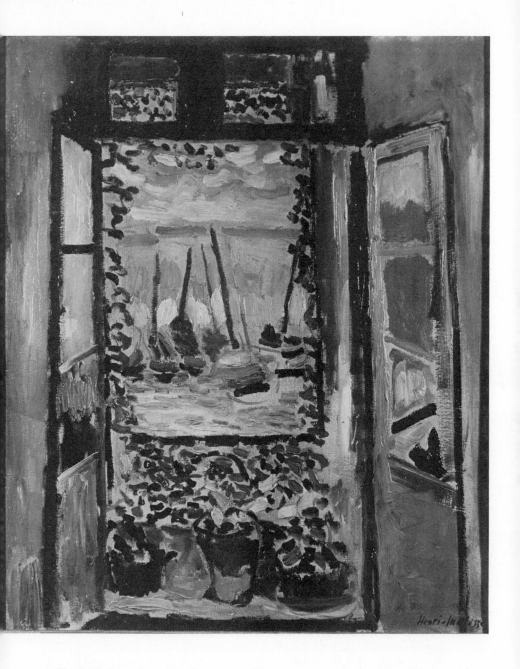

3. Henri Matisse: *Open Window*. 1905. Oil on canvas. 21¾″ × 18⅛″. Private collection.

source of his painting, and the recognition that the painting records more about him than he knows himself. Matisse, who was almost oblivious of how he appeared to others, gave some of the first and clearest descriptions of the reflexive realism of modern art.

It was the pictures of five years and more earlier that gave the clue to the way ahead in 1905. They taught him not only boldness, but also a confidence that the kind of painting that was natural to him was based on oppositions of pure color. But paintings like the *Open Window* had, again, an agitated brilliance. They belied the *calme* that was essential to him. Moreover, painting that was based on oppositions of color needed to be planned in clearly mapped out areas on the picture surface. In the next portrait of his wife the green was fixed and identified as a stripe of shadow between the pinkness of light and the ochre reflection. The accents of red and green in *Girl Reading* (1905–1906) were still scattered rapturously across the canvas. But when he turned again to the mood of arcadian felicity, which epitomized what he most needed from art, the impulsive spontaneity was replaced by a deliberation of design that was new to him.

To look at *Joy of Life* (1905–1906; fig. 4), one must go to the Barnes Foundation in Merion, Pennsylvania, yet one bears it in mind as an imaginary part of any Matisse exhibition. It was the turning point in a struggle that continued nearly all his life, swaying first one way then the other, the struggle (as he wrote long after) with the viewpoint "current at the time I first began to paint, when it was permissible only to render observations made from nature."[23] It was a struggle with a part of himself. The shortcomings of Impressionism had been the subject of avant-garde discussion for twenty years, but Matisse's critical attitude toward it took a special personal turn. The properties of light and color were more precious to him than to any other painter, yet he had a peculiar awareness of the dangers that beset them. There was an ever-present threat that the effect would prove transitory. The attempt "to register fleeting impressions" was obviously vulnerable, but Matisse's training had left him with a conviction that the process of conception must pass through "a certain analytical phase." The opposite method, the intellectual synthesis, held exactly the same danger. "When the synthesis is immediate, it is premature, without substance, and the impoverished expression comes to an insignificant conclusion, ephemeral and momentary."[9]

Matisse's whole development was a search for the kind of light that could be depended on to last—and the preoccupation gave Cézanne a

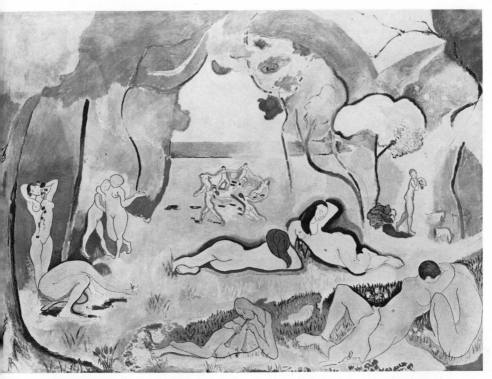

4. Henri Matisse: *Joy of Life*. 1905–1906. Oil on canvas. 68½″ × 93¾″. Collection The Barnes Foundation, Merion, Pennsylvania. Photograph copyright © 1977 by The Barnes Foundation.

special significance to him. He understood Cézanne earlier and better than any of his contemporaries, but his own standpoint was different and he had a talent for distinguishing between an example and a pattern. His attention was concentrated not only on achieving something durable like the art of the museums, but even more on the attainment of a continuous, undisturbed condition—as if the primary object were an inward bliss, which almost anything outside himself might interrupt. He had an obsessive concern with continuity in itself. "One can judge of the vitality and power of an artist when . . . he is able to organize his sensations to return in the same mood in different days."[17] Light changes, and with it one's impressions; obviously art could not depend on them. Yet for Matisse, in one sense or another, it always did depend on them. He needed light to see the picture and one kind of impression was indispensable, his impressions of his own painting. Eventually he dis-

covered the answer, sitting quite still in an apartment in Nice. In old age, when a radio interviewer asked why the Midi held him, he answered: "Because in order to paint my pictures I need to stay for a number of days under the same impressions. . . ."[6]

Divisionism and Fauvism were both inherited from the empirical outlook of the nineteenth century, and both depended on transitory sensations and the evanescent brush mark. The very immediacy of the effect was disturbing; "I want," he wrote, "to reach that condensation of sensations that constitutes a picture."[17] For him, painting existed apart in a region of ideal detachment. The great picture at Merion portrayed it.

The sensations that were condensed in *Joy of Life* were at root experiences of art. The title forms another of Matisse's revealing mottoes, and an appropriate one: he looked to art for the undisturbed ideal bliss of living. All the material of the picture—the conventional arcadia, the juxtapositions of color, which were developed from his sketches, and the accented contour—came in one way or another out of other paintings. The rhythmic drawing was a new development; Matisse once remarked that he preferred Ingres's *Odalisque* to Manet's *Olympia* because "the sensual and willfully determined line of Ingres seemed to conform better to the needs of painting."[24] Ingres's *Bain turc* had been shown at the Salon d'Automne the year before, but the influence, like everything else in *Joy of Life,* was transformed. The consistency of the picture was indeed willfully determined; it reflected a new idea of the needs of painting.

In the foreground of *Joy of Life* rose-pink lovers lie against deep blue-gray and purple grass. Beyond them the same combination of pink and blue outlines the reclining women in a long arabesque. In the distance, dusky pink melts out of the sky across the blue-gray sea. The radiance is concentrated in the center of the lemon-yellow ground. Under the trees it turns into scarlet and orange; emerald green curls through them, making the stem of a tree on one side, foliage on the other. Each color is sinuously outlined, not against its complementary but rather against an amicable counterpart, in a refined and consistent color system of Matisse's own. There is an air of resplendent artifice and a delicate yet extravagant disproportion. "Observations made from nature" are forgotten.

The new condition of painting was quiet and detached; it was *cool,* in a way that empirical and impulsive painting could never be. It was devised deliberately, with much labor. Discussing the picture, Matisse explained why: "I painted it in plain flat colors because I wanted to base

the quality of the picture on a harmony of all the colors in their plainness. I tried to replace the vibrato with a more expressive, more direct harmony, simple and frank enough to provide me with a restful surface."[16]

The early Fauve style, like the paintings of five years before, had been found wanting in the quality that Matisse most needed from art: *calme.* "There was a time," he wrote later, and he may have been thinking of the turn of the century or of 1905, "when I never left my paintings hanging on the wall, because they reminded me of moments of nervous excitement, and I did not care to see them again when I was quiet."[17] The need for harmonious quietness preoccupied him continually. When he began to paint, as he remembered in old age, what meant most to him was that "then I was free, solitary, and quiet."[25]

Matisse once explained his tendency to simplify: "It is only that I tend toward what I feel; toward a kind of ecstasy . . . and then I find tranquility."[26] It may be that all painting is intended, among other things, to present some ideal state. But the quietness that Matisse sought—the plainness of pure color and the "restful surface"—had, evidently, a special significance to him. His ideal not only excluded what was momentary or potentially transitory; it avoided equally anything that was disturbingly expressive. The idea of expression itself had to be redefined until, as he eventually told Georges Duthuit, it was "one and the same thing as decoration." Anything disquieting was unwelcome. Behind this attitude to art there was an acute intolerance of whatever was in any way disturbing or oppressive, and not in art only. He sought in art, and in life as well, hermetic conditions of private self-preservation. When he tried with his usual candor to describe them, he arrived at a definition that seems at first sight extraordinarily inert and self-protective:

> What I dream of is an art of balance, of purity and serenity devoid of troubling or disturbing subject matter . . . like a comforting influence, a mental balm—something like a good armchair in which one rests from physical fatigue.[17]

It is not unusual to require from art a solace and a refuge. Matisse was unique in the realism with which he recognized the need; the resourcefulness with which he pursued it amounted to genius. He demanded of art the expression of an ideal state of being. He did not merely require a representation of a perfect world, although he sought that as well in several different forms. His object was not even directly

sensuous. The senses were continuously engaged, but Matisse half mistrusted them: sensual gratification was itself precarious. Looking at Titian and Veronese, "those wrongly termed Renaissance masters . . . I found in them superb fabrics created for the rich . . . of more physical than spiritual value." After ten years at Nice, spent without interruption in making paintings as sensuously delightful as he could, he concluded "one may demand from painting a more profound emotion, and one which touches the spirit as well as the senses."[18] Looking to the end of the story, we can see that he was demanding nothing less than the independent, abstract re-creation of ideal conditions of existence— states of visible perfection from which the least possibility of physical frustration was eliminated.

At first sight the things that Matisse was excluding from painting— the "moments of nervous excitement," the troubling subjects, and the forced expression—seem more vital than what remains. At some points in his development, the meaning he drew from the world and the meaning he gave to it were willfully, almost artificially restricted. Yet the satisfaction he demanded was so extreme that it amounted to changing the role of painting. He made painting fulfill requirements so exigent that when the demands were met at last, at the behest of the imperious old man in bed, the effect was to alter the place that painting takes in life: to alter our use for it, as Cubism, for example, never did. The achievement of this change in the visual art, without forfeiting its previous luminous substance, was due to Matisse's absorption in his dream. At the present moment, thanks to Matisse, the potential of painting is far more striking than its limits.

Matisse's discovery confronted him with a difficult issue. "A work of art," he wrote, "must carry in itself its complete significance and impose it on the beholder even before he can identify the subject matter." Yet the luminous substance of nineteenth-century painting, which depended on identifiable sensations, had a special and indispensable meaning to him. Twenty years earlier, the avant-garde had faced the crisis of Impressionism; the painters of the 1900s confronted the crisis of representation. But Matisse met them both together. His standpoint was necessarily more complex and apparently less decisive than those of his younger contemporaries. The formula that he arrived at had an element of equivocation: "The painter," he wrote, "must sincerely believe that he has painted only what he has seen."[17] He sometimes faltered when the belief was patently at variance with the facts. Fortunately Matisse (as he said) did not work with theory. His

basic attitude was as purposeful and as single-minded as anybody's. But he was traveling in a direction opposite to virtually all the other painters of his time.

In the end, when the developments of the first half of the twentieth century were complete, it was apparent that while for his contemporaries representation of one kind or another and the basic reference to form had outlasted the luminous substance of painting, with Matisse the reverse had happened. Light had outlasted representation. In considering the apparent inconsistencies of Matisse's development, we have to bear in mind this solitary, epoch-making destination. No one else was traveling the same way. Matisse developed a self-protective, conservative attitude. He had something very personal to protect—a quality that for decades together remained inseparable from conventions of figuration that the rest of the avant-garde had finished with.

Matisse was guarding for painting a quality that was specifically visual, and sculpture came to have for him a double function. In the first decade of the century he often used sculpture to draw off the formal solidity of art into its appropriate medium, so as to leave behind in painting the strictly visual residue, flat and still. Form and formal metamorphosis were canalized into sculpture and preserved there, in case they were needed, as they eventually were. There was a streak of economy in Matisse; however lavish his purpose, nothing was wasted. In later years caution often dictated that each day's work on a picture should be photographed, lest it should be lost and irretrievable. Nothing was lost in sculpture; every stage between the realism of 1900 and the serene architectural resolution of 1930 was cast and preserved. Moreover sculpture, which offered him at intervals another fulfillment of an imaginary ideal, could also give back ideal forms to painting when they were needed again—as they were at the end of the 1920s.

Matisse's natural tendency to clarify and illuminate was already perceptible in his twenties; Gustave Moreau remarked that he was destined to simplify painting. With *Joy of Life* the process accelerated. The second version of *The Young Sailor* (1906) was painted in a mood of impatience with the subtle and responsive vibrato of the first. In place of dappled mutations of green and blue, flat masses of positive color— blue, emerald, and the yellow, orange, and green that rendered flesh—were made to flower out of a plain pink background. Pink had its time of triumph in 1906: Picasso was painting pink pictures at Gosol, even Signac was working in pink. It was hardly possible to combine the empirical method with the kind of imaginative synthesis that Matisse

was now in search of. His influential "Notes d'un peintre" was written in 1908 partly to demonstrate that an artist might justifiably use both in turn. His own immediate need was for a broader, more muscular form, and a visit to Italy in 1907 confirmed this direction. While Picasso set about his last pink picture, which was to change everything, *Les Demoiselles d'Avignon* (fig. 37), Matisse turned to monumental figure compositions of quite another kind; he took up again a wide range of primary color and evolved forms of equal simplicity and positiveness.

Matisse's synthetic method was based on an analysis of the resources of painting that was as perceptive as anything in twentieth-century art. But underneath the perceptive intelligence, there was something compulsive:

> If I put a black dot on a sheet of white paper the dot will be visible no matter how far away from it I stand—it is a clear notation; but beside this dot I place another one, and then a third. Already there is confusion. . . .

He had an acute sensitivity to the slightest hint of the disquieting confusion that threatened a picture; with every additional brush mark the threat grew closer. The only escape from it was through boldness:

> . . . In order that the first dot may maintain its value I must enlarge it as I continue putting other marks on the paper. If upon a white canvas I jot down sensations of blue, of green, of red— every new brushstroke diminishes the importance of the preceding ones. Suppose I set out to paint an interior: I have before me a cupboard; it gives me a sensation of bright red—and I put down a red that satisfies me; immediately a relation is established between this red and the white of the canvas. If I put a green near the red, if I paint in a yellow floor, there must still be between this green, this yellow, and the white of the canvas a relation that will be satisfactory to me. . . . The relation between tones must be so established that they will sustain one another.[17]

There was evidently an equal danger of disturbing conflicts between colors. It required safeguards that were as arbitrary and as drastic: "I am forced to transpose until eventually my picture may seem completely changed when, after successive modifications, the red has succeeded the green as the dominant color."[17] No more extreme reversal could be imagined. Yet Matisse made such changes freely. They were an earnest of the independence and freedom of painting.

. . . As each element is only one of the combined forces (as in an orchestration), the whole can be changed in appearance and the feeling sought can remain the same. A black could very well replace a blue, since the expression really derives from the relationship between colors. One is not tied to a blue, green, or red if their tones can be interchanged or replaced as the feeling demands. You can also change the relationship by modifying the quantity of the elements without changing their nature. That is to say, the painting will still be based on a blue, a yellow, and a green, but in different proportions.[28]

There was something incongruous in Matisse's explanations of the liberties he took with representation. The younger artists were claiming much greater freedom and the leadership of the avant-garde was passing to them. Yet Matisse's almost hypochondriac sensitivity to any disorder in painting was perhaps the most progressive insight of its time. In his analysis of precisely what confusion ensues when a second and a third dot are added to the first, he was setting a new standard of intrinsic purity. Both his analysis and his example affected the whole subsequent climate of painting. The dependence of painters like Kandinsky on the visual richness of Fauvism is clear enough, but Matisse's compulsive Purism was of even greater significance in the years that followed.

The standard of purity he set was a high one. It demanded "Order, above all in color. Put three or four touches of color, which you have understood, upon the canvas; add another if you can—if you can't, set this canvas aside and begin again."[2] His "Notes d'un peintre" was published in many countries; his admirers organized a school in which for a year or two he taught regularly. But, however influential and articulate, Matisse remained deeply aware of the difficulty of the issue that he himself was facing. "Painting," he wrote, "is always very hard for me—always this struggle—is it natural? Yes, but why have so much of it? It is so sweet when it comes naturally."[5] When he was painting pictures like *The Red Studio* (1911; fig. 5), he wrote, significantly, "This all or nothing is very exhausting."[4] Matisse's economy of means was not merely a matter of choice: often he felt it the only way open to him. "When difficulties held up my work, I said to myself: 'I have colors and a canvas, and I must express myself with purity even if I do it in the briefest manner by putting down four or five spots of color or by drawing four or five lines that give plastic expression.' "[1]

Nevertheless some circumstances were more favorable than others. Morocco, for example, notably reduced the gap between the reality and

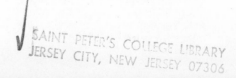

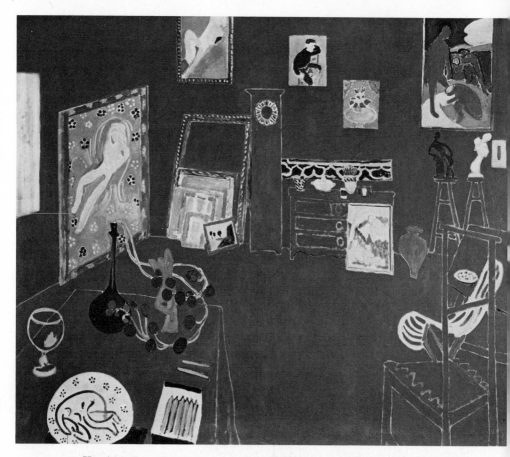

5. Henri Matisse: *The Red Studio*. 1911. Oil on canvas. 71¼″ × 86¼″. Collection The Museum of Modern Art, New York, Mrs. Simon Guggenheim Fund.

the dream. There was something of Matisse's ideal in the light and the style of the place, and his brush always moved more freely there. His explanation is interesting: "These visits to Morocco helped me to make a necessary transition, and to gain a closer contact with nature than would the practice of any theory such as Fauvism had become, lively but somewhat limited."[10] It seems that a place, and especially a southern place, could do for him what his system and his style had been doing. It provided him with what he sought from painting—the satisfactions of a desirable state of being. The move to Nice in 1918 had an analogous effect. The light and the milieu removed the need for his previous style; it was ten years before he evolved another. The confi-

dence in an ideally free and sumptuous world that he gained from his first short visit to North Africa, in 1906, enabled him after his return to paint one of his masterpieces, *The Blue Nude* (1907). The figure, freely realized in blue planes, echoed Cézanne, like much of French painting toward the end of 1907; behind it appeared the pink and green scene of Fauvism. The two were unexpectedly yet quite congruously united in memory of Biskra.

Matisse achieved his boldest synthesis of a pictorial world in decorations. The sketch of *Music* (1907), *Bathers with a Turtle* (1908), and the first *Dance* (1909; fig. 6), were successive stages toward his object. He was working systematically toward the simplest yet largest and most exacting adjustment of color and form that he had ever achieved. "I shall get it," he wrote as he started on the *Dance*, "by the simplest, by the minimum of means, which are the most apt for a painter to express

6. Henri Matisse: *Dance*. 1909. Oil on canvas. 8'6½" × 12'9½". Collection The Museum of Modern Art, New York, gift of Nelson A. Rockefeller in honor of Alfred H. Barr, Jr.

his inner vision."[9] The danger of disquieting confusion was to be banished finally; he ordained it like a monarch: "We are moving toward serenity by simplification of ideas and means. Our only object is wholeness. We must learn, perhaps relearn, to express ourselves by means of line. Plastic art will inspire the most direct emotion possible by the simplest means . . . three colors for a big panel of the *Dance;* blue for the sky, pink for the bodies, green for the hill."[11] As he worked, the effect was intensified progressively. Later he described the result:

> My picture, *Music,* was composed of a fine blue for the sky, the bluest of blues. The surface was colored to saturation, to the point where blue, the idea of absolute blue, was conclusively present. A light green for the earth and a vibrant vermilion for the bodies. With these three colors I had my harmony of light, and also purity of tone. Notice that the color was proportionate to the form. Form was modified according to the reaction of neighboring colors. The expression came from the colored surface, which struck the spectator as a whole."[27]

The progressive process of adjustment was guided simply by the artist's reactions to what he had done. Writing about Matisse, Apollinaire concluded: "We should observe ourselves with as much curiosity as when we study a tree." Matisse probably suggested the idea; he certainly exemplified it. "My reaction at each stage," he said, "is as important as the subject . . . it is a continuous process until the moment when my work is in harmony with me. At each stage, I reach a balance, a conclusion. The next time I return to the work, if I discover a weakness in the unity, I find my way back into the picture by means of the weakness—I return through the breach—and I conceive the whole afresh. Thus the whole thing comes alive again."[28]

Matisse, in fact, grasped as early and as clearly as anyone the essential attitude of twentieth-century painting. The same self-regarding habit that had given him confidence in his direction was applied to the actual process of painting. His point of departure remained his subject, either a visible subject descended from Impressionism or an arcadian one imagined on the neoclassical pattern. His method was to watch his reaction, and his reaction to the reaction, and so on, until the cumulative process gathered a momentum of its own that became irresistible. "I am simply conscious," he wrote, "of the forces I am using, and I am driven on by an idea that I really grasp only as it grows with the picture."[20] He understood an essential irrationality: "Truth and reality in art begin at the point where the artist ceases to understand what he is doing and

capable of doing—yet feels in himself a force that becomes steadily stronger and more concentrated."[16] The traditional starting point might be so modified that it is lost, and replaced by a form as elemental and primitive as the color that filled it, as it was in the final state of *Music* (1910). The result was thus hardly less disconcerting than the work of painters whose invention was centered directly on form from the first. Even so, the fact remains that Matisse's very radical purpose was in one respect conservative: he needed to retain the post-Impressionist starting point, and indeed to return to it over and over again, until he had assured himself from every possible angle that he had preserved the luminous substance that he required from it.

The innovation that placed the painter and his intuitive reactions in the center of the stage was nonetheless a profound one. Even Analytical Cubism retained the traditional extroversion of painting: basically it was an analysis of post-Impressionism, developing the discontinuities and jettisoning the color, but still outward looking and founded on a common experience. Matisse's alternative to the extroversion was a systematic and deliberate self-engrossment. Many painters were more subjective and more inventive. He was distinguished by a certain objectivity, but what he was realistic about was himself and the way he filled the role of painter. Indeed, his view was extraordinarily acute and it yielded new information about the nature of an artistic process. Matisse discerned a method, which has now become the method of virtually all painting. Deliberately basing painting on reactions to painting, he was setting in motion the modern feedback—the closed circuit within which the painter's intuition operates, continually intensifying qualities that are inherent. Whoever feels the radiance of Matisse's last works is experiencing the intensity that came from isolating what was intrinsic not only to a personality but to a whole tradition, and the communally conditioned reflex that it depends on.

There is hardly a greater originality in twentieth-century painting than this sedate, almost comfortable talent for self-regard. It grew on him, and it held obvious limitations, from which he did not always escape. But Matisse's standpoint, which was so close to narcissism, had a real sublimity. He was aware that the painter who is everything to himself has reason for modesty as well as pride. The reaction that he studies is not his alone; the conditioning of the reflex was not due to him. "The arts have a development that comes not only from the individual but also from a whole acquired force, the civilization that precedes us. One cannot do just anything. A talented artist cannot do

whatever he pleases. If he only used his gifts, he would not exist. We are not the masters of what we produce. It is imposed on us."[28]

The inherent light in the conjunction of colors possessed a special magic for him. When he had arrived at the three colors that gave him his "harmony of light," it seemed to him that an actual radiance was generated. As a student he would put his still life in the center of the studio and call the attention of his companions to it: "Look how it lights up the room!"[7] A sour rejoinder is recorded; one of the students said that if light was the object, he would rather have an oil lamp, and the future was apparently on his side. The decades that followed had no use for the idea of painting as a source of light; Matisse alone cherished it. At a certain moment in the evening, as the daylight was fading, *Dance* "suddenly seemed to vibrate and quiver." He asked Edward Steichen to come and look (when his painting puzzled him, he always sent for a friend).[3] Steichen told him that the warmer illumination of evening brought the light red and the darker blue closer together in tone and set up a complementary reflex in the eye, an explanation that was certainly incorrect; in fact the reverse should have happened. In all probability the spasmodic vibration of color, which is felt when the level of illumination sinks near to the threshold of color discrimination, merely encouraged the private magic of inherent light.

It was not only painting that was luminous; his drawings shared the virtue. "They generate light; seen in a dim or indirect illumination they contain not only quality and sensitivity but also light and variations in tone which correspond to color."[20] Matisse thought of his pictures as actually emitting a beneficent radiation; they were extensions of himself, and his excellent opinion of himself extended to them. More than once, when people who were ill looked to him to nurse them, he left a picture with them instead and went off to paint.[9]

Only his art and himself were entirely real to him. As the huge decorations came to fill his studio, more and more of the rest of existence was excluded. Painting was not only a source of painting; it became a part of his subject and soon he was representing a private world in which his own pictures shone like windows, a world that was often sufficiently peopled with his sculptures. For the rest of his life the interiors that he painted were seen as settings for his pictures that shone out as nothing else, and without the slightest incongruity. The virtue of the process was regarded as self-evident. What could art rely on more surely than on art? What could form a more proper study than oneself?

Other painters, almost without exception, were developing the structures of painting. Matisse, at first almost alone, devoted himself to the intuition that the color was real in itself. Solidity was the province of the sculptor. The structure of painting could be rudimentary; the more elemental it was, the better. The primitive had a special value to him. He is said to have introduced Picasso to Negro sculpture. He was in search of a childlike simplicity of definition. The systematic equivalence, which he had found and taught, between the colors of nature and the independent yet analogous systems of color in painting was now too complex for him. He needed not colors but color—a simple and single equivalent, hardly more than a single color. Often the chosen color was red; when he described this color method, the hue that came first was always red. His own impressive beard and hair were sandy red. The color was seen as a continuous medium flooding everything. In *The Red Studio,* the space and its furniture are submerged in it. It is the substance of their existence; there are only the traces of yellow edges to show the immaterial frontier where separate objects once existed. The identity of things is soaked out of them—all except Matisse's own pictures. They remain themselves, simple and lovely, situated at last in their own appropriate world.

Matisse had discovered for color its deepest meaning. Color was seen as all-embracing; it resided in the nature of existence. He had discovered its capacity to make visible an ideal unlimited state of being. In one or two pictures of a few months earlier the color that immersed the separateness of things was blue. In *Conversation* (1909), which is now in Moscow, a strange emotional tension was reconciled in the calm medium of the color. Another of these interiors in which color attained this quality of universality reverted to his old subject of *la desserte.* It began as a blue picture, *La Desserte—Harmonie bleue,* with the pattern of a floral fabric covering both the table and the wall behind it, but before the picture was delivered, Matisse repainted it a uniform and continuous red: the subject of laying a table, which once had been presented in steep recession with the greatest natural richness, was now embedded in a single vertical surface—inlaid in the patterned richness of the pictorial surface.

Patterns in themselves became a part of the all-pervading medium. They grew out of color. Spreading everywhere, they were the sign of its continuous, steady presence. In the famous picture of *The Painter's Family* (1911) in Moscow, the patterns pressed around the figures,

embedding them in an ever-present substance. The existence of things, even the air of obedient domesticity, was distributed evenly all over the canvas. It was indeed, as Matisse wrote, a matter of "all or nothing"; the ideal pictorial wholeness eliminated the separateness of everything.

The patterns in these pictures were inscribed as if on the surface of the canvas. They were not merely areas of illusionistic speckling and stippling like the wallpapers of the Intimists. They were painted directly, as if naïvely, in the way cheap Mediterranean pots are painted. The proliferating patterns developed on every level. There were representations of patterns in the post-Impressionist manner and patterns in the picture surface as well. Sometimes one merged imperceptibly into the other, but the pattern was all-embracing and legible. It represented at the same time an inherent property of color and a recognizable quotation. Matisse's transcriptions of the popular decorative imagery of the cultures that border on the Mediterranean played an essential and original part in his creation of an ideal pictorial milieu. They anticipated quite a different kind of painting—more closely than the popular borrowings of Cubism, because they are more passive, more infatuated.

The patterns are only one of Matisse's means of making visible and pressing an inherent quality of color. They make it, in his phrase, "conclusively present." The conclusive presence of color in *The Red Studio* turns the room that is represented into something larger. The scene takes on the elemental simplicity of some basic natural situation. The spreading color envelops us; we share a common reality with the picture. Matisse wrote: "I express the space and the things that are there as naturally as if I had before me only the sun and the sky, that is, the simplest thing in the world. . . . I think only of rendering my sensations."[16] This was the culmination of the self-identification he had studied from the beginning. In pictures like *The Red Studio* we become aware of the reality of the relationship of which Matisse often spoke toward the end of his life. He explained, for example, that study allowed him "to absorb the subject of my contemplation and to identify myself with it. . . ."[6] He spoke of a painter's need for whatever "will let him become one with nature—identify himself with her, by entering into the things . . . that arouse his feelings."[22] The identification with color gave these pictures a meaning that transcends their domestic subjects. It is significant that the subjects should be domestic, for conditions of living concerned Matisse deeply, but the way in which the subject is transcended is quite outside the specific reference of European painting. In 1910 Matisse had just been to see a great exhibition of Islamic art at

Munich. He said that "the Persian miniatures showed me the possibility of my sensations. That art had devices to suggest a greater space, a really plastic space. It helped me to get away from intimate painting."[11] Yet he was always clear that it was his own sensations that chiefly concerned him. His interest in everything else was strictly limited. Years later, when he was considering visiting a great exhibition of Chinese art, he suddenly realized that he did not wish to: "Je ne m'intéresse qu'à moi." He confessed it "with a curious and almost disarming mixture of shame and pride."[8]

The supremacy that color attained in these pictures was quite new and unparalleled. It was no longer put to any particular descriptive or expressive purpose; it was simply itself—the homogeneous, primary substance. Can anyone forget when he became aware of *The Blue Window?* In a moment one knew the simplest and most radiant idea in the whole of art—the idea that the shapes of things are immaterial except as fantastic vessels—a dish, a vase, a chalice, a bunch of balloons—to contain a bright substance of the world.

The blue fills them. They are gently inflated and rounded by the pressure. In *The Blue Window* (1911) the common color presses outward with a regular, persistent pulse; the descriptive green that preceded it remains visible between the brushstrokes, but the blue has come to stand for all color, all but its precious antithesis, the ochre. In another group of pictures, like *Goldfish and Sculpture* (1911; fig. 7) and *Flowers and Ceramic Plate* (1911), the hues make room for one another; they blossom together outward from the center, hardly touching. But the meaning—the sense of an equitable and serene private world made visible—remains the same. These still lifes painted between the two Moroccan journeys have an incomparable air of ease; all seems well in Matisse's world. His style was already altering and soon it had changed completely. The engrossment with bright color for its own sake, which had seemed the mainspring of his work, was laid aside, as if in store, for twenty years. Matisse turned abruptly to the kind of pictorial structure that was occupying his contemporaries; the relationship with Cubism, in particular, is often noticed, and sometimes misunderstood. The power to range widely and freely among the styles of his time was far from reducing what was specifically personal in his work. The constructive strength and the depth of tone, and underlying them the sense of an extraordinary control and discipline, which all reappeared in the next few years, reflected something in his artistic personality that had hardly been seen since *Carmelina.* It is clear that his final destination could

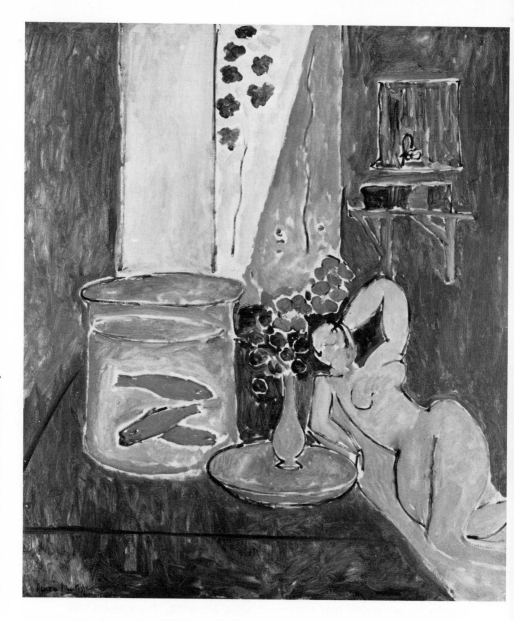

7. Henri Matisse: *Goldfish and Sculpture*. 1911. Oil on canvas. 46″ × 39⅝″. Collection The Museum of Modern Art, New York, gift of Mr. and Mrs. John Hay Whitney.

never have been reached direct from Fauvism: something sharp and purposeful in his nature was missing from it.

The closer contact with nature, which the visits to Morocco had gained for him, grew closer still. The spontaneity of Fauvism had, as he said, become almost a matter of doctrine; it limited him. The new styles were the means of new approaches to his subject. In the portrait of *Yvonne Landsberg* (1914)—the subject of one of the most perceptive of the miniature studies that are embodied in Alfred Barr's great book— the lines of force that were drawn out of the sitter can hardly have been unconnected with the example of the Futurists. Yet the device liberated a quality of energy implicit in the poise and youth of the girl, a quality that would have been beyond the reach of any other means.

These lines were carved and scraped out of the paint; Matisse's frame of mind in these years was extraordinarily ruthless, reckless, and impatient. He was intolerant of anything in his way; he deleted it irritably or scratched it away (leaving untouched perhaps only his glinting, darting emblems, a pair of scarlet and crimson fish), until sometimes almost the whole of the picture seems to be made out of half-eradicated vestiges. He compelled the picture to take on a new form—a delicate but very definite structure of analogy and interplay for which there was no precedent.

A series of pictures was devoted to his painting room on the Quai St. Michel and also to the implications of painting. In one of them the theme is a very precise equivalence between a subject and a picture; the equation is achieved through a resounding chord of emerald and purple. In another (in the Phillips Collection in Washington) the correspondence is one of geometry. The roundness of a nude model drawn in fat, black elliptical contours, who is posing on a square couch, is equated with a variety of elliptical images on square panels dispersed around the room, until it finds its equivalent in a round yellow tray on a square table, with a fragile-seeming vessel in the center. The primitive circle is recovered, as round as the arch of the bridge outside. The *Gourds* (1916) presents a whole chain of such analogies, passing across a zone of the characteristic color of these years, a flat, unbroken black.

There survives from the first autumn of World War I a canvas, which Matisse might hardly have thought complete, called the *Open Window, Collioure* (1914); it is a view between parallel vertical strips of shutter and curtain—blue, gray, and green—into black night. The darkness is ominous, yet the four colors rest calmly together on the

picture surface. The vertical formulations of these years often held a sense of tension. One of the earliest of them and the most disturbing was an iron-gray picture of a *Woman on a High Stool* (1913–1914). The image was later made to preside over the tense space of the *Piano Lesson* (1916–1917). The subjects convey a sense of misery and mute endurance. Only the serene resolution of the pattern holds them still.

Such pictures admitted to painting some of the disquiet that it had long been Matisse's purpose to exclude. The metaphoric style permitted a curious visionary realism, and the emotional expression was deeper than ever before. The vision grew increasingly direct and simple. In *Open Window, Collioure,* the vertical structure turned into the geometry of light; the picture tells more about the natural fall of daylight than anything that Matisse had painted for ten years. The landscapes of this time were as natural and lyrical as anything he painted. The tide of color, which had flowed and ebbed, now began to flow in his work again. Matisse had learned exactly the delicate order of shape in which the color and form of nature best agreed. It is a pattern of softly distended spheres, apparently so easily come by, yet fairly containing the green and blue of earth and sky and holding them gently together.

The strenuous phase was over. For a time he seems, in his suburb of Paris, to have imagined himself in Morocco; a beautiful fluency resulted. When he moved to Nice, the place in itself was enough to maintain his sense of well-being. Painting had merely to reflect it, and Matisse soon began to imagine a special type of subject for the purpose. The endless pantomime of harems and odalisques that the unimpeachable painter and his models performed together in the 1920s has now something incongruous about it. It served a purpose for the painter; with the aid of it he recovered the conditions in which he was free to move forward. He was systematically restoring his faith in painting as a source of undisturbed pleasure, capable of satisfying exorbitant requirements that he had not renounced. He was evidently assuring himself of the real existence of the material on which his dream depended—flooding color, pattern that was everywhere, and the abundance of every sensual delight. Solutions that he had originally arrived at imaginatively he now studied over again, at infinite leisure, from nature. His style was sometimes more naturalistic than it had been since his days as an academic student. Occasionally, as in *Odalisque with a Tambourine* (1926), his approach reminds one that he owned (as well as works by Cézanne, Gauguin, and van Gogh) a nude by Courbet. He evidently needed to

recover for painting the natural reference that was missing in the deliberate stylized images of the twentieth century.

The natural effects that concerned him were reviewed a good deal more systematically than the inconsequent and spontaneous style of the pictures suggested. First the common radiance of colors was identified as a quality of reflected light, filtering into calm shuttered rooms. Then he returned to his old theme of interiors filled not only with light but with the gentle, continuous pulse of southern patterns. He proceeded to relate the robust rhythms of his model more boldly to a Moorish ogee motif. Then the purpose changed again, and he traced the simple forms of flesh against a regular lattice.

Flesh, with various exotic trappings, was a continual subject in the 1920s and 1930s. Painting from nature, he was trying to relive an impossibly voluptuous dream. Yet the issue was crucial for an art such as his, and he had never faced it directly. As always, he was quite clear about his preoccupation:

> My models . . . are the principal theme in my work. I depend entirely on my model whom I observe at liberty, and then I decide on the pose that best suits her nature. When I take a new model I guess the appropriate pose from the abandoned attitudes of repose, and then I become the slave of that pose. I often keep these girls for years, until the interest is exhausted.[20]

He was evolving the form of dream that could be depended on to last. The flesh proved transitory, indeed incongruous, but the fantasy of delight spread to embrace everything.

> . . . The emotional interest aroused in me by them does not necessarily appear in the representation of their bodies. Often it is rather in the lines, through qualities distributed over the whole canvas or paper, forming the orchestration or architecture. But not everyone sees this. Perhaps it is sublimated voluptuousness, and that may not yet be visible to everyone.[20]

His first draft of this passage ended, "I do not insist on it."[19] (The charm of the man's writings often evaporated before they saw the light.) As usual, he knew himself well. His burst of unblushing self-indulgence contributed something indispensable. The wholeness of his pictures came more and more to possess a distributed, sublimated voluptuousness. The final achievement had a pervasive quality of sensual fulfillment that was new to his work.

During most of the 1920s the consistency remained soft and lux-

urious. The rediscovery of the structural order and the sharpness that he required proceeded by stages. The monumentality of *Odalisque with a Tambourine* and the *Decorative Figure* (1927), now in Paris, was apparently suggested by his sculptures. He had to eliminate what was arbitrary and evanescent, at the risk of seeming academic. When he was painting *Grey Nude* (1929), he said—the imperious tone returning: "I want today a certain formal perfection and I work by concentrating my ability on giving my painting that truth that is perhaps exterior but that at a given moment is necessary if an object is to be well carried out and well realized."[18] A little later the last version of the relief of *The Back* (c. 1929) brought him close to the clean-cut simplicity that he needed.

A further step was taken after Dr. Barnes commissioned a mural on a grand scale for his foundation. A mistake in measuring the space compelled Matisse to paint the *Dance* a second time. Possibly this served a purpose; he gained a firmer grasp than ever on a scheme that was more sweepingly and deliberately planned in areas of flat color than any picture before. He invented a technique for handling these areas on the surface of the huge painting with shapes cut out of paper, colored blue and pink in gouache. For the first time he was able to take a direct hold of the basic units of his picture, just as a sculptor takes hold of his forms. The physical control of sculpture was extended to painting, and Matisse was very aware of the analogy when he turned to working with cut paper.

The arabesque of pink against blue in *The Dream* (1935; fig. 8) still had a naturalistic, romantic reference. Matisse seems to have realized almost immediately after it was painted that this style would not lead him to his destination. He found the direction once again in his typical self-regarding, retrospective way. He looked back in particular to Fauvism:

> When the means of expression have become so refined and attenuated that their expressive power wears thin, it is time to return to the essential principles. . . . Pictures that have become refinements, subtle gradations, dissolutions without force, call for beautiful blues, reds, yellows, matter to stir the sensual depths in men. It is the starting point of Fauvism: the courage to return to purity of means.[28]

Some of the pictures that followed were as freely painted as those of thirty years earlier. The apparent spontaneity of others involved a process of long adjustment, deleted time after time with white and

8. Henri Matisse: *The Dream*. 1935. Oil on canvas. 31⅞″ × 25⅝″. Photograph courtesy Pierre Matisse Gallery, New York.

summarily restated in bright color (see fig. 9). The oppositions of color were bolder and flatter than they had ever been in Matisse's work. Sometimes the result was like a poetic kind of heraldry, full of subtle and sophisticated meanings. In *Lady in Blue* (1937), a lady takes up a reflective pose descended from Pompeii and Ingres (like some of Picasso's sitters of the same time). Dressed in blue, she is thinking, and behind her hangs a huge blue image of head-in-hand thoughtfulness. There is an effect of rectitude and even of piety; a necklace wound around her hand is like a rosary and an emblem of repentance. Yet the mimosa-yellow nimbus that radiates from her head suggests that her natural affinity is with another image, a yellow odalisque cradling her head in her arm with sly abandon. So the picture is about attitudes and poses, and about the oppositions between a sensual yellow and a violet blue. But it is also about an all-embracing heart shape, which centers on the heart of the picture, containing yellow, red, and blue successively within one another and enclosing them all in a goblet of black—a symmetrical repeating pattern that enshrines the modish thoughtful pose and distributes its implicit voluptuousness through the picture.

Color had never been so flat and bright before, either in Matisse's painting or anyone else's. The metaphoric richness of *Lady in Blue* became characteristic of his later work. The central shape of the picture, like a heart or a vase or a flower, had a long history, stretching back through the portrait of *Yvonne Landsberg* (1914) to the heart-shaped portrait of his daughter, *Girl with Black Cat* (1910), painted twenty-seven years before. Even earlier, his teaching was full of such analogies. He would point out the likeness of the calf of a leg to a beautiful vase form; a pelvis that fitted into the thighs suggested an amphora.[2] In the last works they served him better than ever, so that the lobed shapes his scissors outlined were not merely philodendrons and polyps but the basic common shapes of everything, natural vessels for color and light.

For a time the meaning remained as sophisticated and delicate as it is in *Pineapple and Anemones* (1949), but then the original impetuous reaction to colors that "contain within them . . . the power to affect the feelings" took over once again. The force of it was cumulative and astonishing. When he painted his last great series of interiors, he was ready not only to sum up all his work but to add to it something of dazzling originality.

The color floods the *Large Interior in Red* (1948) as it did *The Red Studio* nearly forty years earlier. But the meaning is different. The things in the room, not only the pictures on the wall but the flowers that bloom

9. Henri Matisse: *The Moorish Screen.* 1922. Oil on canvas. 36¼″ × 29¼″. Collection Philadelphia Museum of Art, bequest of Lise Norris Elkins.

in a slight iridescent haze on the table, retain their own real quality. They remain whole, as if preserved in redness, with a new and permanent existence. Even the diagonal march of space across the floor and up into the pictures is linked with a pattern of coinciding edges, connecting tables to chair and flowers to picture, so that both are seen as natural properties of the picture's flatness and redness. We become aware that we are in the presence of the reconciliation that is only within the reach of great painters in old age. The canvas radiates it. The redness overflows and people standing in front of the picture to look are seen to have it reflected on them. They are included in it; they share in a natural condition of things and of painting.

Matisse's other mood is seen in *Interior with Egyptian Curtain* (1948). The light it radiates is the vibration generated by oppositions of color. The energy that the conjunction of hues releases is more fully realized than ever. The virility is extraordinary; at last Matisse is wholly at ease with the fierce impulse. Red, green, and black together in bold shapes make the close, rich color of shadow. Outside the window, yellow, green, and black in fiery jabs make sunlight on a palm tree against the sky.

These last pictures demonstrate the nature of pictorial equivalence to the world. After meditating for more than fifty years on the pure color that the nineteenth century had placed in his hands, he had given the two basic equations of Fauvism their final form. The *Interior in Red* offered intimations of elemental unity. In the *Egyptian Curtain* the interaction of color epitomized the energetic force of light. Yet the equations are so simple and self-evident that they confront one irresistibly with the element in painting that is not equated with anything. The realities are the ideal states of energy and of rest, which color creates on the picture surface.

Light, after all, could be handled directly in its own right. For a time he turned from painting to deal with it in actuality in a building, the chapel at Vence. The separable attributes of painting had finally found their appropriate forms. The reality of the picture surface remained, and when he returned to the color of painting, it was as if to a natural substance. He had expanses of paper brilliantly colored to his requirements; to his delight, the doctor insisted that he wear dark glasses to go into the room where they hung. Even the streaks of the gouache were like the natural grain of a raw material. It was the basic substance of painting, the flat radiance of color. He set about it with his scissors.

10. Henri Matisse: *Memory of Oceania*. 1953. Gouache and crayon on cut and pasted paper on canvas. 108¼" × 112⅞". Collection The Museum of Modern Art, New York, Mrs. Simon Guggenheim Fund.

When Matisse began working in cut paper, he had written of drawing with scissors: "Cutting to the quick in color reminds me of the sculptor's direct carving."[21] The association was significant; he was cutting into a primal substance, the basic chromatic substance of painting, which he had extracted from Impressionism and preserved intact, as if alive. The sharp edge he cut defined figure and ground, both at once, as in a carved relief. With each stroke the cutting revealed the character both of the material, the pristine substance of color, and also of an image, a subject. Whether there was an evident motif or none, there was the sense of a subject that transcended it, the radiance and movement of an ideal southern milieu. Sometimes the theme was more mobile and flowing than anything he had painted for many years; the movement was like a dance. In the greatest of the *papiers découpés,* the soaring *Memory of Oceania* (1953; fig. 10), and the radiating spiral of *The Snail*

(1953), the rhythm resides simply in the action and interaction of colors. The movement springs out of a progression that begins, characteristically, with emerald. It expands in every direction, moving in great lazy leaps out to the extremes of violet and orange red. An ideal world was completely realized and the achievement, more than any other, discovered a new reality for painting.

Late in his life a writer tried to persuade him to pronounce against the nonfigurative tendencies of young painters. He answered:

> It is always when I am in direct accord with my sensations of nature that I feel I have the right to depart from them, the better to render what I feel. Experience has always proved me right. . . . For me nature is always present. As in love, all depends on what the artist unconsciously projects on everything he sees. It is the quality of that projection, rather than the presence of a living person, that gives an artist's vision its life.[9]

REFERENCES

Quotations are drawn from the following sources. A date in parentheses shows the year of a particular quotation different from the year of publication.

1. Guillaume Apollinaire, "Henri Matisse," *La Phalange,* December 15, 1907.
2. Alfred H. Barr, Jr., *Matisse: His Art and His Public* (New York: The Museum of Modern Art, 1951), pp. 550–552. (Remarks to the students at the Académie Matisse, recorded by Sarah Stein, 1908.)
3. Barr, *op. cit.,* p. 136. (1910.)
4. Barr, *op. cit.,* p. 152. (Postcard to Michael Stein, May 26, 1911.)
5. Barr, *op. cit.,* p. 144. (Letter to Gertrude Stein, 1912.)
6. Barr, *op. cit.,* p. 562. (Transcription of radio interviews broadcast in occupied France, sent to Pierre Matisse in New York on March 13, 1942.)
7. Jane Simone Bussy, Unpublished memoir. (Simon Bussy, 1898. Quoted by the courtesy of Professor Quentin Bell.)
8. Bussy, *op. cit.* (1935.)
9. Raymond Escholier, *Matisse, ce vivant* (Paris: Fayard, 1956; English trans.: *Matisse from the Life,* London: Faber & Faber, 1960).
10. Escholier, *op. cit.,* p. 104. (Tériade quoting Matisse.)
11. Escholier, *op. cit.,* p. 105. (Diehl quoting Matisse.)
12. Escholier, *op. cit.,* p. 89. (Remarks to Charles Estienne, 1909.)
13. Escholier, *op. cit.* (1947.)
14. Escholier, *op. cit.* (Message read at the opening of the museum at Le Cateau; 1952.)
15. Raymond Escholier, *Henri Matisse* (Paris: Floury, 1937). (1936.)

16. Werner Haftmann, *Painting in the Twentieth Century*. 2 vols. (London: Lund Humphries, 1960; new and expanded edition, New York: Praeger, 1965). Both English editions are completely revised versions of the German editions published in 1954–55 and 1957 by Prestel, Munich.

17. Henri Matisse, "Notes d'un peintre." *La Grande Revue,* December 25, 1908.

18. Henri Matisse, Interview, *L'Intransigeant,* January 29, 1929. Quoted in *Formes,* 1, no. 1, January 1930, p. 11.

19. Henri Matisse, Draft of notes in rebuttal of a proposed article by Claudinet, sent with an undated letter to Simon Bussy, 1938.

20. Henri Matisse, "Notes d'un peintre sur son dessin," *Le Point,* no. 21, July 1939, pp. 8–14.

21. Henri Matisse, *Jazz* (Paris: Éditions Verve, 1947).

22. Henri Matisse (Letter to Henry Clifford, February 14, 1948.) In catalogue of Henri Matisse retrospective exhibition at Philadelphia Museum of Art. 1948.

23. Henri Matisse, Chapelle du Rosaire des Dominicaines de Vence. Vence, 1951.

24. Jean Puy, "Souvenirs," *Le Point,* no. 21, July 1939, pp. 16–37. (1907.)

25. Maurice Baynal, Arnold Rudlinger, Hans Bolliger, Jacques Lassaigne, *History of Modern Painting,* vol. 2. (Geneva: Skira, 1950).

26. Marcel Sembat, "Henri Matisse," *Les Cahiers d'Aujourd'hui,* April 1913.

27. F. Tériade, "Entretien avec E. Tériade," *L'Intransigeant,* January 14, 1929.

28. F. Tériade (Propos de Henri Matisse à Tériade), *Minotaure,* 3, no. 9, October 15, 1936, p. 3. In article "Constance du fauvisme."

The Primitivism of the Fauves, The Brücke, The Primitivism of the Blaue Reiter*

ROBERT GOLDWATER

Primitivism in Modern Art was first published in 1938. At that time African, Oceanic, and pre-Columbian cultures were not seriously considered or valued by historians of art. The study was radical then; it is a classic today. The vitality and pervasiveness of the primitivist impulse in modern art is now beyond question.

Goldwater both identifies the sources for this impulse and describes its modern forms, which include the child cult, eroticism, violent emotionalism, and an attraction to the exotic. In his conclusion Goldwater suggests that all varieties of modern primitivism have a common assumption: The further one goes back—historically, psychologically, aesthetically—the simpler things become, and as they become simpler, they become more profound and more valuable.

He connects various twentieth-century artists, identifying their common ground. For example, he stresses how the Fauves' discovery of African sculpture unleashes a vigorous formal energy, while the German Bridge (Brücke) School applies similar sources toward more personal ends. The Blaue Reiter painters identify with folk and children's art. The following essays make clear these distinctions.

* Reprinted from *Primitivism in Modern Art* (rev. ed. 1966; New York: Random House, 1938).

As organizer and director of the Museum of Primitive Art in New York and Professor of Fine Arts at the New York University Institute of Fine Arts, the late Robert Goldwater was equally at home with a Cameroon figure and a bather by Matisse.

THE PRIMITIVISM OF THE FAUVES

In their knowledge of primitive art the painters who constituted the group known as the Fauves differed in one important respect from Gauguin. He was familiar with some Aztec sculpture and with the work in stone and wood of the South Seas, but, if we except India and Egypt from the list of the primitive, he knew of no other indigenous non-European artistic tradition. The Fauves added African sculpture, and, unaware of the parallel findings of the Brücke in Dresden, prided themselves upon being the first to discover and appreciate its aesthetic values.

The exact date and circumstances of this discovery are still somewhat in doubt, there being numerous claimants for the honor.[1] The most convincing account, and the one traditionally best established, is that by Vlaminck who, in his autobiography, *Tournant Dangereux* (1929), tells of seeing two Negro statues behind the counter of a bistro, among the bottles of picon and vermouth, and of buying them for two liters of aramon, with which he treated the customers present.[2] He bought them because he experienced "the same astonishment, the same profound sensation of humanity" that he had had from the puppets of a street fair, which, however, he had not been able to purchase.[3] In this first recollection Vlaminck does not give the date of his discovery and acquisition, but judging from its context, we may place it in the year 1904, and certainly not before 1903. Recalling this same incident in a book that appeared in 1943, however, Vlaminck places it in 1905, and describes three statuettes: two from Dahomey, painted red, yellow, and white; and one, all black, from the Ivory Coast. Although he had often visited the Trocadéro with Derain, he had until then thought of African art as "barbaric fetishes." Now he was "profoundly moved . . . sensing the power possessed . . . by these three sculptures." Then a friend of his father gave him two more Ivory Coast figures and a large white Congo mask.[4] Derain, who at this time was in close association with Vlaminck, soon saw the statues and admired them. Derain was particu-

larly struck by the mask, which he bought and hung in his studio in the rue Tourlaque.[5] It was there, recounts Vlaminck, that both Matisse and Picasso first saw and were impressed by African art, although their own recollections are somewhat different. Vlaminck never collected extensively; Derain did, adding folk art and the archaic arts of both East and West. Matisse's very considerable collection was perhaps begun as early as 1904, and certainly before 1906. Apollinaire, writing in 1909, said of him: "He likes to surround himself with objects of old and modern art, precious materials, and those sculptures in which the Negroes of Guinea, Senegal or Gabun have demonstrated with unique purity their frightened emotions."[6]

The admiration for this new primitive tradition differed in some respects from any previous appreciation of exotic art. For the first time the products of a native culture were being considered as isolated objects, entirely apart from the context of their creation. Gauguin had had to go to the Marquesas to come upon Polynesian art, and its exotic content and association interested him as much as its form; even his copying of Aztec sculpture took place in the proper setting of a colonial exposition where its foreign origin could not easily be forgotten. Even if the popular origin of Japanese prints was ignored, and they were admired as individual objects of art, they never lost their connection with a definite foreign culture. The admiration called forth by these individual pieces of African sculpture, however, returns in a double sense to an earlier stage in the history of the taste for the primitive: We have mentioned that the first objects of native art were collected as curios, objects that were evidence of the diversity of the human imagination and of the ingenuity of the primitive craftsman. In Vlaminck's appreciation of African sculpture there is still something of this attitude, so that in part he is drawn to these statues by their strangeness and their curiosity, rather than by their qualities as works of art. For this reason he "cannot keep himself from smiling" at the later developments in the history of African art, the determination of its origins, its arrangements and its classification, all of which is taken so seriously.[7] The other side of this attitude (likewise a throwback in taste) is the consideration of these objects as symbols, one might almost say mystical symbols, of the primitive, as is still suggested in Apollinaire's curiously admiring description of them. Thus Vlaminck and the other artists who early collected African sculpture preferred objects that our present knowledge shows are poor examples of their respective styles, either because they are by inferior craftsmen or because they are representative of a late

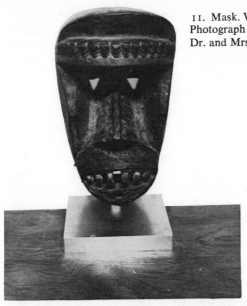

11. Mask. Wood. H. 9″. N'guere tribe, Africa. Photograph courtesy collection of Dr. and Mrs. Norman Dinhofer.

stage of evolution.[8] We may indeed call them "poor" in the purely technical sense of mastery over the material, without introducing any aesthetic qualifications at all. Objects of this kind corresponded better to the idea of the primitive work of art that they were considered as embodying, so that more could be read into them than into highly finished examples. There is here still something of the notion of the compulsory childishness of African technique and its inability to produce accomplished work; it is part of the same preconception that had made it impossible to accept the bronzes of Benin as really African because their technical mastery resembled too closely the work of more developed cultures. Only after 1933 did Derain, then striving to revive the classic tradition, concentrate on Benin sculpture, just because it was the most "evolved" and technically refined of African arts. Thus ignorance concerning primitive culture, once simply a fact, is consciously preserved as a positive value, and the combined (if opposed) attributes of childishness and mystery can still be attached to the primitive object. Even the Surrealist enjoyment of native art contains much of this double exoticism.

In spite of the separation of the statues from their context, therefore, the Fauves' appreciation of African sculpture was not the isolated admiration for the solution of a purely formal problem (fig. 11). In

London, in 1910, Derain found African sculpture "amazingly, frighteningly expressive," both because of its symbolic meaning and because its forms were designed to function in a full outdoor light.[9] Such admiration for primitive works of art did not come about before the time of the Cubists, and even then, such a pure-form point of view was more an ideal than a fact. The aesthetic attitude of the Fauves, while it goes further than that of Gauguin, is still mixed with much of his romanticism. This can be seen in their continuing admiration for anything that is primitive, or that they consider primitive, regardless of whether its formal qualities resemble those of other primitive works that they also admire. Thus Vlaminck and Derain collected not only Negro sculpture, but provincial and popular art as well—the *images d'Epinal* of Gauguin, and the labels on packages of chicory.[10] But the Egyptian and the Asiatic were neither provincial nor bizarre enough for inclusion in this modern curio collection. That such was really their attitude is further borne out by the absence of any direct influence of primitive art upon the painting of the Fauves; there is hardly any trace of either African or Oceanic production in the form or subject matter of their pictures, and while knowledge of Japanese prints makes itself felt, their style was largely absorbed through the medium of Van Gogh's art.[11] The art of the Douanier Rousseau also was known to the group and interested its members, but as Marquet has mentioned, it "remained entirely outside of our work."[12]

Lacking any direct borrowing of subject matter or copying of form from the primitive, in what does the primitivism of the Fauves consist? It is evident in the first place in their choice of subjects to paint, and their relation to these subjects. One of the most common themes is that of nudes bathing in a landscape, a scene neither new nor original, yet given a treatment, quite apart from the method of drawing and the handling of color, that sets it off from anything that has gone before. The figures are not simply placed in a landscape setting that serves them as a scene of action while they yet preserve their human characters distinct from it; they are mixed up with the landscape in such a manner that they become part of it. In the Derain *Bathers* of 1907 (fig. 12), for example, the legs of the figure on the left are covered by the water, while the branches of a tree hide the arms of the figure on the right. The same mixing up and cutting off is found in the Derain *Bathers* of 1908 and in the treatment of the same theme by Vlaminck. Coupled with this is the cutting of figures by the frame of picture, which, by an amputation similarly carried out in the fragmentary character of the landscape, also

12. André Derain: *Bathers*. 1907. Oil on canvas. 51¼″ × 75⅞″. Photograph courtesy The Museum of Modern Art, New York. Private collection, Switzerland.

indicates that they are not considered as set within the natural scene, but as being coextensive with it.

Another aspect of the artist's attitude toward the human beings of their pictures is embodied in the lack of mutual psychological relation or of any active demonstration of emotion in general that these display. The scene portrayed is just a group of figures that stand or sit or lie about, looking into or out of the picture, but almost never at each other. There is no unified action that brings them into mutual play, as in the bathing scenes of Renoir, nor are there various stages of action leading toward the same goal, as in the *Bathers* of Daumier. The poses and gestures of the figures have no exterior determinant that can be grasped by the spectator, but are seemingly compelled solely by the interior mood of each figure. On the other hand the implications of this mood, in its still preserved "synthetist" qualities, differentiate these bathers from the likewise depersonalized constructions of Cézanne. They are, so to speak, not constructions, but reductions. The feeling of mood thus

created, of the rendering of a symbolic scene that is to affect the beholder by its symbolic qualities, by the suggestion of things outside itself, rather than a scene complete in itself and external to the spectator, is forcibly heightened by the filling of the frame by the figures. They reach from the top to the bottom of the picture, and are often incomplete at both extremes. Not being set back into the picture by any strip of foreground, lacking perspective depth and psychological distance, they impose upon the spectator immediately without any intervention of artificial setting; not bearing any relation to each other, but still partaking of a pervasive mood, they have an undetermined, but apparently important, relation to the spectator. We may note this effect in Matisse's *Bathers* (1907), and his *Women by the Sea* (1908), as well as in Vlaminck's *Bathers* and Derain's *Composition* of the same year.

The combination of immediacy and remoteness, of direct, intense appeal and unlimited implication, is not a paradox. The Symbolists (Gauguin, Munch, Hodler) had had similar intentions. We shall find it again in different forms in the later developments from Cubism and in the painting that derives its inspiration from the art of children. Among the Fauves it varies in its application. The shore scenes of Matisse use the broad expanse of sand and water, which is cut off at random and against which the figures are placed in emptiness, while the forest scenes of Derain and Vlaminck achieve the same unlocalized effect by the crowding together of figures and foliage in a uniform pattern so that the scene is indeterminate. This random cutting differs from that of the early Impressionist work of the 1870s in which, though objects are cut by the frame of the picture, they nevertheless retain their identity as complete and discrete objects that happen to finish outside of the frame, that indeed must be completed in the mind of the spectator if the much desired "slice-of-life effect" is to be achieved. This Fauve handling also differs from that of the late Impressionist landscapes in which, though the natural objects—trees, fields, water, and so on—may continue indefinitely, the composition of light upon surface, the true subject of these pictures is self-contained within them (see figs. 13, 14).

It is true that in certain of the Fauve paintings there are figures that, in their bent forms and closed contours, recall certain primitive and prehistoric work. (E.g., Matisse, *Bathers,* 1907, and *Women by the Sea,* 1908; Vlaminck, *Bathers,* 1908 and 1909.) Such similarity is hardly due to direct copying.[13] We may perhaps explain it by this very effort to give the figures meaning beyond themselves, replacing by an isolated emotional symbolism the natural and direct symbolism of the primitive

3. André Derain: *Les Pêcheurs à Collioure*. 1905. Oil on canvas.
8″ × 21½″. Courtesy Perls Galleries, New York.

14. André Derain: *Portrait of Henri Matisse*. 1905. Oil on canvas.
13¼″ × 16¼″. The Philadelphia Museum of Art, A. E. Gallatin Collection.

peoples. In that earlier religious context the single figure is quite naturally a self-sufficient magically efficacious image of a kind that the allusive ramifications of later mythological and hierarchical developments prevent.

These attitudes and effects may be pointed up by a comparison with two other bathing scenes of an earlier period. They are not the only pictures that could be chosen, but they will serve to bring out, by contrast, the Fauve attitude. In the Daumier *Bathers* the movement of the figures is motivated by an obvious action, that of undressing in preparation for the bath. All the figures have this common purpose, and they are shown in different stages of preparation for a common action, beginning on the right and culminating in the nude figure on the left. This figure is presented as unusual in its setting and is contrasted with the landscape in which it is put, both by its differentiation from the other dressed or half-undressed figures and by the way in which it is silhouetted against the background. It is daring both in action and in presentation. In the Fauve pictures not only is the nudity accepted (there being nothing to contrast it with), but by lack of concerted action and by similarity of modeling the figures are made to count in the same way—though not always to the same extent—as the surrounding landscape. A like contrast may be pointed out between these canvases, traditionally labeled "Bathers," although they are devoid of all that this implies of action and interaction, and the correctly named *Bathers* of Renoir. Here the figures are made to constitute a whole separated from an artificial setting by means of an active relation with one another, either actually physical or established through gestures and glances. The nakedness of the figures is brought out by hats and ribbons that lie about, adding piquancy to the scene, while the method of modeling the trees and grass is different from the treatment of the bodies. The Fauves treat their subjects with a combined directness and abstraction that is at the opposite pole from this half-aesthetic, half-sensual conscious appreciation.

If we have discussed the iconography of the painting of the Fauves before dealing with their methods, it is because the latter have usually been given much more consideration. The simplification of means; the use of a broad, unfinished line; the application of large areas of undifferentiated color; the use of pure color; the lack of perspective, both in the individual figures and in the composition as a whole—these are the most obvious characteristics of Fauve painting. Stemming from Gauguin,

from Van Gogh, and from Seurat, they mark a further simplification of the methods of these painters, a simplification that is in two respects primitivizing, but that also had consequences pointing directly away from primitivism.

In the purely technical sense, the broadening of the line, the direct application of color from tube to canvas, the lack of concern about nuances, within the color surface, the neglect of the general finish of the picture are in accordance with the appreciation of children's art and the kind of expressively simple primitive art that the Fauves admired. Like these, the appeal of Fauve painting does not depend upon the mastery of a sophisticated craftsman's skills but upon the immediate effect of the canvas as a whole. The Fauves are not concerned with subtleties of drawing or nuances of color, nor do they worry about carefully balanced masses and harmonious composition. If the Fauve pictures reproduce so badly in black and white, it is because they depend upon the violent effect of broad areas of color that are nearly of the same tonality, colors that impress themselves on the beholder by a common brilliance that disappears in reproduction. The desire is to interpose as little of the consciousness of the technical method as possible while imposing the immediacy of hue and pigment. Even where the actual application of the paint is divisionist in method, it is not really so, since there is no longer any concern about complementary colors or the fusion of these colors into a different whole. Toward the same end the palette is also reduced, only "pure" colors being used—that is, no colors were mixed before being applied; but because no active fusion is required of the spectator, there are even fewer obstacles between him and the painter than in the method of Seurat. In this the Fauves are closer to the manner of Gauguin and his wish to produce flat decorative harmonies than to either of the other principal influences working on them, even though their bright palette and pure colors stem directly from Van Gogh and to a lesser extent from Seurat.

The Fauves' reduction of the means employed to flat color areas and a limited selection of colors give their work directness and immediacy. These are not paintings to be studied and analyzed at length, compositions in which intricate relations can be grasped only after prolonged contemplation. This is not to say that these were inexperienced, unsubtle artists, unaware of tradition and technique. They employed their knowledge to eliminate from their work all that they felt was unnecessary to a single essential effect. The subtlety resides in an analysis that permits simplification, and that since it precedes all actual

painting is never present and can only be inferred. The result is simple and striking, and the appeal of these pictures, both iconographic and formal, is immediate and direct. Their aim is to produce a visual and emotional response that, without reflection, will "engage the whole personality," whether by means that shock, as Derain implies in "reinforcing the expression" of the Ghirlandaio that he copied in the Louvre;[14] or by means that comfort, as in Matisse's wish to make his art "something like a good armchair in which to rest from physical fatigue."[15] Color is to be used "to render emotion without admixture, and without means of construction," to portray the actual "vibration of the individual . . . rather than the object which has produced this emotion."[16] Communication between artist and spectator no longer is through the indirect means of rendering matter in such a way that it will produce in the latter the emotion that it aroused in the former, but emotion is to be rendered directly. "One does not depict matter, but human emotion, a certain elevation of spirit which might come from no matter what spectacle."[17] Such emotion, simple and wholehearted in itself, can only result from simple means.

On the other hand, the replacing of the world of objects by simple human emotion has in it, as we have already noted in our analysis of the composition of certain Fauve pictures, implications far beyond the canvas itself:[18] "The painter remains in intimate contact not alone with a motif, but also with the infinite nebulousness . . . [He] refuses nothing . . . of omnipresent space, let us rather say of extension."[19] Emotionally as well as in its formal structure, the picture becomes a symbol whose very generality increases its possible meaning. This grasping of reality through emotion has been compared with the philosophy that Bergson was contemporaneously expounding at the Collège de France.[20] Without going into the resemblances in detail, we may note the anti-intellectual, antianalytical aspect of the two phenomena, and their similar attempt to grasp reality by means of a return to something fundamental in the human being, to do away with a developed superstructure, with, as Matisse has said, "the acquired means," in favor of something native and simple. Insofar we may speak of both movements as primitivizing.[21]

Their effort to "return to naked simplicity" had induced the Fauves to reduce their methods of communication to one, namely that of color, and to employ this as directly as possible. This very reduction, however, necessitated in the end an amplification and refinement of expression through color that is far removed from the simplicity that was at first

envisaged. Lacking an interior elaboration of the canvas, only one thing can be said with one means, and it was just the elaboration of this means that those who remained closest to the Fauve method undertook. This is first evident in the work of Matisse, whose exclusion of line was never as drastic as was that of some of the later adherents, and is dramatically illustrated in his later career. Already in the *Joy of Life* (1905–1906; fig. 4), "the climax of the Fauve period," which, iconographically, has much of the idealization of simplicity and union with nature that we have noted above, there is "a flowing arabesque of line" and the indication of a succession of planes that are anything but simple.[22] In a composition of this kind the eye must follow the separate parts and move rhythmically about the picture, rather than grasp it as a whole, and it is this that distinguishes *Women by the Sea* (1908) from the static *Music* (1910) as well as the moving *Dance* (1909; fig. 6), close as it is in other respects.[23] In Matisse's painting from 1910 on, the use of color is continually refined, both in the tones used and in their combination in unexpected form, and in their employment to establish (often by extremely knowing allusions to previous styles) the structural composition of the pictures. This is also true of the work of Dufy, in which an apparently childish linear technique has been adapted with the utmost sophistication. His "bad" drawing is elliptical to such an extent—suggesting everything that it pretends it cannot represent—that it is really the exact negation of the child's attempt to set down in accurate detail all that he can recall about an object or a scene. And Dufy adds to this method color harmonies and juxtapositions of line and color that have become ever subtler since his Fauve days.

The other Fauve painters (see figs. 15, 16), also recognized, although in a different way, the difficulty of expressing themselves in colors "whose choice is determined solely by the exigencies of a tonal register."[24] Thus Vlaminck explains that because color led away from the comprehension of the universe, the original reason for its use, he was led to renounce it:

> It was necessary therefore to return to the feeling for things, abandoning the acquired style. Captured by light, I neglect the object. Either one thinks nature, or one thinks light. . . . I had to look for the interior character of things, save the feeling for the object. . . . Thus a more profound comprehension of the universe led me to modify my palette.[25]

Othon Friesz, also seeking "the maximum of expression," was led to renounce "the technique of colored orchestration" in favor of a "return

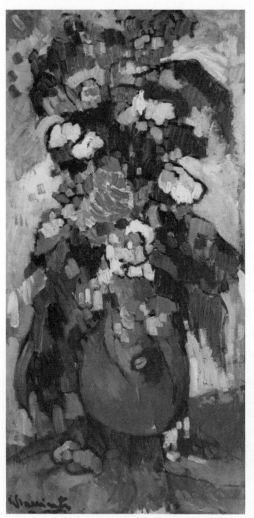

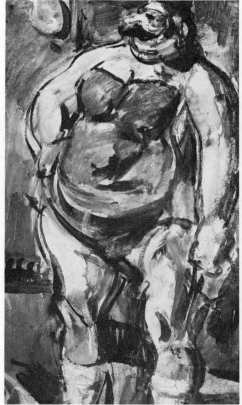

15. Maurice de Vlaminck:
Le Grand Vase de Fleurs. 1907.
Oil on canvas. 41″ × 20½″.
Courtesy Perls Galleries, New York.

16. Georges Rouault: *The Wrestler*. 1906.
Oil on canvas. 16¾″ × 10⅜″.
Courtesy Perls Galleries, New York.

to construction" that would render more adequately the emotions experienced before nature.[26]

These changes were designed to enrich the work. They now seem inevitable, since it appears that this road to simplification had reached its end. But as events were to show, they hardly ensured that the new, more complicated paintings would improve upon the older, "simpler" ones.

With this renunciation we too may halt our study of the search for the primitive and the essential among the Fauves, to begin it again among the works of other painters. In comparison with the conception of Gauguin, that of the Fauves is at once less localized and closer to home. In spite of the tropicalizing of much of their work, the scenes of the Fauves do not have the definite locale or the precise exotic associations of Gauguin's subjects, whether provincial or Polynesian. In their technique, too, the Fauves were more radical than the school of Pont-Aven, abandoning the conscious grace of "objective deformation" in favor of subjective composition. No longer seeking interior equivalents of an exterior world, no longer, that is, Symbolists, they attempt to short-circuit the connection and establish direct communication between individual and universal essentials. In the next essay we shall continue the study of this kind of emotional primitivism, noting how it once more became localized, partly by a return to exoticism and partly by its application to the personal and contemporary environment of the painter.

NOTES

1. It has been maintained by William Fagg in *Nigerian Images* (New York: Praeger, 1963), pp. 19–20, that the arrival in Europe in 1897 of the many Benin bronzes paved the way for the later enthusiasm of French and German artists for very different styles of primitive art from Africa and Oceania. The historical evidence hardly supports this contention. Although Benin art was readily accessible in the museums of Berlin, Dresden, and Munich, it was ignored by the Brücke and Blaue Reiter artists alike, just as Jacob Epstein ignored it in the British Museum. Among the Fauves only Derain came to it years later when his own style had shifted toward naturalism. The naturalism of Benin removed it from consideration by artists whose aesthetic goals were radically expressive and antinaturalistic.

2. Maurice de Vlaminck, *Tournant dangereux. Souvenirs de ma vie* (Paris: Stock, 1929), p. 88, trans. Michael Ross as *Dangerous Corner* (London: Elek, 1955), p. 71.

3. *Ibid.*

4. Cf. Vlaminck, *Portraits avant décès* (Paris: Flammarion, 1943), pp. 105–106. André Level (verbally, June 4, 1934) mentioned that he began collecting in 1904. D. H. Kahnweiler (verbally, June 6, 1934) also placed the discovery of Negro sculpture in 1904, and attributed it to Vlaminck.

5. There was a shop in the rue de Rennes run by Heman (or Sauvage), where the artists bought. Cf. Vlaminck, *Portraits*, p. 107.

6. It is interesting to note that Matisse did not collect Persian miniatures, even though they influenced his work. From 1933 on Derain concentrated on Benin bronzes. Cf. Alfred H. Barr, Jr., *Matisse, His Art and His Public* (New York: The Museum of Modern Art, 1955), p. 553.

7. Vlaminck, *Tourant dangereux*, p. 89.

8. Charles Ratton (verbally, May 27, 1936) was kind enough to show me photographs of objects coming from various collections to substantiate this point.

9. André Derain, *Lettres à Vlaminck* (Paris: Flammarion, 1955), p. 197.

10. René Huyghe, ed., *Histoire de l'art contemporain. La peinture* (Paris: F. Alcan, 1935), p. 105.

11. Quotation from Albert Marquet in Georges Duthuit, "Le Fauvisme, II," *Cahiers d'art*, 4, 1929, pp. 260–261. Barr, *op. cit.*, p. 139, notes that Matisse's *Two Negresses* (1908) "may well be influenced by African Negro sculpture . . . particularly the rigid, thickset figures of the Ivory Coast." The influence on Derain did not come until after 1909, when he had given up the Fauve style.

12. Duthuit, *loc. cit.*

13. Many of the Fauve stylizations of the contours of limbs, heads, and hair are close to Gauguin and his followers. Vlaminck's *Bathers* is a good example.

14. Quotation from Derain in Duthuit, *op. cit.*, p. 268: "J'ai copié au Louvre un Ghirlandaio, jugeant nécéssaire, non seulement de remettre de la couleur, mais de renforcer l'expression. On a voulu me mettre à la porte du Louvre pour attentât à la beauté." The picture is not a Ghirlandaio, but by Giovanni Utili; cf. R. Van Marle, *The Italian School of Painting* (The Hague: M. Nijhoff), Vol. 13, p. 177.

15. Henri Matisse, "Notes of a Painter," trans. Alfred H. Barr, Jr., *Henri Matisse* (New York: The Museum of Modern Art, 1931), p. 35. The following may also be added: "It is through it [the human figure] that I best succeed in expressing the nearly religious feeling that I have towards life. . . . The simplest means are those which enable an artist to express himself best."

16. Duthuit, *op. cit.*, p. 132.

17. *Loc. cit.* These statements seem to anticipate intentions attributed to the Abstract Expressionists of the "New York School" in the 1940s and 1950s.

18. Georges Duthuit, "Le Fauvisme, V," *Cahiers d'art*, 6 (1931), p. 80. Duthuit's analysis itself becomes somewhat mystical: "[La toile] possède une vitalité élémentaire; elle représente la cellule, choisie dans un organisme sans limite, par où la vie supérieure de l'esprit doit s'infuser au corps tout entier."

19. Georges Duthuit, "Le Fauvisme, IV," *Cahiers d'art*, 5, 1930, p. 130. Cf. Bergson.

20. *Ibid.*, p. 132. Bergson's philosophy, insofar as it is primitivizing, is not to be compared particularly with the primitivism of the Fauves; the parallel is

rather between this (and other anti-intellectual theories, e.g., Croce's aesthetic) and the general primitivizing tendency of the time.

21. Marquet and Matisse seem to have been the first to employ the Fauve method, in the sense of using pure, flat color; Marquet puts the date as early as 1898, and considers 1905, usually given as the beginning of Fauvism, as the beginning of the last stage. Duthuit, "Le Fauvisme, II," pp. 260–261.

22. Barr, *op. cit.,* p. 14.

23. Cf. also *Le Luxe* (1906), which has the same quality as *Women by the Sea,* and many of the characteristics analyzed above.

24. Duthuit, "Le Fauvisme, II," p. 262.

25. *Ibid.*

26. *Ibid.,* pp. 259–260.

THE BRÜCKE

The last essay dealt with the primitivism of French artists who were among the first to come into direct contact with primitive works of art. Though influenced by these works, and though Gauguin included some of their motifs in his own paintings, neither he nor the Fauves assimilated their form or their spirit in any serious manner, but were content to let them be external factors that determined style only through the general formation of their taste. This exterior quality may be felt in the extreme generality of the primitiveness of both Gauguin and the Fauves; their striving for the primitive expresses itself in terms apart from the artist, creating a somewhat symbolic effect even in the most direct productions of the Fauves. For this reason their primitivism has been described as still romantic in spirit.

The artists who constituted the Brücke group also knew of primitive painting and sculpture. The creations of the native artists of Africa and Oceania were "discovered" by Ernst Ludwig Kirchner in the cases of the Dresden ethnological museum in 1904, as he recounts in his history of the group, the *Chronik der Brücke*.[1] Whereas Gauguin had known the sculpture of the Marquesas and Easter Island, and perhaps of New Zealand, and the Fauves figures and masks from Africa, the Germans, with proper thoroughness, found both Africa and Oceania at once and in a museum; and as befitted the more advanced state of ethnological collecting in their country, they immediately became acquainted with a range and variety of style that the French took some years to discover.[2] Owing perhaps partly to this circumstance but also to their artistic intentions, they never regarded primitive art simply as a

curiosity, as Vlaminck did in large measure. As Emil Nolde wrote, it was at once "raised up to the level of art . . . pleasing, ripe, original art."[3] It is true that other primitive and exotic arts were being discovered at the same time—Chinese, Indian, Persian, and above all German woodcuts of the fifteenth and sixteenth centuries; nevertheless, since the members of the Brücke did little direct copying and were little interested in purely formal exercises, there is never any question of a borrowing eclecticism in their work. What fascinated them was the power and immediacy of primitive art or, as Nolde said, "its absolute primitiveness, its intense, often grotesque expression of strength and life in the very simplest form."

An element of exoticism nevertheless remains. This is evident not only in their admiration for Gauguin, whose art they came to know either in Germany or, like Nolde, on trips to Paris; or in the clear imitation of Gauguin's voyages and paintings in the work of Max Pechstein, the least original member and one of the later adherents of the group.[4] It can be seen also in the subjects chosen for their pictures, and particularly in those of Nolde. The ironically entitled *Missionary* (1912) and *Man, Woman and Cat* (1912)—although directly inspired by Dahomey sculpture—are interpretations of native life in terms of Dahomey art and show no attempt to copy its formal characteristics. Alongside such pictures as the several paintings of *Masks* (whether of 1911 or 1920; figs. 17, 18)—composed of isolated objects hung close together as one would find them in the documentary cases of a museum—and the *Still life with Dancer* and the *Still life* (1915)—which contain a New Guinea shield placed with other nonprimitive objects—appear such subjects as *Evening Glow, South Pacific* (1915), *New Guinea Natives* (1915), and *Indian Dancers* (1915).[5] These testify to Nolde's voyage to Russia, Japan, the Palau and Admiralty islands, New Guinea, and New Ireland in 1913/14, made perhaps under the inspiration of Gauguin, but after a long familiarity with Oceanic art. This voyage produced no such derivations as Pechstein's.[6] The dates of the pictures are significant because although some, like *Men from Manu* (1914) and *Papuan Family* (1914), were painted during his six-month sojourn, others, done later, show that Nolde had no need to make native portraits or to copy the decorative details of native art, as Gauguin had done: he could transcribe his impressions and his feelings after he got back home. In the pictures of the *Masks* it is difficult to recognize the exact provenance of each object, even at times to tell whether it is

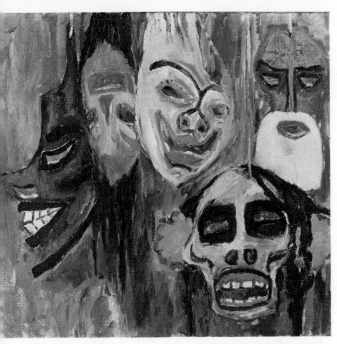

17. Emil Nolde: *Masks.* 1911. Oil on canvas. 28¾″ × 30½″.
Nelson Gallery–Atkins Museum, Friends of Art Collection, Kansas City, Missouri.

18. Emil Nolde: *Masks II.* 1920. Oil on canvas. 28¾″ × 35″.
Courtesy Marlborough Gallery, New York.

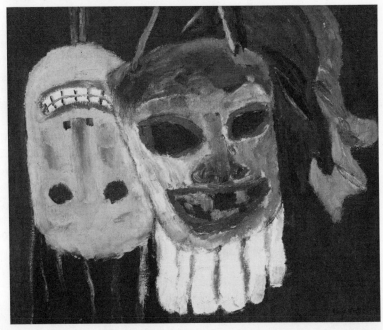

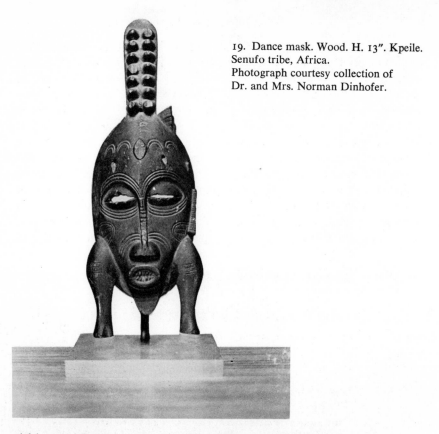

19. Dance mask. Wood. H. 13". Kpeile.
Senufo tribe, Africa.
Photograph courtesy collection of
Dr. and Mrs. Norman Dinhofer.

African or Oceanic (fig. 19). These pictures are not ethnological docu-
ments. They are not even the idealized documents that Gauguin painted,
in which correct details are merged into a whole that is meant to be the
unspoiled essence of the primitive world, a world that, because it is both
symbolic and ideal, remains outside and apart from both the artist and
the native life it is meant to interpret. Rather, the *Masks* are the
primitive in terms of the artist's own emotions, taken out of its context
and put into the artist's head, and are therefore both unlocalized and
immediate, qualities that are most striking in the close-ups of masks and
heads.[7] The change from Gauguin's point of view is toward an interior-
ization of the conception of the primitive, a change whose start we have
noted in the work of the Fauves, and which we will have occasion to
point out again.[8]

It is characteristic of the nonformal quality of the Brücke's appre-
ciation of primitive art that in the painting of Kirchner, its discoverer,

there should be little direct evidence that he knew of its existence (fig. 20). On occasion, he liked to create an environment of "primitive" sculptures for his figure pictures; but, like the "Oceanic" works in *Bacchanal* (1908), he carved such objects himself. It is perhaps possible to see in his sculpture the influence of Cameroon figures and house decoration, the more so since Cameroon was a German colony and its art was well represented in the museums.[9] In *Alp Procession* (1918), a relief in wood, the animal muzzles recall Cameroon work and the method of cutting back from the original surface of the block in order to indicate modeling, creating a zigzag profile outline, is similar to that used by Cameroon sculptors in the carving of their doorposts and lintels.[10] In *Woman's Head* (1912) the modeling of the lozenge eyes, the connection of the brows and the nose, and the projecting mouth and

20. Ernst Ludwig Kirchner: *Die schwarze Grete*. 1907. Oil on board. 20″ × 28½″. Collection Mr. and Mrs. Leonard Hutton.

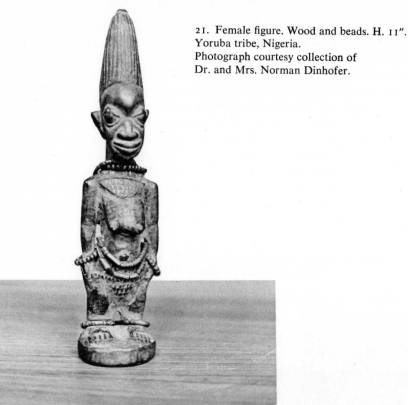

21. Female figure. Wood and beads. H. 11".
Yoruba tribe, Nigeria.
Photograph courtesy collection of
Dr. and Mrs. Norman Dinhofer.

chin likewise recall the Cameroon technique. In Kirchner's other carved figures, however, there is a much more general primitivizing effect. *Bather Drying Herself* (1905) and *Adam* (1920), for example, simply make use of a crude wood technique that recalls popular art wherever it is found, whether in primitive or advanced cultures, rather than the most characteristic work of the primitive peoples.[11] The use of contrasting color, which is found in the above-mentioned figures and again in *Women and Girl,* shows an approach to the primitive that is closer than that of most modern sculptors who have been drawn under this influence. Still affected by the idea of the beginnings of art as it was formed from an incomplete understanding of the archaic Greek, they carefully avoid the application of color and keep the surface of their work as uniform and unaccented as possible.[12] The primitive is conceived as reached by stripping off later layers of unessential accretion in order to

reveal a pure homogeneous core. The primitive is equated with simple uniformity. In reality, of course, the African and the Oceanic artist employs color whenever it will heighten the intensity of his work (as did also the Greek) and does not hesitate to have recourse to a diversity of material if it will serve his purpose (fig. 21), combining wood with metal, shells, feathers, or cloth as he wishes.[13] The color increases the realism of the subject, and while it intensifies, it limits the effect of the artistic conception, giving it a precision of reference that avoids the vague and undetermined symbolism which is usually connected with the primitivism of modern sculpture, but which plays no part, either in form or religious meaning, in the art of the truly primitive.[14] In this sense, if

22. Max Pechstein: *Evening in the Dunes.* 1911. Oil on canvas. 27½″ × 31½″. Collection Mr. and Mrs. Leonard Hutton.

not always in his formal rhythms, Kirchner comes close to the African and the Oceanic spirit.

In our discussion of the attitude of the Fauves toward the primitive, we have remarked upon their use of the nude human figure in a wild landscape setting.[15] We noted especially the union of the figure with nature, and the contrast of its lack of action with an apparent emotional savagery, combining to give the picture a symbolic quality. Both these aspects of the Fauve attitude, and consequently the resulting symbolism, are intensified in the work of the Brücke artists. The settings chosen, as with the Fauves, are either the beach or the forest, and the figures are again given in close-up, covering nearly the entire height of the picture when they are not themselves cut by the frame (fig. 22). Such scenes occur very frequently in the work of Kirchner, who, through a high horizon and a lack of depth in the landscape, makes almost no compositional distinction between the two geographical classifications, just as he employs the same intense palette. This was already apparent in the Fauves' treatment, but in their work broad areas of flatly applied color and straight lines of sea and sky emphasized the extensiveness of the sand and water, while here the more broken color areas and the interrupted contours of the objects minimize the distinction and tend, in either case, to make the setting grip the figures. There is, for example, no difference of immediacy and expanse between *Nude Girls at the Beach* (1912), where there is almost no sky and the red-hued figures are buried in the foliage, and *Four Nudes Under Trees* (1913), where the identical high format is used. This conception is of course not confined to Kirchner, and we may mention as other examples *Red Dunes* (1915) of Schmidt-Rottluff, Otto Mueller's *Girls Bathing* (1921), and Heckel's *Glasslike Day* (1913).

It is characteristic of the manner of conception of these subjects that even where the views are typically northern ones, as in the scenes of beaches or sand dunes—not to mention those of woods und forests, which are perhaps of a more southern nature—the effect achieved should nevertheless be that of a tropical landscape. We have already mentioned this tropicalizing in the work of the Fauves, and here, as in their painting, it results from the effect of the proximity of the spectator to the scene rendered, his feeling that he is in immediate contact with it, rather than viewing it from a distance. This feeling, in its turn, comes from the closeup aspect of the objects depicted, the apparently unfinished, random quality of their choice, and the even distribution of the

composition over the canvas. These elements, present in the Fauves' painting, are here depicted with an ever greater intensity, an intensity further heightened by a darker, more saturated color scheme and a closer juxtaposition of opposing hues. As with the Fauves again, the violence of these pictures is due to the manner of composition of the subject, rather than to any violence inherent in the subject itself. The figures are without an individual psychological character and have no binding relationship or common point of interest. This isolation is even indicated in the titles: The participants are no longer "bathers," whose action issues from an interior volition, they are "nudes under trees," whose meaning and whose significance lie just in the fact of their being under the trees, on the beach, or in the forest. They are to be treated as one with their setting in nature, and it is this assimilation that gives them their meaning. Even the graceful attitudes of the Fauves' figures, indicated by flowing curves and closed contours, have disappeared, and in their place there are flipperlike hands and feet that seem to terminate in and become part of the surrounding foliage.[16]

The paintings of the Brücke that we have discussed so far are in line with the Romantic-Symbolic attitude toward nature and toward the primitive in its union with nature that we have seen in Gauguin and in the Fauves. In Gauguin the type of scene we have been considering was definitely exotic; with the Fauves it was unlocalized; but the painters of the Brücke attempt, unsuccessfully perhaps, to bring to their northern home these equatorially conceived landscapes. They are reinforced in this tendency by the other aspect of their primitivism, an aspect that is more particularly northern in character and that stems from northern prototypes. This side of the primitivism of the Brücke is directly emotional, attempting the portrayal of emotions and passions in as outspoken a manner as possible. The scenes rendered are not simply pleasant views painted with purely pictorial concerns in mind; they are thought of as having some connection with the fundamentals of human life and destiny. They may vary in type and character but there is always an attempt to bring into conscious prominence the essential emotion behind the accidental physical setting. One must not, however, read too much into their rather uniform stylistic intensity. Kirchner was searching for "the natural in man and nature" and in the relationship between man and woman.[17] It is this quest that explains the subjects of these pictures, just as it is connected with the simple bohemianism of the Brücke style of living.

Apart from the landscapes we have discussed and the portraits to which we shall come, the two most frequent kinds of subjects painted by the Brücke artists are cabaret and music-hall scenes and scenes from the Bible. Superficially these have nothing in common; nevertheless both furnish an opportunity to depict emotion at a level of intensity that is rarely reached in the ordinary routine of daily events. (The depiction— often sentimental—of both clown and prostitute as essentially unsullied vessels of goodness and tragedy, which has a long history in modern art, is related to this desire to find concentrated symbols.) In such a picture as Heckel's *Clown and Doll* (1912) the individuality of the figures, the existence of the actors as separate human beings, has almost disappeared in favor of the purely typical roles that they are playing. Their relation is made symbolic of a type relation, of a basic human situation. The figures are of course themselves types; the lack of modeling, the stiffness of gesture, and the compulsory absence of facial expression emphasize still further their lack of individuality. Elsewhere, when such a clear symbol cannot be chosen, the particular, separate character of the subject is done away with by similar means. Above all, the faces are never individualized, the features being given as large unmodeled spots of color within the area of the head. Often, as in Nolde's *Comedy* (1920) or *Be Ye as Little Children* (1929.), it is impossible to tell whether or not certain of the figures are wearing masks, and the undetermined quality of the picture and its power to evoke meanings beyond itself are thereby greatly enhanced.[18]

Such a picture as *Comedy* recalls—in the caricatures of the faces, the vertical alignment of the figures, and the indefinite haze from which the figures emerge with a certain ghostlike quality—the work of James Ensor, whom Nolde visited in 1911.[19] There is, however, this difference —that Ensor's atmosphere is wholeheartedly of another world, whether of the spirit or of the dream, whereas here this world has not been completely exorcised. The result is that while one is at times uncertain whether or not caricature is intended; the terrible quality of these pictures, their hinting at some underlying, basic reality that would be awful if it could but break through in its full power, is much greater than in the work of Ensor. On the other hand, some of the subjects painted by these artists, particularly Kirchner's scenes of cocottes, of brothels, and of the *variétés,* recall Toulouse-Lautrec's treatment of the same type of life.[20] With the French artist, however, the tragedy, whenever it is portrayed, is a personal one; and it is the ironic contrast of the indi-

vidual and the role that counts, so that the superficially amusing elements must always be kept in mind. Kirchner, not bothering with the reality of tinsel charm, immediately does away with the surface qualities and brings into play (in a manner that foreshadows the later work of George Grosz) the underlying forces of human nature that determine the particular situation that he is rendering. In other words, he is plumbing deeper, more primitive depths than either of his predecessors.

It is in this sense also that the religious scenes must be interpreted. They are attempts to bring out the essential, the inner quality of the story, getting rid of everything but the concentrated expression of violent emotion. The dogmatic, the churchly surface is stripped off, and a return is made to a primitive Christianity. For we must recognize here, in spite of the tremendous formal and emotional distance that separates them, an attitude toward religion akin to that of the Nazarenes.[21] The idyllic, pastoral-classicizing quality of these reasonable romantics—their archaizing simplification that preponderates over all realism of detail— is here replaced by a simplification of technique and an omission of all detail, a deliberate suppression of nuance and overtone in favor of a single, undifferentiated, overwhelming emotional effect. Nolde's *Entombment* (1915), through the crowding of its composition, the concentration of its modeling on the closely juxtaposed heads with their large features, and the reduction of these heads to the expression of a single, dominating emotion, becomes a thing of immediate terror. In *The Last Supper* (1909) individual reactions and *affetti* are neglected, and a single group emotion, terrible and wonderful, unites all the figures in one sweeping whole. A similar concentration ties together the series of the life of *Mary of Egypt* (1912; figs. 23, 24), in which, as in *Dance Around the Golden Calf* (1910), Nolde recognizes a relation between sexual drives and religious passion. Where the nineteenth century strives to reach religious truth by ridding itself of historical and geographical accretions, the twentieth century attempts to find it by stripping the emotional overlay of the individual. And where the nineteenth century thought of the primitive, thus revealed, as calm and reasonable, the twentieth sees it as violent and overwhelming.[22] These are some of the differences between the primitivism we are studying and the romanticism out of which it grew.

To a critic who told Emil Nolde that he must make his pictures much milder if he wished to sell them, the artist replied, "It is exactly the opposite that I am striving for, strength and inwardness."[23] The

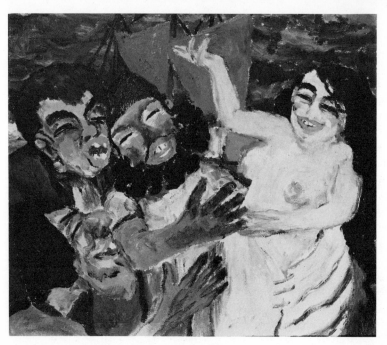

23. Emil Nolde: *Mary of Egypt: In the Port of Alexandria.* 1912. Oil on canvas. 33½″ × 39″. Courtesy Freunde der Kunsthalle, Kunsthalle, Hamburg.

24. Emil Nolde: *Mary of Egypt: Death in the Desert.* 1912. Oil on canvas. 33½″ × 39″. Courtesy Freunde der Kunsthalle, Kunsthalle, Hamburg.

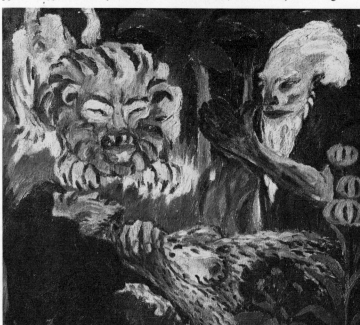

desire that Nolde expresses in this manner comes out very clearly in the portraits and in the figure groups that are combinations of portraits, painted by all the members of the Brücke group. Their interest does not lie in anatomical structure or in the formal relations of cubical mass and surface light and color, but rather in the strong expression of a single dominating character. Toward this end the features, particularly the eyes and mouth, are exaggerated and contrasted with the rest of the head, while the whole figure emerges from a background that is neither clearly indicated nor entirely abstract in character, and that seems pregnant with possible forms. The faces are either devoid of ordinary expression, and with fixed eyes seemingly intent upon something within, as in Nolde's *Woman and Child* (1914) or Schmidt-Rottluff's *Portrait of S. G.* (1911); or they convey a violent, uncontrolled emotion, which is again the product of an interior force rather than related to the outside world, as in Heckel's *Roquairol* (1917) and his *Self-Portrait* (1919; fig. 25) or Nolde's *Excited People* (1913).[24] In these pictures the feeling of a basic controlling force against which there is no rational struggle remains human in its application; in others, where there is some indication of the background, it extends from the outside world so that the figures become the focus of surrounding forces. In such a picture as *Making-up* (1912) by Heckel, the silhouetting of the figures against the background, the dark forms of the figures themselves, and the bare landscape seen through the window, indicate the influence of Munch's

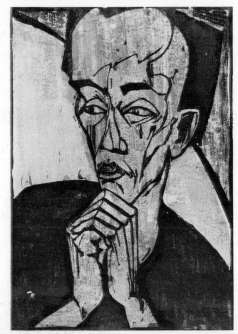

25. Erich Heckel: *Self-Portrait.* 1919.
Color woodcut. 18³⁄₁₆″ × 12¾″.
Collection The Museum of Modern Art,
New York, Purchase.

art. Munch himself, as we have seen, was interested, in the same symbolic way as the other artists of the Jugendstil, in depicting the basic forces of the universe, and he added a violence of emotion that was lacking in the more decorative work of other men.[25] However, he connects emotional violence and the immanent forces of the surrounding atmosphere only with the recognized basic and crucial situations of human life. His people are momentarily "possessed" and seem to await release, while the persons shown by the Brücke are themselves composed of such forces and such emotions.

In analyzing the pictures to which we have referred, we have noted the simplification of form, its definition within simple contours, and the elimination of nuances of modeling and variegations of surface that might detract from the single immediate impression that the artist wishes to convey. To a certain extent such a formal reduction must be accompanied by a similar technical simplification, and at the start of any such process it may be impossible analytically to separate the two. Where finesse of line, for example, is used to depict simple, or simplified forms—as in some of the drawings of Picasso—the result, far from being simple, is one of extreme sophistication. In the work of the Brücke, however, there is. a deliberate coarsening of technique, the beginnings of which we have already seen among the Fauves, and an emphasis upon this coarsening that goes far beyond any such technical necessity. The Fauves made use of thick, unfinished line, but Kirchner reworks his outlines in different colors, leaving the various lines all of an equal strength and not picking out the final contour. In *Portrait of Dr. Döblin* the linear contour has been blurred with pencil and crayon zigzags normal to the curve of the form, and the same conscious coarsening, whose occasional absence in other works proves it not to be a necessary part of the artists' vision, is again present in the pen drawing *Pair in Conversation* (1913).[26] Such a deliberate confusion of the outline, which also occurs in some of Schmidt-Rottluff's work, is due to the influence of children's drawings, where, however, the reworking is a sincere effort to pick out the true contour (see fig. 26).[27] Here the desired effect is of something unstudied, less artistically artificial and consequently truer to the inner qualities of the subject. To the same influences and to the wish for the same effect may be ascribed the filling in of the background of so many of these graphic portraits with an unregulated scribble that again resembles the work of children and that indicates clearly the value given to the immediate and the unfinished.[28]

It is natural that an attitude such as this should create an interest in

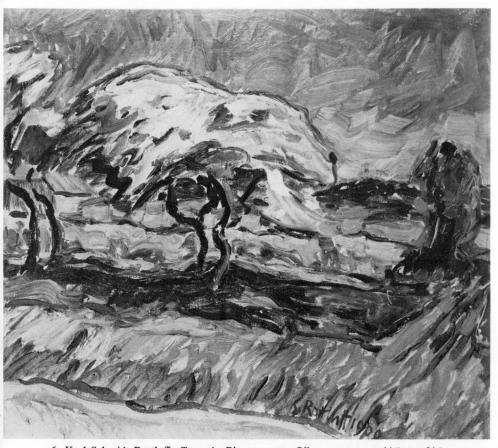

26. Karl Schmidt-Rottluff: *Trees in Bloom*. 1909. Oil on canvas. 27¼″ × 31¾″.
Collection Mr. and Mrs. Leonard Hutton.

modes of artistic production that not only permit but force a crudity of
finish and technique. Nolde praised primitive pottery and sculpture
because it was executed directly in the material that it expressed, with-
out the distortion introduced by preparatory drawings. The great popu-
larity of the woodcut and the linoleum cut among the members of the
Brücke group is due to the opportunity that these media give for bold,
uncomplicated effects of the sharp contrast of large and undifferentiated
areas of light and shade. Gauguin, as we have seen, was fond of the
woodcut for the same reasons, and even chose to simplify the primitive
motifs from which he largely borrowed. The woodcuts of Kirchner and
Schmidt-Rottluff are influenced rather from the "primitive" German
woodcuts of the fifteenth and sixteenth centuries, as is evident not only

in the technique but also in the prevalence of religious subjects.[29] It is significant that the refinement, or rather the lack of refinement, of technique that is used corresponds to a rather early stage in the development of the woodcut, and that the modern artists prefer to reduce the possibilities of even so limited a medium.[30] The tortured aspect of both styles is due more to a correspondence in artistic situation—a correspondence that made the technical borrowing possible—than to a direct copying of the earlier style by the modern artists. The linoleum block is of course the child's medium par excellence, and the interest in the child's artistic education, which grew so rapidly in Germany in the first decade of this century, had given rise to its wide use in schools and art classes.[31] Its use by the Brücke group is further proof not only of the kind of aesthetic primitivism that we have shown to be one of the chief aims of their painting, but of a direct influence from the art of children.

What, then, are the distinguishing marks of the primitivism of the Brücke group? There is in the first place an influence from three kinds of art that were considered primitive: African and Oceanic sculpture, German woodcuts, and children's drawing. The discovery and the interest in Oceanic sculpture marks an extension in the appreciation of the arts of primitive cultures, and also a change toward a more emotional consideration. Second, there is an influence from three artists whom we have seen to be, each in his different fashion, primitivizing themselves: Gauguin, Ensor, and Munch. But the chief characteristic of the primitivism of these artists is a tendency to call all the refined and complicated aspects of the world about them superficial and unimportant and to attempt to get behind these to something basic and important. Their main interest lies in the bases of human character and conduct, and these they conceive as violent and somewhat unpleasant, attempting to express them by simplifications of form and contrasts of color. The "expressionist" character of their art (a term thus far purposely avoided) lies in the thoroughness and the narrowness of this interest, rather than in any purely optical difference from "impressionism."[32] There has been some discussion as to whether primitivism is an essential component of this art or whether it is the result of the desire for a maximum of emotion and the wish to penetrate to the essence of things.[33] On this point there can hardly be any question. The maximum of emotion has not always been conceived in terms that necessitated formal simplification or the reduction of technical means, as witness the Baroque. Nor has the essence of things been thought of as being reached by penetrating, as it were, downward and into the depths, as witness the

rational refinements of the neoclassic. It is just because the search for these qualities takes the form that we have examined that we may characterize the art of the Brücke as primitivizing. The study of Gauguin and of the Fauves has shown that this is not the only manner in which primitivism can manifest itself. In spite of certain exotic tendencies, the Brücke artists are influenced by arts that are less outside their tradition and create symbols from elements—personal and social—that are closer to their own lives than any of their predecessors. The symbols thus become of greater force and of wider application, but, just because they are less objective, they may also become more vague; and into such vagueness, mistaken for generality, any meanings can be read. We shall see, in the work of the artists of the Blaue Reiter, how such a desire for universal meaning can transform the nature of their art.

NOTES

1. The *Chronik* was written in 1913. It is reprinted in Lothar-Günther Buchheim, *Die Künstlergemeinschaft Brücke* (Feldafing: Buchheim-Verlag, 1956), pp. 102–104. In a sense the Brücke discovery of the primitive was antedated by Kokoschka's enthusiasm for Oceanic art, which he found in Vienna's ethnological collections about 1902. But Kokoschka was still in secondary school and not yet an artist. Cf. Edith Hoffmann, *Kokoschka: Life and Work* (London: Faber and Faber, 1947), p. 26.

2. The quality of objects in the German museums was well above that of the pieces in French commerce until after World War I.

3. Emil Nolde, *Das Eigene Leben* (Berlin: Julius Bard, 1931), p. 158. Nolde's opinion of primitive arts in general is worth recording:

> Als etwas Besonderes, wie eine Mystik, stand vor mir die Kunst der Ägypter und Assyrer. Ich konnte sie nicht, wie damals fast allgemein, als "geschichtliche Objekte" nur werten, ich liebte diese grossen Werke, wenn auch es war, als ob ich nicht dürfe. . . . Das folgende Jahrzehnt brachte Einsicht und Befreiung; ich lernte die indische, chinesische, die persische Kunst kennen, die primitiven seltsamen Erzeugnisse der Mexicaner und die der Ur und Naturvölker. Diese waren mir nicht mehr nur "Kuriositäten," wie die Zünftigen sie benannten, nein, wir erhoben sie zu der Kunst, die sie ist, beglückende herbe Urkunst, und das war herrlich. Der Wissenschaft der Völkerkunde aber sind wir heute noch wie lästige Eindringlinge, weil wir sinnliches Sehen mehr lieben als nur das Wissen. Auch Bode war noch grosser Gegner künstlerischer Geltung des Urprimitiven.

Cf. also Nolde's *Jahre der Kämpfe* (Berlin: Rembrandt-Verlag, 1934), pp. 172–173, where he quotes from his 1912 notes for an introduction to an (unpublished) book on primitive art.

4. Pechstein was the only one of the group to collect African art extensively, beginning almost immediately after his introduction to it. Karl Schmidt-Rottluff did not appreciate it until later. Pechstein's attitude always remained external and aesthetic; in contrast to Gauguin's symbolic projections his paintings of the Palau Islands (1913–1914) are "folkloristic reportage with ethnographic indications." Pechstein's work also has in it many other influences: Matisse, Van Gogh, and the Cubists. Directly influenced by Gauguin was Paula Modersohn, in Paris in 1903; she follows both his formal simplifications and his Romantic-Symbolic painting of peasant types. The Worpswede community of which she was a part had many primitivizing elements. Its desire to draw strength from a return to native soil was carried over further in the Bavarian group of *Die Scholle*.

5. Nolde's preferences—Courbet, Millet, Manet—and his dislikes—the eighteenth century, the Impressionists—are characteristic. Cf. Nolde, *Das Eigene Leben,* pp. 143–145.

6. See also *Still Life (Mask, Head, and Green Animal)* (1913), in which the mask and animal are perhaps African; and *Strangeness* (1923), in which there is a New Guinea influence in the birdlike features of the faces.

7. These qualities also occur in the portraits, such as *Artists* (1919) and *Young Couple* (1920).

8. See below, the section of the Blaue Reiter.

9. The kind of sculpture and masks appearing in Nolde's work is that of German (now Australian) New Guinea (*Strangeness,* 1923). Two of the pieces in *Masks* (1920) are from the Cameroon. Two pieces of sculpture, Schmidt-Rottluff's *Head* and Pechstein's *Squatting Figure,* show a knowledge of the forms of Baluba (Congo) heads and masks.

10. Cf. the carved posts and lintel now in the Berlin Museum, reproduced in Eckhart von Sydow, *Die Kunst der Naturvölker und der Vorzeit* (Berlin: Propylaen-Verlag, 1923), pl. 116.

11. The best work of the primitive peoples is, on the contrary, characterized by a careful attention to surface and a high state of finish, since the details have precise iconographic significance.

12. Note the work of Brancusi, of Derain, of Maillol, of Modigliani. Epstein's variations are purely of texture.

13. On the Ivory Coast and in the Cameroon metal and wood are combined; in the Cameroon, beads and wood; elsewhere in Africa, shells and wood. The most diverse combinations of Oceania are those of New Britain and New Ireland.

14. This precision of reference is not often realized by the modern connoisseur; the art of the Bakuba and of Easter Island are examples. Here, as elsewhere, full knowledge might detract much from our present appreciation.

15. See above, pp. 46–48.

16. Cf. Schmidt-Rottluff's *Moonlight* (1919), *Women in Greenery* (1919), etc.

17. W. Grohmann, *E. L. Kirchner* (New York: Arts, 1961), pp. 30–32.

18. The same vague mysterious quality is present in such pictures as Nolde's *Child and Large Bird* (1912) and *Strange Conversation* (1916).

19. See above, pp. 58–59. One of the 1911 *Mask* paintings is perhaps influenced by Ensor.

20. Compare Heckel's *Dying Pierrot* (1912), with its squeezed mannerist composition and its relation to a *Descent from the Cross,* with any French work.

21. At its inception, the Brücke also attempted a similar association of its artists as had the Nazarenes and the Pre-Raphaelites. The Worpswede group also tried to set up a community.

22. Both, nevertheless, go back to what they consider the human qualities at the base of their religions.

23. Emil Nolde, *Jahre der Kämpfe,* p. 44.

24. It is interesting to compare these portraits with Géricault's studies of mad people, where the interest is in the objective rendering of an external countenance. The interest has been reversed.

25. Munch's first success came with the "Sezession" of 1902. In 1906 he did the decorations for Ibsen's *Ghosts,* produced in Berlin by Reinhardt. Cf. Curt Glaser, *Munch* (Berlin: B. Cassirer, 1917), pp. 36, 67.

26. Cf. *Potsdamer Platz* (1913), *Fünf Frauen in der Strasse* (1913), and *Lungernde Mädchen* (1911), where this technique has been used, and contrast these with the drawings: *Zwei Mädchen im Hause* (1906), *Trauriger Kopf* (1906), where the contours have been picked out with a single line.

27. Cf. *Moonlight* (1919). The influence of children's methods of composition also appears: *Fishermen with a Boat* (1919). Kirchner liked to emphasize the relationship of his mature work to his childhood drawings by showing them together.

28. Cf. the preface to the *Berliner Sezession Schwarz-Weiss Ausstellung: November 1911:* "Wir wollen im Gegenteil (to position that only recognizes the 'deutlich zu Ende geführte') auch al das Künstlerische und Interessante, was in den ersten Entwurfen und Studien . . . liegt, an die Öffentlichkeit bringen. So haben wir das Publikum gelehrt, der Kunst in ihren ersten Stadien der Entwicklung . . . nachzugehen und sie zu beobachten."

29. Cf. Kirchner, *Chronik der Brücke,* in which he mentions German fifteenth- and sixteenth-century woodcuts as having been part of his artistic education. Buchheim, p. 102.

30. The idea that simple effects that do not approach those of other media are "proper" to the woodcut is in itself a modern idea; older artists developed all the possibilities of detail. The whole attitude of simplicity due to "truth to the material" (to be found also in modern architecture and sculpture) has certain primitivist implications.

31. C. Ricci, *L'Arte dei Bambini* (Bologna, 1887), was translated into German in 1906: *Die Kinderkunst* (Leipzig, 1906), and this was the beginning of much interest in the artistic education of children; notable experiments were in Munich. Cf. Helga Eng, *The Psychology of Children's Drawings* (New York: Harcourt, Brace, 1931).

32. Georg Marzynski, *Die Methode des Expressionismus: Studien zu seiner Psychologie* (Leipzig: Klinkhardt & Biermann, 1921), pp. 39–41. Marzynski divides all art, from that of children on, into the "copying" and the "symbolic."

33. G. Johannes von Allesch, "Die Grundkräfte des Expressionismus," *Zeitschrift für Aesthetik und Allgemeine Kunstwissenschaft,* 19, 1925, pp. 112–120. And Max Dessoir, Appendix to the above, pp. 118–119.

Zunächst scheint mir, dass der Herr Vortragende nicht genügend die dem Expressionismus eigne Rückkehr zur Primitivität betont hat. Diese Rückkehr ist ja nicht dadurch bedingt, dass die Formenund Farbengebung der Primitiven besonders ausdruckskräftig ist, sondern sie Entspricht dem Drange, der sich auf vielen Gebieten unseres gegenwärtigen Lebens bemerkbar macht: Wurzelhaftigkeit, Ursprünglichkeit, unverstümmelte Erlebnisfähigkeit zurveckzuerobern. Dieses Streben nach Ursprünglichkeit liegt den von Herrn v. Allesch hervorgehobenen zwei Haupstabsichten der expressionistischen Kunst zugrunde . . .

Cf. also Wilhelm Waetzoldt, Appendix to the same:

Der Expressionismus kennzeichnet sich als eine romantische Bewegung durch seinen Drang zur Elementarität. Wieder ist das Elementare, Primitive, das Zeitlichferne und Räumlichweite, weil es den unverstellten, reinen und starken Ausdruck zu tragen scheint, das Ziel der Künstlerischen Sehnsucht. Was für die Romantik des anhebenden 19. Jahrhunderts das Mittelalter war, ist heute Orient, Eiszeit, Bauren-, Kinder- und Negerkunst.

THE PRIMITIVISM OF THE BLAUE REITER

In continuing the discussion of emotional primitivism we do more than move from the north of Germany to the south, and from a group that took form in 1906 to one that had its official beginnings in 1911. The painters of the Blaue Reiter knew a wider selection of aboriginal styles, were more conscious of their kinship with a variety of primitive and exotic arts, and were more articulate about that kinship than were the artists of the Brücke. How closely the relation that they expressed at length in their writings was adhered to in their pictures we shall have to examine. In many respects, however, their primitivism, though it does not stem from it, continues the primitivism of the Dresden group. We have seen that in relation to the attitude of Gauguin and to a lesser extent to that of the Fauves, who had already expanded Gauguin's position, the elements from which the Brücke was influenced and the means through which it expressed its primitivism were both closer to the artist and of a wider, more general application. This double process of interiorization and expansion is further carried on by the painters of the Blaue Reiter, is carried (at least in this particular line of development) as far as it is possible for any modern artist to go.

The best indication of the acquaintance of the Munich group with

primitive art and of their appreciation of its various manifestations is to be found in its elaborate manifesto (edited by Kandinsky and Marc in 1911 and published in 1912), from which the group derives its name.[1] There, in addition to examples of their own work and that of their French contemporaries whom they admired, we find illustrations of figures from New Caledonia, the Malay Peninsula, Easter Island, and the Cameroons; a Brazilian mask, and a stone sculpture from Mexico; a Russian folk statuette and Russian folk prints; Egyptian puppets and an archaic Greek relief; Japanese woodcuts, Bavarian glass painting of the fifteenth and sixteenth centuries, and German nineteenth-century folk pictures; a thirteenth-century head of a stonecutter, fourteenth-century tapestries, and a Baldung-Grien woodcut. In addition there are European and Arabian children's drawings and watercolors, and many popular votive pictures. Such a diverse array of arts that are considered primitive or are for some reason, as we shall see, thought of as allied to the primitive, demonstrates an acquaintance and an interest in the history of art far beyond that of the members of the Brücke. It indicates further some principle of appreciation that—while it may in part contain elements of the curio collecting of Vlaminck, the violent emotional interest of the Brücke, or the formal apprehension of primitive style peculiar to nascent Cubism—must go beyond any of these in order to unite such a diversity of artistic expression. That the selection is not simply a haphazard one is shown by the absence of any examples of arts that might be considered developed or sophisticated. We wish to discover what brings all these objects together as "primitive."

The relation that the artists of the group felt toward these examples of "primitive" art, and the manner in which they themselves judged their appreciation, may best be gathered from extracts from their own writings. A trip to Vologda province, while he was still a student at Moscow University, had first suggested to Kandinsky that "ethnography is as much art as science." But the decisive experience was the "great impression" made upon him by the African art that he saw, in 1907, at the Berlin ethnographic museum.[2] In January 1911, shaken by his study of African and Peruvian sculpture in the same museum, Franz Marc wrote to Auguste Macke: "We must be brave and turn our backs upon almost everything that until now good Europeans like ourselves thought precious and indispensable. Our ideas and our ideals must be clad in hair shirts, they must be fed on locusts and a wild honey, not on history, if we are ever to escape from the exhaustion of our European bad taste."[3]

In 1910, also before the formation of the Munich group, Kandinsky expressed himself thus, in the book later published as *The Art of Spiritual Harmony:*

> When there· is a similarity of inner tendency in the whole moral and spiritual atmosphere, a similarity of ideals, at first closely pursued but later lost to sight, a similarity in the inner feeling of any one period to that of another, the logical result will be a revival of the external forms which served to express those inner feelings in an earlier age. An example of this today is our sympathy, our spiritual relationship with the Primitives. Like ourselves, these artists sought to express in their work only internal truths, renouncing in consequence all consideration of external forms.[4]

We have already seen the essentials of this attitude in Nolde's estimate of his own aims, but this is the first time that it has been directly applied in the judgment of primitive art.[5] It will have been noticed that in the illustrations of the *Blaue Reiter* children's art appears for the first time on exactly the same basis as the primitive. For though the Brücke was influenced by the technique of children's art, this is the first time that we find an express appreciation of its qualities and of the reasons for their importance to the modern artist. These Kandinsky explains in an article in the *Blaue Reiter:*

> In addition to his ability to portray externals, the talented child has the power to clothe the abiding inner truth in the form in which this inner truth appears as the most effective. . . . There is an enormous, unconscious strength in children, which here expresses itself, and which places the work of children on as high (and often on a higher) a level as that of adults. . . . The artist, who throughout his life is similar to children in many things, can attain the inner harmony of things more easily than others. Christ said: "Suffer the little children to come unto me, for theirs is the kingdom of heaven."[6]

Kandinsky points out that it is here that the roots of the "new realism" lie, because the simple and naïve rendering of the shell of an object brings out its inner values.[7] Henri Rousseau, who "with a simple and convincing gesture has shown the way . . . and revealed the new possibilities of simplicity," is the father of this new realism. In "The Masks," another article in the same manifesto, August Macke expresses a similar appreciation of these arts, and the same neglect of external form:

> To hear the thunder is to feel its secret. To understand the speech of forms is to be nearer the secret, to live. To create forms is to

live. Are not children creators who build directly from the secret of their perceptions, rather than the imitators of Greek form? Are not the aborigines artists who have their own form, strong as the form of the thunder?[8]

For this reason "the art forms of the peasants, of the primitive Italians, of the Japanese, and of the Tahitians" have the same exciting effect upon the artist as if they were forms of nature, perhaps an even greater effect, because of their lively expression.[9]

To carry out in one's own work the attitudes toward art of those whom we may perhaps group together under the name of "simple" people, as it is defined in the quotations we have given, requires no superficial copying of their form or subject matter. Rather it should find its expression in a relation of the artist to contemporary life similar to that of these other artists to their own environment. And in fact in the work of the members of the Blaue Reiter we find no secondary formal derivation from primitive, exotic, or archaic styles. The direct influences that are present are those of medieval religious art and folk art. This is most evident in the work of Heinrich Campendonk, who, himself a painter on glass, developed under the influence of votive pictures painted under glass, and of more recent peasant art.[10] This derivation of Campendonk's painting is shown not only in the subjects that he chooses, scenes of the farm, uniting in their iconography the most important elements of country life—cattle, fowl, farmhouse, and church all brought into the same canvas, as in *The White Tree* (1925)—or of idyllic landscapes that bring together people and animals, as in the *Bavarian Landscape* (1925). The composition of these pictures, the disproportion of the figures and their arrangement according to importance, the placing of the figures in their broadest aspect, the perspective that puts objects above rather than behind, all indicate their relation to folk art. And the "realistic" aspect of the modeling—the careful indication of details such as the veins of the leaves and the hooves of the animals—is proof of the same influence.[11]

All this means that in these pictures Kandinsky's theory of the parallel roles of the primitive and the modern artist has been considerably overreached. In effect, the artist has attempted to lose his own personality as part of a complicated culture, and, by sinking it in his conception of those folk craftsmen whose products he admires, to reproduce (rather than to imitate) not only their techniques but also their subject matter and the spirit of its interpretation. We have come a

long way from Gauguin's interpretation of Breton peasant life in terms that lay outside of that life, and from his desire to render the "simple" qualities that he found in it. The artificiality of this aim lies not in a misinterpretation of those qualities, natural to any sophisticated observer, but in the very idea that the artist can become other than an exterior observer of things of which he is not really a part. Yet it is the direction taken, rather than the desire itself, that constitutes the Brücke's primitivism. It lies in the fact that, seeking the mystical essence of the universe, these artists, instead of becoming one with the infinite, found that essence in the simple minds of peasant folk or at least in those whom they considered as such, and tried to interpret the world as such people interpret it (fig. 27).[12]

27. Marc Chagall: *The Flying Carriage.* 1913. Oil on canvas. 42″ × 47¼″. Collection The Solomon R. Guggenheim Museum, New York.

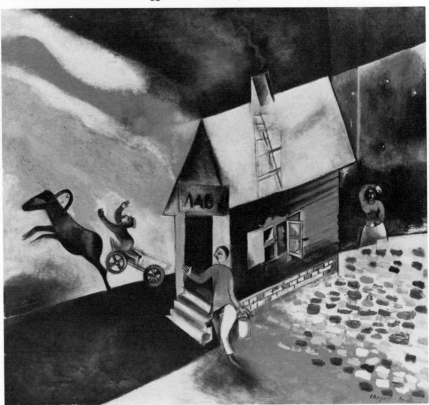

Kandinsky shied away from this sort of folkloristic identification, although he was familiar with the folk art of Russia. He believed that his 1889 Vologda expedition, plus his predilection for the "hidden and the mysterious," saved him from the "bad influence" of folk art. For whatever reasons, he was only momentarily attracted by such a style (fig. 28).

28. Wassily Kandinsky: *Murnau Obermarkt.* 1908. Oil on board. 25¾" × 20½". Collection Mr. and Mrs. Leonard Hutton.

In the paintings of Campendonk there also appear wild animals, animals shown idyllically at home in nature, at peace with one another and with man. This is evidence of the third important influence that helped to form Campendonk's art, that of his older contemporary, Franz Marc. In Franz Marc's letters, written during his years in the German army, there are indications of the desire to paint the world as it is felt by creatures other than himself. In this case, significantly, he attempts to identify his way of thinking, not merely with simple human beings, but with the manner in which animals perceive and interpret the world.

> Is there a more mysterious idea for an artist, than the conception of how nature is mirrored in the eyes of an animal? How does a horse see the world, or an eagle, or a doe, or a dog? How wretched, how soulless, our convention of placing animals in a landscape which belongs to our eyes, instead of sinking ourselves in the soul of the animal in order to imagine his perception . . .[13]

No exception can be taken, says Marc, to the artistic logic of a Picasso or a Robert Delaunay; each renders his own interior world and does not bother really to "see" the object he paints. It is not, however, the exterior of the object that counts, this is given by science.

> The most important part of a thought is the predicate. The subject is its premise. The object is an unimportant afterthought making the idea special and banal. I can paint a picture: the roe; Pisanello has painted such. I can however also wish to paint a picture: "The roe feels." How infinitely sharper an intellect must a painter have, in order to paint this. The Egyptians have done it. The "rose." Manet has painted that. The rose "flowers." Who has painted the "flowering" of the rose? The Indians.[14]

It is among the Egyptians and the Indians that Marc finds affinities with what he wishes to do.

The measure of execution of such an intention is naturally difficult to judge, particularly by one who is neither beast nor artist. Purely technically, there is little that can be called its expression, nor are there any features traceable to the direct influence of the primitive as opposed to the folk arts. In Campendonk's pictures there are occasional attitudes of animals that recall Paleolithic wall paintings, as in the repetition of the bent legs, the line of the back and neck, and the general silhouette character of the doe in the *Bavarian Landscape;* but in Marc's renderings there is no echo of this early art.[15] Some influence of folk art is present, however, as witness for example the joyous cow given in broadside in the foreground of *The Cows* (1911). The chief manner in

which Marc's conviction is expressed, aside from the simple fact of the concentration of most of his work on the portrayal of animals, is in the linear and formal rhythm of his pictures. The animal bodies themselves have rhythms, sometimes staccato—as in the *Frieze of Apes* (1911)—but, more usually, smooth unbroken curves from one end of the body to the other, through which Marc tries to express the energy and vitality, the harmony and wholeness that he admires in the animal world and that for him set it apart from the psychological conflicts and social struggles of humanity. In the *Blue Horses* (c. 1911) and the *Gold Horses* (1912) this expressive curve, which extends from muzzle to hindquarters, is repeated in each animal, so that there is an impression of unity of purpose and mood uniting the members of the group. The same continuity of spirit, expressed through continuity of design, determines the more angular forms of the *Frieze of Apes,* in which the movement proceeds from one beast to the other in an unbroken pattern.[16]

But the method through which Marc's intention is most clearly expressed is by the repetitions of contour in the shapes of the animals and the shapes of the landscape. In the famous *Red Horses* (1911) the contour of the hills in the background repeats, in its rise and fall, the undulations of the backs of the horses so that, with the heads of the horses excluded, the two are practically identical. One might say, in this picture alone, with its open spaces and its clear separation of the animals from the landscape, that this is simply a method of composition such as other painters have used, and carries with it no further intention.[17] From an examination of other pictures, however, in which the setting is crowded in upon the forms of the beasts so that the two merge into a single rhythmical whole or into a single movement that is the chief if not the sole formal impression of the canvas, it becomes evident that Marc wishes to convey the unity of beast and nature, for in his vision "the entire life and being of animals seemed to be part of an existing natural order." In both the *Blue Horses* and the *Apes* this is so much the case that the separation of the animals from the natural forms—when it is accomplished by the observer—does not change the total formal effect of the picture, though it is indispensable for the grasping of Marc's intention. The unity is further conveyed by the identity of coloring throughout the picture, at the same time the abstract quality and its symbolic intention are heightened by the arbitrary coloring and its freedom from nature. Marc's purpose here is to express a pantheistic conviction, to convey the underlying harmony of the universe, lost by

modern man, in symbolic canvases "that belong on the altars of the coming spiritual religion."[18]

The general trend of Franz Marc's painting in the remaining five years of his life is toward an abstract art. In view of his desire for a direct expression of inner truths and his judgment of man as ugly, this would not be surprising, even without the influence that we know came from his fellow artists.[19] It is characteristic, however, and demonstrates the connection of what Marc himself recognized as an inner constraint to the abstract with the primitivistic·development we have been outlining, that he should at the same time have wished to have a close relation with the folk and with folk art. "Artists are only the interpreters and fulfillers of the will of the people," he says; and deploring that at present the people do not want anything, he combats the naturalistic art of the nineteenth century in order that "folk art, that is the feeling of the people for artistic form" may once again arise.[20]

In contradistinction to Campendonk, the wish for a future folk art rarely expresses itself in Marc's work by the copying of folk arts of the past. In the *Yellow Cow* (1911; fig. 29) and in the *Unfortunate Land of Tyrol* (1913; fig. 30), with its childlike horses and abbreviated landscape symbols, something of the folk influence does come through, but these are isolated instances. Though influenced by the work and theories of his friend Kandinsky, and even more by those of Delaunay—whose paintings had been included in the 1911 exhibition as an example of the "great abstract" tendency, and whose writings Paul Klee translated— Marc's pictures do not lose their connection with his previous artistic intentions, but rather, in the formalistic straightening of their lines and the simultaneous breaking up of animal and landscape forms into an almost indistinguishable planar pattern, carry further the merging of the organic unit with the essential rhythms of the world as a whole.[21] This is in itself a mystical rather than a primitivistic aim, a desire to give symbolic form to the "underlying mystic design" usually hidden by surface appearance; but Marc's preoccupation with animals, and his concentration upon their mystical union with the universe to the exclusion of any human subject matter, justifies an emphasis upon the primitivist aspects of his mysticism.[22] In his last work, however, these aspects are increasingly confined to the meaning and intent of the pictures, which, formally, become more variegated and elaborated. Thus the most important painting of the period, *Animal Destiny* (1913), goes far beyond any of the more naturalistic works of 1911 in the complication of its linear pattern; yet the indistinguishable intermingling of

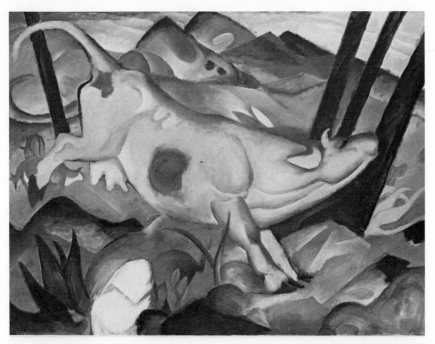

29. Franz Marc: *Yellow Cow*. 1911. Oil on canvas. 55⅜″ × 74⅞″. Collection The Solomon R. Guggenheim Museum, New York.

30. Franz Marc: *The Unfortunate Land of Tyrol*. 1913. Oil on canvas. 52″ × 79″. Collection The Solomon R. Guggenheim Museum, New York.

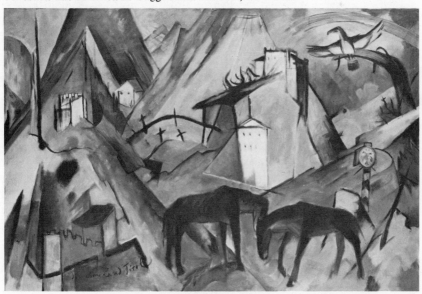

stylized animal and natural forms is meant to express the same pathetic union with the animal soul as did those pictures. That such is indeed Marc's purpose can be seen from the very titles of the *Dog Before the World* (1912), *The Fear of the Hare* (1912), and the *World-cow* (1913), in which, as in *Animal Destiny,* human longings and imaginings and the desire for mystical oneness with the universe have been read into the animal bodies.

In patterns of color, as well as in abstract design, Marc's art at the time of his death was moving closer to the "objectless" painting of Kandinsky, with whom he had been in contact since 1911.[23] In asking to what extent these first abstract "compositions" and "improvisations" of the older artist are primitivist, we must make a double distinction.[24] In the first place, they are not primitivist in the sense of having a simple, undivided form without interior complication and differentiation. The color harmonies are subtle, many colors are used, and the balance of lines and forms has in it several elements; lines are clean and careful and the whole is highly finished. Nor is the search for the fundamental bases of art that Kandinsky has expressed in his two books, *Über das Geistige in der Kunst* and *Punkt und Linie zu Fläche,* in itself necessarily primitivist.[25] Others before have searched for the fundamentals of art without thereby being primitivist. Line is one of the elements of art, and the circle and the square are pervasive forms in the geometrical analysis of nature as well as of painting. In the importance he gave to these forms—both as direct abstract experiences and as symbolic equivalents of the creative forces and the structure of the universe—Kandinsky was greatly influenced by Oriental, especially Indian philosophy, ideas (whether learned at first or second hand) that were very much in the air in both Russia and Germany.

It is rather the emotional tenor of the analysis that Kandinsky gives, his attribution of stresses and strains to lines themselves instead of to their effect upon the beholder, the inner kinship that he established between certain lines and colors, the "spiritual" affinity between colors, temperatures, and certain states of mind, his "silent" colors and his lines that have no desire to leave their surface, which are primitivist in their tendency.[26] For all the intellectuality of his analysis, with its careful building up from smaller elements to a diversified superstructure and its distinctions and parallels, Kandinsky's final purpose is not only anti-intellectual, but more than that, it is opposed to the separation of emotional variations and nuances. It is not a series of romantic emotional experiences resulting from the interplay of the most elaborated

and finest-spun faculties of imagination and intellect for which Kandinsky is striving, but rather the sinking and losing of the whole personality in a single emotion. The analogy of Bergsonian philosophy, to which we have referred in our discussion of the painting of the Fauves, does not come to mind by chance in connection with an art outwardly so different:

> Reason was discovered to be incapable of grasping true reality, which one tried to penetrate with the aid of intuition. . . . Intuition permits one to see everything at once, instead of by a summation of parts. . . . Thus, in a manner analogous to that of philosophy, art hopes . . . to give absolute views, to seize the eternal.[27]

The analogy is apropos here, as it was with the Fauves, because here too the intention is to do away with "the acquired means" in favor of an appeal to fundamental elements in human nature, and to appeal to them in their undeveloped, undifferentiated form.[28] The quotations that we have given at the beginning of this section show that Kandinsky was not unaware of this primitivizing tendency, though he states it in the rather misleading form of an affinity with true "primitive" art. We may give one further passage:

> Just as art is looking for help from the primitives, so these men (who renounce materialistic science) are turning to half-forgotten times in order to get help from their half-forgotten methods. . . . Frau Blavatzky was the first person . . . to see a connection between these "savages" (the Indians) and our "civilization."[29]

Much the same attribution of pathetic qualities to line and color symbols characterizes the explanations of Paul Klee's *Paedagogisches Skizzenbuch*.[30] In accordance with the greater influence on Klee of children's art, Klee's symbols remain more intellectual in that they must be grasped as individual wholes before they can be understood. Thus the arrow, important in Klee's theories and in his art, made up of a combination of lines and colors, must be seen as a unit before it can carry its message to the beholder, even though its "father is the thought."[31] Similarly the other symbols of air, water, and earth, simplified as they are in their rendering, correspond more closely to the child's "intellectual" grasp of them as unit meanings than do elements such as Kandinsky's, which have a more direct and immediate access to the emotions of the spectator. Klee's art has also its purely mystical side, as his liking for the writing of the German Romantics confirms, and as the undetermined way in which he uses his childish symbols so that they may give rise to

uncontrolled reverie indicates; but the very use of these symbols, as Marc's use of animals, demonstrates a valuing of the simple as such and for itself.[32]

With this symbolic animism, whose relation—true or false—to that of more primitive peoples was quite consciously realized by the painters of the Blaue Reiter, the process of interiorization and expansion of primitivizing elements is carried as far as may be along emotional lines.[33] Beginning with a wider and more sophisticated acquaintance with exotic and primitive arts than had the members of the Brücke group, the artists of the Munich association try to unite the search for human fundamentals with a search for corresponding fundamentals in the universe outside. The primitive arts from which they draw a stimulus includes fields that are as far removed as are certain of those of the Brücke group, yet they also include folk arts that are closer to home than any naïve art which had thus far provided inspiration. At the same time, while their animal and folk subject matter is more specifically primitive in its limited reference, their painting is technically subtler and more complicated than either that of the Fauves or of the Brücke; while the fundamental emotions to which they appeal are both vaguer and more general. The general emotional basis of human nature has replaced the specific, violent primitivizing emotions of the Brücke, finally resulting in a fusion of an emotional primitivizing and an emotional pantheism. Further than this, as we have seen with the Fauves, who arrived at much the same position by a different road, the broadening of the primitivizing base cannot go.

NOTES

1. Franz Marc and Wassily Kandinsky, eds., *Der Blaue Reiter* (Munich: R. Piper, 1912). Already prepared in November 1911; cf. Alois J. Schardt, *Franz Marc* (Berlin: Rembrandt-Verlag, 1936), p. 103. Its writing thus precedes the first Blaue Reiter exhibition of December 1911. At about this same time, the Viennese Egon Schiele, visiting Klimt in his house in Hietzing (to which Klimt moved in 1911), noted his large collection of exotic art: "Around the room were hung in close proximity Japanese woodcuts and two large Chinese paintings. On the floor lay Negro sculptures, in the corner by the window stood a red and black Japanese armor." Quoted in Arthur Roessler, *Errinerungen an Egon Schiele* (Vienna, 1922), pp. 50–51.

2. Kandinsky, in a 1930 letter to Paul Westheim, reprinted in Max Bill, ed., *Essays über Kunst und Künstler* (Stuttgart, 1955), pp. 123–128.

3. Quoted in Werner Haftmann, *The Mind and Work of Paul Klee* (London: Faber, 1954), p. 53.

4. W. Kandinsky, *The Art of Spiritual Harmony*, trans. M. T. H. Sadler (London: Constable, 1914), p. 6. Written in 1910; published in German in 1912. It must be noted that Kandinsky holds that "the Primitive phase . . . with its temporary similarity of form, can only be of short duration."

5. It should be remarked that for certain types of primitive art at least—e.g. the Bakuba of the Congo, and the Maori of New Zealand—"consideration of external form," that is, the exact rendering of realistic detail, is of the utmost importance.

6. W. Kandinsky, "Über die Formfrage," *Der Blaue Reiter*, pp. 92–93.

7. *Ibid.*, p. 94. "Henri Rousseau, der als Vater dieser Realistik zu bezeichnen ist, hat mit einer einfachen und überzeugenden Geste den Weg gezeigt."

8. A. Macke, "Die Masken," *Der Blaue Reiter*, pp. 21–22. See also G. Biermann, *Heinrich Campendonk* (Leipzig: Klinkhardt & Biermann, 1921), pp. 6–7.

9. Macke, *op. cit.*, p. 23. Cf. also, in answer to a questionnaire, Macke, "Das neue Programm," *Kunst und Künstler*, 12, 1914.

10. Biermann, *op. cit.*, p. 5.

11. In his attempt to assimilate the folk spirit, Campendonk went to live among the Bavarian peasants, and led a peasant life.

12. The art of Marc Chagall, admired by the followers of the Blaue Reiter (cf. Herwarth Walden, *Einblick in Kunst* [Berlin: Der Sturm, 1924], *passim*), has no basis in a plastic folk tradition, though much of it is inspired by the legends of Chagall's native Witebsk, particularly those pictures painted after his return to Russia in 1917. Its individual elements are allied rather to children's art (e.g. *The Enclosure*, 1926), combined on a personal dream basis, except where the iconography is directly given by the inspiring legend.

13. Franz Marc, *Briefe*, 2 vols. (Berlin: Cassirer, 1920), I, p. 121.

14. *Ibid.*, I, p. 122.

15. The parallels drawn between Marc's animals and those of Altamira (W. Paulcke, *Steinzeitkunst und Moderne Kunst* [Stuttgart: Schweizerbart, 1923], p. 40) do not seem to me to be accurate. In *The Bull* (1911) there is only the most superficial resemblance of posture. The same is true of some of Kandinsky's shorthand methods, as in *Lyrisches* (1911).

16. Other examples are *The Small Blue Horses* (1911), *The Small Yellow Horses* (1912), *The Tower of Blue Horses* (1913).

17. Nicholas Poussin is perhaps the outstanding example of the use of this method of composition; even he employed it to express a unity of "mode." Marc's nudes of this time confirm the influence from Cézanne suggested by this landscape, and the "classic" Cézanne was of course related to Poussin.

18. The theories of color attributed to Marc by Schardt (*op. cit.*, pp. 74–77), insofar as any conscious use was made of them by Marc, derive from Kandinsky; later there was the influence of Delaunay.

19. Cf. Marc's letter of April 12, 1915, quoted by Schardt, p. 140: "Ich empfand schon sehr frueh den Menschen als hässlich, das Tier schien mir schöner, reiner, aber auch an ihm entdeckte ich soviel Gefühlswidriges und Hässliches, so dass meine Darstellung instinktiv, aus einem inneren Zwang, immer schematischer, immer abstrakter wurde."

20. Aphorism No. 31, quoted by Schardt, *loc. cit.* Article in *Pan,* March 21, 1912, quoted by Schardt, p. 104. Cf. also letter of September 8, 1911, to Auguste Macke, in which folk art is discussed as showing the artist how to unite again with the people.

21. Some examples are: *Tiger* (1912), *Doe in a Monastery Garden* (1912), *Leaping Horse* (1912), *Interior of Wood with Birds* (1913). *The Wolves [Balkan-war]* (1913), seems to be influenced by Kandinsky's *Lyrisches* (1911).

22. Cf. letter of April 12, 1915, to his wife: "Der unfromme Mensch, der mich umgab (vor allem der männliche), erregte meine wahren Gefühle nicht, während das unberührte Lebensgefühl des Tieres alles Gute in mir erklingen liess." For a study of similar "animalitarianism" see George Boas, *The Happy Beast in French Thought of the Seventeenth Century* (Baltimore: Johns Hopkins Press, 1933).

23. For example: *Sunrise* (1914), *Cheerful Forms* (1914).

24. Kandinsky's first purely abstract compositions probably date from 1911, although the date is sometimes given as 1910. Cf. A. H. Barr, Jr., *Cubism and Abstract Art* (New York: The Museum of Modern Art, 1936), p. 64.

25. W. Kandinsky, *Über das Geistige in der Kunst* (Munich: Piper, 1912); *Punkt und Linie zu Fläche* (Munich: Langen, 1926).

26. Kandinsky, *Punkt und Linie* . . . , chap. I, *passim.*

27. Will Grohmann, *Kandinsky* (Paris: Cahiers d'art, 1930), p. xvi. For a mystical feeling about raw material, see the Kandinsky, *Selbstbiographie* (Berlin: Der Sturm, 1913), *passim.*

28. In *Punkt und Linie* . . . , p. 7, Kandinsky explains that if art is to be rescued, it will not be by going to the past, as the French have done, but by the ability of the Germans and Russians "in die tiefen Tiefen absteigen."

29. Kandinsky, *The Art of Spiritual Harmony,* pp. 27–28.

30. Paul Klee, *Paedagogisches Skizzenbuch* (Munich: Langen, 1925), *passim.*

31. *Ibid.,* III, p. 26.

32. Note the influence on Klee of the German Romantic Christian Morgenstern, beginning in 1911. Klee's liking for the Byzantine (trip to Italy, 1901, Ravenna) can hardly be held to be primitivistic.

33. For confirmation of this, cf. Johannes Molzahn, "Das Manifest des absoluten Expressionismus," *Sturm,* 10, no. 6, 1919, p. 98.

Other Romantic Currents: Klee to Ernst*

ROBERT ROSENBLUM

In *Modern Painting and the Northern Romantic Tradition,* Rosenblum posits an alternate reading of modern art. In so doing, he discredits the notion of French exclusivity: that the course of modern art is a series of necessary formal deductions from Manet to Cézanne to Picasso. Rosenblum reexamines entrenched categories, classicism and romanticism, as in his earlier *Transformations in Late Eighteenth Century Art* (Princeton, N.J.: Princeton University Press, 1967).

His argument is that there exists a romantic tradition outside of national and historical boundaries. This romantic sensibility—melancholic and otherworldly—extends from Caspar David Friedrich to Mark Rothko. He first locates this tradition in German painting of the early nineteenth century, in artists such as Friedrich and Philipp Otto Runge, distinguishing qualities of form and feeling that he then perceives in the art of a broad range of modern masters from Vincent Van Gogh to Max Ernst, including Wassily Kandinsky, Piet Mondrian, and Paul Klee.

The following section on Klee is illuminated by the author's broader sights. His fresh historical synthesis was suggested earlier in "The Abstract Sublime" (*Art News,* 1961).

Robert Rosenblum is Professor of Fine Arts at the New York University Institute of Fine Arts.

* Reprinted from *Modern Painting and the Northern Romantic Tradition, Friedrich to Rothko* (New York: Harper and Row, 1975).

The drastic rejection of the empirical world in Kandinsky's and Marc's work before World War I is of such enormous consequence for the twentieth-century phenomenon of abstract art that it is easy to forget that their work also looks backward to Romantic traditions, then over a century old, in which spirit would triumph over matter and in which art would become the vehicle for communicating the quasi-religious experiences of childlike innocence or apocalyptic destruction, of the beginnings and ends of the universe, of the supernatural mysteries revealed in the world of nature. Such preoccupations, in fact, haunt the art of many other twentieth-century Northern masters, whose use of the fullest autonomy of line, color, and shape within the shallow spaces defined by Fauvism and Cubism has tended to make their formal means obscure their Romantic ends.

Such a master is Paul Klee. His aesthetic order, unlike Marc's, is on a sufficiently high level to compete successfully with the highest standards set by the School of Paris, but the universe he constructs is one that, in imagery and intentions, has little, if anything, to do with the masters of early twentieth-century French art. Associated as he was with the Blue Rider in 1911 and 1912, Klee was closely aware of Marc's and Kandinsky's search for spiritual truths beneath the surfaces of nature; and his friendship with Marc actually had specific repercussions on both Marc's work and his own. It was Klee who suggested to Marc that he change the title of *The Trees Show Their Rings, the Animals Their Veins* to *The Fate of the Animals* (1913), and it was Klee who took the responsibility, after Marc's death, of restoring the lower right-hand corner of the painting when it had been damaged by fire.[1] Klee, in fact, must have absorbed much of Marc's attitude toward animals as mysterious creatures through which humans could experience closer affinities with nature's secrets.

Thus, Klee's *With the Eagle* (1918; fig. 31) continues Marc's search for empathy with the experience of dumb animals, in this case providing the spectator with a vertiginous, literally bird's-eye view that, from a central aerial summit, surveys the panoramic vista below, with its fragmented glimpses of an Alpine cottage, a reindeer, and the pine trees and other flora that rise and fall on this mountainous topography. But if Klee's image still depends upon those premises of Romantic empathy with animals that dominated Marc's ambitions, his reading of this subhuman world seems far less metaphysical in tone, marked rather by a more whimsical and pixilated atmosphere more appropriate to fairy tales than to philosophical speculation. The all-seeing eagle's eye itself is

more of an ideograph than anything in Marc, conjuring up the kind of magic associated with, on the one hand, an Egyptian hieroglyph and, on the other, a child's drawing. Indeed, the parallels such a work offers with the conceptual style of children's art are ones Klee himself sought out in a characteristically Romantic pursuit of an uncorrupted purity of vision. Even as early as 1902 Klee virtually repeated Runge's sentiments of exactly a century before. He wished, he said, "to be as though newborn, knowing absolutely nothing about Europe, ignoring poets and fashions, to be almost primitive."[2] And he often found in the art of those untainted by decadent Western traditions, for example, the art of children and even of the insane, the means of reaching this purity.[3]

It was, in fact, Klee's particular genius to be able to take any number of the principal Romantic motifs and ambitions that, by the early twentieth century, had often swollen into grotesquely Wagnerian

31. Paul Klee: *With the Eagle*. 1918. Watercolor and gouache. 7¼″ × 10″. Courtesy Kunstmuseum, Bern, Paul Klee Stiftung.

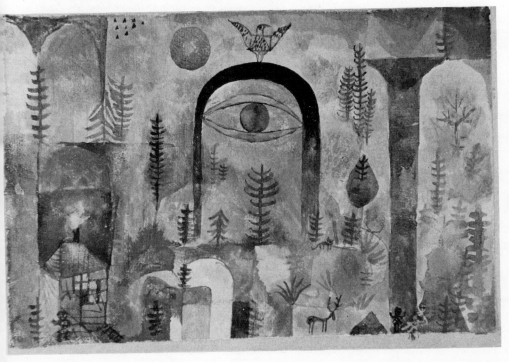

dimensions, and to translate them into a language appropriate to the diminutive scale of a child's enchanted world. For Klee, the megalomaniac and the spiritual are suddenly viewed, as it were, through the other side of the magnifying glass, disclosing a tiny cosmos that mirrors with fresh magic the grandiose mysteries dreamed of by the Romantics. Thus, it was characteristic of him that when he, as a Swiss, inevitably painted one of the same Alpine heights that Hodler had painted before him, *The Niesen* (1915, fig. 32; 1910, fig. 33), he viewed it not as some sublime, Olympian pinnacle of nature's majesty, beyond man's reach yet still in the natural world, but rather as a fantastic, fairy-tale construction, more pyramid than mountain, and accompanied by twinkling ideographs for stars, moon, and sun that might have been conjured up by a magician. The mood is more like E. T. A. Hoffmann than Nietzsche.

Throughout Klee's work, Romantic themes abound. Not only did

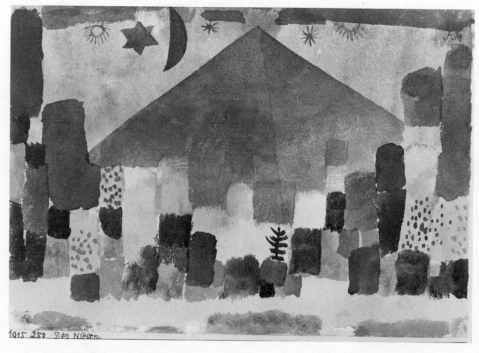

32. Paul Klee: *The Niesen.* 1915. Watercolor on paper and cardboard. 7″ × 10⅛″. Courtesy Kunstmuseum, Bern, Hermann and Margrit Rupf Foundation.

he seek to evoke the mysterious experiences of animals—the way an eagle surveys the terrain below, the way a cat stalks a bird, the way a fish starts at a baited hook—but he wished, as so many Romantics had before him, to penetrate into the secret lives and feelings of trees and flowers, to capture the miracles of organic growth and change, the blossoming of plants, the magical passage from one season to another. In an essay published in 1920, "Schöpferische Konfession" (generally translated as "Creative Credo"), he articulated once again ideas that had been voiced by many Romantics, claiming that the making of art was a metaphor of the Creation, that it mirrored divinity the way the terrestrial mirrors the cosmic, that it could serve to assist mankind in experiencing the mysteries of religion and of God.[4]

Given Klee's fervent search for these quasi-religious secrets of nature, it is no surprise to find in his art among the richest twentieth-

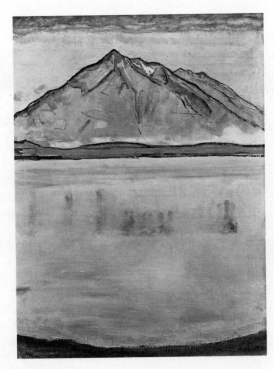

33. Ferdinand Hodler: *The Niesen*. 1910. Oil on canvas. 26⅛″ × 19½″. Courtesy Kunstmuseum, Bern.

century demonstrations of the survival of the pathetic fallacy. In *Mountain in Winter* (1925; fig. 34), for example, he effectively resurrects the very emotion we experience before Friedrich's leafless trees in a wintry mountain setting. Here, in the foreground, a lone tree, set in a position of iconic centrality, is poignantly silhouetted against a snow-covered mountain landscape, whose icy planar intersections are as impalpably translucent as the rays of cold light that might emanate from the dim, remote winter sun in the foggy sky. As in Friedrich, we feel not only the skeletal chill of death, but the promise of life in the quivering branches of the tree, which, like a human being, seems dramatically pitted against this harsh, deathly environment.

Like a deity, it is the sun and its heat that so often provide in Klee's art the supernatural forces that control the phenomena of nature here on earth and that give the cycles of the seasons an almost sacramental magic in their extinction and then resurrection of life. In *Before the Snow* (1929), we again focus on a single sentient creature, a tree that responds to the slow, but irrevocable coming of winter. The very colors begin to bleach away the vital greens at the tree's core, in favor of an autumnal rust that in turn harbors the chilly white of the winter ahead; and the fluid, irregular web of lines conveys the image of a vital organism that is withering and flaking before our eyes. It is a visual metaphor that realizes Klee's wish to make "a cosmos of forms which is so similar to the Creation that only the slightest breath is needed to transform religious feeling, religion into fact,"[5] and it is a visual metaphor that also translates Friedrich's and Runge's scrutiny of the palpitant, God-given life of trees and flowers into the more overtly symbolic language of twentieth-century organic abstraction.

The same veneration of the powers of heat and light can be seen in Klee's *Arctic Thaw* (1920), which again attempts to find a visual equivalent of the energies of the sun as they begin to work their warming and melting effect upon a landscape as frozen as that of Friedrich's *The Polar Sea* (1929). A glowing yellow solar orb and its reflections seem to generate the miraculous force that finally releases the life imprisoned in a landscape of frozen white blocks that slowly liquefy before our eyes. It is an image of a quiet miracle on earth that, in more abstract terms, fulfills the ambitions of Friedrich's disciple Carl Gustav Carus, who, in his letters on landscape painting of 1815 to 1824,[6] envisioned a new kind of art, an *Erdlebenbildkunst* (that is, "pictorial art of the Life of Earth"). By this, Carus meant a close and passionate scrutiny of natural phenomena imbued with a sense of the supernatural mysteries that lay

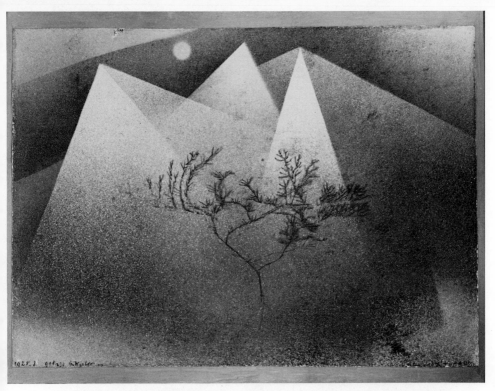

34. Paul Klee: *Mountain in Winter*. 1925. Watercolor and chalk on paper. 11¼″ × 14½″. Courtesy Kunstmuseum, Bern, Hermann and Margrit Rupf Foundation.

beyond the changing surfaces of the most humble terrestrial events: the blossoming of flowers, the slow changes of natural light, the movement of clouds, the cycle of the seasons.

For Klee, perhaps the most intense revelation of these mysteries could be found in the world of plants, trees, and flowers, which provided, as they had so many Romantics, metaphors of the secrets of life. For example, one of the pictorial ideas is "an apple tree in blossom, its roots, the rising sap, its seeds, the cross section of its trunk with annual rings, its sexual functions, the fruit, the core with its kernels."[7] It is a description that, in its combination of botanical exactness and a sense of the miracle of organic growth, corresponds to a recurrent Romantic attitude that can be traced from Runge and Palmer through Van Gogh, Nolde, and, as we shall see, even Mondrian; and it is also a description that corresponds closely to Klee's genius for fusing what seems almost an objective translation of these natural data into a language of uncanny magic.

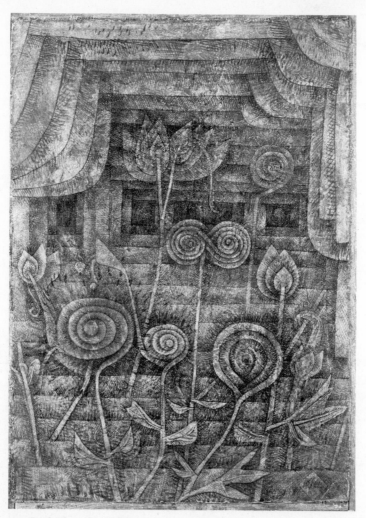

35. Paul Klee: *Spiral Blossoms.* 1926. Watercolor and pen on plasterboard. 16″ × 12″. Courtesy Galerie Beyeler, Basel.

In *Spiral Blossoms* (1926; fig. 35), as in so many Romantic paintings of flowers, we leave the scale of the human world in order to study at closest range the organic swell and curl of blossoms, which, in response to solar light and heat, appear to be expanding in unwinding coils and in radiant, intensifying colors. Again, as in Romantic flower paintings, the particularity of each blossom becomes a symbol of a universal life force. So saturated are Klee's botanical images with a kind

of animistic power that, at times, they even metamorphose into human-
oid creatures, as in *Flower Face* (1922), where Runge's capacity to
transform growing plants into otherworldly cherubs, symbolic of unseen
mysteries, is rejuvenated in a masklike double image that not only
relates the organic configurations of a flower to human physiognomy but
creates a new deity, a flower-god, in the Romantic pantheon of "natural
supernaturalism."

Although it was primarily the metaphors of nature—animals, plant
growth, the changes of the seasons—through which Klee perpetuated in
a new language so many Romantic images and ambitions that would
seize, in a microcosmic blade of grass, the mysteries of the cosmos, he
also revitalized many other Romantic motifs, from Gothic architecture
to the endlessly evocative theme of a maritime journey. In his *Departure
of the Boats* (1927; fig. 36) he resumes Friedrich's motif of outward-
bound ships that move slowly toward undefined spaces and destinies

36. Paul Klee: *Departure of the Boats.* 1927. Oil on canvas. 20⅛″ × 25¾″.
Collection Nationalgalerie, West Berlin. Jörg P. Anders, photographer.

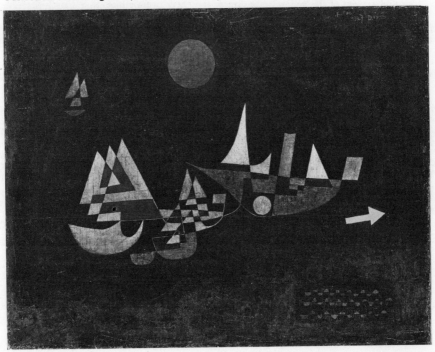

under the enchanted spell of a moonlit sky. Though the motif had become common coin in nineteenth-century art, Klee, as usual, was able to revitalize its potential mysteries by the power of his own symbolic language that here renders this nocturnal voyage all the more haunting by the inclusion of an arrow pointing to an unstated destination, and by the fusion of the night sky and sea into a continuous black plane that conceals the horizon and leaves us afloat in inky shadow.

NOTES

1. For further details, see Frederick Spencer Levine, "An Investigation into the Significance of the Animal as a Symbol of Regression and the Representation of the Theme of Apocalypse in the Art of Franz Marc" (Master's thesis, Washington University, 1972), pp. 16–17.

2. From journal of June 1902, quoted in *Paul Klee* (New York: The Museum of Modern Art, 1945), p. 8.

3. For the fullest and subtlest discussion of Klee's relation to the art of children and of the general question of the early twentieth-century search for simplicity and purity, see Robert Goldwater, *Primitivism in Modern Art* (rev. ed. 1966; New York: Random House, 1938), especially pp. 199ff.

4. For a convenient English translation of the "Creative Credo," see Victor Miesel, ed., *Voices of German Expressionism* (Englewood Cliffs, N.J.: Prentice-Hall, 1970), pp. 83–88.

5. *Ibid.,* p. 87.

6. Carl Gustav Carus, *Neun Briefe über Landschaftsmalerei geschrieben in den Jahren 1815 bis 1824* (Dresden, 1955).

7. Miesel, *op. cit.*

Introduction, The History of Cubism, Cubism as a Stylistic and Historical Phenomenon*

EDWARD FRY

For its profound impact on picture making and its sheer prestige, the artistic phenomenon known as Cubism stands alone in twentieth-century art. And yet, basic issues and large questions continue to preoccupy and divide its critics. This was true in the beginning. The style evolved in pre–World War I Paris, and immediately a body of conflicting programs appeared. Despite appearances, there is no system to Cubism, nor is a principle of vision easily derived from the paintings themselves. Early commentary represented an effort on the part of artists and critics to render Cubist works more intelligible to the public. Among these, Gleizes and Metzinger, *Du Cubisme* (1912; English trans., Robert Herbert, ed., *Modern Artists on Art,* Englewood Cliffs, N.J.: Prentice-Hall, 1964), and Guillaume Apollinaire, *Les Peintres Cubistes* (1913; English trans., 2d rev. ed.; New York: Wittenborn & Co., 1949), stand as the most important.

This essay by Fry presents a broad survey of Cubism, from 1907 to 1914, written as an introduction to some of these documentary texts. And Fry depends upon these early writings for his basic assumptions. He sees Cubism as realistic in essence and in his discussion of the

* Reprinted from the Introduction to *Cubism* (New York: McGraw-Hill Book Co., 1966).

problematic nature of Cubist reality, he draws parallels to contemporary philosophy.

Important recent literature on the subject includes: John Golding, *Cubism: A History and an Analysis 1907–1914* (Boston: Boston Book & Art Shop, 1959); Robert Rosenblum, *Cubism and Twentieth Century Art* (New York: Abrams, 1961); Leo Steinberg, "The Philosophical Brothel" (*Art News,* September–October, 1972), and selections from *Other Criteria: Confrontations with Twentieth-Century Art* (New York: Oxford University Press, 1972); Alfred H. Barr, Jr., *Picasso, Fifty Years of His Art* (New York: The Museum of Modern Art, 1946).

Edward Fry teaches art history on the faculty of Colgate University.

INTRODUCTION

The effects of Cubism are reverberating still throughout modern culture, but today at a distance of half a century it is possible to view with a certain clarity this extraordinary moment in history. For we are now becoming aware of the seminal quality of the decade ending in 1914, during which fundamental new ideas and methods were established in painting, sculpture, architecture, literature, music, science, and philosophy. In many of these fields the radical innovations of the pre–World War I years are still operative, or at least they remain as important influences against which more recent ideas must be tested. It was a period that saw the emergence of Mann, Proust, Apollinaire, Gertrude Stein; of Gropius and Frank Lloyd Wright; of Stravinsky and Schönberg; of Planck, Rutherford, Einstein, Bohr; and of Croce, Poincaré, Freud, Bergson, and Husserl. In painting and sculpture these same years produced Matisse, Picasso, Braque, Gris, Léger, Delaunay, Duchamp, Mondrian, Malevich, Kandinsky, Brancusi, Archipenko, Boccioni, and Lipchitz, to name only the most prominent of a brilliant galaxy of artists;[1] the aesthetic innovations and achievements of these years were fully as important and as far-reaching as the work of scientists and intellectuals. It was, as will one day be recognized, one of the golden ages of Western civilization.

The evolution of painting, and of Cubism in particular, shared with science the common characteristic of drawing upon late-nineteenth-century achievements, but, in so doing, of intensifying and transforming

them. The result was the overthrow of much of the heritage of the nineteenth and earlier centuries. In certain respects Cubism brought to an end artistic traditions that had begun as early as the fifteenth century. At the same time, the Cubists created a new artistic tradition that is still alive, for they originated attitudes and ideas that spread rapidly to other areas of culture and that to an important degree underlie artistic thought even today. Cubism first posed, in works of the highest artistic quality, many of the fundamental questions that were to preoccupy artists during the first half of the twentieth century; the historical and aesthetic importance of Cubism, therefore, renders it worthy of the most serious attention.

The study of Cubist art, however, presents difficulties of several kinds. As a style first of all it evolved very rapidly through a series of complex stages. Thus it is necessary to follow its development chronologically and in precise detail, for crucial changes, particularly in Picasso, often took place during a period of months or weeks, as opposed to years or decades in older historical styles. This accelerated rate of stylistic change seems to have become the rule in twentieth-century art, and it may well be the effect of increased rates of change in other areas of a culture, particularly in the speed of communications. In the case of Cubism, however, it is quite possible that certain critical steps, once taken, implied, if not determined, subsequent developments, and that the genius of Picasso himself simply forced the pace of stylistic evolution.

Problems of chronology, therefore, are of the greatest importance in the study of Cubism. The very density of interaction at that time among a relatively large number of extremely gifted artists makes it necessary to consider dates most carefully. The central figure, Picasso, usually did not put a date on his paintings during the Cubist period, sometimes only giving a place name on the back of the canvas. Although an invaluable catalogue of his works has been maintained and is being published in a series of volumes,[2] it is not complete and contains numerous errors of fact. Hence one must often turn to such biographical evidence as summer vacation trips in order to date Picasso's works, as is true also, to a lesser extent, of Braque and other Cubists. Neither Braque nor Picasso exhibited extensively before 1914, but other Cubists did so widely, and one must frequently turn to the now rare exhibition catalogues of the period for documentation of their works. Problems of chronology in Cubist collages are, however, occasionally simplified when identifiable and datable newspaper clippings appear in them.

As for the theoretical background of Cubism, Picasso and Braque,

the two most important Cubists, have left us few if any written statements from before 1914 of their artistic ideas and intentions. Their ideas were their paintings, from which fact has arisen the cloud of theories and interpretations surrounding Cubism, a process that began with the frequently misleading writings of Guillaume Apollinaire and that has continued to the present day. Every generation looks at the past in a new way, according to the needs of its time or in order to find justification for its own art. Thus lasting works of art inevitably gather around themselves layer upon layer of successive reinterpretations; often it is only from a long distance in time that a work of art may be seen disinterestedly and more or less whole. But Cubism belongs to the relatively recent past, of which the present is still a part, and we cannot yet hope to situate it completely either in relation to its own time or to Western culture in general. For the present, therefore, it is perhaps most useful for us that we become more fully aware of what the Cubists and their friends thought were their original intentions, not forgetting at the same time that great works of art possess qualities and implications that surpass the ideas and forces that accompanied their birth.

NOTES

1. See the following exhibitions for cross sections of the period: *1907*, Amsterdam, Stedelijk Museum, 1957; *1912*, Köln, Wallraf-Richartz Museum, 1961; *1914*, Baltimore, Museum of Art, 1964. "Years of Ferment," Los Angeles, U.C.L.A. Art Gallery, 1965.
2. Christian Zervos, *Picasso* (Paris, 1932), 14 volumes published to date. A similar catalogue of the works of Braque is being published in installments by the Galerie Maeght, Paris; see also the preliminary catalogue of Braque by Georges Isarlov: *Georges Braque* (Paris, 1932). An as yet unpublished catalogue of the works of Gris has been made by Mr. Douglas Cooper. [Currently there are twenty-nine volumes of the Zervos catalogue, the last published in 1975.—Eds.]

THE HISTORY OF CUBISM

Cubism developed with extraordinary rapidity between the years 1907 and 1914. From 1914 until about 1925 there were a great many artists painting in a Cubist mode, but this later phase produced relatively few stylistic innovations that had not already been anticipated to some

extent during the prewar years. By the mid-1920s, a crisis emerged in Cubism as in European art generally, bringing to an end a period of almost twenty years during which Cubism had been the predominant force behind an entire artistic generation.

In its beginnings, however, and until about 1912, Cubism was an exclusively Parisian phenomenon, and it probably could not have been born elsewhere, for reasons of history, geography, and culture. No other city in the world in the early years of the twentieth century could boast of a comparable century-long history of outstanding artistic activity; and the relatively central location of Paris in western Europe served only to facilitate the migration of the most gifted young artists and writers from Spain, Italy, Germany, Russia, and the Low Countries toward this cultural mecca. Paris offered them not only the challenge of their most gifted contemporaries, but also its great art museums; it offered a tradition of moral and intellectual freedom and an artistic bohemia in which they could live cheaply at the edge of society without suffering the ostracism inflicted by the bourgeoisie in smaller, more conservative, and less cosmopolitan European cities. In retrospect it is not surprising that, by the early part of the twentieth century, Paris contained an astonishing number of young men of genius, whose presence constituted an intellectual "critical mass" that soon produced a series of revolutionary cultural explosions.

In painting the first of these was Fauvism, a derogatory label given to the work of Henri Matisse (1869–1956) and his followers, who, starting in about 1904, used color with an unprecedented freedom, intensity, and arbitrariness. No less important was the discovery, and appreciation for the first time on aesthetic grounds, of African and Oceanic art; this discovery was made by several of the Fauve painters, notably Vlaminck, Derain, and Matisse himself. "Primitive" sculpture was shortly to play a brief but important role in the evolution of Cubism (see figs. 11, 19).

But Fauvism on the whole did not mark a decisive advance beyond the innovations of late-nineteenth-century painting. Rather, it was a recapitulation and intensification of such previous developments as the modified pointillism of Signac, the brilliant coloristic achievements and expressive brushwork of Van Gogh, and Gauguin's decorative color patterns. The masterpiece of Fauvism, Matisse's *Joy of Life* (1906; fig. 4), epitomizes the essentially conservative nature of the Fauvist enterprise in its consummate summing-up of tendencies in late-nineteenth-century painting, combined with a lingering flavor of Jugendstil arabesque.

Above all the *Joy of Life* does not put forth any new conceptions of space, although depth is compressed somewhat in the manner of Manet's *Luncheon on the Grass* (1862–1863), and curiously enough the composition itself is remarkably akin to that of Ingres's *The Golden Age* (1843–1847).

It is only in relation to this contemporary Fauvist context that the radically new qualities of Pablo Picasso's (1881–)* *Demoiselles d'Avignon* (fig. 37) emerge most clearly. Finished by the middle of 1907,[1] it is probably the first truly twentieth-century painting. For whereas Fauvism marked a summing-up of late-nineteenth-century art, *Les Demoiselles* contained new approaches both to the treatment of space and to the expression of human emotions and states of mind. It is not difficult to imagine that twentieth-century art as we know it today might have developed along far different lines without this first revelation of Picasso's genius.

In *Les Demoiselles* Picasso posed and attacked many problems at once, some of which he was to resolve only during the course of the following seven years. The subject, a brothel scene, recalls Picasso's interest, during his previous blue and pink periods, in episodes from the lives of those on the margin of society, as in fact he himself lived during his years in Montmartre, beginning in 1904. But while the brothel as a theme appeared frequently in late-nineteenth- and early-twentieth-century painting, as for example in Toulouse-Lautrec and Rouault, Picasso's version is as far removed from the spirit of irony or pathos of his predecessors as it is from the empathy and restrained lyricism of his own earlier painting.

But what makes *Les Demoiselles* a truly revolutionary work of art is that in it Picasso broke away from the two central characteristics of European painting since the Renaissance: the classical norm for the human figure, and the spatial illusionism of one-point perspective. During the year previous to the completion of *Les Demoiselles,* Picasso had turned to various sources in his search for a new approach to the human figure, the most influential of these being Iberian sculpture, El Greco, and the work of Gauguin, particularly his carved sculpture. But the decisive influence on his thinking was African sculpture, which, despite his published denial,[2] he must certainly have discovered by the winter of 1906/07 if not before. The examples of sculpture from the Ivory Coast and other French colonies in West Africa, which he saw either at the

* Picasso died on April 18, 1973.—Eds.

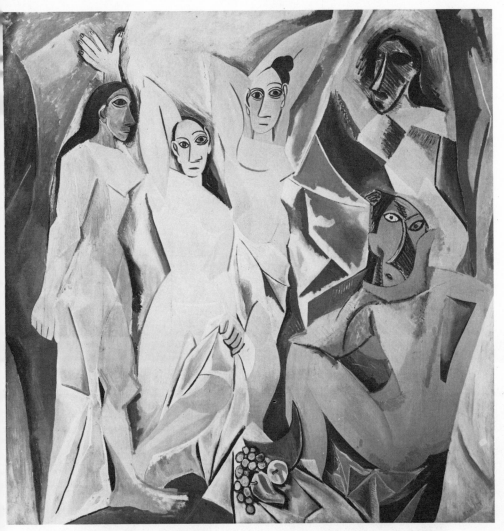

37. Pablo Picasso: *Les Demoiselles d'Avignon*. 1907. Oil on canvas. 96″ × 92″. Collection The Museum of Modern Art, New York, acquired through the Lillie P. Bliss Bequest.

Trocadéro Museum (today the Musée de L'Homme), in the private collections of his friends, or at the shops of secondhand dealers, undoubtedly inspired Picasso to treat the human body more conceptually than was possible in the Renaissance tradition. This new approach appears most clearly in *Les Demoiselles* in such details as the reduction

108 EDWARD FRY

of human anatomy to geometrical lozenges and triangles, as well as in the abandonment of normal anatomical proportions. African influence is even clearer in the masklike faces of the two right-hand figures, which were probably finished later than the rest of the painting.[3]

These departures from classical figure style are more than simply a variation on an existing tradition; they mark the beginning of a new attitude toward the expressive potentialities of the human figure. Based not on gesture and physiognomy but on the complete freedom to re-order the human image, this new approach was to lead to the evocation of previously unexpressed states of mind, particularly in the hands of the Surrealists and above all by Picasso himself in his great works of the 1930s and later 1920s.

The treatment of space is, however, by far the most significant aspect of *Les Demoiselles,* especially in view of the predominant role of spatial problems in the subsequent development of Cubism. The challenge facing Picasso was the creation of a new system of indicating three-dimensional relationships that would no longer be dependent on the convention of illusionistic, one-point perspective. To help him he had little but the tentative solution offered by Paul Cézanne (1839–1906), whose work had recently been shown in several large retrospective exhibitions in Paris, beginning in 1904.[4] Although as a result of his associations with the Impressionist generation there always remained in Cézanne's art a strong residue of optical empiricism, by the mid-1880s he had developed a way of denying illusionism by means of integrating surface and depth in his paintings, particularly by *passage*—the running together of planes otherwise separated in space—and other methods of creating spatial ambiguity; at the same time, however, one must remember that Cézanne's intentions were very different from those to which the Cubists would later apply his methods.

In addition Cézanne had broken with the Renaissance tradition of composition by which forms were disposed harmoniously within the illusionistic stage space of one-point perspective. Cézanne, instead, had gone a step beyond the break with tradition represented by the Impressionists' optical realism, to a realism of the psychological process of perception itself. Thus in painting a motif, Cézanne would, by the 1880s, organize his subject according to the separate acts of perception he had experienced; houses and other solid objects were depicted as the artist had conceptualized them after a long series of perceptions. And, in the overall composition of a painting, Cézanne would organize parts of the whole into perceptual areas, within which "distortions" occurred in

the interests of formal contrast and the realization of a visual gestalt of the highest possible unity, as is particularly noticeable in his still lifes.

The art of Cézanne contains yet further complexities, particularly with regard to his use of color; but, when Picasso was studying him in the years between 1906 and 1910, what he found of greatest interest must have been the tentative suggestion of an alternative to Renaissance perspectival space. In *Les Demoiselles* one finds Cézannian *passage* linking together foreground and background planes, just as there is a precedent for Picasso's schematic treatment of human anatomy as much in Cézanne's houses and nudes as in the figures of African sculpture. But in using his stylistic means, Picasso went far beyond Cézanne. The grouping of figures in *Les Demoiselles* exceeds in its arbitrary boldness the most audaciously structured of Cézanne's Bathers compositions; and Picasso combines multiple viewpoints into a single form to a degree that Cézanne, with his heritage of Impressionist fidelity to the visual world, would never have attempted. During the summer of 1906, at Gosol in Spain, Picasso had begun to combine the profile view of a nose with the frontal view of a face, as he did in the two central figures of the *Demoiselles;* but the figure in the lower right-hand corner of the painting shows a far more radical application of the same idea. In what was probably the last part of the painting to be executed, Picasso created a female nude whose masklike face, back, and breasts are all visible at once; with this figure Picasso dismissed at once both one-point perspective and the classical tradition of figure style.

The role of color in *Les Demoiselles* is no less significant than the treatment of space, to which it is in fact related. The predominant scheme of the painting is the strong pink and ochre that Picasso had been using during his pink period of the previous two years. But the figure in the upper right-hand corner displays a modeling of the face and breast by means of striations in blue; and where the modeling of the nose would ordinarily be indicated with dark shadowing, Picasso has used bright, alternating bands of fauvelike green and red, the juxtaposition of which creates strong simultaneous contrast. Similarly, in the lower right-hand nude, the schematically reshuffled features are modeled in blue.

These areas represent Picasso's first attempt to devise a workable alternative to the traditional system of modeling by chiaroscuro or its equivalent. Modeling by color is of course not new in itself; it appears in Byzantine art, in much medieval art, in Sienese painting, in many Italian artists of the Quattrocento, in Grünewald and his contemporaries, in

such Mannerists as Rosso, in Rubens and Delacroix, and more recently in Cézanne and the Fauves. But in *Les Demoiselles* Picasso utilizes color modeling in conjunction with his abandonment of one-point perspective, thus freeing himself equally from the single vantage point and from a similarly specified, and therefore accidental, source of light. Here again his only precursor since the Renaissance was Cézanne; and here as in other ways, Picasso, even while following Cézanne's lead, far surpassed him in exploring the radical possibilities of such an idea.[5]

The problem of how to indicate the relation of volumes to each other without the use of chiaroscuro, and at the same time without the total suppression of local color, was not to be resolved until the invention of papier collé in 1912. The importance of *Les Demoiselles,* however, is that in it Picasso mounted a frontal attack not only on these but on almost all the other problems that were to preoccupy him and Braque for the following six years. Equally fascinating is the diversity of cultural elements that meet in *Les Demoiselles,* ranging from Cézanne and Fauvism to Iberian sculpture, El Greco, Gauguin, and African art. *Les Demoiselles d'Avignon,* more than any other painting of its time, was a crossroads of aesthetic forces, which the prodigious gifts of its creator fused, if only imperfectly, into a great work of art and a turning point in the history of Occidental painting.

Picasso was not to attempt so ambitious a work as *Les Demoiselles* until almost two years had passed. During the remainder of 1907 and the first part of 1908 he further explored the formal and expressive possibilities suggested by African sculpture; then, during the second half of 1908, he returned to another of the elements that had gone into *Les Demoiselles* with a series of landscapes and still lifes that show a renewed and careful study of Cézanne. These two interests were by no means divorced from each other, and in fact Picasso explored them both more or less concurrently during 1908; this ability to develop two or more ideas simultaneously has remained with Picasso throughout his career.

An event of decisive importance for the future history of Cubism occurred toward the end of 1907, when the poet Apollinaire introduced to his friend Picasso the young painter Georges Braque (1881–1963).[6] Braque, who was almost the same age as Picasso, had during the previous two years been one of the leading Fauve painters, but during 1907 he had begun to give a more formal, almost Cézannian, structure to his paintings; now, this meeting with Picasso was to change his art

completely. By the end of 1909 Braque and Picasso were seeing each other almost daily, and this close artistic association, which lasted until World War I, was to become the fountainhead of Cubism.

But when Braque first met Picasso and saw *Les Demoiselles,* he had had no preparation for the shock that this confrontation must have produced. His first reaction as a painter was the *Grand Nu* (begun in December 1907[7] and exhibited in the Salon des Indépendants of 1908).[8] A drawing that must have immediately preceded the *Grand Nu* gives us a revealing insight into Braque's first response to *Les Demoiselles:* Braque grasped the tremendous implications of the lower right-hand figure in Picasso's composition, and in his restatement of Picasso's ideas he arrived at the genesis of his own monumental nude. In the *Grand Nu* we can almost sense Braque's struggle to come to terms with Picasso's thinking, which he must not have understood at all well at first. But Braque did in this painting use Cézannian *passage* to create a tightly interlocked spatial system in the background; and in the figure itself he followed Picasso's lead in combining several points of view into a single image.

During the summer of 1908, Picasso was painting Cézannian landscapes and still lifes, first in Paris and later, during August, at La Rue-des-Bois, a small town in the Île de France.[9] At the same time Braque was in southern France near Marseille, at L'Estaque, where Cézanne himself had frequently painted. Braque's landscapes of this summer reveal a much more literal study of Cézanne than does the contemporary work of Picasso. His *Houses at L'Estaque* (1908; fig. 38) nevertheless demonstrates Braque's sensitive assimilation of the same aspects of Cézanne that interested Picasso; and a comparison with his *Grand Nu* of a few months earlier shows the progress he had made in this direction. At a much later date Braque said of this crucial moment in his development that at first he had been blinded by the brilliance of Provençal color and light, but that gradually "it was necessary to find something deeper and more lasting."[10]

Like Picasso, Braque was learning to stand on Cézanne's shoulders, extracting from his art its structural and nonillusionistic features while discarding Cézanne's lingering interest in observed visual detail. A series of these L'Estaque paintings, when rejected by the jury of the 1908 Salon d'Automne, formed the nucleus of a Braque exhibition in November 1908 at a small gallery in Paris that had been recently opened by a young German, Daniel-Henry Kahnweiler, who was later to become the dealer for all the leading Cubists. In his review of this

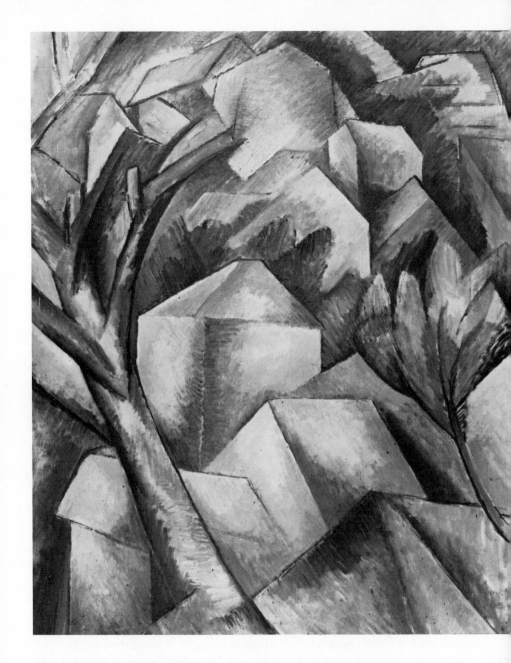

38. Georges Braque: *Houses at L'Estaque.* 1908. Oil on canvas. 28½″ × 23¼″.
Courtesy Kunstmuseum, Bern, Hermann and Margrit Rupf Foundation.

exhibition the critic Louis Vauxcelles used the word *cubes* for the first time in relation to the new style that was emerging.

The rapidity with which Braque advanced along the path of a post-Cézannian art may be seen in a *Still Life with Fruit* (late 1908), in which a complex system of intersecting planes defines volumes in space in an already proto-Cubist nonillusionistic manner; the debt to Cézanne is still considerable, as in the perspective distortion of the banana in the lower left-hand corner, recalling Cézanne's similar treatment of curving roadways. But Braque had now begun to use chiaroscuro in the decidedly arbitrary way that became a characteristic of his and Picasso's paintings until 1912. Braque's choice of a single, three-dimensional solid as the subject of his painting also became the rule in his and Picasso's work of the following three years. For as the Cubist painter Juan Gris said much later, this early period of Cubism was primarily a matter of the relation between the painter and the objects that he painted, rather than the relations between the objects themselves.

During the winter of 1908/09 Picasso completed his monumental *Three Women,* on which he had been working intermittently since the spring of 1908. This painting marks the end of a crucial phase in Picasso's early Cubism that began with *Les Demoiselles* and during which the artist was seeking both new formal and new expressive values. *Three Women* is really a summation of the previous two years; and historically it bears a symmetrical relation to *Les Demoiselles,* by comparison with which it is more successful and unified, though less ambitious. In the succeeding five years Picasso devoted himself almost completely to formal problems, to the exclusion of the haunting new states of mind that he had created in *Les Demoiselles, Three Women,* and many other paintings of 1907 and 1908.

During the summer of 1909 Picasso spent several months in the village of Horta de San Juan in his native Spain. In Paris during the spring of 1909 he had already begun to use large, shaded facets that reduced the human figure to a sculptural assemblage of geometrical solids. At Horta he continued in this direction with a series of landscapes and in a group of portraits of his mistress, Fernande Olivier. In *Houses on a Hill* Picasso returned with renewed intensity to a Cézannian style, including Cézanne's high eyepoint. A photograph by Picasso[11] of the landscape at Horta shows, however, that he was applying his assimilated knowledge of Cézanne to a quite realistic portrayal of the motif; such paintings in fact were a retreat from the tense ambiguities of spatial structure in the *Three Women* (1908/09). These geometrical simplifica-

tions recall Cézanne's famous remark about the cylinder, the sphere, and the cone; and for one of the few instances in its history one can speak of "cubes" in a Cubist painting. It is not difficult at this point to see why Picasso and his friends appreciated the works of the Douanier Rousseau, whose untrained but extraordinary sensibility also apprehended forms in a schematic, conceptual way, as may be seen in *Village Street Scene* (1909).

In depicting the houses in his Horta landscapes, however, as well as in his portraits of Fernande Olivier, Picasso continued to combine separate points of view into a single image. But from the standpoint of the future development of Cubism, it is evident from Braque's *Château at La Roche-Guyon,* painted in this same summer of 1909, that he had reached a more advanced position than Picasso in the application of the lessons to be learned from Cézanne.

Before Braque had met him at the end of 1907, Picasso had been alone in his search for a new art; and until 1909 the two of them were without followers. But by 1909 at least one other painter in Paris had begun to draw important conclusions from the study of Cézanne. Fernand Léger (1881–1955) had arrived, in such works as his little-known *The Bridge* (1909), at a point comparable with that of Braque's L'Estaque paintings of the previous year. But where Braque had shown an instinctive painterly delicacy, Léger's robust personality revealed itself even at this early moment. *The Bridge* nevertheless shows an understanding of Cézannian *passage* and its potentialities for creating a new system of indicating space. During 1911, when Cubism had become a widespread movement, this stage of Léger's art would be reflected in the paintings of such newcomers as Le Fauconnier and Gleizes. But in 1909 Léger, and to a lesser extent his friend Robert Delaunay, were the only painters besides Picasso and Braque who were exploring the heritage of Cézanne in a significant and creative way. Léger, who met Picasso toward the end of 1910,[12] was shortly to embark on the development of his own version of Cubism, which has qualities in common with the contemporary work of Picasso and Braque. His *Nudes in the Forest* (1909–1910[13]) does not represent a major advance over *The Bridge* except that here, for almost the first time, Léger used the cylindrical forms that were by 1913 to become an essential feature of his pictorial vocabulary; as early as the autumn of 1911 Léger was being called not a Cubist but a "tubist."[14] It should be noted that in the *Nudes in the Forest,* despite superficial appearances to the contrary, Léger created a traditional hollowed-out space, using as in *The Bridge* a

perspectival diminution of scale and a Cézannian high eyepoint. The same may be said of Picasso's *Houses on a Hill,* although to a much lesser extent. It is not at all accidental that, in order to avoid this traditional illusionistic effect, Picasso and Braque painted very few landscapes after 1910, limiting themselves almost completely to figures and still lifes placed against a nearby flat background and as seen from a relatively close range.

By the end of 1909 Braque and Picasso had become close friends; and in their work they had arrived more or less independently at very similar, though not identical, styles. Braque in fact often originated startling new ideas of his own, as in the *Pitcher and Violin* (winter 1909/10). Here the faceting of forms has reached a point where the intersecting planes have begun to follow an artistic logic of their own, as much in accordance with the rhythmic structure of the painting as with the necessity of describing the subject. Lighting, or rather the contrast of light and shadow, has now also been completely subordinated to the demands of pictorial structure. As an indication of this new balance between art and reality, Braque painted an illusionistic nail at the top of the painting, as though to indicate by means of the shadow it casts that his canvas is simply a flat, painted surface that is tacked to a wall. This device is an example of the idea, which was becoming current by 1911, of the *tableau-objet,* the painting as object. By comparison, a still life by Picasso, painted early in 1910, seems to remain an extreme development of Cézannian ideas; for example Picasso still respects the exterior contours of objects, whereas in the *Pitcher and Violin* Braque did not hesitate to violate the contour of the violin.

Picasso, however, was soon to take the same step, as in his magnificent *Portrait of Ambroise Vollard,* the Parisian dealer who had exhibited him as early as 1901. Begun probably by the end of 1909, this portrait was not finished until late in the spring of 1910;[15] not only is it an astonishing likeness, but when compared with Cézanne's portrait of Vollard, Picasso's version reveals the distance the artist had traversed since his Cézannian paintings of 1908. Vollard is seated facing us; behind him is a table, on which are a bottle, on his right, and an upended book, on his left. Picasso has even included the handkerchief in Vollard's breast pocket. The whole surface of the painting is a series of small, intersecting planes, any one of which, because of *passage,* may be understood as being both behind *and* in front of other, adjoining planes. Picasso does not hesitate now to violate the contours of forms in the interest of his overall pictorial structure; but within this dense, yet flat

structure he has placed clues that enable the viewer to recognize the subject.

The real subject, however, is not Vollard but the formal language used by the artist to create a highly structured aesthetic object. Obviously it would be incorrect to call this painting an abstraction, since it bears a specific relation to external, visual reality; indeed, the persisting fascination of this and other Analytical Cubist paintings of the following two years is precisely the result of an almost unbearable tension experienced by the viewer. He is delighted by the intellectual and sensuous appeal of an internally consistent pictorial structure, yet he is also tantalized by the unavoidable challenge of interpreting this structure in terms of the known visual world. This exquisite tension between the world of art and the world of perceptual experience persists until the end of 1912. Then, with the invention of collage and papier collé, Cubism enters a stage in which the work of art, though at least as basically realistic as before, is nevertheless far more independent of the visual world than is the Analytical Cubism of 1910.

Another portrait by Picasso, of Wilhelm Uhde, the German critic, connoisseur, and collector of Cubism, is contemporaneous with the Vollard portrait, but it is not quite on the same high level of subtlety and richness of realization. But the Uhde portrait, like that of Vollard, foreshadows an important step taken by Picasso during the summer of 1910, which he spent at the coastal village of Cadaqués in the northeast corner of Spain. There, as Kahnweiler has rightly emphasized, Picasso abandoned the use of faceted, closed forms in favor of planes with long, straight edges that disregarded the contours of objects; now, more than ever before, the subject was linked to the flattened structural continuum of the whole surface of the painting. As a result, the subject became yet more elusively difficult to comprehend than before; the term *hermetic* has often been applied to the 1910 to 1911 works of Picasso and Braque.

With Picasso at Cadaqués with his friend André Derain (1880–1954), who, like Braque, had previously been a Fauvist. Derain has sometimes been mistakenly associated with Cubism, but, as his view of *Cadaqués* reveals, Derain in 1910 was already the traditional painter he would remain for the rest of his life, strongly influenced by Cézanne yet unable to create a significant style of his own.

Although Picasso's Cadaqués paintings were an important step, they are not the single most crucial moment in the history of Cubism. Rather, at Cadaqués, Picasso shifted the balance between pictorial struc-

ture and the description of the visual world further toward structure, as was already becoming apparent in his *Portrait of Vollard.* The new emphasis on formal elements is evident in the *Portrait of Kahnweiler* (autumn 1910). Compared with the Vollard portrait, the subject is less recognizable, although the painting was certainly based on Kahnweiler's appearance. He is shown seated, wearing a watch chain, his hands clasped in his lap; to his right is a bottle and glass. Behind him is a table, and on the wall in the upper left-hand corner of the painting is a wooden sculpture from the French colony of New Caledonia in the Pacific. Picasso owned two pieces of New Caledonian sculpture as early as 1908; they are visible in a photograph of his studio at the Bateau-Lavoir. Indeed, in this portrait Picasso seems to have made a deliberate and witty juxtaposition between his sitter and the Oceanic sculpture, since he made room for it in his composition by placing Kahnweiler's head off center. As at Cadaqués, the planes are no longer bounded by the closed form of the object, but instead they continue freely from one part of the composition to another, giving the effect of being alternately solid and transparent. Chiaroscuro contrast has become equally flexible, now totally divorced from any illusionistic function and used only to indicate the relations between planes. With this new emphasis on structure since Cadaqués, Picasso reduced his palette to browns, grays, and black; but even in 1909 he had largely restricted himself to ochres. By the end of 1910 Braque had similarly limited his palette.

Braque was to follow the same course as Picasso in finally abandoning closed form and concentrating on planar structure. His view of *Sacré-Cœur* (early summer, 1910) is still quite clearly relatable to the motif. By the end of 1910, however, Braque was painting works in which the original objects are hardly recognizable, as in his *Still Life with Decanter and Glass,* which was as close as Braque ever came to abstract painting. This still life is also notable for being oval, as were many paintings by him and Picasso after 1910. The oval, or sometimes circular, shape solved the problem of what to do with the corners in a Cubist composition, and it was also another indication that the artist considered his painting to be a real object in itself, more than simply an illusion of the visual world.

During 1910 Léger too had begun to emphasize the two-dimensional relations of formal elements in his paintings, but he followed a method different from that of Picasso and Braque. Léger's approach was to emphasize the contrast between the amorphous, translucent quality of clouds or smoke, and the hard, geometrical structure of houses or of his

tubular figures, as in *The Wedding* (1910–1911), painted as a wedding present for the poet André Salmon. In works such as this Léger achieved a balance between subject and pictorial structure comparable to that in the works of Picasso and Braque of mid-1910; yet unlike them, Léger devised his formal means by a literal adaptation of visual effects in nature, and he also respected the closed contours of objects.

The painter Jean Metzinger (1883–1956) followed Picasso and Braque more closely. His *Nude* (1910) shows a knowledge of Picasso's attempts to abandon closed form, but Metzinger did not apply the idea consistently or with sufficient understanding. The result is a chaotic mixture of Cubism and traditional illusionistic painting. Metzinger was nevertheless the only painter besides Léger whose work in 1910 approached the artistic aims of Braque and Picasso.

Until early 1912 the Cubism of Picasso and Braque remained generally within the confines of their art at the end of 1910, for at that moment the possibilities of the style had suddenly become so rich that almost two years were necessary for their exploration before a further change could take place. Thus the *Still Life with Clarinet,* painted by Picasso during the summer of 1911 when he and Braque were at Céret in the French Pyrenees, represents a continuation of the stylistic innovations of his *Portrait of Kahnweiler,* but with one significant change. In this still life are a clarinet,[16] a pipe, a bottle, a musical score, and an opened fan, all on a table top and with each object indicated by means of at least one characteristic or recognizable detail. Such a still life is more ambitious than most of his paintings since the *Three Women* (1908–1909), because here Picasso has used his by now fully developed Analytical Cubist style to depict not one but many discrete objects, and he has sought furthermore to relate them all to each other, in a non-Cézannian way, as well as to an overall diamond-shaped compositional scheme. The fact that this and other paintings of the same period are extremely difficult to read points to a problem inherent in this stage of Cubism. For while it is suitable for paintings of a single figure or object, which are in the majority at this time, a complex system of interocking, monochromatic planes becomes dangerously obscure when the artist seeks, in Gris's words, to reveal not merely the relation between the object and himself but between the objects themselves. That the artists recognized this problem is evident in the rapid development of its solution with the invention of collage Cubism in 1912. But before that moment they acknowledged the danger of reaching a point of complete

abstraction that would have been the antithesis of the always realistic orientation of Cubism by introducing not only realistic clues but also words, letters, and numbers into their compositions. Braque had begun to do so in the spring of 1911, and Picasso soon followed suit. The effect of this stratagem was to prevent their paintings from appearing to be absolutely flat abstractions, even while they remained objects. For the presence of typographical signs such as letters or numbers, which by nature are only two-dimensional, would by contrast force the composition on which they were superimposed to be understood as a three-dimensional image. These words and letters were never chosen arbitrarily but almost always referred to a specific aspect of the objects being portrayed, such as the name of a newspaper. Later this device was to become an essential element in collage Cubism, but a good example of Braque's use of it may be seen in the *Still Life with Harp and Violin* (early 1912). In addition to a harp in the background there is a still life with a bottle, glass, violin, musical score, and a newspaper (*EMPS*) of the period, the full name of which was *Le Temps.* Braque perhaps also intended to make a play on words, by which (*T*)*EMPS* would refer both to a newspaper and to a musical beat.

Analytical Cubism reached its zenith in a dozen or more paintings of a single figure by Picasso and Braque, during 1911 and early 1912. Typical of these great paintings is Picasso's *Man with Violin* (late 1911; fig. 39). The subject is identifiable through realistic clues provided by the artist—an ear, his goatee, buttons on his coat, and the strings and sound holes of a violin. It has proved tempting with such works to speak of the dissection or analysis of masses, and of the combination of multiple points of view, with implications of a "fourth dimension" or of non-Euclidean geometry; many critics have offered such explanations of these works. It is important to remember, however, that by the end of 1911 neither Picasso nor Braque was any longer painting directly from nature. One may legitimately speak of the combination of separate viewpoints in *Les Demoiselles d'Avignon,* Picasso's figure paintings done at Horta, and other examples of pre-1910, Cézannian Cubism. But by 1911 Cubism was as much an autonomous, internally consistent style with a new formal vocabulary of its own as it was a means for describing the immediately visible world. The unresolvable tension between these two functions in Analytical Cubism is the source both of its greatness as an art and of its misinterpretation by critics.

Therefore, in confronting a painting like the *Man with Violin,* one must not try to establish an equivalent in the known visible world for

each of its components; the painting presents a man and a violin, it does not represent them. The violinist's head is not simply a summation of different points of view, but the product of an intellectual process by which are superimposed separate planar schemes for the man's head, followed by a process of uniting the resultant forms in order to make a pictorially consistent structure. The *Man with Violin* in fact presents the viewer with an experience that has ultimately a relation to the visible world but that, like a Renaissance painting, is more directly based on stylistic conventions inherited or, as in Picasso's case, invented by the artist. Instead of experiencing the illusion of masses situated within a space by means of the convention of one-point perspective, the viewer is confronted by a different set of conventions, which in this case produce the effect of flatness but not of spacelessness; for the figure in Picasso's painting has a density and thickness far greater than its surroundings, and yet paradoxically and miraculously this figure projects neither forward nor backward into space. In any given area of this composition the planes may describe an aspect of the subject. But their primary function at the same time is, as in the *Still Life with Clarinet,* to take part in the nonillusionistic spatial structure of the painting and to contribute to the overall architecture, here pyramidal, of the composition. The problem for the Cubist painter was thus simply a new version of that which faced a Renaissance or Baroque artist when with each brushstroke he had to fulfill simultaneously the requirements of anatomical modeling (or landscape topography) and those of perspective, light, and composition. And, like the great artists of the past, Picasso and Braque worked by intuition, rather than by following rules as their lesser followers unfortunately did.

Nineteen eleven saw the spread of Cubism beyond the circle of Picasso and Braque. The cause of its spread is not easy to explain precisely, but undoubtedly it owed much to such figures as the omniscient and ubiquitous Apollinaire, who had been an intimate friend of Picasso since 1905 and who knew and frequented apparently every advanced artistic milieu in Paris. Metzinger, who knew Picasso by 1910 if not before, must also have been instrumental in the spread of Cubist ideas, particularly through his friendship with Gleizes and with other artists who met at the home of the writer Alexandre Mercereau.

The result of this spread of Cubism became publicly known in the Salon des Indépendants of the spring of 1911 and at the 1911 Salon d'Automne, in both of which the new adherents to Cubism formed a

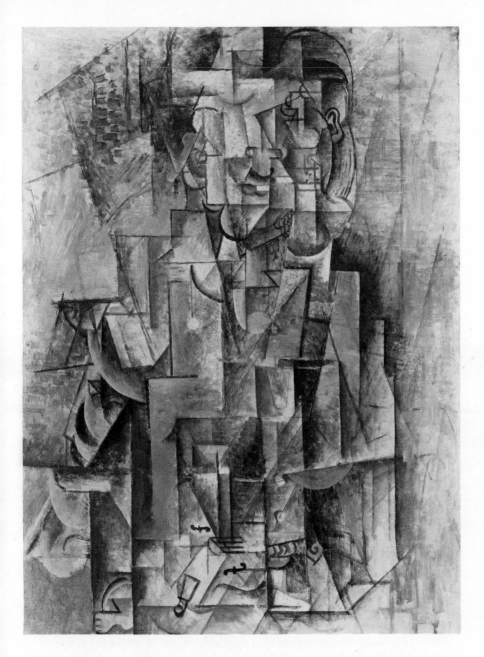

39. Pablo Picasso: *Man with Violin*. 1911–1912. Oil on canvas. 39″ × 29″. The Philadelphia Museum of Art, The Louise and Walter Arensberg Collection.

distinct group; during 1911 also the term *Cubism* came into general usage. None of these painters, however—Gleizes, Metzinger, Le Fauconnier, Lhote, and many others—contributed anything new or essential to the Cubism of Picasso and Braque; and few, if any of them, really understood it. Furthermore, it is difficult to believe that these newcomers to Cubism arrived at their art independently of Picasso and Braque, who must in the end be considered the one source from which the new style spread. The art of Delaunay is an exception; although he knew Picasso by 1910, his intentions were never basically Cubist, save in the broadest sense.

Léger's painting, however, was at this time a genuine alternative to the Cubism of Picasso and Braque, as has been discussed above. His *Study for the Woman in Blue* (1912) is a further development of the contrasts between curves and geometrical solids in *The Wedding* of the previous year. Now Léger has suppressed illusionistic space, and like Picasso and Braque he has dispensed with closed form in order to create a powerful composition of color planes, related to the subject of the painting but not subordinated to it. But he did not follow Picasso and Braque in their use of arbitrary, grisaille planes, interlocked by *passage*. Instead he passed directly from the amorphous puffs of smoke or cloud in *The Wedding* to their formal descendants in the flattened geometrical patterns of *The Woman in Blue,* thus bypassing some of the problems of hermetic obscurity in Analytical Cubism.

The influence of Léger's formal vocabulary may be seen in Albert Gleizes's (1881–1953) *Man on Balcony* (1912; fig. 40). But whereas Léger, like Braque and Picasso, had come to avoid motifs with deep space, Gleizes attempts to combine a foreground figure with distant landscape. The result is only superficially a Cubist painting and in fact contains traditional deep space and perspective diminution of scale. In the foreground figure as well Gleizes used traditional chiaroscuro in the modeling of the face and elsewhere, a technique that he was to abandon when he arrived at a truly Cubist style in 1914. The work of Gleizes is characteristic of the rapidly growing number of painters who during the years 1911 to 1914 adopted something of the external substance of Cubism, but little if anything of its essential qualities.

In the spring and summer of 1912 the art of Picasso and Braque underwent a series of crucial changes, which brought to an end one phase of Cubism and inaugurated a second that was to prove even richer in possibilities than the first. By the end of 1911 the two artists had found that the formal language of Analytical Cubism, brilliant though its

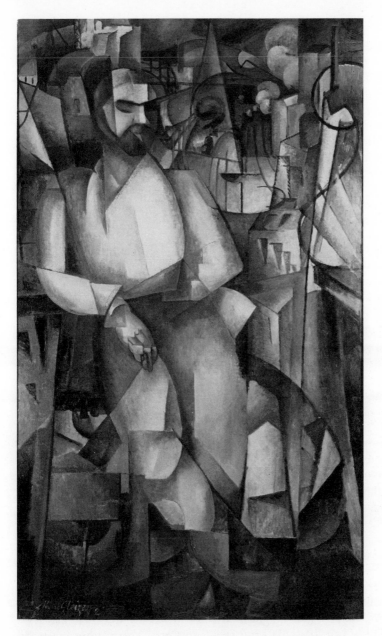

40. Albert Gleizes: *Man on Balcony* (Portrait of Dr. Morinaud). 1912. Oil on
canvas. 77″ × 45¼″. The Philadelphia Museum of Art, The Louise and Walter
Arensberg Collection.

aesthetic results had been, was becoming increasingly inadequate to describe the visual world. In addition, the problem of color, which had been almost completely neglected in the works of 1910 and 1911, had yet to be resolved; for the color of objects was as much a part of their visual qualities as was their form. Although a way had been found to depict reality without the use of traditional chiaroscuro and perspective, the artists' fascination with intricate spatial structures during 1910 and 1911 had all but overshadowed the question of color. These very triumphs of form could perhaps have been achieved only at the expense of color, which would have been still another variable in an already dangerously complex artistic equation; now, however, in a few paintings of late 1911 and early 1912, both Picasso and Braque made tentative efforts to reintroduce it.

Also during early 1912 the objects in the paintings of these two artists became somewhat easier to recognize, and in order to make them yet more recognizable Picasso and Braque began to indicate their textures. In the spring of 1912 Braque started to imitate the graining of wood, first by means of conventional brushwork, then by using a house painter's comb. Picasso soon copied this technique but he also applied it to other effects, notably to the simulation of hair, as in *The Poet*.

The problem of describing visual reality without resort to illusionism was thus being attacked in various new ways; much the most important step in this direction however was Picasso's incorporation of a ready-made facsimile of an object into a still-life painting, in May 1912.[17] His *Still Life with Chair Caning* (fig. 41) is the first Cubist collage; in a still-life scene at a café, with lemon, oyster, glass, pipe, and newspaper, Picasso glued a piece of oilcloth on which is printed the pattern of woven caning, thus indicating the presence of a chair without the slightest use of traditional methods. For just as the painted letters *JOU* signify *JOURNAL,* a section of facsimile caning signifies the whole chair. Later Picasso would go one step further and incorporate into his collages actual objects or fragments of objects, signifying literally themselves.

This strange idea was to transform Cubism and to become the source for much of twentieth-century art.[18] But its immediate usefulness to Cubism was not to emerge until a few months later, when in September 1912[19] Braque glued strips of artificially wood-grained wallpaper into a *Still Life with Fruit Dish and Glass*. These strips, indicating the drawer and top of a wooden table, were the first example in Cubism

of the use of pasted paper, or papier collé;[20] and with this innovation most of the problems remaining in Cubist art were to be resolved.

In Braque's first papier collé the strips of paper *signify* both the color and the texture of an object, while the forms and interrelations of objects are indicated by means of the vocabulary of lines and planes perfected during the previous two years. Since 1910 Braque and Picasso had dispensed with closed form; so now, with papier collé, the strips of pasted paper were not restricted to the contours of the objects they

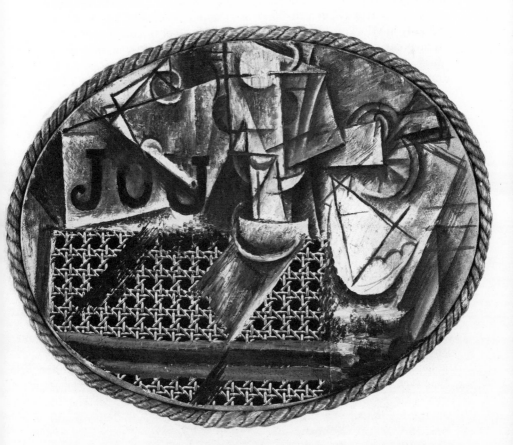

41. Pablo Picasso: *Still Life with Chair Caning.* 1912. Oil, pasted oilcloth, and rope. 10⅝″ × 13¾″. Photograph courtesy The Museum of Modern Art, New York, copyright © 1977 by S.P.A.D.E.M., Paris.

signified. The artist was now free to compose the strips of paper in a papier collé according to a scheme of pattern and color aesthetically independent of all realistic intent, even while these same colored or patterned papers conveyed information about the objects depicted.

These pieces of pasted paper also eliminated all vestiges of illusionistic space; the papier collé is concretely and absolutely flat. But these paper strips could also, when the artist so desired, express spatial relations directly, by overlapping each other or by their relation to lines drawn over or under them. And, as in 1910 and 1911 Cubism, a spatial ambiguity that itself denied illusionism could be created by means of mutually interlocking strips, overlapping each other in one sequence at a given point of juncture but in a different sequence at a second point. Lines and planes indicating the formal qualities of objects could be drawn across, or separate from, the paper strips, so that both the color

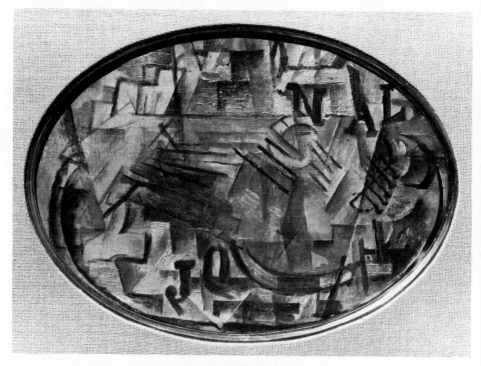

42. Georges Braque: *Mandolin and Newspaper.* 1911. Oil on canvas. 9½″ × 13¾″. Courtesy Sidney Janis Gallery, New York.

and the form of an object might be described. The previously existing dilemma of local color versus chiaroscuro was thereby eliminated; and with the discovery of a technique involving neither brushwork nor oil pigment, the Cubist break with previous artistic methods and attitudes was virtually complete.

Both Picasso and Braque had experimented during 1912 with cardboard relief constructions, of which only a few survive; and undoubtedly these constructions, which they continued to make in 1913 and 1914, contributed measurably to the invention of papier collé, as did also very possibly a renewed study of certain types of African sculpture. As soon as Braque had made the first papier collé, he and Picasso proceeded rapidly to develop its enormous potentialities with all the brilliance and subtlety that had gone into the Cubist masterpieces of 1910 and 1911 (see figs. 42, 43). But in contrast to Braque's generally

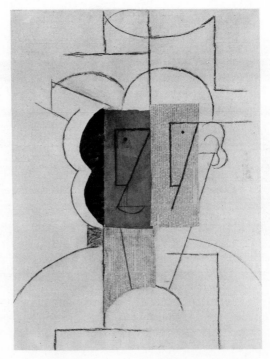

43. Pablo Picasso: *Man with a Hat*. December 1912. Charcoal, ink, and pasted paper. 24½″ × 18⅝″. Collection The Museum of Modern Art, New York, Purchase.

more straightforward and often lyrically serene use of the new medium, Picasso discovered in papier collé a means of creating paradox, ambiguity, and wit, as in one of the greatest of all papiers collés, his *Still Life with Violin and Fruit* (early 1913[21]). Here in one instance Picasso uses newsprint—*(JOU)RNAL*—in a collagelike way to signify literally a newspaper on a table. Elsewhere in the picture he gives a purely arbitrary significance to the newspaper fragments; in the upper left-hand corner, to indicate fruit in a dish he has pasted printed illustrations of apples and pears above a segment of newsprint, which in this instance signifies the bowl of the fruit dish, while below it an absolutely blank white strip of paper indicates the stand of the fruit dish. Paradoxically, the cutouts of fruit seem to overlap each other, yet physically they do not. The wood-grained papers identify alternately the violin and the table on which it sits; there is also a second white strip, related compositionally to the first, which signifies the unshadowed side of the fingerboard and neck of the violin. At the bottom, a large piece of newspaper functions both as an abstract compositional element and as a sign for the tablecloth; at the lower left a grid of horizontals and verticals adds stability to the otherwise unanchored diagonals above and also indicates the presence of a chair. Superimposed on the newspaper at the right, and at a cocked angle to it, is a second, smaller piece of newspaper, on which in turn is a drawing. The drawing and the small cutout together signify a wineglass, in a highly condensed and conventionalized manner; many formal characteristics of the glass have here been fused, if only tentatively, into a single image. This type of condensed image, when fully perfected, was to play a highly important role in later Cubism. Even the transparency of the wineglass has been indicated by the fact that its paper cutout is at an angle to the larger newsprint fragment, here used literally, beneath it: thus the transparent, refractive quality of the empty glass is emphasized. Finally, as if aware of the extraordinary freedom and inventiveness of his achievement, Picasso has not neglected the witty implications of the newspaper captions: *LA VIE SPORTIVE* ("the sporting life") and *(APP)ARITION!* Such wordplay soon became a deliberate component in Cubist collages, especially in those of Gris.

Braque's generally more direct, but no less breathtaking, use of papier collé is well illustrated in his *Still Life with Mandolin, Violin and Newspaper* (*Le Petit Eclaireur*) (mid-1913). On the left, a segment of paper cut in a bulging curve stands for the characteristic silhouette of a mandolin; in the center, a square cut from a paper strip indicates its round sound hole, while the hole is repeated in line on the third, vertical

strip. At the right, the violin is suggested by its characteristic outline and by a displaced hint of its own f-shaped sound-hole.

Papier collé inevitably had a powerful effect on the paintings of Picasso and Braque, as may be seen in the latter's *The Violoncello* (1912), where despite the medium of oil paint the appearance is that of superimposed strips of paper. Picasso did not hesitate to combine mediums; his *Still Life with Violin and Guitar* (early 1913) is executed in oil, cloth, and plaster, as well as wood-grained papier collé.

At this point it is well to take a brief look at the course taken by Picasso and Braque since 1910. By early 1910, a temporary balance had been struck between the demands of reality and those of art; this balance was to tip sharply in favor of art after Picasso's Cadaqués paintings and during 1911. During 1912, numerous efforts were made by both Picasso and Braque to redress this balance without sacrificing the innovations in formal vocabulary of the previous two years. This effort culminated in collage and papier collé at the end of 1912. Compared with the hermetic quality of Picasso's *Still Life with Clarinet* (1911), his *Still Life with Violin and Guitar* (1913) is far more easily legible, once the viewer understands the new conventions established by collage and papier collé; yet the artist was not forced to make any concessions to the traditional means of illusionism. At the same time, the methods of papier collé gave the artist an almost limitless freedom in formal organization. Thus a new balance was struck in which, almost miraculously, the interests both of reality and of art could be served to the maximum degree, and by means that were completely independent of past artistic traditions.

Juan Gris (1887–1927), who had been living in Montmartre near his Spanish compatriot Picasso since 1906, was quick to understand the significance of collage; there were in fact few painters other than Picasso, Braque, and Gris who worked in the new medium, especially before 1914. (Exception must be made, however, for the Italian Carlo Carrà, who was ostensibly a Futurist but whose collages at their best may be compared with those of the Cubists.) Gris began to paint seriously in 1911; he passed rapidly through a Cézannian, "analytical" period and by 1912 was creating an austere, though usually highly coloristic, Cubist style of his own, as distinct from that of Picasso and Braque as was Léger's. His *The Washstand* (*Le Lavabo*) (1912) is a collage, incorporating a fragment of a mirror in the upper center of the composition. Since his subject called for a mirror at that point, Gris reasoned in his characteristically rigorous fashion that no technique of

painting could give the equivalent of the reflecting qualities of the mirror itself. This painting was shown at the "Section d'Or" exhibition of October 1912; and in this, as well as in many later works, Gris used the golden section, in combination with a modular system, in laying out his composition.[22]

Also in the "Section d'Or" exhibition was Metzinger's *Portrait of Albert Gleizes* (1912). While Metzinger rather naïvely combined separate eyepoints in this painting, he also adopted a brighter color scheme than he had previously used, probably influenced by Gris and the return of color in the papiers collés of Picasso and Braque. Metzinger also imitated the appearance, but not the mathematical precision, of Gris's system of composition by means of the golden section, an indication of the newcomer's early influence on other Cubists.[23]

By 1914 Gris had reached a point in his version of Cubism that was without an exact counterpart in the work of Picasso and Braque; his *Teacups* of that year is especially interesting as an example of Gris's contribution to papier collé. Almost the entire surface of the canvas is covered with pasted paper, laid out according to a strict geometrical system. The pasted paper is in turn covered with a complex Cubist composition drawn on top of it. The references to reality follow a method similar to that of Picasso and Braque, except that Gris maintained the integrity of objects far more than they did, and was more fond of making objects appear transparent. The newspaper fragment inserted in this work is a highly amusing example of wit in Gris's collages, for the twin photographs on the front page are of the pedestal to a statue before and after the passage of a law forbidding the pasting of notices on public buildings; the ironic reference to collage is obvious.

Léger's art by 1913 was neither so complex nor so subtle as that of Picasso and Braque, but its plastic vigor was unexcelled. He made a large number of paintings in 1913 and 1914 that he called Contrasts of Forms (fig. 44). The tubular forms and flat areas in these paintings are a culmination of his work since 1910. By 1914 Léger had developed a theory, based ultimately on his study of Cézanne, by which he thought he could achieve the maximum of pictorial contrast in the largest number of ways: contrasts of color, based not on the scientific investigations of light by the neo-Impressionists, but on strictly formal considerations; contrasts of straight and curved lines; contrasts of solids with each other and with flat planes. The result was at times completely abstract and had more to do with an almost animistic belief in visual dynamism for its own sake than with Cubism, although usually these Contrasts of

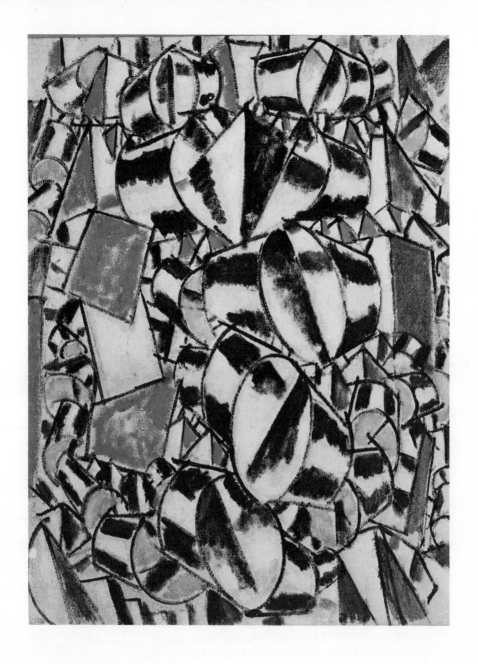

44. Fernand Léger: *Contrasts of Forms.* 1913. Oil on burlap. 51″ × 38″. The Philadelphia Museum of Art, The Louise and Walter Arensberg Collection.

Forms had an ostensible subject and were devoid of illusionistic space. After World War I, however, Léger was to pursue his own version of a later Cubist style.

During 1913 and 1914 so many artists in Paris had turned to Cubism that it temporarily became the universal language of avant-garde painting. By means of printed reproductions and of works sent to exhibitions in England, Holland, Germany, Russia, and the United States, Cubism on the eve of World War I was exerting an overwhelming influence on young painters everywhere. In Paris, many artists of little intrinsic talent turned to painting Cubist pictures, which reflected only the slightest understanding of the style. Others, such as Marcoussis, Reth, and even the young Diego Rivera, came closer to the essentials of Cubism.

Another tendency that may be noted in passing was the application of the idea of simultaneity to both painting and literature. Simultaneity was the rather naïve idea, derived from the writings of Apollinaire, Gleizes, Metzinger, and others, and practiced also in the early poetry of Mercereau, that was used in describing the simultaneous presence in a Cubist painting of separate points of view. Since this simultaneity implied movement, and hence time, the "fourth dimension" and non-Euclidean geometry were also frequently cited as justifications.

An interesting though rather literal-minded application of the idea of simultaneity may be seen in the works of Gleizes and Metzinger, and in some of the paintings of Delaunay: at the same time as the artist shows us an object seen from several sides at once, he also brings together objects distant in space and otherwise not visible simultaneously. This tendency, which has been called "epic" Cubism[24] because of the often wide-sweeping landscape views either implied or directly presented, is well exemplified by Metzinger's *The Blue Bird*[25] (early 1913). Three female nudes are in various postures, and the blue bird is held by the uppermost figure; in other parts of the composition are numerous birds, grapes in a dish on a table, the striped canopy of a Paris café, the dome of Sacré-Cœur in Montmartre, and a ship at sea. So far as Cubist style is concerned, however, Metzinger's painting has little in common with the art of Picasso and Braque: there is no coherent presentation of visual reality by means independent of the Renaissance illusionistic tradition. Metzinger's treatment of the figures and the spatial composition as a whole are what in fact could only be called sub-Cubist.

With the outbreak of war in 1914 there inevitably came a sharp break in the artistic life not only of Paris but of all Europe. Of the principal Cubists, only Picasso and Gris, being Spaniards, were not mobilized, and it is to the work of these two that one must turn for the final stage of the style. During the latter part of 1913 and in 1914, Picasso had turned temporarily toward expressionistic and decorative concerns in his painting, even while remaining within the limits of Cubism; and during the next ten years he was also to alternate between Cubism itself and a linear, realistic neoclassicism that nevertheless contained Cubist elements. But during the year before war was declared, a new idea was emerging in his work and in that of Braque and Gris, which concerned the creation of signs that would summarize in one form many characteristics of a given object; the wineglass in Picasso's *Still Life with Violin and Fruit* collage was an early example of this new idea.

It is probable that at this moment African sculpture played a renewed role in Cubism, for, as Maillol later remarked, the Negro sculptors often had the gift of combining "twenty forms into one."[26] African sculpture also presents analogies to the way in which a given material in a Picasso collage may signify itself but elsewhere in the same collage is given arbitrarily a different signification; similarly, in African sculpture a solid may indicate a void, and vice versa, or a concave form may stand for something that in nature is convex.

Signs had played an important role earlier in Cubism, ever since late 1910 or early 1911 when artists ceased to depend on the direct observation of nature. Realistic clues appeared in the hermetic paintings of 1911, and the words that Picasso and Braque put in their works were literally signs for newspapers or other printed material; Braque also used words for their associative meanings, as with the word *BAR* or the names of drinks in café still lifes, or musical terms and even names of composers in pictures containing musical instruments. In collages, either an object literally signified itself, or a portion of an object, such as the fragment of a newspaper title, signified the whole. Now the sign was to assume a more central role in Cubism.

The *Man Leaning on a Table,* a masterpiece of 1916, is a summation of Picasso's prewar art, but it also contains the germ of later or Synthetic Cubism. The pointillist dots of his decorative, 1913 to 1914 détente are still present; but so is his mastery in organizing spatially interlocked planes, accumulated with the experience of the previous five years. The large size of the planes is an outgrowth of papier collé, which

in turn was itself the fulfillment of Picasso's and Braque's break with closed form in 1910. But the new element in this work is Picasso's use of condensed signs for the head, torso, and leg of the figure, and for the legs of the table: all the formal qualities of an object are "synthesized" into a single characteristic, but highly conventionalized, new form. As in papier collé, the color of this synthesized form could be related to that of the original object, or, as became usual, it could quite arbitrarily play a part in the color system of the whole painting. This color system could be almost, but not completely, independent of the formal structure; there remained the necessity of indicating, where desired, the continuity of a given plane, to which therefore would be assigned the same color wherever it reappeared. Even this limitation could be dispensed with if the artist wished to heighten the ambiguities of spatial relations between planes, thus denying illusionistic space, or if the demands of the overall composition were paramount. Hence, the only limitation upon the artist was topological: he must not allow two areas of the same color accidentally to adjoin each other when the spatial organization of the painting dictated otherwise.

All these aspects of form and color are evident in the next, and final, stage of Cubism, which might be called synthesized Synthetic Cubism. In such works as Picasso's *Still Life with Pipe and Glass* or Gris's *The Man from Touraine* (both of 1918) the condensed signs for objects are themselves combined into a tightly structured composition. In addition to the usual Cubist interlocking color planes, the individual synthesized signs are related to each other by a variety of other means, most prominent of which is visual rhyming, a device that first appeared in some of Picasso's papiers collés during 1912 and 1913: morphologically similar elements, such as circles, are emphasized in the separate signs to which they belong. The composition as a whole could also be forced into a unifying geometrical pattern, which could itself be the original point of departure of the painting, particularly in the work of Gris; Gris was in fact primarily responsible for this final stage in Cubism. The often crystalline appearance of these late Cubist works appealed particularly to the Purists Ozenfant and Jeanneret, who found in them inspiration and justification for their own non-Cubist art.

Picasso's *Three Musicians* (fig. 45), of which there are two versions, is the crowning masterpiece of synthesized Synthetic Cubism; in it is summed up all the long, complicated process of discovery and invention that began in 1907. We are now in a purely stylistic realm, at a long remove indeed from visual reality: each element in the *Three Musicians*

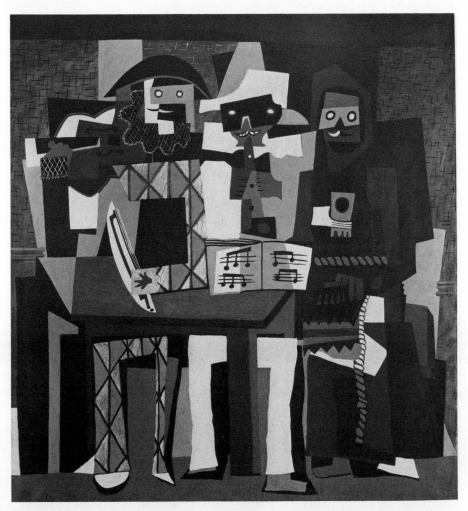

45. Pablo Picasso: *Three Musicians*. 1921. Oil on canvas. 80″ × 74″. The Philadelphia Museum of Art, A. E. Gallatin Collection.

is presented by means of a sign, which itself is the product of a long historical evolution; and all the signs are in turn related to each other by the greatest number of means possible, including visual rhymes, interlocking planes, and the color scheme. As evidence of Picasso's joyous and absolute mastery of his art, one finds here and there visual puns, such as the profile silhouette of a human head just above the musical score·in the center of the painting.

After the war, Léger developed a version of Synthetic Cubism roughly comparable to that of Picasso, as in *The Discs* (1918–1919); but, as before 1914, Léger's art had more to do with visual dynamism than with pure Cubism. Léger's espousal of the city (1919; fig. 46) and the machine as subjects for his works of the 1920s was a direct reflection of his artistic temperament. His formal means, however, often paralleled those of Picasso's Synthetic Cubism. Braque, who was severely wounded in the war, made an effort in 1917 and 1918 to recapitulate his immediately pre-1914 style, and he also painted a few "crystalline" synthetic works. By the 1920s, however, he was launched on a personal version of Synthetic Cubism, which he was to practice until his death and which, with its rich color and broad painterly qualities, heralded the reemergence of an artistic sensibility that before

46. Fernand Léger: *The City*. 1919. Oil on canvas. 90¾″ × 117¼″. The Philadelphia Museum of Art, A. E. Gallatin Collection.

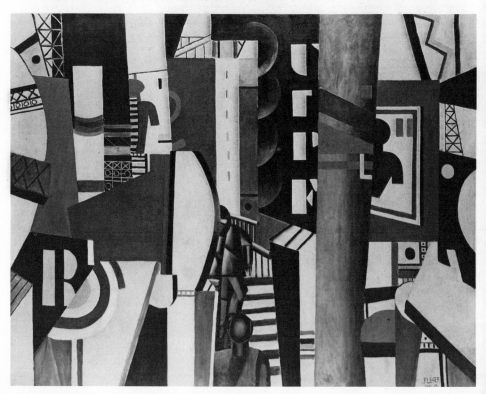

1908 had found its expression in Fauvism. Juan Gris, progressively weakened by an illness to which he succumbed in 1927, continued until the end to work according to the methods of synthesized Synthetic Cubism, although except for some still lifes of 1926 and 1927 his paintings of the 1920s gradually became more realistic.

As had also been the case before 1914, later Cubism was practiced by numerous painters both in Paris and in other artistic centers; but by approximately 1925 all the potentialities of the style had been realized by its creators, while the lesser followers, by their very prolific and mediocre production, were only hastening its decay. The most gifted artists of the period were beginning to respond to other, less rational and more emotionally expressive realms of human experience. Those who had participated in Cubism must have come to feel much as did the sculptor Jacques Lipchitz when he exhorted Gris and his other Cubist friends to escape the Golden Cage of their formal principles and to use the language they had learned for saying something.[27] Picasso, the greatest artist in the first half of the twentieth century and at almost all times the architect and leader of Cubism, was himself in 1925 to turn away from his own superb creation. The expressive intensity of his blue period and of *Les Demoiselles d'Avignon,* which had for so long been suppressed or sublimated in a long series of brilliant formal inventions, emerged in his *Three Dancers* (1925), never again completely to disappear. With this work, Cubism as a living style came to an end, although both Picasso and virtually every other artist of the next four decades remained indebted in one way or another to what is still today the greatest single aesthetic achievement of the century.

NOTES

1. See D.-H. Kahnweiler, "Huit entretiens avec Picasso," *Le Point*, Souillac, October 1952, p. 22.

2. See Zervos, *Picasso* (Paris, 1932), vol. 2, part 1, text opposite pl. 11.

3. See Alfred H. Barr, Jr., *Picasso, Fifty Years of His Art* (New York: The Museum of Modern Art, 1946), p. 257, note to p. 56.

4. *1904* Salon d'Automne, 33 works; *1905* Salon d'Automne, 10 works; *1906* Salon d'Automne, 10 works; *1907* Salon d'Automne, 56 works; Galerie Bernheim Jeune 16–29 June 1907, 79 watercolors; Cézanne was also included by Bernheim Jeune in group exhibitions in 1906 and 1907. The dealer Ambroise Vollard, who had exhibited Picasso as early as 1901, had the largest stock of Cézannes of any dealer during these years.

5. The striated hatchings seen in *Les Demoiselles,* and also in a few still lifes of the summer of 1907, may quite possibly derive from African sculpture; a Dogon wooden door with this type of striation entered the collections of the Trocadéro in 1906. (Information by courtesy of M. Jean Laude, Paris.) See Marcel Griaule, *Arts de l'Afrique noire* (Paris, 1947), p. 65, pl. 53.

6. See D.-H. Kahnweiler, "Du temps où les cubistes étaient jeunes," *L'Oeil*, Paris, January 19, 1965, p. 28; cf. also his "Cubism: The Creative Years," *Art News Annual,* New York, 1955, pp. 107 ff.

7. See Douglas Cooper, *Georges Braque* (London: The Arts Council of Great Britain, 1956), p. 28.

8. See *L'Intransigeant,* Paris, March 20, 1908; also *The Architectural Record,* New York, May 1910, p. 405.

9. A postcard from Picasso at La Rue-des-Bois to Gertrude Stein is postmarked August 14, 1908; Picasso-Stein correspondence, Yale University.

10. Quoted by Guy Habasque, in his "Cubisme et phénoménologie," *Revue d'Esthétique,* Paris, April–June 1949, p. 154, note 1.

11. See Gertrude Stein, *Autobiography of Alice B. Toklas* (New York: Random House, 1933), p. 110; see also *Transition,* No. 11, Paris, February 1928, p. 91.

12. See Douglas Cooper, *Fernand Léger et le Nouvel Espace* (Geneva, 1948), p. 36.

13. It was first exhibited in the Salon des Indépendants, spring 1911.

14. Louis Vauxcelles, in *Gil Blas,* Paris, September 30, 1911.

15. Picasso–Stein correspondence.

16. In many of their other Cubist still lifes Picasso and Braque painted not a clarinet, as is usually stated, but an oboe.

17. Information given to Mr. Douglas Cooper by the artist. But this still life has recently been dated November 9, 1912, supposedly on Picasso's word. See David Duncan, *Picasso's Picassos* (New York: Harper & Row, 1961), p. 207.

18. See William Seitz, *The Art of Assemblage* (New York: Doubleday & Co. for The Museum of Modern Art, 1961).

19. See Douglas Cooper, *Georges Braque,* p. 35.

20. Picasso used a piece of pasted paper in a drawing of 1908 (Guggenheim Museum, New York, collection J. K. Thannhauser; illustrated in Zervos, *op. cit.,*

vol. 2, part 1, 66), but it was to make a repair in the drawing. In the Musée des Beaux Arts, Strasbourg, there is a collage containing a strip of newspaper, by André Utter (1886–1948), who inhabited Montmartre and knew Picasso. It is dated, falsely, 1909; the newspaper clipping is from *Le Journal*, Paris, of March 14, 1914.

21. The newspaper clippings in this work are from *Le Journal*, Paris, December 6, 9, 1921.

22. A line, or the dimension of a painting, is divided by the golden section if the smaller part is to the larger part as the larger part is to the whole; taking the whole as 1, the larger part equals approximately 0.618. See William Camfield, "Juan Gris and the Golden Section," *Art Bulletin*, New York, March 1965, pp. 128–134.

23. Gris and Matisse became friends during 1914 and spent part of that summer together; and in a few of his subsequent paintings, notably the *Piano Lesson* (1916), Matisse used the golden section.

24. See Daniel Robbins, "From Symbolism to Cubism: the Abbaye of Créteil," *Art Journal*, New York, Winter 1963–1964, pp. 111–116.

25. There is no significant connection with Maeterlinck's 1910 play of the same name.

26. See Judith Cladel, *Maillol* (Paris, 1937), p. 127.

27. Irene Patai, *Encounters: The Life of Jacques Lipchitz* (New York: Funk & Wagnalls, 1961), pp. 181–182.

CUBISM AS A STYLISTIC AND HISTORICAL PHENOMENON

Cubism is a generic name that has been given to a varied range of art produced between 1907 and the middle or late 1920s. As has been shown, there is a great difference between the Cubism of Picasso, Braque, and Gris, and that of other painters. This difference is based ultimately on the degree to which the artist in question succeeded in breaking with the European illusionistic tradition; and the formal means associated with this break also indirectly involved a choice of subject matter. It may be argued that those artists who did not break with illusionism in a stylistically coherent way were nevertheless the creators of another sort of Cubism, different from that of Picasso, Braque, and Gris, but equally valid as a style. In fact, however, the pre-1914 works of these artists—Gleizes, La Fresnaye, Le Fauconnier, Metzinger, Lhote, and many others—when examined closely reveal in almost every case a still illusionistic, or at best Cézannian, conception of painting,

concealed beneath a half-understood adaptation of the formal means of Picasso or Braque. The same artists later usually followed one of two courses; either, like Villon by 1913 or Gleizes by 1914, they assimilated the style of the leaders and followed in their wake; or, like Lhote and Le Fauconnier, they reverted to the traditional style that had been the basis of their art even at its most cubistic moments.

All the critics of Cubism, both during its life-span and afterward, agree that its intentions were basically realistic. It is certainly easy to recognize how much more dispassionately realistic it was than such other styles of the period as Futurism or German Expressionism. An indication of this ultimate reliance on the visual world is the fact that a true Cubist painting contains as subject matter only those objects that might plausibly be seen together in one place. The real problem, therefore, is the precise nature of Cubist reality, compared with the treatment of reality in earlier art, and whether or not the character of this Cubist reality changes with the evolution of the style.

Two of the standard explanations of Cubism offered by its defenders were that it portrayed a reality of conception, not of vision, and that nevertheless the Cubists were seeking the truth in visual experience. Paradoxically, both of these statements are true, but this seeming dilemma may be most clearly resolved with a review of the previous half century of the artistic tradition to which Cubism belongs.

Gleizes's and Metzinger's *Du Cubisme* and Apollinaire's *Les Peintres Cubistes* both refer to Courbet as a spiritual ancestor of Cubism, and in one sense they are correct. Courbet wished, as had few painters before him, to exclude from his art those symbolic, literary, and historical dimensions that had preoccupied European art for a thousand years and more; out of the total spectrum of possible artistic functions he chose to concentrate on capturing what was strictly visible to his own eyes. While he often unwittingly included much more than the record of his visual experience, his successors, the Impressionists, were more single-minded in their adherence to this goal, and they went beyond Courbet in choosing subjects that were as nearly emptied of symbolic content as possible. To these neutral subjects they were applying, by the mid-1870s, a technique that in retrospect may not appear scientific but that may certainly be termed an empirical realism of retinal perception.

From this newly achieved style emerged numerous sequels, but for the history of Cubism the most important was the art of Cézanne. Maintaining the Impressionists' restricted range of neutral subjects—

landscape, still life, portraiture—Cézanne discarded fidelity to direct retinal experience in favor of an art that, although less directly and literally realistic, reflected more faithfully than did Impressionism the complex psychological process of visual perception itself.[1]

Objects in the paintings of Cézanne assume a "distorted," nonperspectival form as a result of multiple perceptions from discrete points of view, accumulated and then expressed in a single composite shape. Such a process led inevitably to an emphasis on qualities of form rather than those of texture and color, although where necessary Cézanne utilized color contrasts to model the volumes resulting from this process of multiple perceptions. Similarly, in his compositional methods, Cézanne organized his forms into discrete areas corresponding to the limits of the human visual field; within these areas, he further "distorted" objects for purposes of achieving contrasts of form, so that, for example, lines would meet each other at right angles. Within these smaller areas he also realigned and reshaped objects in the interest of an overall unifying two-dimensional structure; as, finally, he did for the composition in its entirety, where, using *passage,* he also created pictorial unity between near and distant objects, especially in his landscapes.

This complex style, which cost Cézanne immense pains in realizing each painting, was, as has been shown, one of the principal sources of early·Cubism. But what Cézanne accomplished in remaining faithful to his "little sensation," the careful recording of the process of perception and the aesthetic ordering of that process, was used by Picasso and Braque for very different purposes. Retaining the same restricted range of subject matter as their predecessors, Picasso and Braque at first (1908–1909) assimilated Cézanne's art. They then intensified certain of its characteristics—*passage,* multiple viewpoints—to such a degree that what, in Cézanne, had been the means of remaining faithful to the process of vision, became by 1912 the foundation of a new, completely nonillusionistic and nonimitative method of depicting the visual world. The peak of what was in fact a new convention of realism was reached in the papiers collés and paintings of 1913 and 1914, after which the artists turned to exploiting the more strictly aesthetic properties of their· inventions.

The change in the approach to the visual world between Cézanne and 1913 to 1914 Cubism has a parallel in the history of philosophy with the differences between the thought of Henri Bergson (1859–1941) and Edmund Husserl (1859–1938). In such works as his *Intro-*

duction à la Métaphysique (1903) or *L'Evolution Créatrice* (1907)
Bergson stressed the role of duration in experience: with the passage of
time an observer accumulates in his memory a store of perceptual
information about a given object in the external visible world, and this
accumulated experience becomes the basis for the observer's conceptual
knowledge of that object. This process is analogous to the methods of
Cézanne[2] and of the Cubists in 1908 to 1910. After Picasso's Cadaqués
paintings of mid-1910, pictorial structure became a more powerful guide
than the accumulated experience of vision; what Cézanne had made into
a composite image remained separate, in 1911 and 1912 Cubism, as
superimposed, interwoven, or adjoining planes.

After 1911 the Cubists no longer worked directly from a model in
nature; and in the papiers collés and paintings of 1913 and 1914, which
contain no illusionistic space, there was no prior Bergsonian accumula-
tion of knowledge through multiple perceptions in time and space.
Instead the Cubists proceeded directly to an ideational notation of forms
that were equivalent to objects in the visible world without being in any
way illusionistic representations of those objects. With the invention of
papier collé it became possible to indicate all the spatial, coloristic, and
textural qualities of objects; and the development of the sign in Synthetic
Cubism completed the repertoire of formal means by which the visible
world might be described. However, this notation of the visible world in
the Cubism of 1913 and 1914 included not all the qualities of a given
object, but only those that characterized it sufficiently well—its charac-
teristic form, color, texture, silhouette—to permit unequivocal recog-
nition.

The relation of Picasso's and Braque's 1913 and 1914 Cubism to
the experiential world very closely parallels the method of so-called
eidetic reduction in the phenomenology of Husserl. This parallel was
first noted by Ortega y Gasset in 1924[3] and has been discussed most
fully by Guy Habasque.[4] Husserl sought in the years before 1914 to
establish a method of apprehending existence which should be indepen-
dent of psychological explanations, and which he set forth in his *Ideen*
of 1913.[5] This method of eidetic reduction, concrete,[6] purely descrip-
tive,[7] and based on intuition,[8] can be used to arrive at the essence of an
object, at those essentials that qualify it if secondary determinations are
to qualify it also;[9] these essentials shall include its morphological
essences as opposed to ideal, abstract, geometrical concepts,[10] and shall
include all but a specifically individual content.[11] Later, in his *Médita-
tions Cartésiennes,*[12] Husserl clarified his approach by means of con-

crete examples, such as that of the apprehension of the essential qualities of dice cubes.[13]

The striking similarities between Husserl's method and the art of Picasso and Braque in 1913 and 1914, although historically coincidental, provide an obvious contrast to the psychologically oriented methods of Cézanne and Bergson. Picasso and Braque also worked not by rule but by intuition; when describing the essential qualities of objects they never tied their forms to a specific object, save when in collage a real object stood for itself and for the class of all similar objects. In the papiers collés and, later, in the fused signs of Synthetic Cubism, the forms chosen were invented, not copied from nature; and this product of intuitive invention differed fundamentally from the Cézannian composite form, which was the result of a cumulative psychological process, closely tied to visual experience. And, also unlike Cézanne, the form chosen was only one of many possible choices. As Apollinaire remarked, a chair will be understood as a chair from no matter what point of view it is seen if it has the essential components of a chair; or as Picasso remarked to Leo Stein, the brother of Gertrude, before 1914: "A head . . . was a matter of eyes, nose, mouth, which could be distributed in any way you like—the head remained a head,"[14] a mode of thought analogous to the method of composition by tone-row in the music of Schönberg and other twelve-tone composers.

The differences between Cézanne, or early Cubism, and Cubism after 1912 may be defined in another way as a shift from an art of induction that proceeds toward an ideal immanence, to an art of deduction that arrives at a transcendental essence;[15] this process of deduction in turn depends upon certain preexisting ideas,[16] whether gained through Bergsonian experience or through pure creative imagination. A similar contrast can be seen also in a comparison between sculpture of the idealizing classical tradition and the specific, signifying qualities in African sculpture, as Gris himself recognized.[17]

A further contrast between Cézanne, as well as the Impressionists, and the 1913 and 1914 Cubism of Picasso and Braque is that while the nineteenth-century artists used abstract stylistic means of depicting reality, those of the Cubists were concrete and literally tangible as in collage; a difference between the nineteenth and twentieth centuries that has been noted in other areas of culture, notably in technology.[18] A situation somewhat similar to that in painting may be seen in literature also; for while Proust achieved what would seem to be the ultimate possibilities of Bergsonian psychology, such writers as Hemingway, and

later Robbe-Grillet, have employed what can well be termed a concrete, phenomenological method in the novel.

There is one interpretation of Cubism that is perhaps worthy of special comment, namely that it should be associated with Mannerist art of the sixteenth century. Undeniably there are spatial ambiguities in both Cubism and Mannerism, often as a result of similar formal means;[19] and it is tempting to assign similar roles to the intrusion of such alien artistic influences as that of Dürer in sixteenth-century Italy and African art in twentieth-century France. Gustav René Hocke[20] and others have cited the cubistic tendencies of Dürer, Cambiaso, and Bracelli, and the Mannerist quality of twentieth-century Cubism, as aspects of a larger general tendency that reappears at various moments in European culture. The cubistic drawings of Dürer and other artists of the sixteenth century have, however, almost nothing in common with the art of the twentieth-century Cubists. In addition, Cubism is as an art anything but Mannerist, although its spread perhaps indirectly encouraged the reevaluation of sixteenth-century Mannerism carried out during the 1920s by Dvořák, Friedländer, and other pioneering historians. But, in a historical context, a style is Mannerist in relation to a previous normative style; and in the twentieth century Cubism has if anything played the role of such a normative style.[21] It is indeed one sign of its greatness that Cubism was able to furnish artists of the stature of Schwitters, Duchamp, and countless others after them with a norm from which to borrow, or against which to react, in creating their own styles.

The heritage of Cubism to later artists has in fact been primarily that of its formal principles, whereas the specifically phenomenological character of its realistic intentions has found few if any disciples. Thus the flatness of the picture plane, the idea of the *tableau-object,* the nonillusionistic interrelations of pictorial planes, collage, and other nontraditional technical means—all products of the Cubist aesthetic— became fundamental if not dogmatic values in much subsequent twentieth-century art. The intensive elaborations and variations upon these principles by innumerable painters have often been justified in the name of artistic research, a justification that was repudiated originally by Picasso himself. This reflexive[22] attitude, in which the subject of art is its own formal language, may well deserve the epithet "Mannerist" in the pejorative sense.

A more creative use of the Cubist heritage was made by those who

used its methods for expressive purposes, as Picasso has continued to do, most notably in *Guernica* (1937), and as have numerous other artists, from Klee to de Kooning.

The historical paradox of Cubism is, finally, that in providing the final break with an artistic tradition almost five hundred years old, it nevertheless revitalized and extended that tradition by redefining its realistic premises. In place of an outworn illusionism and the discarded spiritual or symbolic values that it had served, the Cubists united a new interpretation of the external world with formal inventions adequate for that interpretation. In so doing they founded a new tradition, the destiny of which still lies in the future.

NOTES

1. See Maurice Merleau-Ponty, "Cézanne," in *Sens et Non-Sens,* Paris, 1948, pp. 15–49.

2. See George H. Hamilton, "Cézanne, Bergson, and the Image of Time," *College Art Journal,* New York, 1956, pp. 2–13.

3. See his "Sobre el punto de vista en las artes," *Revista de Occidente,* Madrid, February 1924, pp. 129–160; note especially pp. 159–160. English trans.: "On Point of View in the Arts," *Partisan Review,* New York, August 1949, pp. 822–836; also included in Ortega y Gasset, *The Dehumanization of Art and Other Writings on Art and Culture* (New York: Doubleday & Co., 1956).

4. See his "Cubisme et phénoménologie," *Revue d'Esthétique,* Paris, April–June 1949, pp. 151–161.

5. *Ideen zu einer reinen Phänomenologie und phänomenologischen Philosophie* (Halle, 1913; English trans.: London 1931; reedited: *Ideas: General Introduction to Pure Phenomenology,* New York: Collier Books, 1962).

6. See Gaston Berger, *Le Cogito dans la Philosophie de Husserl* (Paris, 1941), p. 36.

7. *Ideen,* section 59.

8. *Ibid.,* section 24.

9. *Ibid.,* section 2.

10. As, in contrast to Cubism, is true of the Purism of Ozenfant and Jeanneret. Cf. *Ideen,* section 59.

11. *Ideen,* section 75.

12. Paris, 1931; English trans.: *Cartesian Meditations* (The Hague, 1960). For a later critique of Husserl's ideas, see Maurice Merleau-Ponty's *Phénoménologie de la Perception* (Paris, 1945), especially the introduction. (English trans.: *Phenomenology of Perception,* London, 1962.)

13. *Méditations,* section 17.

14. See Leo Stein, *Appreciation. Painting, Poetry, and Prose* (New York: Crown Publishers 1947), p. 177.

15. See Husserl, *Ideen,* section 61.

16. Note Picasso's remark on the preexisting idea, quoted by Kahnweiler in his *Juan Gris* (Paris, 1946), p. 83; English ed. (New York, 1947), p. 40.

17. See his statement on Negro art in *Action,* Paris, April 1920, p. 24; Quoted by Kahnweiler, *Juan Gris,* p. 276 (French ed.; English ed., p. 137). See also Michel Leiris, "Les Nègres d'Afrique et les arts sculpturaux," in *L'Originalité des Cultures,* Paris, UNESCO, 1953, p. 358.

18. See Henri van Lier, *Le Nouvel Age* (Tournai, 1962), pp. 35 ff.

19. See Anne Armstrong Wallis, "A Pictorial Principle of Mannerism," *The Art Bulletin,* New York, 1939, pp. 280–283.

20. In *Die Welt als Labyrinth* (Rowohlt 50/51) (Hamburg, 1957), pp. 112 ff.

21. See a general discussion by Werner Hofmann, "Manier und Stil in der Kunst des 20. Jahrhunderts," *Studium Generale,* Berlin, January 1955, pp. 1–11.

22. See Henri van Lier, *op. cit.,* pp. 159–162.

Collage[*]

CLEMENT GREENBERG

Greenberg explains the necessary evolution of collage from Cubism. Collage is the introduction of extra-artistic materials such as pasted paper (papier collé) into the work of art. It appears in 1912 in the work of Picasso and Braque at a point when their paintings were verging on complete abstraction. Greenberg scrutinizes these paintings, the motives behind each formal decision. He finds that the collage concept was a means for the artists to reintroduce representation, and, in so doing, to assert the flat and literal surface of the picture plane. Collage is understood to follow the "inner formal logic" of Cubism.

The idea that art and art history have inner formal logic is central to Greenberg's formalism. His theory, presented in the now-classic essay "Modernist Painting" (*Art and Literature,* Spring 1965), begins with the premise that self-criticism is the essence of "modernism." Its task is to render each art "pure," that is, to develop characteristics intrinsic to the medium. For example, painting must rid itself of literary content. Because he sees "flatness alone as unique to painting," Greenberg suggests that modern painting, which begins for him with Manet, "oriented itself to flatness as it did to nothing else." Cubism is his exemplary style.

* Reprinted from the revised version, *Art and Culture* (London: Thames and Hudson, 1973; Boston: Beacon Paperbacks, 1965).

Greenberg's modernist aesthetic has significantly affected our think-ing about art in recent years. As a mode of perception, formalism was highly valued by leading art critics of the 1960s. Its prestige has since begun to wane.

Among the earliest champions of Abstract Expressionism, Clement Greenberg has been writing criticism in a variety of journals since the 1930s.

Collage was a major turning point in the evolution of Cubism, and therefore a major turning point in the whole evolution of modernist art in this century. Who invented collage—Braque or Picasso—and when is still not settled. Both artists left most of the work they did between 1907 and 1914 undated as well as unsigned; and each claims, or implies the claim, that his was the first collage of all. That Picasso dates his, in retrospect, almost a year earlier than Braque's compounds the difficulty. Nor does the internal or stylistic evidence help enough, given that the interpretation of Cubism is still on a rudimentary level.

The question of priority is much less important, however, than that of the motives which first induced either artist to paste or glue a piece of extraneous material to the surface of a picture. About this, neither Braque nor Picasso has made himself at all clear. The writers who have tried to explain their intentions for them speak, with a unanimity that is suspect in itself, of the need for renewed contact with "reality" in face of the growing abstractness of Analytical Cubism. But the term *reality,* always ambiguous when used in connection with art, has never been used more ambiguously than here. A piece of imitation-wood-grain wallpaper is not more "real" under any definition, or closer to nature, than a painted simulation of it; nor is wallpaper, oilcloth, newspaper, or wood more "real," or closer to nature, than paint on canvas. And even if these materials were more "real," the question would still be begged, for "reality" would still explain next to nothing about the actual *appear-ance* of the Cubist collage.

There is no question but that Braque and Picasso were concerned, in their Cubism, with holding onto painting as an art of representation and illusion. But at first they were more crucially concerned, in and through their Cubism, with obtaining *sculptural* results by strictly non-

sculptural means; that is, with finding for every aspect of three-dimensional vision an explicitly two-dimensional equivalent, regardless of how much verisimilitude might suffer in the process. Painting had to spell out, rather than pretend to deny, the physical fact that it was flat, even though at the same time it had overcome this proclaimed flatness as an aesthetic fact and continue to report nature.

Neither Braque nor Picasso set himself this program in advance. It emerged, rather, as something implicit and inevitable in the course of their joint effort to fill out that vision of a "purer" pictorial art which they had glimpsed in Cézanne, from whom they also took their means. These means, as well as the vision, imposed their logic; and the direction of that logic became completely clear in 1911, the fourth year of Picasso's and Braque's Cubism, along with certain contradictions latent in the Cézannian vision itself.

By that time, flatness had not only invaded but was threatening to swamp the Cubist picture. The little facet planes into which Braque and Picasso were dissecting everything visible now all lay parallel to the picture plane. They were no longer controlled, either in drawing or in placing, by linear or even scalar perspective. Each facet tended to be shaded, moreover, as an independent unit, with no legato passages, no unbroken tracts of value gradation on its open side, to join it to adjacent facet planes. At the same time, shading had itself been atomized into flecks of light and dark that could no longer be concentrated upon the edges of shapes with enough modeling force to turn these convincingly into depth. Light and dark in general had begun to act more immediately as cadences of design than as plastic description or definition. The main problem at this juncture became to keep the "inside" of the picture—its content—from fusing with the "outside"—its literal surface. *Depicted* flatness—that is, the facet planes—had to be kept separate enough from *literal* flatness to permit a minimal illusion of three-dimensional space to survive between the two.

Braque had already been made uncomfortable by the contraction of illusioned space in his pictures of 1910. The expedient he had then hit upon was to insert a conventional, trompe-l'oeil suggestion of deep space *on top* of Cubist flatness, between the depicted planes and the spectator's eye. The very un-Cubist graphic tack-with-a-cast-shadow, shown transfixing the top of a 1910 painting, *Still Life with Violin and Pitcher,* suggests deep space in a token way, and destroys the surface in a token way. The Cubist forms are converted into the illusion of a

picture within a picture. In the *Man with a Guitar* (early 1911; fig. 47) the line-drawn tassel-and-stud in the upper-left margin is a similar token. The effect, as distinct from the signification, is in both cases very discreet and inconspicuous. Plastically, spatially, neither the tack nor the tassel-and-stud *acts* upon the picture; each suggests illusion without making it really present.

Early in 1911, Braque was already casting around for ways of reinforcing, or rather supplementing, this suggestion, but still without introducing anything that would become more than a token. It was then, apparently, that he discovered that trompe-l'oeil could be used to undeceive as well as to deceive the eye. It could be used, that is, to declare as well as to deny the actual surface. If the actuality of the surface—its real, physical flatness—could be indicated explicitly enough in certain places, it would be distinguished and separated from everything else the surface contained. Once the literal nature of the *support* was advertised, whatever upon it was not intended literally would be set off and enhanced in its nonliteralness. Or to put it in still another way: depicted flatness would inhabit at least the semblance of a semblance of three-dimensional space as long as the brute, undepicted flatness of the literal surface was pointed to as being still flatter.

The first and, until the advent of pasted paper, the most important device that Braque discovered for indicating and separating the surface was imitation printing, which automatically evokes a literal flatness. Block letters are seen in one of his 1910 paintings, *The Match Holder;* but being done rather sketchily, and slanting into depth along with the depicted surface that bears them, they merely allude to, rather than state, the literal surface. Only in the next year are block capitals, along with lower-case letters and numerals, introduced in exact simulation of printing and stenciling, in absolute frontality and outside the representational context of the picture. Wherever this printing appears, it stops the eye at the literal plane, just as the artist's signature would.[1] By force of contrast alone—for wherever the literal surface is not explicitly stated it seems implicitly denied—everything else is thrust back into at least a memory of deep or plastic space. It is the old device of the *repoussoir,* but taken a step further: instead of being used to push an illusioned middle ground farther away from an illusioned foreground, the imitation printing spells out the real paint surface and thereby pries it away from the illusion of depth.

The eye-undeceiving trompe-l'oeil of simulated typography supple-

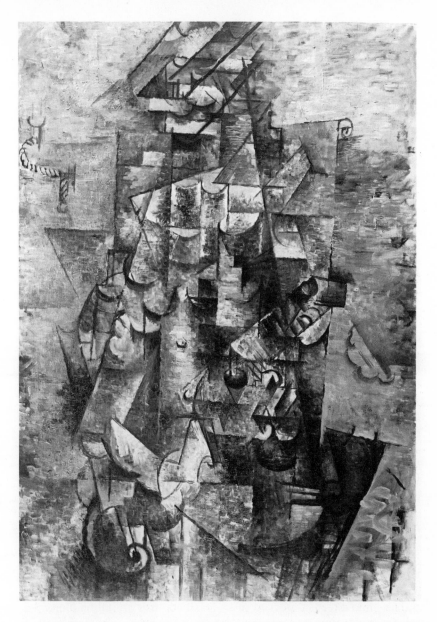

47. Georges Braque: *Man with a Guitar*. 1911. Oil on canvas. 45¾″ × 31⅞″.
Collection The Museum of Modern Art, New York, acquired through the Lillie P.
Bliss Bequest.

ments, rather than replaces, the conventional eye-deceiving kind. Another literally and graphically rendered tassel-and-stud embeds flattened forms in token depth in Braque's *Portuguese* (1911), but this time the brute reality of the surface, as asserted by stenciled letters and numerals, closes over both the token illusion of depth and the Cubist configurations like the lid on a box. Sealed between two parallel flatnesses—the depicted Cubist flatness and the literal flatness of the paint surface—the illusion is made a little more present but, at the same time, even more ambiguous. As one looks, the stenciled letters and numerals change places in depth with the tassel-and-stud, and the physical surface itself becomes part of the illusion for an instant: it seems pulled back into depth along with the stenciling, so that once again the picture plane seems to be annihilated—but only for the fraction of another instant. The abiding effect is of a constant shuttling between surface and depth, in which the depicted flatness is "infected" by the undepicted. Rather than being deceived, the eye is puzzled; instead of seeing objects in space it sees nothing more than—a picture.

Through 1911 and 1912, as the Cubist facet plane's tendency to adhere to the literal surface became harder and harder to deny, the task of keeping the surface at arm's length fell all the more to eye-undeceiving contrivances. To reinforce, and sometimes to replace, the simulated typography, Braque and Picasso began to mix sand and other foreign substances with their paint; the granular texture thus created likewise called attention to the reality of the surface and was effective over much larger areas. In certain other pictures, however, Braque began to paint areas in exact simulation of wood graining or marbleizing. These areas by virtue of their abrupt density of pattern stated the literal surface with such new and superior force that the resulting contrast drove the simulated printing into a depth from which it could be rescued—and set to shuttling again—only by conventional perspective; that is, by being placed in such relation to the forms depicted within the illusion that these forms left no room for the typography except near the surface.

The accumulation of such devices, however, soon had the effect of telescoping, even while separating, surface and depth. The process of flattening seemed inexorable, and it became necessary to emphasize the surface still further in order to prevent it from fusing with the illusion. It was for this reason, and no other that I can see, that in September 1912, Braque took the radical and revolutionary step of pasting actual pieces of imitation-wood-grain wallpaper to a drawing on paper, instead of trying to simulate its texture in paint. Picasso says that he himself had

already made his first collage toward the end of 1911, when he glued a piece of imitation-caning oilcloth to a painting on canvas. It is true that his first collage looks more Analytical than Braque's, which would confirm the date he assigns it. But it is also true that Braque was the consistent pioneer in the use of simulated textures as well as of typography; and moreover, he had already begun to broaden and simplify the facet planes of Analytical Cubism as far back as the end of 1910.

When we examine what each master says was his first collage, we see that much the same thing happens in each. (It makes no real difference that Braque's collage is on paper and eked out in charcoal, while Picasso's is on canvas and eked out in oil.) By its greater corporeal presence and its greater extraneousness, the affixed paper or cloth serves for a seeming moment to push everything else into a more vivid *idea* of depth than the simulated printing or simulated textures had ever done. But here again, the surface-declaring device both overshoots and falls short of its aim. For the illusion of depth created by the contrast between the affixed material and everything else gives way immediately to an illusion of forms in bas-relief, which gives way in turn, and with equal immediacy, to an illusion that seems to contain both—or neither.

Because of the size of the areas it covers, the pasted paper establishes undepicted flatness *bodily,* as more than an indication or sign. Literal flatness now tends to assert itself as the main event of the picture, and the device boomerangs: the illusion of depth is rendered even more precarious than before. Instead of isolating the literal flatness by specifying and circumscribing it, the pasted paper or cloth releases and spreads it, and the artist seems to have nothing left but this undepicted flatness with which to finish as well as start his picture. The actual surface becomes both ground and background, and it turns out—suddenly and paradoxically—that the only place left for a three-dimensional illusion is in *front* of, *upon,* the surface. In their very first collages, Braque and Picasso draw or paint *over* and *on* the affixed paper or cloth, so that certain of the principal features of their subjects *as depicted* seem to thrust out into real, bas-relief space—or to be about to do so—while the rest of the subject remains embedded in, or flat upon, the surface. And the surface is driven back, in its very surfaceness, only by this contrast[2] (see fig. 48).

In the upper center of Braque's first collage, *Fruit Dish,* a bunch of

grapes is rendered with such conventionally vivid sculptural effect as to lift it practically off the picture plane. The trompe-l'oeil illusion here is no longer enclosed between parallel flatnesses, but seems to thrust through the surface of the drawing paper and establish depth *on top* of it. Yet the violent immediacy of the wallpaper strips pasted to the paper, and the only lesser immediacy of block capitals that simulate window lettering, manage somehow to push the grape cluster back into place on the picture plane so that it does not "jump." At the same time, the wallpaper strips themselves seem to be pushed into depth by the lines and patches of shading charcoaled upon them, and by their placing in relation to the block capitals; and these capitals seem in turn to be pushed back by *their* placing, and by contrast with the corporeality of the wood graining. Thus every part and plane of the picture keeps changing place in relative depth with every other part and plane; and it is as if the only stable relation left among the different parts of the picture is the ambivalent and ambiguous one that each has with the surface. And the same thing, more or less, can be said of the contents of Picasso's first collage (see fig. 41).

In later collages of both masters a variety of extraneous materials are used, sometimes in the same work, and almost always in conjunction with every other eye-deceiving and eye-undeceiving device they can think of. The area adjacent to one edge of a piece of affixed material—or simply of a painted-in form—will be shaded to pry that edge away from the surface, while something will be drawn, painted, or even pasted over another part of the same shape to drive it back into depth. Planes defined as parallel to the surface also cut through it into real space, and a depth is suggested optically which is greater than that established pictorially. All this expands the oscillation between surface and depth so as to encompass fictive space in front of the surface as well as behind it. Flatness may now monopolize everything, but it is a flatness become so ambiguous and expanded as to turn into illusion itself—at least an optical if not, properly speaking, a pictorial illusion. Depicted, Cubist flatness is now almost completely assimilated to the literal, undepicted kind, but at the same time it reacts upon and largely transforms the undepicted kind—and it does so, moreover, without depriving the latter of its literalness; rather, it underpins and reinforces that literalness, re-creates it.

Out of this re-created literalness, the Cubist subject reemerged. For it had turned out, by a further paradox of Cubism, that the means to an

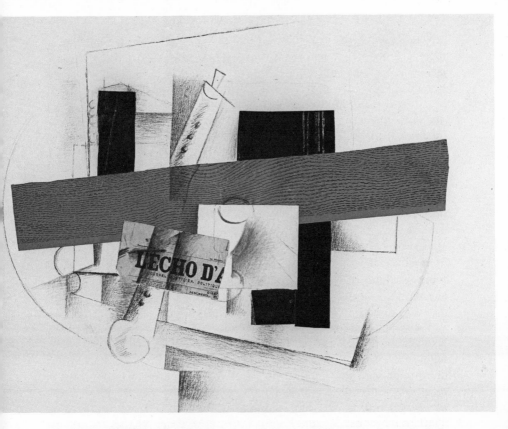

48. Georges Braque: *The Clarinet.* 1913. Collage, pasted paper, charcoal, chalk, and oil. 37½″ × 47⅜″. Photograph courtesy Sidney Janis Gallery, New York. Private collection.

illusion of depth and plasticity had now become widely divergent from the means of representation or imaging. In the Analytical phase of their Cubism, Braque and Picasso had not only had to minimize three-dimensionality simply in order to preserve it; they had also had to *generalize* it—to the point, finally, where the illusion of depth and relief became abstracted from specific three-dimensional entities and was rendered largely as the illusion of depth and relief *as such:* as a disembodied attribute and expropriated property detached from everything not itself. In order to be saved, plasticity had had to be isolated; and as the aspect of the subject was transposed into those clusters of more or

less interchangeable and contour-obliterating facet planes by which plasticity was isolated under the Cubist method, the subject itself became largely unrecognizable. Cubism, in its 1911 to 1912 phase (which the French, with justice, call *hermetic*) was on the verge of abstract art.

It was then that Picasso and Braque were confronted with a unique dilemma: they had to choose *between* illusion and representation. If they opted for illusion, it could only be illusion per se—an illusion of depth, and of relief, so general and abstracted as to exclude the representation of individual objects. If, on the other hand, they opted for representation, it had to be representation per se—representation as image pure and simple, without connotations (at least, without more than schematic ones) of the three-dimensional space in which the objects represented originally existed. It was the collage that made the terms of this dilemma clear: the representational could be restored and preserved only on the flat and literal surface now that illusion and representation had become, for the first time, mutually exclusive alternatives.

In the end Picasso and Braque plumped for the representational, and it would seem they did so deliberately. (This provides whatever real justification there is for the talk about "reality.") But the inner, formal logic of Cubism, as it worked itself out through the collage, had just as much to do with shaping their decision. When the smaller facet planes of Analytical Cubism were placed upon or juxtaposed with the large, dense shapes formed by the affixed materials of the collage, they had to coalesce—become "synthesized"—into larger planar shapes themselves simply in order to maintain the integrity of the picture plane. Left in their previous atomlike smallness, they would have cut away too abruptly into depth; and the broad, opaque shapes of pasted paper would have been isolated in such a way as to make them jump out of plane. Large planes juxtaposed with other large planes tend to assert themselves as *independent* shapes, and to the extent that they are flat, they also assert themselves as silhouettes; and independent silhouettes are apt to coincide with the recognizable contours of the subject from which a picture starts (if it does start from a subject). It was because of this chain reaction as much as for any other reason—that is, because of the growing independence of the planar unit in collage as a *shape*—that the identity of depicted objects, or at least parts of them, reemerged in Braque's and Picasso's papiers collés and continued to remain more conspicuous there—but only as flattened silhouettes—than in any of their paintings done wholly in oil before the end of 1913.

Analytical Cubism came to an end in the collage, but not conclusively; nor did Synthetic Cubism fully begin there. Only when the collage had been exhaustively translated into oil, and transformed by this translation, did Cubism become an affair of positive color and flat, interlocking silhouettes whose legibility and placement created allusions to, if not the illusion of, unmistakable three-dimensional identities.

Synthetic Cubism began with Picasso alone, late in 1913 or early in 1914; this was the point at which he finally took the lead in Cubist innovation away.from Braque, never again to relinquish it. But even before that, Picasso had glimpsed and entered, for a moment, a certain revolutionary path in which no one had preceded him. It was as though, in that instant, he had felt the flatness of collage as too constricting and had suddenly tried to escape all the way back—or forward—to literal three-dimensionality. This he did by using utterly literal means to carry the forward push of the collage (and of Cubism in general) *literally* into the literal space in front of the picture plane.

Sometime in 1912 Picasso cut out and folded a piece of paper in the shape of a guitar; to this he glued and fitted other pieces of paper and four taut strings, thus creating a sequence of flat surfaces in real and sculptural space to which there clung only the vestige of a picture plane. The affixed elements of collage were extruded, as it were, and cut off from the literal pictorial surface to form a bas-relief. By this act he founded a new tradition and genre of sculpture, the one that came to be called "construction." Though construction sculpture was freed long ago from strict bas-relief frontality, it has continued to be marked by its pictorial origins, so that the sculptor-constructor Gonzalez, Picasso's friend, could refer to it as the new art of "drawing in space"—that is, of manipulating two-dimensional forms in three-dimensional space. (Not only did Picasso found this "new" art with his paper guitar of 1912, but he went on, some years afterward, to make some of the strongest as well as most germinative contributions to it.)

Neither Picasso nor Braque ever really returned to collage after 1914. The others who have taken it up have exploited it largely for its shock value, which collage had only incidentally—or even only accidentally—in the hands of its originators. There have been a few exceptions: Gris notably, but also Arp, Schwitters (fig. 49), Miró, E. L. T. Mesens, Dubuffet, and, in this country, Robert Motherwell and Anne Ryan. In this context Gris's example remains the most interesting and most instructive.

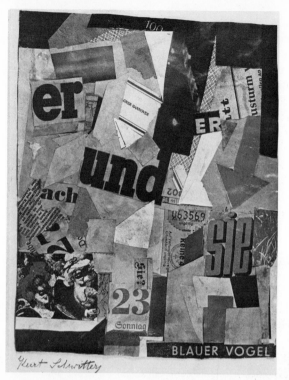

49. Kurt Schwitters: *Blue Bird*. 1922.
Collage. 8½″ × 6¾″.
Photograph courtesy
Annely Juda Fine Art, London.

Braque and Picasso had obtained a new, self-transcending kind of decoration by reconstructing the picture surface with what had once been the means of its denial. Starting from illusion, they had arrived at a transfigured, almost abstract kind of literalness. With Gris it was the opposite. As he himself explained, he started out with abstract flat shapes, to which he then fitted recognizable images and emblems of three-dimensionality. And whereas Braque's and Picasso's subjects were dissected in three dimensions in the course of being transposed into two, Gris's first Cubist subjects tended—even before they were fitted into the picture, and as if preformed by its surface—to be analyzed in two-dimensional and purely decorative rhythms. It was only later that he became more aware of the fact that Cubism was not a question of decorative overlay and that the resonance of its surfaces derived from an abiding concern with plasticity and illusion which informed the very renunciation of plasticity and illusion.

In his collages almost more than anywhere else, we see Gris trying to solve the problems proposed by this fuller awareness (fig. 50). But his collages also show the extent to which his awareness remained incomplete. Because he continued to take the picture plane as given and therefore not needing to be re-created, Gris became perhaps too solicitous about the illusion. He used pasted paper and trompe-l'oeil textures and lettering to assert flatness, but he almost always completely sealed the flatness inside an illusion of conventional depth by allowing images rendered with relatively sculptural vividness to occupy, unambiguously, too much of both the nearest and farthest planes.

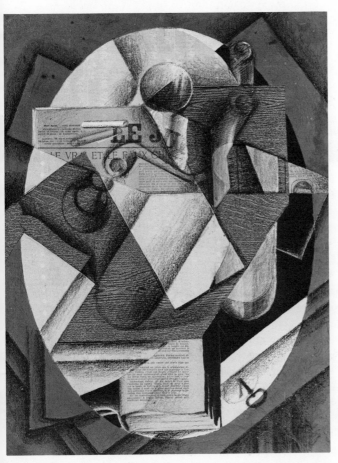

50. Juan Gris: *The Table.* 1914.
Collage. 23½″ × 17½″.
The Philadelphia Museum of Art,
A. E. Gallatin Collection.

Because he shaded and modeled more abundantly and tended to use more explicit color under his shading, Gris's collages seldom declare their surfaces as forthrightly as Picasso's and Braque's collages do. Their total *presence* is thus less immediate and has something about it of the removedness, the closed-off presence, of the traditional picture. And yet, because their decorative elements function to a greater extent solely as decoration, Gris's collages also seem more conventionally decorative. Instead of the seamless fusion of the decorative with the plastic that we get in Picasso and Braque, there is an alternation, a collocation, a mere juxtaposition of the two; and whenever this relation goes beyond juxtaposition, it leads more often to confusion than to fusion. Gris's collages have their merits, but only a few of them deserve the unqualified praise they have received.

But many of Gris's oils of 1915 to 1918 (see fig. 51) do deserve their praise. In all justice, it should be pointed out that his paintings of those years demonstrate, perhaps more clearly than anything by Braque or Picasso, something which is of the highest importance to Cubism and to the collage's effect upon it: namely, the liquidation of sculptural shading.

In Braque's and Picasso's very first papiers collés, shading stops being pointillist and suddenly becomes broad and incisive again, like the shapes it modifies. This change in shading also accounts for the bas-relief effects, or the velleities to bas-relief, of the first collages. But large patches of shading on a densely or emphatically patterned ground, such as wood grain or newsprint, tend to take off on their own when their relation to the model in nature is not self-evident, just the way large planes do under the same circumstances. They abandon their sculptural function and become independent shapes constituted by blackness or grayness alone. Not only did this fact contribute further to the ambiguity of the collage's surface; it also served further to reduce shading to a mere component of surface design and color scheme. When shading becomes that, all other colors become more purely *color*. It was in this way that positive color reemerged in the collage—recapitulating, curiously enough, the way "pure" color had emerged in the first place for Manet and the Impressionists.

In Analytical Cubism, shading as shading had been divorced from specific shapes while retaining in principle the capacity to inflect generalized surfaces into depth. In collage, shading, though restored to specific shapes or silhouettes, lost its power to act as modeling because it

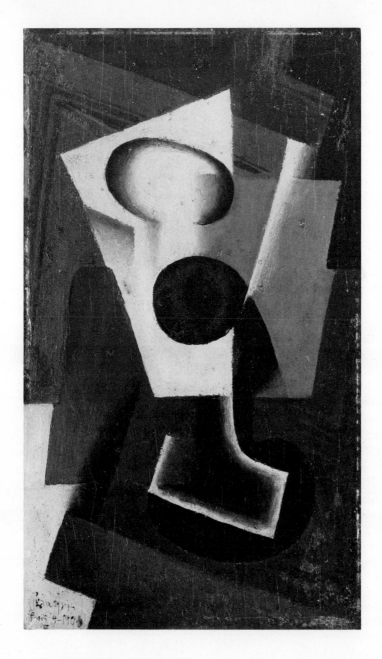

51. Juan Gris: *Still Life*. 1917. Oil on panel. 7½″ × 13″. The Philadelphia Museum of Art, A. E. Gallatin Collection.

became a specific shape in itself. This is how and why shading, as a means to illusion, disappeared from the collages of Braque and Picasso, and from their Cubism never really to reappear.[3] But it was left to Gris, in his pictures of 1915 to 1918, to elucidate this process and its consequences for all to see—and, in doing so, to produce, finally, triumphant art. Gris's Cubism in this period—which is almost as much Analytical as it is Synthetic—separated, fixed, and immobilized, in oil on wood or canvas, some of the overlapping stages of the transformation that Cubism had already undergone in Braque's and Picasso's glued and pasted pictures. The cleanly and simply contoured solid black shapes on which Gris relied so much in these paintings represent fossilized shadows and fossilized patches of shading. All the value gradations are summed up in a single, ultimate value of flat, opaque black—a black that becomes a color as sonorous and pure as any spectrum color and that confers upon the silhouettes it fills an even greater weight than is possessed by the lighter-hued forms which these silhouettes are supposed to shade.

In this phase alone does Gris's art, in my opinion, sustain the main tenor of Cubism. Here, at last, his practice is so completely informed by a definite and steady vision that the details of execution take care of themselves. And here, at last, the decorative is transcended and transfigured, as it had already been in Picasso's, Braque's, and Léger's art, in a monumental unity. This monumentality has little to do with size. (Early and late, and whether in Picasso's hands or Braque's, Cubism has never lent itself with entire success to an outsize format. Even Léger's rather splendid big pictures of the late 1910s and early 1920s do not quite match the perfection of his smaller-scale Cubism of 1910 to 1914.) The monumentality of Cubism in the hands of its masters is more a question of a vision and attitude—an attitude toward the immediate physical means of pictorial art—thanks to which easel paintings and even "sketches" acquire the self-evident self-sufficiency of architecture. This is as true of the Cubist collage as of anything else in Cubism, and perhaps it is even truer of the collage than of anything else in Cubism.

1959

NOTES

1. Picasso and Braque left most of the pictures of their Analytic period unsigned for this very reason apparently. The corners or margins in which the signatures would have had to be placed were just those areas of the pictures that could least afford having attention called to their literal flatness [1972].

2. "If illusion is due to the interaction of clues and the absence of contradictory evidence, the only way to fight its transforming influence is to make the clues contradict each other and to prevent a coherent image of reality from destroying the pattern in the plane. Unlike the Fantin-Latour, a still life by Braque . . . will marshal all the forces of perspective, texture, and shading, not to work in harmony, but to clash in virtual deadlock. . . . There are black patches . . . where Fantin-Latour painted high-lights. . . . [Cubism succeeds] by the introduction of contrary clues. Try as we may to see the guitar or the jug suggested to us as a three-dimensional object and thereby to transform it . . . we will always come across a contradiction somewhere which compels us to start afresh."—E. H. Gombrich, *Art and Illusion*, pp. 281–283 (New York: Pantheon Books, 1960) [1972].

3. This is wrong. Picasso and Braque continued to use discreet shading off and on well into 1914, and in Picasso's case even longer, to pry flat planes apart. I'm mortified not to have noticed this sooner, and a little surprised not to have been caught out on it [1972].

The Futurist Goal,
The Futurist Achievement*

JOSHUA C. TAYLOR

With manifestos, exhibitions, and public appearances, the Futurists shocked a world that extended from Italy to Tsarist Russia. Their ideas traveled throughout Europe with a speed matching the modern technological revolution that they worshiped. Taylor examines Italian Futurist art and writings from the most creative years, 1910 to 1916, and defines their distinctive place in modern art. Despite their cry "revolt," the Futurists retraced their steps through post-Impressionism and Fauvism and exchanged ideas with French Cubism. Futurism was less a style than an ideology or impulse that affected the visual arts, poetry, music, and politics, as Taylor demonstrates. Their aim to reform art was part of a broader program to change life.

Recent studies on Futurism include: Marianne Martin, *Futurist Art and Theory, 1900–1915* (London: Oxford University Press, 1968); Max Kozloff, *Cubism/Futurism* (New York: Charterhouse Books, 1973); *Futurist Manifestos,* ed. Umbro Apollonio (New York: The Viking Press, 1973).

Joshua Taylor is Director, National Collection of Fine Arts, Smithsonian Institution, Washington, D.C.

* Reprinted from the exhibition catalogue *Futurism,* The Museum of Modern Art, New York, 1961.

THE FUTURIST GOAL

With cries of "Burn the museums!," "Drain the canals of Venice!," and "Let's kill the moonlight!," the Futurist movement burst upon the consciousness of an astonished public in the years 1909 and 1910. For the first time artists breached the wall erected between conventional taste and new ideas in art by carrying their battle directly to the public with the noise and tactics of a political campaign. Taking their cue from the anarchists, with whom as youths they were in sympathy, the self-styled Futurists published shocking manifestos negating all past values, even art itself. Fighting their way toward a new liberty against apathy, nostalgia, and sentimentality, they became for a very wide public the symbol of all that was new, terrifying, and seemingly ridiculous in contemporary art. Newspapers throughout the world—in Tokyo, Chicago, London, Moscow—published snatches of their startling credo and accounts of their antics, with the result that—even before there was something distinguishable as Futurist painting—the term *Futurism* became a commonplace.

That so violently launched a movement should come out of Italy is not altogether surprising, for in no other country did the youth feel so completely subjugated to the past, deprived of a world of its own. The complacent Italian public was content with guarding a tradition and obstinately refused to notice new events in art and literature, at home or elsewhere.[1]

As for the term *Futurism,* there is no mystery about its origin, nor was it a word thrust by chance upon the artists as were *Impressionism, Fauvism,* and *Cubism.* It was coined in the autumn of 1908 by the bilingual Italian poet, editor, and promoter of art Filippo Tommaso Marinetti to give ideological coherence to the advanced tendencies in poetry he was furthering in the controversial periodical *Poesìa.* He thought at first of calling it "Electricism," then "Dynamism," but in "Futurism" he recognized at once the word that would stir the minds of the hopeful young. The chosen term was announced to the world in an impassioned manifesto published on the front page of the respected Paris newspaper *Le Figaro,* February 20, 1909. At the same time, hundreds of copies of the manifesto in Italian were mailed throughout Italy to people of importance.

Organized by Marinetti, who was already noted for his declamation of poetry, the poets who rallied under the new banner (they included such writers as Aldo Palazzeschi, Paolo Buzzi, and Libero Altomare) staged a series of public assaults on the poetic sensibilities of the nostalgically inclined Italian audiences, shouting their manifesto and reading their surprising poetry in theatres from Trieste to Rome.

In February 1909, Carlo Carrà, Umberto Boccioni, and Luigi Russolo met with Marinetti, who had heretofore given little thought to the visual arts, and proposed that painters also be included in the movement. With Marinetti's enthusiastic support the three young artists drew up a manifesto of their own that their friends Aroldo Bonzagni and Romolo Romani joined them in signing. Eventually Boccioni's close friend Gino Severini, who had been painting in Paris since 1906, also agreed to subscribe to the document. Initially published as a broadside by *Poesìa,* the manifesto caused sufficient comment to make Romani and Bonzagni reconsider and withdraw. On the manifesto's "official" publication dated February 11, 1910, appeared instead the name of Giacomo Balla, the precise and systematic divisionist painter in Rome, teacher of both Severini and Boccioni. These five, Balla, Boccioni, Carrà, Russolo, and Severini, became "the Futurist painters."

Boccioni, Carrà, and Russolo took their place beside the poets in the tumultuous theatrical presentations (the "Manifesto of Futurist Painters" was first read from the stage of the Chiarella Theatre in Turin, March 8, 1910), sharing with them the whistles, shouts, and open combat (to say nothing of barrages of rancid spaghetti and overripe fruit) with which their declarations met.

The public remembered chiefly the negative side of the Futurists' campaign—their denial of morality, of the rights of woman, of the sanctity of the past—but the artist had to concern himself with the positive bases of creativity. What was the nature of the new freedom? What did it mean for art? "Futurism," remarked Giovanni Papini, "has made people laugh, shout, and spit. Let's see if it can make them think."[2]

Because the Futurist painters early adapted to their own use some of the formal language of Cubism, their painting has often been considered a kind of speeded-up version of that classically oriented movement. In spite of the obvious testimony of Futurist writing and, more significantly, the painting itself, critics have persisted in seeing Futurism as an analytical procedure like early Cubism, differing only in its aim to represent motion, a goal better realized in moving pictures. Balla's

charming little dog on a leash (1912; fig. 52) has misled many in understanding the aims of Futurism.

Motion for the Futurist painter was not an objective fact to be analyzed, but simply a modern means for embodying a strong personal expression. As different as their procedures were, the Futurists came closer in their aims to the Brücke or, better, to Kandinsky and the Blaue Reiter, than to the Cubists. And in their iconoclasm and concern for the vagaries of the mind, they had not a little in common with Dada and the Surrealists.

52. Giacomo Balla: *Dynamism of a Dog on a Leash.* 1912. Oil on canvas. 35⅜" × 43¼". Albright-Knox Art Gallery, Buffalo, New York. Courtesy George F. Goodyear and The Buffalo Fine Arts Academy.

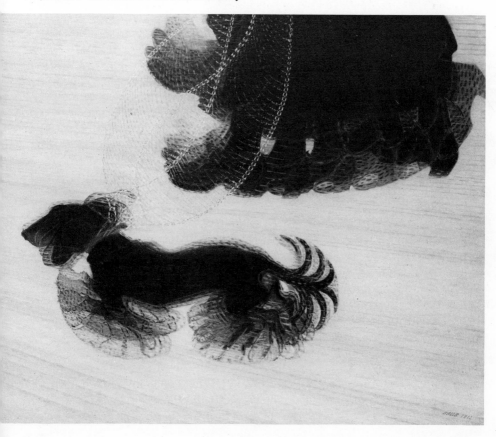

The Modern Pegasus

> Dieu véhément d'une race d'acier,
> Automobile ivre d'espace,
> qui piétines d'angoisse, les mors aux dents stridents . . .
> —Marinetti, "A mon Pégasse" ("A l'Automobile de course")[3]

Marinetti, in substituting a modern racing car for the classical winged symbol of poetry, set the pace for much that would follow in the Futurist movement. Not only did the automobile with its violently pulsing, noisy life typify the modern world, spawned on science and devoted to mechanical achievement, it stood as well for a staggering speed that surpassed in its power the wings of Pegasus. Yet in assuming the role of Pegasus, the motorcar became more than a proof of physical achievement; it became the symbol of a new kind of spiritual transport. Marinetti was not belittling poetic imagination. He wished to rekindle it in modern terms.

"We choose to concentrate our attention on things in motion," wrote Severini, "because our modern sensibility is particularly qualified to grasp the idea of speed. Heavy powerful motorcars rushing through the streets of our cities, dancers reflected in the fairy ambiance of light and color, airplanes flying above the heads of the excited throng . . . These sources of emotion satisfy our sense of a lyric and dramatic universe, better than do two pears and an apple."[4]

Like many of their fellows elsewhere, the Italian Futurists were fighting the estrangement from the world, the lonely isolation of the individual that was not only the inheritance of the artist but a common threat to modern man. They rejected firmly the temptation to brood over man's plight, sentimentalizing over his helplessness in the way fashionable at the turn of the century. They turned against the Lombard tradition that encouraged a crepuscular sadness to invade the works of even the most methodical divisionists. With Nietzschean arrogance they despised the weak and the timid, the thoughtful or hesitant, and wished to feel themselves rash, audacious, and capable of infinite accomplishment. They wanted their art to restore to man a sense of daring, an assertive will rather than submissive acceptance, to break through the insulating shell of self by sheer force if need be. "We want to re-enter life," they wrote; and to them life meant action.

Dynamism was a magical word for the Futurists. It signified the difference between life and death, between participation in an evolving,

expanding universe and withdrawal into an eddy of personal isolation. They looked upon the world with the same eager expectation as the Transcendentalists, but the world they saw was not the quieting realm of tree and sky; it was the world of modern science that triumphed over nature, promising always something new in its rapid development toward an undetermined end. Dynamism was at its heart. Theirs was a transcendentalism founded on a whole new universe. "We are the primitives of a new, completely transformed, sensibility," they boasted. The new sensibility accorded emotional value to a mechanized world.

A Dynamic Perception

Like Kandinsky, the Futurists initially found the key to their expression in the complex color of Impressionism. Rather than rebelling against the Impressionists as did the Cubists, they looked upon them, rather than on Cézanne, as the founders of modern art.[5] They agreed with them that no object, moving or still, can be seen in isolation, but absorbs its surroundings just as it contributes to them. The Futurists saw this interplay between object and environment, expressed by the Impressionists in their complex broken color, as a continuous reciprocal activity and wanted to make the action more patent by extending its influence to the very forms of the objects. They wished, further, to add to this complex relationship between an object and its surroundings the effect on the forms of actual motion in space, since to our perception movement changes the shape of an object quite as much as does light.

They looked upon all objects, in fact, whether a static bottle or a racing horse, as embodying two kinds of motion: that which tends to move in on itself, suggesting in its centripetal force the internal mass of an object; and that which moves outward into space mingling its rhythms with those of other objects and eventually merging with space itself. With Bergson they agreed that to the perception there is no such thing as a definite, isolated object. There are only intimations of objects within the continuous flux of color and form that we perceive. Boccioni's "line/force" was devised to express this shifting relationship between "objectivity" and constant change, depicting neither the object itself nor its motion, but a synthesized image of both.

This is not so irrational a procedure as it may sound. Our mind is characterized less by the images it stores than by its activity in shifting and reassociating the images, admitting at the same time constantly new material. In their compositions that seem to move and grow continu-

ously, the Futurists were attempting to talk the mind's own language, exploiting the mind's capacity for association and sequential observation to produce a new aesthetic satisfaction consistent with their modern consciousness.

They noted further that we cannot isolate the impact of our various senses. Touch, sound, smell may mingle wtih sight to influence our emotional reaction. And then memory, that powerful and uncontrollable image-giver, makes its contribution. "To perceive," quoted Severini from Bergson, "is after all nothing more than an opportunity to remember."[6] This was the rich body of experience from which the Futurists drew their pictorial material.

In order to clarify the notion of what their revivified perception meant, the Futurists used all manner of images, many of which their detractors thought hilariously funny. "Our bodies enter into the divans on which we sit, and the divans enter into us; just as the tram going by enters the houses, and they in turn hurl themselves upon the tram and merge with it." Distance, either of time or space, does not exist. "And sometimes on the cheek of the person to whom we are talking in the street we see the horse going by a long way off." Such examples served only to suggest the wide scope of perception that makes the world more real, more present. They were meant to turn attention toward experience rather than toward the external object.

From their vivid awareness of the complexity of perception sprang the Futurists' primary concept of dynamism. They found an equation between the activity of the outside world and the activity of the mind that released their imprisoned sense of self and gave them a new confidence in their creative powers.

In their "Technical Manifesto" they said their goal in organizing a painting was "to put the spectator in the center of the picture." But what they were hoping was that by making the spectator participate in the complex activity suggested by the forms, colors, and fragments of objects, they were allowing the painting to take effective possession of his mind. They might have said with equal justice, "we want to thrust the world into the mind of the spectator."

What they strove for was an *Einfühlung,* an empathy with the world of things, an identity between object and emotion that was becoming the key to a new art of forms. "We do not want to observe, dissect, and translate into images," wrote Boccioni in rejecting objective analysis as a basis for painting, "we identify ourselves with the thing, which is profoundly different."[7] "We Futurists," said Carrà, "strive with the force

of intuition to insert ourselves into the midst of things in such a fashion that our "self forms a single complex with their identities."[8]

Such statements bring at once to mind the ideas of some of the German Expressionists; it is not surprising that Marc was strongly influenced by Futurist painting. But Marc strove for identification with the animal world, escaping the city with its mechanical innovations in which the Futurists took delight (see figs. 29, 30). In contrast to the Futurists, most of the German painters seem to have courted a more exotic or bohemian world.

That a mystical identity should be sought not through contemplation but through action is hardly a new and wholly modern idea. In a surprising article of 1912 Auguste Joly compared the procedure to the practices of the primitive mystic in his Orphic rites, wrestling with the direct experience of the physical world to transcend it in the climax of the orgy.[9] The association is apt. There is something of the orgy in much of Futurist art, created in an effort to kindle magic in an unmysterious world. There is, moreover, the same insistence on primitive sensibility, on beginning with the personal and the known rather than the traditional and learned, that is always the starting point of the mystic. "To understand the new beauties of modern painting," they declared, "the soul must again become pure."

Giovanni Papini began a bitter article in January 1913 by listing five types: the savage, the child, the delinquent, the insane, the genius.[10] "These," he told his readers, "are the last remains of primary and original man, of true man." Only these, who were outside the boundaries of "rational" society, could be looked to as inspiration for creativity. Only these could still respond wholly to the voice of intuition. Only they still enjoyed a unified perception.

With great faith in untutored genius, Carrà and Boccioni helped spark an extraordinary exhibition in Milan in the spring of 1911. Anyone with something original to say in a work of art was invited to exhibit: children, workmen, those who used only form and color, Impressionists, and "those who draw from their own sensibility and from nature a world of forms and colors that contrasts with reality but is in harmony with the mind." Significantly the freest and most daring paintings shown were those of the Futurists themselves.

"Hurrah! plus de contacte avec la terre immonde!"[11]

Although in their manifestos the Futurists exalted mechanics and science, their paintings were rarely concerned with mechanical forms.

Their words, not their painting, relate to the mechanized compositions of Léger. Inspired by the excitement of the new city, they translated their emotions in very human terms. They were forced to humanize the machine, rather than mechanize man, because underneath their ruthless pronouncements and praise of war was an intensely personal idealism. Only through the revivification of personal experience, through a new definition of self, could they triumph over a threatening world to reach a sublime spiritual peace.

In spite of their constant threat of chaos, at the core of each of their compositions, at the climax of every action, they sought an intuitive intimation of an ideal order. It was not a preestablished order, to be sure, nor were they willing to describe it in terms of a *section d'or* or other formal scheme. Only in the highest moment of activity did they sense it. But it existed nonetheless, always just beyond the reach of definition. Futurism was indeed an apt word to describe their confident search for that which lay always just ahead. At a time of cultivated cynicism they expressed an optimism that was looked upon as puerile by some, as a salvation by others.

Whether it is a *Cyclist* (1913) by Boccioni, one of Severini's *Expansion of Lights* (1914), or a *Flight of Swifts* (1913) by Balla, the experience of continuous movement generated by the painting finds eventually a kind of resolution. The motion or interplay does not stop, yet at a given point we feel that we have reached the climax, the moment of maximum concentration in the picture. This is not the same as recognizing finally the architectural stability underlying the dislocations of a Cubist painting; we do not leave the work with a new assurance of formal law and order, first threatened and then reestablished. Instead we are boldly launched or cunningly enticed to set out on an untrackable path that fragments and expands to take us well beyond the limits of our normal movement, and we are thus released into a realm of ideal motion that escapes the checks and measures of our physical world. This release is the Futurist's moment of ecstasy, his contact with the "universal rhythm" that grants him the freedom of the superman . . . "dans l'infini libérateur."

NOTES

Note: Material cited that is to be found in the *Archivi del Futurismo,* eds. Maria Drudi Gambillo and Teresa Fiori (Rome: De Luca, 1958), is here referred to as in *Archivi.*

1. An exception was the Florentine periodical *La Voce,* founded in 1908, which was an important force in encouraging rebellion against tradition and fostering the discussion of new ideas concerning society and the arts. Certainly the Futurists owed much to its renovating spirit.

2. "Il significato del Futurismo," *Lacerba,* 1, no. 3, February 1, 1913, p. 22.

3. Published initially in *Poesìa,* 1, no. 7, 1905, the poem was reprinted in *La ville charnelle,* 1908.

4. Introduction to the catalogue of Severini's exhibition at the Marlborough Gallery, London, April 1913 (*Archivi,* p. 115)'.

5. See Carrà, "Da Cézanne a noi Futuristi," *Lacerba,* 1, no. 10, May 15, 1913, pp. 99–101 (*Archivi,* pp. 160–163).

6. Introduction to the catalogue of Severini's exhibition, London, 1913 (*Archivi,* p. 113). Bergson's writing was early known by Carrà, Severini, Soffici, and probably Boccioni. Sustaining Soffici's point (made in *La Voce,* 3, no. 52, December 28, 1911, p. 726) that the Cubists, especially Gleizes, Le Fauconnier, and Léger, did not at all express Bergson's concepts, Boccioni pointed out that the Futurists, on the other hand, did ("Il dinamismo futurista e la pittura francese," *Lacerba,* 1, no. 15, August 1, 1913, p. 170). He earlier had quoted Bergson to support his theory of motion, in "Fondamento plastico della scultura e pittura futuriste," *Lacerba,* 1, no. 6, March 15, 1913, pp. 51–52 (*Archivi,* pp. 169, 144).

7. "Fondamento plàstico . . . ," p. 52 (*Archivi,* p. 144).

8. "Piani plàstici come espansione sfèrica nello spazio," *Lacerba,* 1, no. 6, March 15, 1913, p. 54 (*Archivi,* p. 146).

9. "Le futurisme et la philosophie," *La Belgique artistique et littéraire,* July 1912. The bulk of this article was republished by the Futurists in a pamphlet with an Italian translation.

10. "Il giorno e la notte," *Lacerba,* 1, no. 1, January 1, 1913, p. 3 (*Archivi,* pp. 130–133). It is ironical that, under Papini's leadership, the Futurists should have so violently attacked Croce's aesthetic theory since, in their efforts to restore the importance of intuitive values, they shared much. Croce later criticized the Futurists, however, for hurling themselves too thoughtlessly at an abstract utopian goal; they considered him too much a pedant. Carrà, however, recalled a sympathetic conversation with Croce at Naples in 1911 (*La mia vita,* Rome: Longanesi, 1943, p. 148).

11. Marinetti, "A mon Pégasse."

THE FUTURIST ACHIEVEMENT

To search for a "Futurist style" in the work of the original Futurist painters is a fruitless activity. Although they often spoke of stylistic means in their manifestos and articles—line/force, simultaneity, interpenetration of planes, etc.—these were just so many ways of getting at a content they believed important. Futurism did not grow out of the discovery of a new formal language; it cannot be discussed in the same

terms as Cubism. Taking their cue from the audacious poets who had already gone well beyond the free verse of the French Symbolists, each artist sought creative liberty through whatever iconoclastic means seemed most effective to him.

Futurism was not a style but an impulse, an impulse that was translated into poetry, the visual arts, music, and eventually into politics. "Futurism is only the praise, or if you prefer, the exaltation of originality and of personality," Marinetti declared to an interviewer in 1911; "the rest is only argument, trumpeting, and blows of the fist."[1] The nature of the Futurist impulse in politics, it might be added, should not influence the assessment of its achievement in art.

When the "Manifesto of Futurist Painters" was defiantly proclaimed from the stage of the Politeama Chiarella in Turin on March 8, 1910, there was as yet nothing that could be distinguished as Futurist painting. The manifesto was only a bid for freedom, and the neglected artists singled out for praise were the quite unsensational divisionist painters Giovanni Segantini and Gaetano Previati, and the remarkable but impressionist sculptor Medardo Rosso. Although the "Technical Manifesto," published on April 11, 1910, lays the groundwork for a new kind of painting, it also is written in the future tense: a setting forth of hopes and expectations rather than a defense of accomplishments. A Futurist painting had yet to be created.

There were two stylistic forces behind the painters who signed the manifestos: the tradition of Italian divisionism (derived from the French neo-Impressionists), and the international linear style of Art Nouveau, which still persisted in Italy as it did elsewhere. The systematic division of color inspired by Seurat and Signac had a somewhat different consequence in Italy, however, than in the North. For one thing it was rarely separated from quite specific expressive ends. The brooding landscapes of Segantini and the emotive, lyrical compositions of Previati have little in common with the paintings of Signac and Cross. The North Italian divisionist painters never succeeded in being objective in their view of nature, nor could they become chiefly concerned with pattern. Nature in the delicate, haunting paintings of Victor Grubicy, for example, is always the reflection of a state of mind.

In the work of Giacomo Balla, also, who studied in his native Turin before spending some months in Paris in 1900, can always be detected an underlying but quite specific emotional suggestion. In the painting *Work* (1902), and even more in *Bankrupt* of the same year, the directly evoked mood of the painting is attached to a wider human

significance. In one, beyond the somber nocturnal obscurity and the subtly reflected rays of the lamp, is the suggestion of the weary city laborer; in the other, the minutely described door hides the tragedy of a bankrupt, ignored by the children who thoughtlessly scribble on the sealed portal. Such pathos of incomprehension and isolation is a recurrent theme in Balla's early painting.

In this regard it is worth noting that Carlo Carrà's first successful composition (1908) depicted a melancholy pregnant woman being comforted by a friend. Carrà, too, had gone to Paris in 1900, to work on decorations for the international exposition; later he spent some time in London. He admired the paintings of Turner and Constable and the French Impressionists, but his youthful work shows little influence from them. In 1908 he became associated with the active organization in Milan, the Famiglia Artìstica, and it was there that he showed his *Horsemen of the Apocalypse* (1908), a translation of his sober views of the world into allegorical terms. Both the linear composition and the broken color owe much more to the Italian Previati than to the French; but the style is secondary to the ponderous subject matter.

Also Luigi Russolo, who has less formal training than the other painters in the group, began with such subjects as *The Triumph of Death, The Sleeping City* (in which the clouds become amorous writhing figures), and a strange symbolic portrait of Nietzsche. These were all carefully executed etchings that were shown in an exhibition at the Famiglia Artìstica in March 1910, in which Boccioni, Carrà, and Bonzagni also participated. In his painting, on the other hand, Russolo also showed himself to be a well-trained divisionist.

Both Gino Severini and Umberto Boccioni, fascinated by divisionism, studied with Balla in Rome and got from him both a belief in a disciplined study of color and light and an interest in lowly subjects. But Severini settled in Paris in 1906, and his charming *Spring in Montmartre* (1909) shows how completely in three years he had absorbed the taste of his new environment. The patterned composition harks back to Vuillard of an earlier date, and the mosaiclike strokes are closer to Signac than to Balla. Already he has put behind him the strong sentimental impulse of the others.

Boccioni, introspective, restless, ambitious, went through a troubled period of development. The romantic melancholy expressed in his little drawing of 1902 remained always in the background to conflict with his desire for action and social protest shown, for example, in the lively drawing of a crowd from 1908. In 1902 Boccioni left Rome to

study the Impressionists in Paris; later, in 1904, he settled for some months in Russia with a family he had known in France. But the effect of this travel is hard to find in the works he painted in Padua between 1905 and 1907, and the Milanese paintings of 1908 and 1909.

His portrait of the sculptor Brocchi, painted in Padua (c.1907), shows a complete command of Balla's divisionist technique, a fresh eye for composition—also inspired by Balla—and a willingness to distort form for his pictorial purposes. Similar qualities characterize his bold self-portrait (1908), in which the figure is pushed to one side and the space plunges back in a deep, eccentric perspective. Newly settled in the city, Boccioni included in the background a typical scene of the out-skirts, using material that he often repeated in these years and that eventually led to his first major Futurist work, *The City Rises* (1910; fig. 53).

But the illustrations Boccioni drew in 1908 for popular magazines in order to survive in the city show that he still could think in terms of allegory, sentiment, and the free linear style of Art Nouveau.[2]

In the winter of 1909/1910 Boccioni discovered new possibilities in his divisionist studies. He began to let light eat into the forms, creating a much more dramatic interaction between color and light, and space and solid. His rhythmic contours gave way to complex planes of light and shade. Futurism did not at once suggest a new style to Boccioni, but encouraged a new boldness of execution and a more adventuresome exploration of effect. His richly colored and adroitly characterized portrait of Signora Maffi, *La Maestra di Scena,* was shown in Venice, July 1910, as a Futurist painting. Its bold impressionism was the first step.

The Painters Meet the Public (Milan, May 1911)

The first heralded group showing of paintings under the Futurist banner took place within the context of the extraordinary jury-free exhibition that opened in Milan on April 30, 1911. Some of the paintings had been shown late in December at the "intimate" exhibition of the Famiglia Artìstica, but this was the first exhibition in force. "If you don't want to cover yourself with shame, giving proof of ignominious intellectual apathy . . . hurry to intoxicate your spirit before *50 Futurist paint-ings,*" they advertised. With pride they quoted the critic of the *Corriere*

della Sera: "The maddest coloristic orgy, the most insane eccentricities, the most macabre fantasies, all of the drunken foolishness possible or imaginable."[3]

Since the publication of the "Technical Manifesto" in April 1910, the Futurists of Milan had worked hard to realize in paint what they so confidently had set forth in words. The various ideas in the manifesto, obviously suggested by different members, could hardly be embodied in one style of painting, and Carrà, Boccioni, and Russolo each worked in the direction that seemed most "Futurist" to him. Meanwhile Severini in Paris, having completed his intricately patterned painting, *The Boulevard* (1910), set out in his own Futurist direction with a huge canvas of dancers and crowd, *The "Pan Pan" at the Monico* (1910). Balla, in Rome, was quietly expanding his careful divisionism to

53. Umberto Boccioni: *The City Rises.* 1910. Oil on canvas. 78½" × 118½". Collection The Museum of Modern Art, New York, Mrs. Simon Guggenheim Fund.

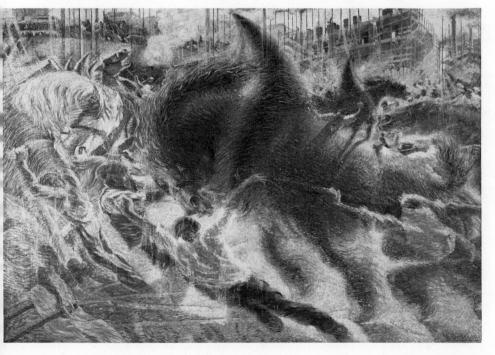

create more dynamic relationships of light and color, already detectable in his *Street Light* (1909; fig. 54).

Russolo, the least gifted as a painter but one of the most thoughtful of the group, was fascinated with the possibility of combining responses of different senses in a painting. This synesthetic interest, so much a part of Symbolist poetry and the self-consciously decadent sensualism in France in the late 1880s, he early demonstrated in *Perfume* (1909–1910), in which color and shapes are meant to evoke a heady, languorous scent. In more strictly Futurist language was a huge painting completed for the exhibition, entitled simply *Music* (1911). A dark violet musician seated at a keyboard creates a music that spirals and radiates around him, illuminating variously colored masks that correspond to the differing moods of the music. He is shown in various positions as he plays, and the spiral design is continuous. It is a literally conceived work, in design like some of the drawings of Romolo Romani that take their cue from Art Nouveau, but it has its fascination as the masks seem to appear and disappear.

Carrà, who was probably responsible for many of the major technical points of the manifesto, although the language is clearly Boccioni's, set himself an ambitious program. Possibly taking a suggestion from Libero Altomare's poem, "Swimming in the Tiber," recited by Marinetti with great effect at many Futurist presentations, he created a painting in which the forms and colors of the swimmers and the flowing water mingle in a single continuous pattern. In the manifesto it had been pointed out that there are two forces that tend to destroy the concreteness of form: light and motion. Carrà has demonstrated the idea in his painting in which the bright ripples of the water, the broad patches of divisionist color, break up the forms that are already made angular and elongated through motion. The painting as a whole, however, still relies on the persuasive continuous rhythm of Art Nouveau, luring the viewer to follow rather than to place himself in the midst of the scene.

This is less true of another painting from the period that does in a sense sweep the observer into space. This is *Leaving the Theater* (1910–1911), of which Carrà later remarked, "I believe that this canvas . . . is one of the paintings in which I best expressed the conception I then had of pictorial art."⁴ The shadowy figures pushing out into the night, the diffuse form of the snow, the broken color, all help to break down the sense of a fixed point of view, creating instead the effect of an active rhythmic environment that surrounds the viewer. This, at least, is what Carrà was working toward, and what he achieved

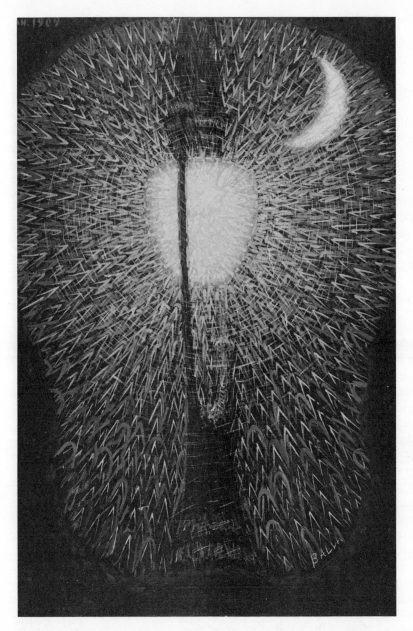

54. Giacomo Balla: *Street Light*. 1909. Oil on canvas. 68¾″ × 45¼″. Collection
The Museum of Modern Art, New York, Hillman Periodicals Fund.

with notable success in his ambitious painting the *Funeral of the Anarchist Galli* (1910–1911). Here Carrà used stabbing rays of light interrupted by paths of abrupt action to paint a picture of "combat" rather than of men fighting. It suggests Marinetti's recommendation to the Futurist poets to use only the infinitive of the verb so that the action would not be limited to a single agent: we are more aware of actions than of actors.

Carrà was remembering an unhappy incident he had witnessed some six years before. At the funeral of the anarchist Angelo Galli, who had been killed during the general strikes in Milan in 1904, a riot developed involving mounted policemen and the angry crowd. In the midst of the thrusting lances and flailing sticks, the red-draped coffin was almost knocked from the shoulders of the pallbearers and trampled underfoot. This is the moment that impressed itself on Carrà's memory and that now he recalled.

The principles underlying the composition are exactly those of the "Technical Manifesto." Arms multiply into a series of lines that describe the continuity of their action. So important, in fact, do these lines of motion become that they tend to dissolve the form of the arms themselves. Light, too, is transformed into visible energy, shining directly at us and breaking every area into active parts. "Everything moves, everything runs, everything rapidly evolves." Color, also, plays an active part. For all its fine divisionist strokes, the colors do not fuse; based on the contrast of complements rather than on graduated sequences, it sets up a struggle of its own. "Congenital complementary-ism is an absolute necessity in painting," the manifesto stated.

The interaction of light and the multiple images of motion create an environment of activity hard to escape. Yet the activity does not belong specifically to any single figure. We identify ourselves instead with the activity as a whole and lose ourselves in it. Looking back on this picture, Carrà considered it the prime example of the declaration, "We will put the spectator in the center of the painting."[5]

Boccioni, too, was concerned with the evocation of action, but his painting went in quite a different direction from that of Carrà. Probably his first serious effort to embody the new hectic life of the Futurist in painting was his *Riot in the Gallerìa* (1910).[6] The Gallerìa of Milan or, more precisely, the Restaurant Savini in the Gallerìa, was the regular meeting place of the avant-garde literary set and the Futurist painters. It was the beginning and ending point of most of their propaganda cam-

paigns. Boccioni chose an environment he knew well and a situation not unfamiliar to an active Futurist.

But as personal as the situation may have been, the painting conveys little personal excitement. Its handsomely composed color scheme, the formal design of the impressive architecture painted with the precision of Balla, encourage us to view with some detachment the activity of the crowd. The figures seem suspended in motion as if caught by a waiting camera. Their excitement is not enough to force the walls to bend to their frantic rhythm or to shatter the steady light. The scene is active and fascinating, but we are not in the center of the action.

Boccioni later rethought the problem and, in April 1911, produced another tumultuous crowd scene, *The Raid,* in which, as the carefully dated drawings indicate, he attempted to draw the observer closer to the action. His method was closer to Carrà's. But somehow the viewer still remains outside.[7]

This cannot be said of a very large painting on which Boccioni began work probably in the summer of 1910. Ever since coming to Milan in 1908, he had made studies of the city. "I feel that I want to paint the new," he confided to his diary in March 1907 after a trip to the city, "the fruit of our industrial time. I am nauseated by old walls and old palaces, old motives, reminiscences . . . I want the new, the expressive, the formidable."[8] He haunted the periphery where buildings were under construction and factories billowed smoke, and took particular pleasure in sketching the huge workhorses that seemed to personify the harnessed force of the new industry.

He decided to bring together his various impressions into one work dedicated to labor. The growth of the composition was slow. At first he was content to assemble the horses and their drivers in a rather static plan. But as he worked, one huge horse began to assume the responsibility of all, pushing well past the center of the painting, dragging his driver with him. Next the buildings lost their static detachment and took on some of the push of the big horse; and light, exploding from the background, began to dissolve the individual forms. "I have tried for a great synthesis of labor, light, and movement," he wrote to the director of the Gallery of Modern Art in Venice.[9]

It is at this point in the painting, when the parts are shattered to obey the powerful rhythm of the whole, when light unites itself with physical action to make even the divisionist color a source of aggressive movement, that specific time and place lose their importance and we are

caught up in an all-consuming action that seems universal in its implica-
tion. This was the dynamic abstraction toward which Boccioni was
working. Different indeed from the painting by Carrà, Boccioni's *The
City Rises,* as the painting was later called, overcomes the detachment
of the viewer not by complexity of form but by sheer driving force.

At the same time Boccioni was evolving an image of staggering
physical power, he was exploring a very different means of expression.
Although the relentless activity of *The City Rises* typified one side of
Boccioni's character—the side that drew him to the provocative activity
of Marinetti—the brooding, emotional qualities he had shown as a young
man were not easily suppressed. There was poetry to be found in aspects
of life other than force.

Speaking of a painting on which he was working in the early
autumn of 1910, he wrote:

> I hope it really will be the first of a long series of paintings that I
> want to do in which color becomes a sentiment and a music in
> itself If I am able (and I hope to be) the emotion will be
> produced with the least possible reference to the objects that
> brought it about. The ideal for me would be a painter who, want-
> ing to evoke sleep, would not associate himself with the mind of
> the being (man, animal, etc.) sleeping, but would be able by means
> of lines and colors to evoke the *idea* of sleep, that is, universal sleep
> beyond the accidentality of time and place.[10]

The studies for his painting *Mourning* (exhibited December 1910)
show him groping for such simple, expressive forms. Clearly with the
model of Edvard Munch in mind (for example, his startling lithograph
The Cry), he tried transforming literally rendered faces showing grief
into diagrammatic masks that expressed the emotion directly and almost
anonymously. The most elaborate study is a kind of compromise be-
tween the description of the face and the expressive rhythm of the line.
The finished work is a haunting expression in strange color and disturb-
ing form.

Another painting embodying a single emotion, even more elaborate
and complex in organization, was shown for the first time in May 1911.
The Laugh (fig. 55) is a tribute to one of those bubbling and infectious
sounds that spreads from person to person, then group to group, until it
seems eventually to convulse the entire atmosphere. *Mourning,* with its
histrionic gestures, was a far easier and more conventional subject.

From the moment of their inceptions the two paintings were

thought of in entirely different plastic terms. Instead of the elongated, angular, taut forms of *Mourning, The Laugh* began with full, rounded, floating lines, well epitomized in the plume of a fantastically large hat. The composition, like the sound, radiates from the plump, untroubled face of the happy protagonist, pulling objects and people alike into its persuasive path. Doubtless these rolling, boisterous forms were much more in evidence in the painting when it was first shown than in its present form. Marinetti mentioned later in the year that the painting had been slashed by some unconvinced visitors to the Milan exhibition. Evidently Boccioni re-created the work on new canvas, taking the

55. Umberto Boccioni: *The Laugh.* 1911. Oil on canvas. 43⅜″ × 57¼″. Collection The Museum of Modern Art, New York, gift of Herbert and Nannette Rothschild.

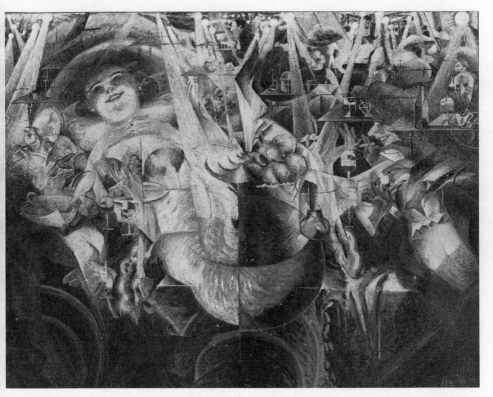

opportunity to add the angular forms and "cubist" bottles and glasses that have no place in the original sketches nor in carrying out his stated expressive theory. Probably the revised version was made late in 1911 after his return from a hasty viewing in Paris of the recent works of Picasso and Braque and his friend Severini.[11]

These paintings of Carrà, Russolo, and Boccioni, at the "Free Exhibition of Art" in May 1911, showed the public that Futurist painting was more than invective and theory. It demonstrated, moreover, that painting could successfully undertake new problems of expression. Yet to the eyes of a man well schooled in the recent art of Paris, the attempts were weak and unsuccessful. Ardengo Soffici, painter and critic, damned the exhibition and was in turn set upon by the Futurists.[12] The encounter was fruitful: not only did it eventually bring Soffici and Giovanni Papini, his colleague on the lively Florentine periodical *La Voce,* to the support of Futurism, it spurred the painters to more critical judgments of their experiments in painting.

The Futurist Assault on Paris (February 1912)

Having established an image of their work before the public of Milan, the Futurist painters set out on a more ambitious program. Marinetti made arrangements for an exhibition of their paintings in Paris during the coming winter and, aware of the significance of such an exhibition among the most advanced artists of the day, they became even more self-conscious about their procedures.

Again Boccioni was drawn in two opposing directions: toward the analysis of the world around him and his way of perceiving it, and toward the free expression of a state of mind. The first interest was encouraged by his contact with happenings in Paris, maintained through his close friend Severini and infrequent articles on the new tendencies.

The unusual painting of his friend Ines, *Study of a Woman Surrounded by Houses,* probably painted in the summer of 1911 and left unfinished, makes a distinct departure. Not only are the dislocated forms much bolder, but there is a greater openness to the composition. Abrupt straight lines take the place of continuous curves and melting surfaces. The eye moves freely back and forth and around, not pushed by a dominating force. The "dynamism" of the painting is generally diffused throughout the entire area.

So close in general spirit is the freely mounting composition of the painting to one of Delaunay's Tour Eiffels (1911; fig. 56), reproduced

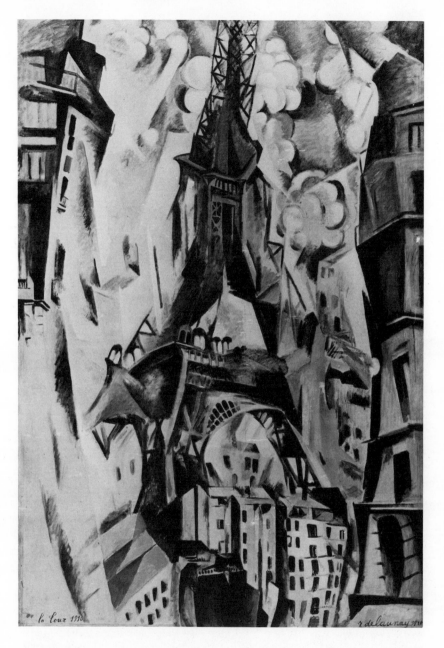

56. Robert Delaunay: *Eiffel Tower*. 1911. Oil on canvas. 79¾″ × 54⅝″. Collection The Solomon R. Guggenheim Museum, New York.

in an article by Roger Allard that appeared at just this time, that it is hard to believe Boccioni was not impressed by it.[13] It was the hint he needed to escape the concept of motion in a painting as being limited to muscular activity. The difference, for example, between *Street Pavers*, doubtless painted at this time, and *The City Rises,* from not many months before, is enormous. The rhythm in the *Pavers* is traded back and forth among the figures, no single form preempts the center of attention, and the color spots are so large and separate that they seem to float in a world of their own. This tendency toward free construction built on angular lines and planes had been developing in Boccioni's drawings for some while. Only a slight suggestion was necessary to permit it to take over the paintings. As for color, some of the free studies of *The City Rises* show what an easy step it was from the divisionist color of that forceful painting to the open atmospheric color of the *Pavers.*

This was the moment also for Boccioni to demonstrate his conception of a painting of simultaneity. His *The Noise of the Street Penetrates the House* (1911) is like opening a window on a noisy city: workmen climb ladders and shout, horses are everywhere, and the houses crowd around the viewer with the same mounting energy as in the *Woman Surrounded by Houses*. With a centripetal force it all crowds in at once upon the consciousness.[14]

Russolo, too, experimented with simultaneous images. In his *Memories of a Night* (1911) various events and unforgettable visions come together in a dreamlike fusion. This quite different aspect of simultaneity is equally a part of the Futurist conception. Not everything happening at once is synthesized, but a series of occurrences in time are juxtaposed in the memory. Russolo was careful to illustrate literally some Futurist statements: the horse with multiple legs, the horse appearing on the cheek of the woman, etc. But more important is the free, dreamlike association that relates the composition of the painting more to a process of thought than to a process of vision. It is one more aspect of painting as a state of mind.

The exhibition in Paris would mark the first appearance of Severini with the group, and he too put forth a special effort. In his quiet way he had made contact with all of the new tendencies developing in French painting, yet had continued in his own direction. The charming, patchwork *Boulevard* was his first bold step. By then he had absorbed many of the formal preoccupations of his Paris fellows, and the geometrical

breaking up of form seemed less a daring conquest for him than for his colleagues in Milan. But the Futurist interest in night life, in the simultaneous sight, sound, and motion of the crowded environment of the city appealed to him, and he turned his attention to it. His little painting, *The Modiste* (1910), entangles light, reflections, forms in an active but poised interplay. There is none of that polemical force in Severini that had become a characteristic of the Milan group, but his paintings are no less original. His huge *The "Pan Pan" at the Monico* (now destroyed), which was one of the major works at the Paris exhibition and on which he had worked for over a year, is an extraordinary reevocation of lively dance rhythms, noisy chatter, and snatches of music. It is a completely lyrical painting with none of the burden of social protest or violent emotion assumed by the work of Boccioni. In its purely lyrical quality lie both its strength and its weakness.

In a hasty trip to Italy, where he met Carrà and Russolo for the first time, Severini saw the works of his fellow Futurists and was appalled that they so little resembled the paintings of his friends in Paris. Their resistance to principally formal preoccupations struck him as *retardataire*. Impressed by his criticism, Carrà and Boccioni (and possibly Russolo), with the aid of Marinetti, made a brief trip to Paris in the autumn of 1911 to see at first hand the most recent trends in painting.[15] Introduced to many artists by Severini and viewing hastily the Salon d'Automne, they saw much that impressed them. With many new ideas in mind, they hurried home to complete old and make new works for the Paris exhibition, more confident in their use of an international language.

Apollinaire reported in his chatty column of the *Mercure de France* on November 16, 1911, that Boccioni had told him a good deal about the aims of Futurism. "If I understood correctly," wrote the bemused Apollinaire, ". . . they are above all preoccupied with expressing sentiments, almost states of mind (that is an expression employed by M. Boccioni himself) and with expressing them in the strongest manner possible."

"So I have painted two canvases," Apollinaire reported Boccioni as saying, "one expressing departure, the other arrival . . . To mark the difference in feeling I have not used in my painting of arrival a single line from the painting of departure."[16] Thus stated, the idea does sound as puerile as Apollinaire thought it, but the works to which he referred are by no means simple. Boccioni had developed rather complete versions of his imposing triptych, *States of Mind* (1911), before going to

57. Umberto Boccioni: Study for *States of Mind: The Farewells.* 1911. Pencil. 23″ × 34″. Collection The Museum of Modern Art, New York, gift of Vico Baer.

France, using the kind of free expressive forms that characterized *Mourning* and *The Laugh*. *The Farewells* (1911; fig. 57) was constructed of flamelike lines in which embracing couples were wafted like Paolo and Francesca. In *Those Who Stay* (1911), persistent depressing vertical lines engulfed the vague forms of figures slumping off into the distance. In contrast, *Those Who Go* (1911) was marked by the clacking rhythm of a moving train; glimpses of fleeting houses and anxious faces barely escaped the mad rush of diagonal lines.

These expressive procedures did not change in the finished works, but contact with the Cubists gave Boccioni new insight on how complex a spatial organization could be without a loss of clarity. So he painted a new version of the triptych on his return from Paris, destroying all vagueness of form, giving his panels a new concreteness, far from the haze of Impressionism. He glimpsed the possibility of a whole new vocabulary.

The new vocabulary, however, did not change the aim of the painting; *The Farewells,* for example, has an effect far different from a Cubist work. In spite of the angular parts, there is a constant rhythmic flow, welding images together and creating an expressive, emotional unity. The restless motion never stops, never reaches a point of stasis. Then too, objects, although treated summarily and reduced to geometric simplicity, have an insistent way of reclaiming their identity. The numbers are not a formal play as in the contemporary work of Picasso, but help bring to mind the train; the green swirls become embracing figures, and the superimposed straight lines suddenly identify themselves as railroad cars. Boccioni's subject matter is not to be escaped or pushed aside. The triptych retained its title: *States of Mind.*

Russolo, also emboldened by happenings in Paris, struck out in a new direction not at all related to Cubism. His huge painting *Revolt* translates into geometric terms, almost the terms of a hieroglyph, the force expressed in such a painting as Boccioni's *The City Rises.* Russolo was a methodical artist, and once a pictorial problem was clear in his mind he proceeded to execute it with directness and simplicity. Here the houses are not distorted as if caught up in the passionate expression of the artist, but are simply tipped at an angle of forty-five degrees, thus becoming an arrow for the advancing wedge of the crowd. The painting has a sense of force, yet is painted with analytical detachment.

Of the three, Carrà was, at the moment, the most susceptible to the formal harmonies of Cubism. He was ready to turn his back for a while on matters of social conscience (his grim *Martyrs of Belfiore* simply disappeared from view) and devote himself to a more lyrical kind of painting. In *The Jolts of a Cab* (1911) and in *What the Streetcar Said to Me* (1911) he created free rhythmic images that mimic in their repetition and sudden dislocation of form the erratic patterns of city noise. The sense of sound in these paintings is as important as in the dancers of Severini; the patterns cannot be explained by a scheme of visual analysis (see fig. 58). Of the two, the *Streetcar,* with its sharp angles and blocky forms, has more in common with Cubist painting, but its jerky movements that refuse to coalesce into a static unity mark its Futurist inspiration. Then too, in both, awareness of the situation represented is an essential part of the painting; the works are at once directly expressive in form and evocative in subject.

Carrà's portrait of Marinetti and another painting shown in Paris, *The Woman with Absinthe,* come closest to the paintings of the Parisian Cubists. Yet here too the concept of the painting as a plastic rendering

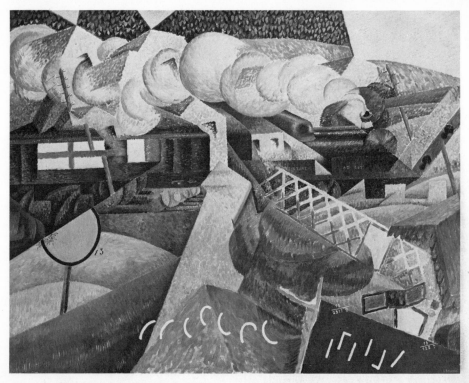

58. Gino Severini: *Red Cross Train*. 1915. Oil on canvas. 35¼" × 45¾". Collection The Solomon R. Guggenheim Museum, New York.

of a state of mind takes precedence over the play of forms. Although the portrait is now much altered (an inscription was added later by Marinetti himself), the poet still looks hypnotically from the canvas, suspended among the swinging planes of light and space.

The paintings shown, then, at the gallery of Bernheim-Jeune from February 5 to 24, 1912, were not all created in innocence, far from the influence of Paris. But in their essence they made a startling contrast with the evident trend in Parisian painting. Cubism tended to move away from significant subject matter, often using but a few simple objects in order that full attention might be paid to the formal transformation; color had been subjugated to other interests in the reaction to Impressionism and all it stood for; and the artists strove for ever greater discipline in the organization of form. Now a group of painters appeared who immersed themselves in subject matter—actually depending on it as a freeing force—reveled in the full sensuous range of Impressionist color, and substituted activity for form and excitement for contemplation.

Whether they wished to be or not—and the Italians were very irritating in their insistence on the originality of their purely Italian movement—the Paris painters were impressed. Grudgingly Apollinaire concluded in a rather disdainful article: "In fact the new art that is developing in France seems to have concerned itself with no more than the melody; the Futurists come to teach us, with their titles not with their works, that it could be elevated to a symphony."[17] The vigor with which the Futurists promoted the very ideas that were strangest at the moment to Paris, was hard to ignore.

So far as the public was concerned, newspapers throughout the world reported the exhibition, and illustrated articles on the movement, serious or mocking, became common Sunday supplement material. The *New York Sun* devoted a full page to the artists on February 25; on March 29 Margaret Hubbard Ayers explained to the readers of the *New York Evening Journal* that the "Futurist artists see through mental eyes"; and the *Literary Digest* published a feature article with illustrations. Great interest was shown in Japan, Greece, Denmark, Russia, and of course in Germany and England.

After its close in Paris, the exhibition moved to the Sackville Gallery in London (March), then to the Sturm Gallery in Berlin (April), and on to Brussels (June), The Hague (August), Amsterdam (September), and Munich (October). In Berlin most of the paintings were purchased by Dr. Borchardt (on terms that proved unfortunate for the artists), who continued to circulate the paintings. Beginning with the exhibition in Paris, Futurist painting took its place beside Futurist theory as an international force in art.

NOTES

1. *Le Temps*, Paris, March 14, 1911 (*Archivi*, p. 473).
2. See, for example, "Allegorìa del Natale," *Illustrazione Italiana*, 35, no. 52, December 27, 1908, p. 617; his illustrations on pages 486 and 521 of the same issue are, however, closer in style to his paintings.
3. From a broadside advertising the Futurist participation in the exhibition.
4. Carrà, *La mia vita* (Rome: Longanesi, 1943), p. 161.
5. *Ibid.*, pp. 73–74.
6. Possibly because of its confusing association with the dated drawings for *La Retata* (April 1911), this painting has sometimes been dated later. Its composition, however, is close to the illustrations of 1908, and its color is consistent with other works of 1910. Such a painting would seem hardly possible after *The City Rises* or Carrà's *Funeral of the Anarchist Galli*.

7. *The Raid* (*La Retata*) is in a Paris collection. The studies called *Baruffa* (The Museum of Modern Art and Winston Collection) are a similar effort, probably dating shortly before this time.

8. Boccîoni, *Opera completa*, p. 309 (Archivi, p. 225).

9. The revealing letters from Boccioni to Nino Barbantini, the progressive director of the Gallery of Modern Art, were published by Guido Perocco in the exhibition catalogue *Primi espositori di Ca' Pesaro, 1908–1919,* Venice, August 28, to October 19, 1958, pp. 114–120.

10. *Ibid.,* p. 116.

11. This hypothesis is further supported by the caricature of the painting in *Uno, due e . . . tre* (June 17, 1911), in which only the flowing circular lines are used to suggest its character.

12. "Arte lìbera e arte futurista," *La Voce*, 3, no. 25, June 22, 1911, p. 597. There are many descriptions of the encounter between Soffici and the Futurists; for one see Carrà, *La mia vita*, pp. 149–151.

13. "Sur quelques peintres," *Les Marches du Sud-Ouest*, 2, June 1911, p. 62. Also reproduced were works by Le Fauconnier, Gleizes, and Léger. Boccioni later referred to the article in "Il dinamismo futurista e la pittura francese," *Lacerba*, 1, no. 15, August 1, 1913, p. 170. Interestingly enough, Allard pointed out that Delaunay was following a Futurist principle (derived, certainly, from the manifestos, not painting). This point is ably discussed by Maurizio Calvesi in "Il Futurismo di Boccioni: formazione e tempi," *Arte Antica e Moderna*, 2, April–June 1958, pp. 149–169.

14. The title of this painting, which dates probably from the summer of 1911, and that of *Visioni Simultànei,* much more Cubist in form and doubtless painted after the trip to Paris, have sometimes been exchanged. Reproductions of the paintings in *The Sketch,* London, March 1912, together with the descriptions in the London catalogue, help in establishing the correct identity.

15. The trip to Paris is remembered very differently by Severini than by Carrà. Severini recalls Russolo as being there; Carrà does not. Certainly there is little direct evidence in Russolo's painting.

16. "Les Futuristes," *Le Petit Bleu,* Paris, February 9, 1912. The relationship of Apollinaire to the Futurists is complicated. Obviously restive with the Cubist will to severe formal abstraction, he welcomed the fresh expressive subject matter and lyrical color of the Futurists. According to Severini he almost decided to use "Futurism" as the organizing term of his *Méditations Esthétiques* instead of "Cubism." But the nationalistic combativeness of the Futurists and Apollinaire's pride in Paris were not compatible. He lavished his attention instead on the Orphism of Delaunay and was roundly attacked by the Futurists for attributing their ideas to another. (See Boccioni, "I Futuristi plagiati nella Francia," *Lacerba,* 1, no. 7, April 1, 1913, pp. 99–101, in answer to Apollinaire's article in *Montjoie!,* March 18, 1913.) Doubtless Apollinaire's theory was strongly influenced by Futurism; it is doubtful, however, if this aspect of Delaunay's painting owes much to the Italian painters. The controversy, which raged for some time, is discussed by M. Calvesi in "Il Futurismo e l'avanguardia Europèa," *La Biennale di Venezia,* 9, nos. 36–37, July–December 1960, pp. 21–44.

17. Guillaume Apollinaire, *Anecdotiques* (Paris: Gallimard, 1955), p. 49.

Drawing as if to Possess*

LEO STEINBERG

Leo Steinberg looks freshly and with "other criteria" at Picasso's work, with particular attention to the 1930s, the 1940s, and the 1950s. The formalist critics have tended to devalue the art from these decades by reducing Picasso's achievement to "flattening out" the picture plane in Cubism. They have failed, if not feared, to see what Steinberg calls the "most uncompromising three-dimensional imagination that ever possessed a great painter." So Picasso, allegedly "the great flattener of twentieth-century painting," is here given his full dimension. To recover, to "possess" three-dimensionality without recourse to pre-Cubist illusionism, this was Picasso's challenge and passion, according to Steinberg.

In this essay Steinberg reveals how the artist's compulsion to realize a vision around, through, and behind his figures led to "unheard-of visualizations of simultaneity." These visualizations are shown to be different from Cubist "simultaneity of point of view." Further, Steinberg demonstrates that this impulse to render an encompassing vision pervades Western art.

One of the most distinguished scholars and critics of our time, Leo Steinberg is Benjamin Franklin Professor of Art History at the University of Pennsylvania. He has written extensively about Renaissance, Baroque, and modern art.

* From "The Algerian Women and Picasso at Large," *Other Criteria: Confrontations with Twentieth-Century Art* (New York: Oxford University Press, 1972). Revised for publication in this volume.

A Picasso drawing of 1931 shows a sculptor at work·on a statuette (fig. 59). I compare it with a small oil of similar subject by the seventeenth-century Fleming Gonzales Cocx (fig. 60). Such comparisons are unproductive if they stop at the similarities, but they are good for telling the differences. In the painting the artist's bespectacled gaze and meticulous operation converge on one patch of surface—one patch at a time. In Picasso's drawing, the sculptor's wide-angle vision circles the figure, and the statue turns at the touch of his hand; hence its double exposure, the lineaments of a frontal anatomy imprinted on a three-quarter back view. We are assured that the figure is understood in the round.

Shortly thereafter, Picasso launched a series of erotic drawings and prints—again the female body in the grasp of a male (fig. 61).[1] But whereas, in the statuette, possession through total knowledge was symbolized in the overlay of an alternative aspect, no distinction of aspects is allowed in *The Embrace*. The possessed woman, downed and en-

59. Pablo Picasso: *The Sculptor*. August 4, 1931. Drawing. 12½″ × 10″. Seattle Art Museum, LeRoy M. Backus Collection.

60. Gonzales Cocx: *The Sense of Sight*. c. 1650. Oil on wood. 7⅛″ × 5½″. Collection Royal Museum, Antwerp.

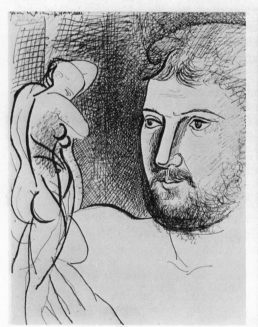

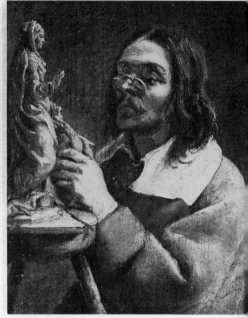

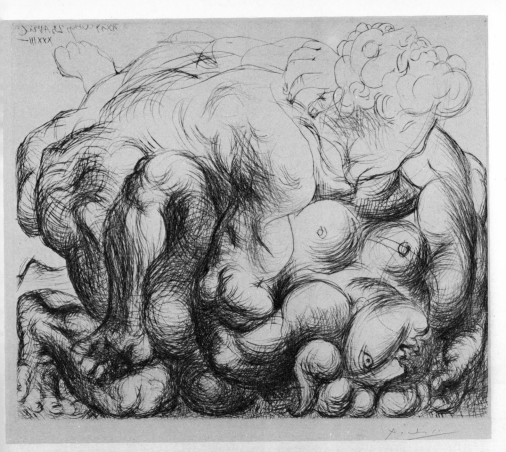

61. Pablo Picasso: *The Embrace.* 1933. Drypoint etching. 11⅝″ × 14⅝″. Bloch 31.

gulfed, clings too close for seeing. Blind grappling overwhelms every aspect, so that the viewer, rather than receiving multiplied visual data, experiences some of the visual disorientation which attends carnal knowledge.[2] The differences between the subjects of artist and ravisher are plain enough—in Picasso's dream of total envelopment they are opposite poles. But they share their reference to a single compulsion. Both reach for that knowing intimacy which Picasso's iconography confounds in a twofold expression of creation and love.[3]

The will to have the full knowledge of what is depicted, the refusal to be confined to an aspect, is not Picasso's alone. It pervades Western art, fed by multiple impulses to all of which Picasso responds. The impulse may be sensual, released by fantasies of erotic fulfillment; it

may be cognitive—an intellectual anxiety for complete information, like
wanting a picture of the back of the moon; and it may be moralistic,
spurred by the preacher's injunction to remain undeceived by the fair
face of appearance.

In the late Middle Ages the preacherly impulse gave rise to such
images as the "Prince of the World" on the facade of Strasbourg
Cathedral. The figure stands at the inner jamb of the southwestern
portal—a witless fop smiled upon by Five Foolish Virgins; nor do they
see that a rip in his garment exposes his arse and spine crawling with
toads.

Or this macabre contrivance: a late fifteenth-century ivory pen-
dant detached from a rosary (Museum of Fine Arts, Boston, figs. 62,
63). The obverse represents a young bridal pair, the damsel in the
tender embrace of her groom. But the figures are worked in the round
and intended for manipulation, so that you could not finger the lovers

62, 63. Ivory bead from a rosary (front and back views), French or Flemish.
c. 1500. Courtesy Museum of Fine Arts, Boston.

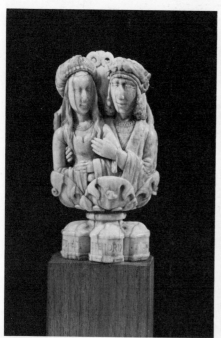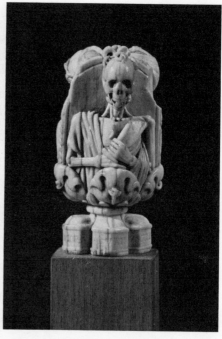

without feeling grim Death behind. Taking their love at face value, you would be missing its future tense and God's plan for the whole; which is why the museum has the object installed against a small mirror. Scaled to a lady's hand, it was designed to transmit that surpassing knowledge which is not stayed by the facade of romantic love.[4]

Such blatant moralizing seems at first sight remote from Picasso's mentality. Yet a personal version even of this homiletic mode, whether adapted or newly conceived, does appear in his work. The theme—I am thinking of the skull-girl portraits of 1940 (fig. 64)—may be that of death ingrown with youth; or, more often, of an animal nature impaled with the human, both natures faceting a single core. The bitterness, the brutality of these wartime images reflects their historical moment. But as visualizations of coincident opposites, they bespeak a lifelong obsession with the problem of all-sided presentment—an obsession so keen, that whatever means Western art may have found to display front and back

64. Pablo Picasso:
Head of a Woman. June 26, 1940.
Ink drawing. Z. XI, 54.

simultaneously, Picasso appropriates all those which he came too late to invent.

Four such means were developed within the traditional system of naturalism and focused perspective: front and back in juxtaposition; the averted back revealed by a mirror; the averted back shown to a responsive watcher upstage; and the *figura serpentinata*. They are four ways of harmonizing an ideal of omnispection with the logic of a fixed point of view. A description of each in turn is in order, for Picasso's art passes through them continually even as it breaks free.

About-face in sequence. "Because the *Danae,* previously sent to Your Majesty, had appeared entirely from the front, I wished [in the present *Venus and Adonis*] to show the opposite side, to the end that the chamber where [these pictures] will hang, may become more delightful to see." Thus Titian to his client Philip II of Spain in a letter of 1554. He adds that an *Andromeda* currently under contract "will display yet another view."[5] Titian was doing more than pandering to the salacious taste of a king; he was showing off the power of painting. As his theme was the female nude, he would render it from all angles, silencing the sculptor's taunt that painting, being one-sided, was the weaker of the two sister arts. And he would treat the king's chamber as Giorgione before him had treated one canvas alone. For Giorgione, "to prove that painting shows more to a single view than sculpture does," had painted a nude soldier half turned, while a limpid stream, a looking glass, and the high gloss of a discarded corselet reflected his various aspects.[6] Both masters followed a canonic procedure—displaying frontal and dorsal views of otherwise similar figures by juxtaposing them in one visual field.

The idea was rooted deep in antique compositional principles. One can trace it from late Archaic reliefs to such Hellenistic baroque groups as the *Farnese Bull.* And if Renaissance masters thought the device too banal, they knew how to disguise it, the game being to maintain hidden identities in variation. In Pollaiuolo's *Martyrdom of St. Sebastian* (London), the two foreground archers are inversions of one another: as one loads a crossbow, his comrade nearby (repeat) loads a crossbow, being but himself again seen from behind. And Pollaiuolo surely did not mean their identity to go unperceived.

Examples of such procedure abound at every level of sophistication. The verso adjoined to the recto is the common means of conveying, or holding on to, full information about three-dimensional objects. You

find it in modern coin catalogues and documentary photographs (such as our figs. 62 and 63), and you find it again and again among Picasso's early study sheets of female nudes. At first glance the expository arrangement of his *La Lola,* for instance (fig. 65), seems comparable to the Master P.M.'s engraving, *The Women's Bath* (fig. 66): both works exhibit a schematic sequence of front, back, and side, plus one squatter flexing a leg. Yet the two works are worlds apart. One sees at once how the abstraction of Picasso's line prevents his successive images from dispersing. The fifteenth-century German engraver models each insulate aspect in order to know. Picasso, knowing each aspect, wants to have them in simultaneity. He will, if necessary, spend the next fifty years learning how.

The paradigm of the sequential mode is the *Three Graces*—a cool deliberate exposition of anterior and posterior aspects (fig. 67).[7] Endlessly copied in Roman times, the group was enthusiastically revived in the Renaissance and remained a staple of Salon art. One is somewhat

65. Pablo Picasso: *La Lola.* 1905. Drawing. 15″ × 10⅞″. Owned by the artist's estate. Z. XXII (supplement), 189.

66. Master P.M.: *The Women's Bath.* Late fifteenth century. Engraving 7¾″ × 6⅜″.

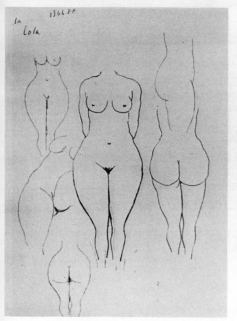

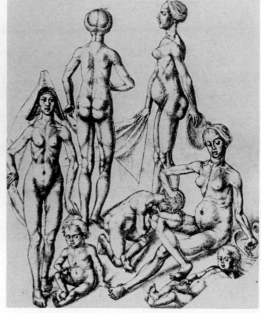

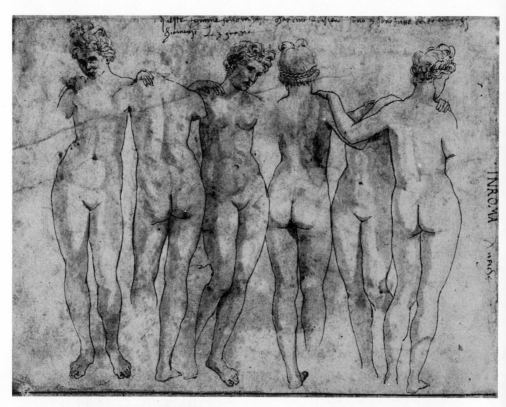

67. Antonio Federighi: *The Three Graces.* c. 1450. Pen drawing. Collection Graphische Sammlung, Munich.

surprised to discover that this Late Hellenistic invention passed into the twentieth century as no other antique has been able to do. The *Three Graces* inspire Gauguin, Matisse, Delaunay, Maillol, Lehmbruck, and Braque. They are constant in Picasso's oeuvre where, from 1905 onward, they reappear in almost every period.[8] It was their two-dimensional about-face routine which allowed the *Three Graces* to survive the flattening of twentieth-century art.

The reflected reverse. A fifteenth-century account of a lost picture by Jan van Eyck describes women bathing, ". . . the reverse of their bodies being visible in a mirror, so that their backs as well as their breasts could be seen."[9]

This is one mode of simultaneity which Picasso disdains. The mirror's dependability in giving back a predictable likeness—though it

delighted great masters from van Eyck to Matisse—leaves him un-moved. In his vast output, literal mirroring is remarkably rare.[10] One lonely *Seated Nude* of 1922 (Z. IV. 454) bestows an off-shoulder glance on her sad mirrored self—but the subject is dropped for ten years. Then, in 1932, two famous paintings emerge during a three-day spell: *The Mirror* of March 12, depicting a sleeper whose lucid posterior is assigned to the looking glass; and, two days later, the *Girl Before a Mirror,* standing face-to-face with her image.[11] These pictures are proof that Picasso does not spurn mirrors as such—only their prosaic fidelity. As in allegories and fairy tales, his mirrors are oracular instruments that tell secrets, or instruments of transformation. The catoptrics are magical. And the reflections revealed—unlike workaday mirror images—strive out of their frames to rejoin their originals.

A mirror resemblance, after all, is always elsewhere. From the viewpoint of the body's integrity, it disassembles; so that we grasp its identity with the thing mirrored not by intuition, but by inferring it from relational clues. A girl's mirror image, whether addorsed or confronted, cannot but widen the gap between her knowable aspects. Object and image, even if carefully hyphened by means of proximity and obvious likeness, repel one another. They do not cohere; they want to diverge like one's own two hands back to back.

Picasso seems to regard this as a fault that requires correction. In a series of drawings dated September 18–19, 1941, he includes a nude seated at a three-quarter-length mirror. And the progress of the series (figs. 68, 69, 70) plots a gradual *rapprochement,* until the woman and her reflection have coalesced, her blended aspects at once simultaneous and indivisible. Compare such pictures as Bedoli's *Portrait of a Girl* (Parma), Velázquez's *Venus* (London), Ingres's *Comtesse d'Ausson-ville* (Frick), or Matisse's numerous paintings and drawings with posed models reflected: the effect is a dispersion of aspects rather than palpable continuity; the form is fielded but not embraced. And though the volume of information is doubled, the loss in sensuality is, for Picasso, the wrong price to pay.

Implied rearward aspect. Delacroix's *Journal* for September 14, 1854, describes hearing Mass in the Church of St. Jacques at Dieppe. After a brief account of the ceremony, which ends with the Kiss of Peace, he concludes: "One could make a beautiful picture of that final moment, taken from behind the altar."[12] Delacroix—like the heir of Baroque art he aspires to be—sees in depth and imagines his physical vision re-

68, 69, 70. Pablo Picasso: *Nudes in an Interior*. September 18, 1941. Ink drawings. 8¼" × 10⅝". Z. XI, 298, 306, 301.

bounding from its own vanishing point, so as to visualize the scene in reverse.

 The pictorial stage of Renaissance and Baroque art makes frequent appeal to a character whose function it is to personify such rebounding vision. You find him in the depths of depicted space, focusing on the rearward aspect of some powerful foreground form of which we are not shown enough. The upstaged observer, a painted figment, becomes our functioning double. He colludes with our own seeing to round out the protagonist form in its fullness.

 In the most moving early examples of such co-opted vision, the watched protagonist is a Christ with his back to us—like Mantegna's *Christ Harrowing Hell;* or H. S. Beham's *Man of Sorrows Appearing to Mary*—an engraving whose dramatic action gathers in one searching gaze aimed at what we cannot see (fig. 71). Baroque masters will stretch such dramatized sight lines to the full depth of the scene. Thus Rembrandt's *Denial of St. Peter* (Amsterdam): Forgathered near the picture plane is the group about the Apostle; as Peter puts off the questioning maid, Christ, recessed in deep space, turns his head looking,

71. H. S. Beham: *Man of Sorrows Appearing to Mary*. 1519. Engraving.

so that Peter's lapse is seen, as it had been foreseen, *de profundis*.

Or else the foreground motif is a canvas under attack—as in Rembrandt's *Painter Before His Easel* (Boston), and in Velázquez's *Las Meninas*. Both pictures rivet attention on the glance of the painter; behind the reverse of the canvas, we see its obverse observed.

And even this pure baroque mode of suggestion Picasso retains. In some pre-Cubist works, and again during the 1930s, he had allowed watchers upstage to function dramatically—though with no intent to promote a stereometric illusion.[13] But just this is unmistakably the effect of the couped head on the horizon in *Girls with a Toy Boat* (1937; fig. 72). The two huge little heroines in the foreground, remarkable for developed feminine charm and wholly preoccupied with their toy, are spied upon from afar. Someone in earnest is eyeing them, an immense rock with a face in it, yet clearly one of their kind and, I think, masculine. Who else looks so avid watching from across the divide? He studies the seaward aspect of what we watch from the shore. The apparent all-sidedness of the foreground figures owes much to their

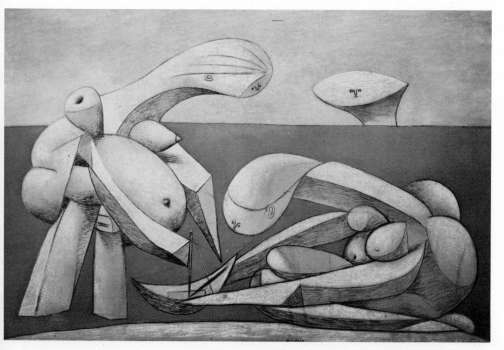

72. Pablo Picasso: *Girls with a Toy Boat*. February 12, 1937. Oil, pastel, crayon on canvas. 50½" × 76¾". Collection Peggy Guggenheim, Venice.

modeled openwork fabric—but almost as much to the inquisitive rover peering from beyond the high sea.[14]

Serpentination. In a note to Vasari acknowledging the gift of a drawing, Aretino (1540) praises a certain nude which, "bending down to the ground, shows both the back and the front."[15] He was describing a frontal figure doubled over like a hairpin, a headlong variant of the Mannerist *figura serpentinata*. Its elastic anatomy, lengthened at most by two or three vertebrae, displays front and back simultaneously, incorporating both views at once on its own jackknifing spine, that is to say, without recourse to repetition, external props, or assisting witnesses. In sixteenth-century pictures, such figures tend to approach at full speed, bending down so precipitously that the back signals before one becomes aware of diminished frontality. Indeed, in the best hairpin figures, the torso swerves aside as it folds over so as to leave as much as possible of the front elevation in view.[16]

Thematically, such figures draw their justification from the narrative context. It wants a catastrophe to discharge both the requisite speed and the conflicting emotions—curiosity conquering fear, solicitude interfering with flight, and so forth. Hence the complex rotation of a figure such as Paolo Farinati's *Andromeda* (fig. 73): fleeing the dragon, she has to maintain equilibrium as she falls in love on the run.

The more common variety of serpentination, which requires no strenuous pretext, is the reclining or standing figure revolving on its main axis. Its motivation is sensual; it suggests well-being, self-admiration, or erotic enticement. You would not believe the amount of enticing frontage a Mannerist backview can show; Jan van Hemessen's *Judith,* for instance (fig. 74)—and Picassos galore (figs. 75, 76). The understanding of this motif in our culture is immediate and universal. Pinup models posing for calendar art tend to work up a *figura serpentinata;* and their photographer, if he has a sense of his craft, knows just how much expository rotation is needed to meet the terms of an "eyeful."

Picasso's draftsmanship, always ready to wring female figures to ensure that all breasts and buttocks show, impounds every known form of

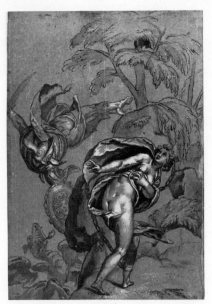

73. Paolo Farinati: *Perseus and Andromeda.* Drawing. 16″ × 11½″. Collection of Her Majesty the Queen, Windsor Castle.

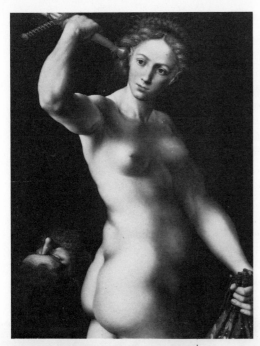

74. Jan van Hemessen:
Judith. c. 1560. Oil on panel.
39¼" × 30⁷⁄₁₆". Courtesy
The Art Institute of Chicago,
The Wirt D. Walker Fund.

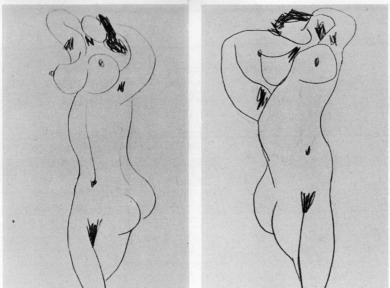

75, 76. Pablo Picasso: Studies of a nude. 1939–1940. Pencil drawings. 6⅛" × 4".
Z. X, 234 and 235.

serpentination from the stores of the past.[17] The *Bathers* (Fogg), a drawing of 1918 famous for its classical reminiscences, exhibits both Mannerist types—one woman atwist on a spiral waist, and a jackknife figure capping the composition. Sometimes the source is mocked, as in the aquatint entitled *La Puce* (Bloch 359). Dated 1942, it was produced for the Vollard edition of Buffon's *Natural History* to illustrate "The Flea." For reasons unstated but not far to seek, the etching was excluded from the published edition. It is of course based on the Late Hellenistic *Aphrodite Callipyge*—the "Venus of the handsome behind" who turns about to acknowledge her other aspect (fig. 77). I know that Picasso's conception seems trifling; but the frivolous virtuosity of his adaptation is that of a passionate, possessive eye. Since the statue's pose, seen from the normal front view, amounts to a promise—the promise, that is, of its implied rearward aspect—Picasso synchronizes promise and actuality by flipping half of the torso around, and makes it work without seeming discontinuity.

77. Pablo Picasso: *La Puce* (center). 1942. Aquatint. 14⅜″ × 11¼″. *Aphrodite Callipyge*. Late Hellenistic. National Museum, Naples.

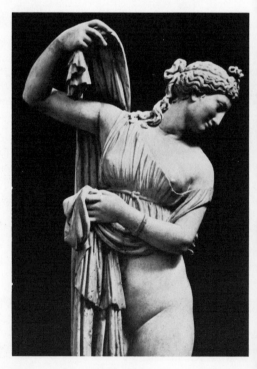

Frivolous subject matter is no serious deterrent to work. Picasso made a beautiful line drawing on December 6, 1953, a drawing which visualizes an imposing measure of three-dimensionality—in spatial depth as well as volumetric displacement (fig. 78). The subject is a roundelay of six frisky nudes holding hands. It is a bravura performance, like a Chinese brush painting; thinking and ceaseless practice precede, and no fumbling thereafter. The success is especially remarkable at the two ends, where the projecting of a round dance poses its greatest challenge: how to sustain the continuity of the circular motion through the foreshortened depths of the turns. Picasso meets the challenge with two brilliant solutions. At the left the dancers are stacked three deep, showing—like his many Three Graces—front, side, and back in succession; at the right one frolicking nude alone incorporates all phases in one. I suggest tilting the drawing ninety degrees to appreciate the cunning of her serpentination. But serpentination here is mere pretense. Such gyrations as hers, or as those of the girl with the flea,

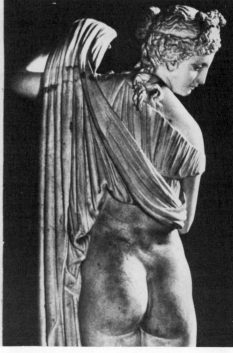

78. Pablo Picasso: *La Ronde*. December 6, 1953. Ink drawing. 17½″ × 19⅞″.
Z. XVI, 32.

presuppose a disjunctive maneuver far beyond anatomical elasticity.
And this antecedent disjunction, followed by impulsive reconstitution,
situates Picasso's dancer outside the limits of Mannerism in a universe of
his own.

For most of Picasso's twisting anatomies serpentination is in fact a
misnomer. It suggests that the action is athletically self-induced and
thus, in principle, traceable from the model. Whereas the model's seem-
ing turns and versations are largely induced by Picasso's unique ap-
proach to the nature of contour. Picasso's line tends to snare a hidden
dimension—at certain strategic moments it becomes a horizon, at every
point of which the mind can sight into depth and zoom in. He draws like
the style on a kymograph. While his stylus pretends to pan along the

outline of a cylinder, his imagination makes that cylinder turn like a drum or spit, so that a longitudinal contour ends up recording an implied transverse motion. And the agility of Picasso's gyrating limbs resembles that drum rotation; it is part gesture, but in complicity with his own zooming eye. When he traces the innocent flank of a body, he seems not to be thinking a margin but a continuous hither and thither. A meander of three-dimensional reference collapses into a one-dimensional line.

Is it not astonishing that the figure in the *Nude Girl Asleep* (fig. 79) can register as a front view even though no less than one third of her back shows at the top, and another third at the bottom? The power behind the conception (and the laborious fieldwork preserved in the studies[18]) is belied by the winsomeness of the subject. Yet the verve of the body and its internal strain disguised as sweet rest are of a Michelangelesque quality of imagination. And a half century of Picasso's art underlies that upper contour which rides in such smooth ambiguity from nape to hip.

79. Pablo Picasso: *Nude Girl Asleep*. February 28, 1954. Pencil drawing. 9½″ × 12⅝″. Z. XVI, 249.

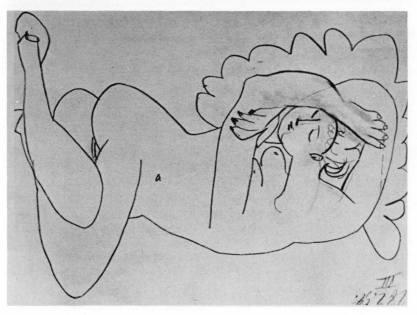

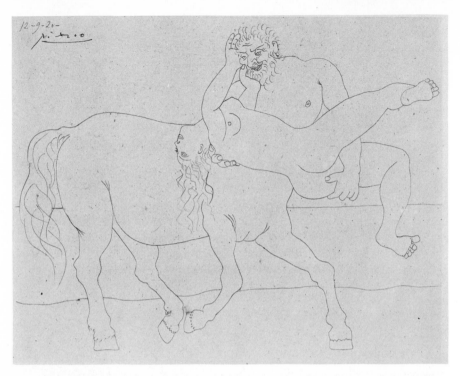

80. Pablo Picasso: *Nessus and Dejaneira*. 1920. Pencil drawing. 8¼″ × 10¼″. The Museum of Modern Art, New York, acquired through the Lillie P. Bliss Bequest.

The principle was well in hand by 1920. Already then a bland contour that seemed only to sail at the edge of a volume could engender that volume as a revolving form. In the *Nessus and Dejaneira* drawing (fig. 80) the linear trace of the bride's torso from left breast to right groin is rendered as if on a turning shaft. It moves on a surface itself moving in depth, and the rotation enclosed by the contour can no longer be rationalized as a posture of serpentination. The writhing of a nymph in distress merely helps to trap the roll of foreshortened planes in the economy of a line.

But Picasso's impulse to possess the delineated form in a simultaneity of multiple aspects runs even deeper within his past. Its earliest monumental expression takes us back to the pre-Cubist moment. A new bid for symbolic solidity is made in the large 1908 *Bather* (fig. 81)—a standing nude on which some of Picasso's most famous distortions appear for the first time. Carefully synthesized and conscientiously

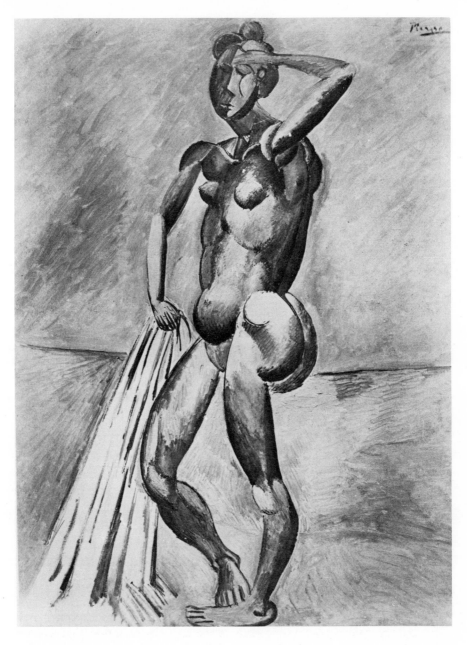

81. Pablo Picasso: *The Bather*. 1908. Oil on canvas. 51⅛″ × 38¼″. Private collection. Z. II, 111.

transferred from its preparatory drawing (Z. 11, 110), the painted figure shows both pubis and rump, and a good deal more backbone than a frontal perspective allows. The splay-out principle by which Cézanne had bonded inanimate objects into the painted field is applied to the female anatomy, but with a contrary purpose: to confirm a known fullness of body by wrenching its averted sides into view.

Unlike the four modes of simultaneity that imply a fixed point of vantage, the implication of Picasso's *Bather* is that of a vision cut loose. Here emerge those effects which encourage talk of circumspicuous or circumambient sight, of visual rays bent around corners, etc. The early literature of Cubism gave currency to the notion that the new painters designed a figure as though they had toured it to collect impressions of its various aspects. "They move round the object, in order to give . . . a concrete representation of it, made up of several successive aspects," wrote Metzinger in 1911.[19] Such descriptions are overly rationalistic; who has not had the experience—especially with the Cubism of Picasso —of seeing the work confound its interpreters? The liberties Picasso takes in the *Bather*'s figure by transgressing its contours seem superficially simple, but every explanation is doomed if it fails to locate itself in a constellation of possibilities. In the *Bather,* for instance, the excess visibility at spine and buttocks may record the artist's bent vision; it may equally well stand for the object itself revolving, as though the Bather's torso had ceded its boundaries to the directions of motion. The thought of the body turned, or of the body signaling its capability for such turning, is as inviting an explanation as the restlessness of an ambulant viewer. And then again, is not touch involved—the pencil as delegate of the groping hand? And beyond these poetics lies a simpler hypothesis: that we are dealing with a conflation of representational modes; that the use of separate vantage points trained upon the body at rest is but a graphic device for maximum density of information—disturbing only because it amalgamates the traditional painterly mode with the diagrammatic. None of these interpretations can be ruled out; ambiguous simultaneity is part of Picasso's essential approach to the rendering of the external world.

In the *Bather,* where the overspill from the optical silhouette makes its first dramatic appearance, we are given a further clue in the figure's physical action, and in the impacted solidity which that action achieves. The far side of the Bather's face, her pronated right arm and her twisted right leg—not obviously pigeon-toed but in-turned—all these together promote one massive implosion; the whole of the body's right side

grinds inward upon the fixed left. Once again, the appearance of aspects interlocking and fused is generated by the figure's gestural energy co-operant with the artist's eye.

It is essential to Picasso's multiaspected imagery that the object he draws meet his circumspection halfway. His marvelous evocation of gesture feeds a devouring vision. The subjects cooperate, as when, thirty-three years after the *Bather,* a cross-legged nude with crossed breasts sits up with both buttocks showing and both knees to the fore (fig. 82); the very action of left and right thighs intercrossing, the sheer impetus of their involution, shakes up and shuffles the elements of frontality, causing further overlaps of antipodal aspects. The image is a weird junction of wills—the depicted action abetting the grasp of an encompassing vision and compounding the visualization of corporeality.

82. Pablo Picasso:
Seated Nude. 1941.
Drawing. Z. XI, 332.

It is here, I believe, in the emphatic substantiation of bodies, that Picasso's lifelong explorations of simultaneous front-and-side, fore-and-aft, in-and-out, etc., depart from—and far transcend—the original intentions of Cubism. Yet the phrase "Cubist simultaneity of point of view" has been with us so long that it was taken to cover whatever else in that line there was to invent. The phrase, and the engaging concept behind it, substituted for looking. If Cubism had done it all in the teens of the century, why fuss about Picasso still doing it forty years later? But the truth is that Cubism had not done it at all—except in bestowing the license for what remained to be done. Cubism had been a transformation of remembered solids into a system of discontinuous notations and fragments. The world it inherited was the world's theatre spaced out with objects, and its effect on the imaging of these objects was to unsolder their structure and scatter their parts. Whereas in Picasso's subsequent work, the two-dimensional Cubist field, with its staccato of abbreviated or dismembered particles, was taken for granted. Its creator had been at home in it for a generation. And the task he now set himself was to recover the stereometry of the body without regressing to pre-Cubist illusionism, to restore sensuous presence to things conceived and maintained in the flatlands of post-Cubist space. Simultaneity of aspects aiming at consolidation became the efficient principle of a new constructivism.

For this enterprise—in which Picasso was to find himself increasingly isolated—Cubism furnished some of the tools, but no more; its own so-called simultaneities are of a different order. Their function is always disjunctive; a bottle in elevation separates from its support by posing against a tabletop shown in plan; the elliptical brim of a pipe bowl floats free to be cocked as a circle; here and there glimpses appear of a sidelong facet splintering off a dice cube or human head. The purpose is not the embodiment of solid structures but, on the contrary, their dismemberment for insertion in an occasional semantic space of uncertain depth.

Within the Cubist style, the very ideas of aspect-simultaneity and corporeality are antagonistic; they disfranchise each other. The crystalline structures of the first Cubist phase (1908–1910) retain a good deal of residual density, but they reveal little interest in simultaneous point of view. (Picasso's *Ambroise Vollard* is as frontal as a portrait by Raphael.) And by the time that interest develops in Cubism's later phases, the signs standing for objects are drained of mass, leaving whatever had once been incorporated dispersed.

Picasso's late work, beginning around World War II, picked up the loosened facets yielded by the atomizing forces of Cubism; what he did with them was something new. From 1940 onward his faces and nudes look for firmness of structure. So do his animals, from bulls to birds; likewise his chairs and tables. But their solidity hardly relies on such tried devices as perspective and chiaroscuro. It depends rather on the close weave of disparate aspects—partial views summoned from different compass points and their interpenetrating convergence once again symbolizing three-dimensional form (fig. 83).

The female body, for instance. Continually rearranged like a hand of cards in a space without depth, it remains locked within contours that define a coherent self. The body's familiar landmarks, its conceptual commonplaces, serve as exponents of vagrant aspects. A right profile settles upon a left side. A cloven curve, fetched from behind, buttocks a frontal view. A dotted bosom becomes the prefix to any aspect soever, so that a forward figure bent over sprouts breasts at the shoulder blades.

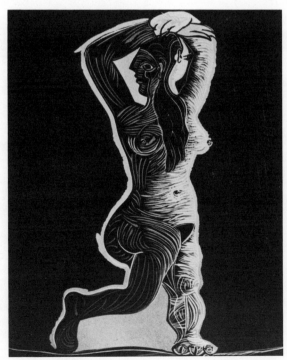

83. Pablo Picasso:
Grand Nu de Femme. 1962.
Linoleum cut. 25¼″ × 21″.
Bloch 1085.

A *Sleeping Nude,* prone on her stomach, shows her top sunnyside up and her face facing both ways, like the cover of a book dropped and splayed out on the floor (fig. 84). Yet the body coheres; we see neither Cubist dismemberment nor schematic disjunction. The figures work, and Picasso's draftsmanship makes their irrational translocations seem genuinely informative. As the scrambling of aspects continues, always centripetal, always generating coherence, one looks and keeps looking, marveling how these impossible contradictions become necessities, until you wonder how we ever put up with the poor showing of one-sided representation.

Could a cartographer do it? Could he make the world's other side present to the imagination by entering Pacific islands on the Atlantic? Picasso's feat was to have fashioned a syntax of elastic pseudoanatomi-

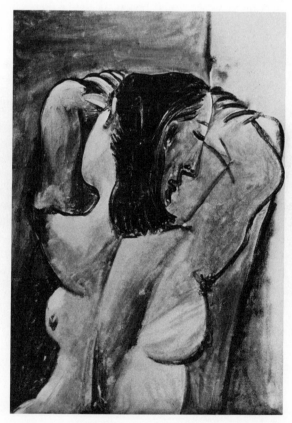

84. Pablo Picasso:
Sleeping Nude. 1941.
Oil on canvas. 36¼" × 25⅝".
Z. XI, 198.

cal intervals, an invented grammar within which such transpositions do not simply register as jokes or mistakes. The displacements themselves are not hard to make; making them work, making them human, required the better part of Picasso's life.[20]

Meanwhile, however, the settled notion that Cubism was a release from visual fixity, intended to represent objects from all sides at once, blinded us to the goals and inventions of Picasso's post-Cubist years. Wherever in the 1930s, or 40s, or 50s, Picasso achieved an unprecedented realization of simultaneity, the effect was duly noted as a "characteristic Cubist device," implying that the old genius was living comfortably off his early investment.

Surveying Picasso's lifelong commitment to the theme of woman as partner embraced, to the larger theme of embracing vision, and to the ultimate mystery of an embrace gifted with a sight, one arrives at a disturbing conclusion. That the inventor of Cubism has had to cope in himself with the most uncompromising three-dimensional imagination that ever possessed a great painter; and that he flattened the language of painting in the years just before World War I because the traditional means of three-dimensional rendering inherited from the past were for him too one-sided, too lamely content with the limited aspect—in other words, not 3-D enough.

NOTES

1. Cf. the drawing of 1933 in The Art Institute of Chicago, reproduced in Christian Zervos, *Picasso: Oeuvre Catalogue* (Paris, 1932 ff), VIII, 112 (hereafter cited as Z. followed by volume and figure number). Cf. also the impressive series of etchings of the same year (Georges Bloch, *Pablo Picasso: Catalogue de l'oeuvre gravé et lithographié,* I [Berne, 1968], nos. 28–31; and Bernhard Geiser, *Picasso: Peintre-Graveur* [Berne, 1955], nos. 339, 372). The drypoint *Embrace* here reproduced is Bloch 31.

2. The violence of these "embraces" has misled some to regard them as scenes of rape. But one must look at these women's hands, which never claw or repel; and at their faces, which never show signs of fear, pain, or revulsion. In fact, the action is never a rapist-victim, subject-object relation. So strong is the projection of bilateral sexual fulfillment, that the image may as well represent the woman's fantasy of transverberation.

3. The secret is aired in several etchings of the "347" series, such as the plate dated September 8, 1968/II, which equates the act of painting with coitus. The painter—apparently Raphael—seems to have strayed into Picasso's iconography

by way of Ingres's *Raphael and His Mistress.* (See L. Steinberg, "A Working Equation," *The Print Collector's Newsletter,* November–December 1972, pp. 102 ff. Ingres's painting, formerly in the museum at Riga, Latvia, exists in other versions at the Fogg, Cambridge, and at the Gallery of Fine Arts, Columbus, Ohio.)

4. Later graphic folk art popularized the moral antithesis of front and back in the image of *Frau Welt*—personified worldliness: a fine woman's face to the fore and a Death's Head behind. Broadsheets of the sixteenth and seventeenth centuries symbolize front/back antinomy by bisecting the figure along a central divide: the elegant right half depicting the wordly state, the other, the bare bones of death, understood as lurking behind. The visual analogue is with Janus and Annus, personifications of the new year, both of whom are commonly represented with a face fore and aft, as is the figure of Prudence. Common, too, in the late Renaissance is the figure of two-faced Fraud, whose hidden hag's visage belies the young face in front.

We may add that, according to an ancient Hebrew myth, Adam was originally created androgynous, with a male face before and a female face *rere-regardant.* But God "changed His mind, removed Adam's backward-looking face, and built a woman's body from it." See Robert Graves and Ralph Patai, *Hebrew Myths* (New York, 1966), p. 66.

5. The full text of Titian's letter is given in Stefano Ticozzi, *Vite dei pittori: Vecellj di Cadore* (Milan, 1812), p. 512.

6. See Giorgio Vasari, *The Lives of the Painters . . . ,* ed. G. Milanesi (Florence, 1906), I, p. 101, and IV, p. 98.

7. I reproduce the Siena version as drawn by Antonio Federighi (c. 1420–1490). The drawing is inscribed in the artist's hand: "These women are in the house of the Cardinal of Siena; they are three, I copied them from the front and from the back. They are called the *Three Graces.*"

8. Cf. the *Three Dutch Women* (1905), Musée de l'Art Moderne, Paris.

9. Bartolommeo Fazio (Facius) in *De viris illustribus* (1456), discussing Joannes Gallicus (Jan van Eyck). The lost painting was in the possession of Cardinal Octavianus. For the full text and the Latin original, see L. Baldass, *Jan van Eyck* (London, 1952), p. 84 and note 1.

10. A number of drawings made on February 5, 1935 (Z. VIII, 248, 250, 252) depict a metamorphic nude sketching before a mirror to portray herself from her realistic reflection; the reflection is evidently something else.

11. Gustav Stern Foundation, New York, and The Museum of Modern Art, New York.

12. "On ferait un joli tableau de ce dernier moment, pris de derrière l'autel" (Delacroix, *Journal,* ed. Yves Hucher [Paris, 1963], p. 203).

13. Watchers upstage appear in the *Salomé* drypoint, and in *La Coiffure,* The Metropolitan Museum of Art, New York (both 1905); then again in the *Mino-tauromachy* etching, Bloch 111, and in the *Blind Minotaur,* aquatint, Bloch 97. More interesting in the present context is the *Drawing Lesson* (1926): a boy drafts-man peering from behind the distal side of a table tries his hand at a still life—three apples laid out in front. Notwithstanding the general Cubist idiom, the ro-tundity of the fruit—the very problem of three-dimensional rendering—is symbolized in the convergence of glances, ours and his.

14. Picasso's great *Seated Bather* (1929) has been cited for the similarity of

its openwork structure. But the comparison also reveals how much more spatial recession Picasso demands in 1937, and how his distanced voyeur contributes to the volumetric effect.

15. See the *Lettere sull'Arte di Pietro Aretino,* ed. Ettore Camesasca (Milan, 1957–1960), no. CVII, p. 175.

16. Outstanding examples of hairpin or jackknifing figures in Renaissance art are found in Michelangelo's *Brazen Serpent* spandrel on the Sistine Ceiling, and in Tanzio da Varallo's *Defeat of Sennacherib,* Novarra, Museum. The type is anticipated in the Christ figure of Butinone's *Descent from the Cross,* Chicago, Art Institute (33.1004). Cf. also Rosso's early drawing, *Christ on the Cross,* Haarlem, Tyler Museum. For a type intermediary between jackknifing and spiraling serpentination, but still designed to display front and back at the same time, cf. Rosso's *Moses and the Daughters of Jethro,* Uffizi, and Mabuse's woodcut, *Hercules and Dejaneira,* reprod. in H. Pauwels, *et al., Jan Gossaert genaamd Mabuse,* exhibition catalogue, Rotterdam, 1965, cat. 73.

17. An almost pure Mannerist figure, represented as part of a sculptural group, occurs in Picasso's etching of March 30, 1933, from the Suite Vollard, *Sculptor, Reclining Model and Sculpture of Horse and Youth* (B. 55). More personal explorations of the jackknifing type occur in Picasso's numerous drawings, from 1938 to 1944, of women bending over to wash their feet. (E.g., Z. IX, 200, 322, 331, 338, 382, 383; also Z. XIII, 291.) These doubled figures are complementary to the back-bends developed around the studies for the *Crucifixion* (1930). The Magdalen's stricken body is given as the jackknife reversed, with no body landmarks left out of sight.

18. Cf. Z. XVI, 249 ff.

19. See Edward F. Fry, *Cubism* (New York, 1966), p. 66.

20. Imitating Picasso's distortions, photographers have repeatedly tried to create images "in the round" by splicing disparate aspects together, or by keeping the shutter open while the model or the camera moved. It seems to me that these attempts fail because the photographer is unable to impose necessity and rightness of shape on the intervals between displaced features.

Introduction to De Stijl*

HANS L. C. JAFFÉ

The De Stijl movement is the major Dutch contribution to modern art. The group took its name "the style" from their magazine, founded in Holland in 1917 by Theo van Doesburg in close association with Piet Mondrian, Bart van der Leck, and other painters, poets, and architects. Their creed was total abstraction; their art, a paradigm for universal harmony. De Stijl had a profound impact upon the arts, and architecture is perhaps its most conspicuous achievement. (See Reyner Banham, *Theory and Design in the First Machine Age,* New York: Praeger Publishers, 1960.)

Jaffé made his first comprehensive study of the history and character of the movement in *De Stijl, 1917–1931* (Amsterdam: Meulenhoff International, 1956). In this essay he summarizes the character of De Stijl, tracing its growth and defining the cultural climate that shaped the group's consciousness.

Hans Jaffé is Professor of Modern Art at the University of Amsterdam.

* Reprinted from *De Stijl* (New York: Harry Abrams, n.d.).

The De Stijl movement is characterized from its very beginnings, in the summer of 1917, by a close relationship between its members' artistic works and their writings; practical creative work and theoretical examination of the results go hand in hand. It is thus also typical of the foundation and development of De Stijl that the artists—painters, sculptors, architects, and writers—made their collective bow in 1917 with the first issue of a new journal, *De Stijl,* edited by Theo van Doesburg.

Van Doesburg, founder and guiding spirit of the De Stijl group, continued to edit the journal until his early death in 1931. With this modest publication, financed for the most part from his own pocket, he created a platform for the voices of boldness and progress, for the avantgarde in the fullest and best sense of the phrase. He had realized early on that in the cultural situation of the early twentieth century works of pure art needed to be accompanied by a theoretical exposition, even, often, by an apologia—that the artist had to explain and defend his revolutionary innovations. His own alert, lively mind always responded to this need with great enthusiasm, but Van Doesburg went beyond this in that he persuaded the friends whom he had gathered during 1917 to collaborate in the artistic program of De Stijl to express their theories in words and to publish their views on the implications of their work in *De Stijl.* In the first number of the journal the contributions are preceded by an introduction in which Van Doesburg formulates very clearly the editorial line on the relationship between artistic work and theory.

> This periodical hopes to make a contribution to the development of a new awareness of beauty. It wishes to make modern man receptive to what is new in the visual arts.

The journal was thus to provide the theoretical accompaniment to the practical artistic achievements of the members of the group—a contribution that Van Doesburg held to be of the greatest importance and influence. He considered exposition of this kind to be the duty of the truly modern artist, who was not just an "artisan," a craftsman, but resembled the research scientist in his intellectual activities. Once again the introduction to the first number of the journal expressed his views clearly:

> The Editors will try to achieve the aim described above by providing a mouthpiece for the truly modern artist, who has a contribution to make to the reshaping of the aesthetic concept and the awareness of the visual arts. Since the public is not yet able to appreciate the beauty in the new plasticism, it is the task of the

professional to awaken the layman's sense of beauty. The truly modern—*i.e.*, conscious—artist has a double vocation; in the first place, to produce the purely plastic work of art, in the second place to prepare the public's mind for this purely plastic art. To serve this end, a periodical of an intimate character has become necessary. The more so, since public criticism has been unable to make good the lack of appreciation for abstract works of art. The Editors will make it possible for professionals to fulfil this latter task themselves.

In so doing, this periodical will create a more intimate contact between artists and the public, between the practitioners of the different visual arts. By the mere fact that the modern artist is enabled to write about his own work, the prejudice that the modern artist works according to preconceived theories will disappear. On the contrary, it will appear that the new work of art does not derive from theories accepted *a priori,* but rather the reverse, that the principles arise out of creative activity.

With these clear, concise sentences Van Doesburg expounded the relationship of theory to practice in the De Stijl movement and defined the journal's position in the group's work. The reader had to be alive to the duty imposed on him by the journal: to be fully conscious of the feelings, impressions, and sensations he experienced while looking at works of art. In spite of that, the articles in the journal are of secondary importance, the harmonic accompaniment to the creative thematic material of De Stijl.

With the artistic work of the De Stijl group, as with their writings, it is possible to speak of a collective oeuvre. As in the early Cubist works, there is hardly any perceptible difference, in the early stages of De Stijl, between the works of the principal artists: pictures by Mondrian, Van Doesburg, and Van der Leck painted in 1917 resemble each other almost as much as works by Picasso and Braque in 1909 or 1912. In both cases a common attitude of mind exists both to the world in general and to art, and this attitude finds its visual expression in the work of the De Stijl artists and then, almost immediately, its definition in the pages of *De Stijl.*

What was this common ground from which sprang both the artistic works and the writings of the De Stijl group? What was the common factor that united such different personalities as the painters Mondrian, Van de Leck, Huszár, the sculptor Vantongerloo, the architects Oud, Van 't Hoff, and Wils, under the leadership of Theo van Doesburg, in a group that was joined over the years by such artists as Domela, Vordemberge, and Lissitzky, the architects Rietveld, Van Eesteren, and

Kiesler, poets like Hans Arp and Hugo Ball, as well as such disparate figures as Gino Severini, Constantin Brancusi, Georges Antheil, Anthony Kok, and Werner Graeff? De Stijl's creed, with regard to practical creativity, can be summarized in a few words: first and foremost, total abstraction, i.e., the complete rejection of literal reality as it appears to the five senses; following from this principle, a severe restriction of creative terms to the basic minimum: the straight line, the right angle —in other words, the horizontal and the vertical—and to the three primary colors, red, yellow, and blue, and the three equally primary noncolors, black, gray, and white.

This is the arsenal of means of expression with which the De Stijl group created a new kind of visual art: *de nieuwe beelding, die neue Gestaltung,* Neoplasticism, one of the decisive, revolutionary movements in the visual arts, a movement, moreover, that soon spread beyond the borders of Holland throughout the whole of Europe, and has exerted an influence upon the creative art of the world today that can hardly be overestimated. This influence cannot be explained only by the discipline, the rigorous restraint, and the technical mastery of the group; the secret of De Stijl's influence lies in the fundamental principle of its philosophy, in the concept of harmony and the suppression of individualism.

But before we discuss the intellectual background and philosophical roots of De Stijl, a few short notes on the formation of this revolutionary movement are called for. There can be no doubt of the time and place of its formation: the group and the journal were founded in the late summer of 1917 in Leiden, where Theo van Doesburg was living at the time. Van Doesburg, who had long nursed plans for an association of progressive artists in Holland, was the real founder, and in 1917 had already won over three other painters to his ideas: Piet Mondrian, Bart van der Leck, and Vilmos Huszár. Each of the four had his own contribution to make to a new revolution in style, but only when the four joined forces did a chemical reaction, as it were, produce a new movement in painting, the art of De Stijl.

Piet Mondrian was the oldest and most mature of the four. Born in Amersfoort in 1872, he was already forty-five in 1917; he had made something of a name for himself by the end of the nineteenth century as a landscape painter in the style of the Hague school, a rather provincial style derived from the school of Barbizon. His early works are typical of a young artist in the process of developing his talents, but give no

indication of the revolutionary genius that was to evolve later. Mondrian himself, however, saw his development as an artist laid out in front of him like a long, straight path, which was to lead him, in his own words, "ever forward" to a progressively clearer and more definite artistic expression of reality. His early subjects, mostly trees and windmills (1909; fig. 85), show an increasingly strict tautness and simplification in their treatment, the shapes are arranged on one plane in great complexes, emphasized by the way the color is used. Around 1907 came a phase when Mondrian fell under the influence of the Fauvists and the Dutch Luminists: his coloring at this period, partly due also to the use of an almost pointillist technique, became purer and simpler. By 1910 Mondrian's interests were veering once more toward form: in his desire to ally himself with the Cubists he took, in 1911, the important step of

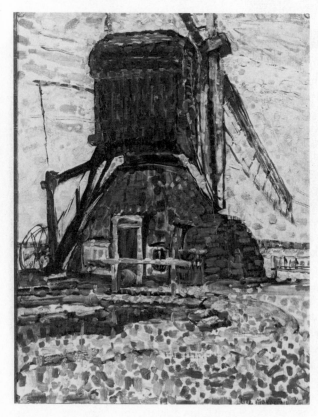

85. Piet Mondrian:
Windmill. 1909. Oil on canvas.
17¼″ × 13½″. Courtesy
Sidney Janis Gallery, New York.
Collection
Mr. and Mrs. James H. Clark.

moving from Holland to Paris. The strong urge toward simplification and intensification at this period is plain in the various series of pictures on the same subjects: the series of trees (1912; fig. 86), the two versions of *Still-Life with Ginger Jar,* the series of sand dunes, the church facades, and the lighthouses, in which Mondrian's path moves in an obvious progression from the reproduction of literal reality to the discovery of compositional values. In the course of this process of artistic transition the objects gradually lose their identity and their plastic independence, and become parts of the compositional unity of the picture.

During his stay in Paris, from 1911 to 1914, Mondrian's path continued steadily in this direction; his Cubist pictures became even more taut and severe, since as far as possible he straightened out curves,

86. Piet Mondrian: *Apple Tree in Bloom.* 1912. Oil on canvas. 30½″ × 42″. Courtesy Sidney Janis Gallery, New York.

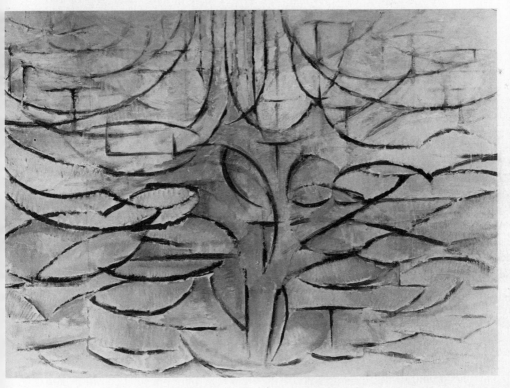

eliminated diagonal lines, and above all, composed the rhythm of his pictures from a structure of straight lines and right angles. In the works of these years he took Cubism further than the original Cubists: he went beyond the bounds of Cubism and came very near to abstraction.

This style, still essentially Cubist, reached its climax in the following period. In 1914 Mondrian had to leave Paris to go to his father's sickbed in Holland, where he was forced to remain for the next four years by the outbreak of World War I and the German invasion of Belgium. During these four years he took up once more the theme of the sea, and the pier at Scheveningen became the subject of a series of pictures: that is, the rhythm of the waves breaking on the perpendicular structure thrusting out into the sea was the point of departure for his studies and paintings. The pictures in this cycle date mostly from between 1915 and 1917 (see fig. 87); as time passes, they move further away from the starting point, and, finally, in the great picture of 1917, the subject of the pier and the sea is only a faint memory in the compositional rhythm.

This shows plainly enough the stage Mondrian had reached in 1917, and the contribution he had to make to a new style. His works from the beginning of 1917 are characterized by two typically Cubist traits: the subordinate role of color—the pictures in the pier and ocean series are almost monochrome, the subject not being one that inspires a lavish use of color—and the centripetal scheme of composition, drawing the compositional forces toward the two centers of an oval. Mondrian's contribution to the new collective oeuvre of De Stijl thus consisted of a well-advanced, if not quite completed, movement toward abstraction, and in a logical development of Cubist compositional principles that went further than anything to be found in the work of any of the Cubists themselves at that time.

Very soon after, in the second half of 1917, Mondrian's pictures in the new style began to appear, the first of a long series of pictures with variously shaped rectangles on a white background. This is the first stage of the new development; in the second stage Mondrian turned again to the short fragmentary lines that composed his Cubist pictures and combined them with the colored rectangles. Finally the very short, independent, fragmentary lines became continuous lines, on the one hand enclosing the colored shapes, on the other linking the colored shapes and the white background, weaving them into a solid, expanding plane. These purely two-dimensional compositions form the starting point for Mondrian's Neoplasticism, which he developed logically and

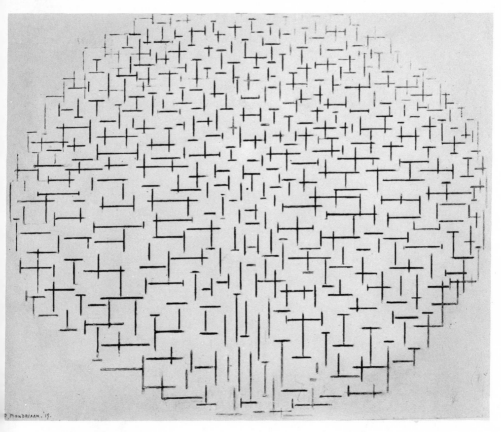

87. Piet Mondrian: *Composition No. 10.* 1915. Oil on canvas. 33½″ × 42½″.
Photograph courtesy Sidney Janis Gallery, New York. Collection Rijksmuseum,
Kröller-Müller, Otterlo.

patiently after his return to Paris; over the years he painted a fascinating
series of masterpieces, each one evolving as a direct consequence of the
one before it. These works of Mondrian's, painted after the decisive
event of the founding of De Stijl, are characterized by color and centrif-
ugal composition—two attributes in direct opposition to his earlier
works. The picture no longer contracts toward its focal points to make
an oval, but spreads outward, the rhythm spills over the edges of the
painting, and while the interplay of the colored shapes is cut by the
frame, it is by no means brought to a halt. Thus what happened in the
middle of 1917—the formation of a freely associated group dedicated to

a new style—is reflected in Mondrian's work; although his development can be seen as one inevitable process, the foundation of De Stijl forms the watershed in his work (fig. 88).

Besides Mondrian, Bart van der Leck, born in 1876 and so four years his junior, made an essential contribution to the foundation of the new art. His early work belongs to the same category as Mondrian's first pictures—landscapes in the style of the Hague school—but later Van der Leck went his own way. Instead of experimenting with Fauvism and Cubism he joined the group of Dutch Monumentalists, whose aim was to achieve in the mural the superpersonal style of the past. In the pictures Van der Leck painted between 1908 and 1912 he developed a characteristic style of simplification and stylization; illustrating books helped him to limit his expressive terms more strictly. He brought this style to perfection around 1912; the background of his pictures assumes the flat severity of a wall; every suggestion of three-dimensional perspective has disappeared; figures appear in profile or full face as sharply delineated silhouettes. *The Tempest* (1916) represents the climax of this style: against a wall-like, white background, large firmly outlined plane shapes in primary colors confront each other in vivid opposition. Van der Leck's contribution to the new art lies in this method of composition with large, geometrically defined planes in primary colors, still representational, but already completely two-dimensional.

Then in 1917 Van der Leck began to produce pictures that are remarkably similar to those that Mondrian was painting at the same time; colored rectangles and fragmentary lines are distributed on a white background and the compositional principle is similar to the rhythm of Mondrian's works, the picture being dominated by a sense of outward movement. These works appear to be fully abstract, and only a careful comparison shows how they have developed from earlier compositions with figures. Van der Leck and Mondrian created a new compositional principle simultaneously and the "family likeness" of their works is often reminiscent of the similarity between pictures by Braque and Picasso in the early years of Cubism. Mondrian himself declared in an autobiographical essay in later years that he first saw this new principle of abstract composition in the work of Van der Leck. Mondrian remained true to this principle and to abstraction throughout the rest of his life, while Van der Leck went back to using the same expressive terms in the rendering of figurative subjects. By doing so, beginning with his *Rider* (1918), he opened a rift between his views and the collective ideas of De Stijl. Nevertheless, in his general attitude he was faithful to

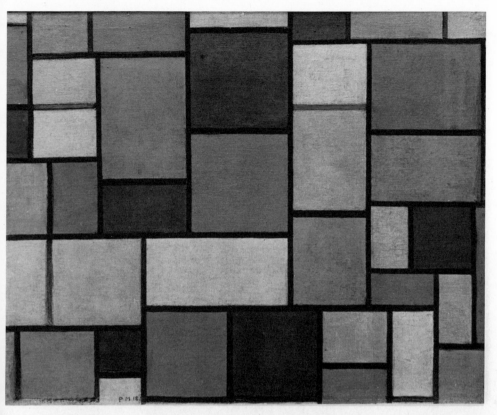

88. Piet Mondrian: *Composition*. 1918. Oil on canvas. 19⅜″ × 23⅞″. Photograph courtesy Sidney Janis Gallery, New York. Collection Max Bill.

the spirit of De Stijl: he raised the expressive medium of painting to a level above the merely personal, thus accomplishing the most fundamental aim of De Stijl. Moreover, his attempts in later years to create space by the strength of color added a new dimension to De Stijl's plasticism.

Theo van Doesburg, born in 1883, was much younger than his friends, the two painters, but he began to paint not long after they did. He too went through a phase of Fauvism and early expressionism, and consequently the painting of Kandinsky and his book *On the Spiritual in Art* had a formative influence on his artistic personality. At the outbreak of war his career was interrupted by military service; only in 1916 was he able to resume his place in the world of art, to which he brought,

besides a thorough grounding in theory, a strongly developed feeling for composition that he had learned from the work of Cézanne. For Van Doesburg, too, 1917 was a year of decisive changes, in which he painted pictures particularly close in their compositional principles—both in color and in rhythm—to the works of Mondrian and Van der Leck; Van Doesburg, too, contributed to the almost anonymous, collective oeuvre of De Stijl at that time, an identity that was mainly possible because the dynamism, which eight years later was to cause his break with Mondrian, did not yet dominate his painting. Van Doesburg, the guiding spirit of De Stijl, did not, as a painter, claim a place of distinction among his comrades; it was in working with them and beside them that he made his contribution to the foundation of the new style (fig. 89).

The fourth and youngest of the painters who together evolved the new painting of De Stijl was Vilmos Huszár, born in 1884. His contribution is equally worthy of attention, for he had been looking since 1914, in paintings on glass and in graphic work, for a form whose chief characteristics would be simplicity and severity of composition. The Dutch Monumentalists were not without influence on the contribution he had to make to the new painting.

And so, in 1917, four artists merged in a new unity, four elements underwent a kind of chemical reaction to form a new substance. But, as often happens in chemical processes, the affinity of the elements is not enough in itself to bring the new compound into being. A catalyst is also necessary, a factor that is not included in the resulting compound but that releases the reaction. The role of catalyst in 1917 was played by the philosopher M. H. J. Schoenmaekers, a neighbor of Mondrian and Van der Leck in Laren. Schoenmaekers, a remarkable, fascinating personality, both mystic and mathematician, had expounded his Hegelian theories on the nature of the world and reality in two books: *Het nieuwe Wereldbeeld* (*The New Image of the World*) and *Beginselen der beeldende Wiskunde* (*Principles of Plastic Mathematics*). He believed that on the basis of his method and with the aid of mystic concentration he would be able to plot the path to knowledge and understanding of the structure and meaning of the universe, but above all it was by the emphasis he laid on the mathematical structure of the universe that Schoenmaekers showed the four painters the plane on which they could find each other. His philosophy was the catalyst in the foundation of De Stijl: after experiencing it there were no longer four adjacent, related but separate oeuvres, but one unified, collective oeuvre, greater than the sum of its parts.

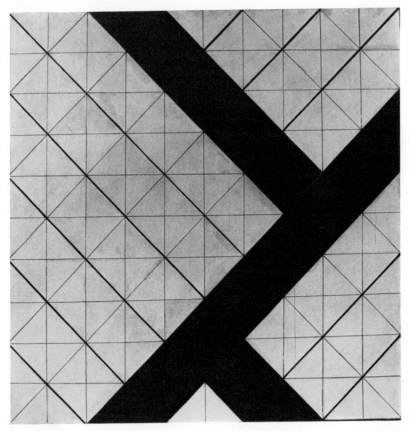

89. Theo van Doesburg: *Contrecomposition VI*. 1925. Oil on canvas. 19¾" × 19¾". Photograph courtesy Annely Juda Fine Art, London.

Of course Schoenmaekers's theories were not the only cause of this conjunction of genius. Another important one was the awareness of that intellectual and spiritual atmosphere that is nowadays called Zeitgeist and in the vocabulary of De Stijl was "the general consciousness of the age." The De Stijl artists always attached great value to this atmosphere, and in their very first manifesto "the general consciousness of the age" is the starting point of their considerations:

> There is an old and new consciousness of the age. The old is con-
> nected with the individual. The new is connected with the universal.
> The struggle of the individual against the universal is revealing
> itself in the World War as well as in the art of the present day.

The war is destroying the old world with its contents: the dominance of the individual in every field.

The new art has brought forward what the new consciousness of the time contains: balance between the universal and the individual.

The artists of De Stijl saw in the events of their age a trend toward collectivization, to depersonalization as well as to mathematical exactitude, to the precision of the formula. They read the symptoms of this revolution in values in many different facts of everyday life, which they regarded with enthusiasm and sympathy: technology appeared to them to be the clearest sign of the new age, a herald of the future; in the work of machines they recognized a perfection, a regularity of which the human hand is incapable. But they also believed they could observe the same trend in other manifestations of modern life: in the organization of political parties, of the masses, of the trade unions. In every problem the element of chance, which was an inherent factor of every individualist kind of solution, was being forced to give way to the generalization of the formula, of the abstract solution. The modern work process seemed to them to be a prototype of this new form of life, and the blueprint its visible symbol. They compared the blueprint to a musical score where the composer's work already exists, complete and entire, on the page of manuscript; performance is a technical matter and can be left to craftsmen. They extended this conception of creation to painting: the value of a work of art no longer lay in its execution but in the creative idea from which it grew. Painting was thus no longer restricted to the surface of the canvas—it had moved into new realms, and it was this advance that the journal *De Stijl* supported: in its pages all the implications, ethical and political, of the new painting were to find a chance of expression and a fair evaluation.

This new attitude to reality and the extension of painting's horizons was also justified for the De Stijl artists by yet another fact: the invention and perfection of photography. After this development, it seemed to them that it could no longer be the task of the artist to capture for eternity the outward appearance of things; instead his aim should be to reveal the laws that govern all visible reality but that are veiled and distorted by what is actually seen. These are the laws that obtain everywhere in daily life; they take shape in the scientific formula and in mechanized production alike, as well as in the pulsating rhythms of life in a large city. The De Stijl group observed all these symptoms of

a "new life" with warm sympathy, and regarded them as the source of their inspiration.

This clear emphasis on the longing for "new life" is itself a phenomenon of the age. It was at this time, in the middle of World War I, that artists and philosophers, scientists and poets were realizing that the old norms had lost their validity and that it was necessary to find a new scale of values for the future. The search, which took the form of a utopian idealism, won particular support in Holland, an island of neutrality during the war; the forces of innovation were concentrated in this domain of spiritual and intellectual combat.

De Stijl was founded in neutral Holland during World War I, and it is not going too far to assert that this art could not have originated in any other country. The argument is often advanced that one proof of the Dutch nature of De Stijl lies in the resemblance of the pictures to the Dutch landscape as seen from an airplane or a church tower. This explanation seems superficial to me, particularly in view of the fact that all the De Stijl artists had been through a naturalistic phase in their early work, which was well behind them. It is true that Holland is the only country in the world where the horizon is an optical fact and not an imaginary line, and the eye of the artist cannot be closed to such a fact. Yet, one should, perhaps, take the explanation further: the Dutch landscape is not De Stijl's source of inspiration, but rather both have a common origin. The Dutch landscape is an artifact: its appearance has been imposed on it by principles of economical expediency and practical sense, following the fundamentals of Euclidean geometry. The straight lines and the right angles are the testimony to centuries of human labor. The precision and clarity of geometrical shapes play a vital part in the work of reclamation; the new land must be protected against the sea, against nature. The straight line and the right angle are the signs of man's struggle against nature and of the eventual triumph of man's labor over its capricious power. The straight line and the right angle are the signs of man's assertion of his will against the curves and bends, the acute and obtuse angles that belong to natural, organic creation. It is for the very same reasons that the straight line and the right angle dominate in the work of De Stijl: the triumph of the human mind over arbitrary and capricious nature finds here its visible expression, its plastic form. The urge toward perfection, the determination to build in spite of the forces of nature, have been Holland's inheritance for centuries, a na-

tional trait that manifests itself once more in the painting of De Stijl.

It is not hard to find other sources of the new art in Holland; every aspect of De Stijl and its works can be related to its Dutch origins. Perhaps the most obvious taproot of De Stijl is Dutch puritanism, which is not confined to one religious sect: every Dutchman is a Puritan to a greater or lesser degree. Certainly in the sixteenth century Calvinism played a decisive role in forming Dutch spiritual and intellectual attitudes, and in the twentieth century it is certainly no empty coincidence that almost all the members of the De Stijl group came from strict Calvinist families, so that a connection is established between their rectilinear and rectangular principles and the rigidity of religious orthodoxy. The history of Calvinism furnishes apt parallels: the first act of Calvinism in Holland was the destruction of religious images, and we could certainly call the De Stijl group true successors of the iconoclasts. There are obvious similarities in the motives of both groups; for the iconoclasts every image of a saint was a diminution, an infringement of the absolute divinity of the Creator; every image of a part of creation seemed to the De Stijl artists an infraction, a mutilation of the divine purity of the laws of creation. The fundamentals of their thought ran along parallel tracks, for this absolutist, puritanical way of viewing the world is an inherent part of the Dutch character. Perhaps the most revealing indication of parallels between Dutch and Puritan thought is the double meaning of the word *schoon,* which means both "pure" and "beautiful." The parallel is expressed with equal clarity in the works of De Stijl, the beauty of which arises from their immaculate purity.

It is not hard to find examples of a similar conception in the art of the past: the serene purity of Vermeer's interiors, the bright clarity of Saenredam's churches, the simple orderliness of Pieter de Hooch's rooms are all visual expressions of the purifying spirit of puritanism. But the supreme example of this way of thought and feeling is surely Spinoza, whose principal work bears the title *Ethica more geometrico demonstrata* ("Ethics revealed by the geometrical method"). In view of the ethical content of their words one could also use this title for the collective oeuvre of De Stijl. Spinoza chose the geometrical method of presentation in order to be able to prove the principle of his ethics in a way that transcended personal arbitrariness and was thus irreproachable. The artists of De Stijl had a similar purpose when they chose to restrict their means of expression to elements of unalterable validity in order to be able to give creative form to the essential content of their philosophy: harmony. This compulsive search for the absolute, this

desire to transcend nature must be included among the Dutch origins of
De Stijl (figs. 90, 91).

The restriction of expressive terms to the elemental served the most
important aim of the De Stijl movement: the purification of the arts.
Purification, cleansing, in this case meant, above all, autonomy. De Stijl
wanted to release the arts from their dependence on extraneous systems
of values and give each art the freedom to obey only its own laws. This
independence of the arts had a twofold significance for the group. They
wanted to free the plastic arts on the one hand from the necessity of
representing any random object belonging to the natural world and, on
the other hand, from another kind of random chance, from the subjec-
tive, temperamental whims of the individual. That art should be obliged

. Piet Mondrian: *Composition in Blue and Yellow.*
37. Oil on canvas. 22″ × 17¾″. Photograph cour-
y Sidney Janis Gallery, New York.

91. Piet Mondrian: *Composition with Red,
Yellow and Blue.* 1928. Oil on canvas. 48¾″
× 31½″. Photograph courtesy Sidney Janis
Gallery, New York.

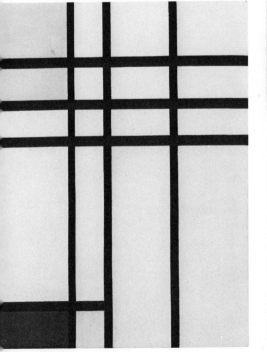
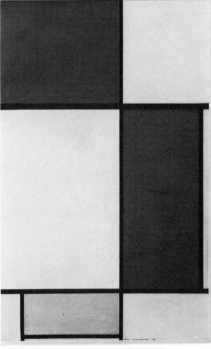

to be dependent on either of these kinds of chance seemed to the De Stijl group a threat to its existence; for this reason they placed a total ban on representation—i.e., of the shapes of recognizable objects—in their art, and also limited the stock of their expressive means so severely that any subjective whim seemed to be ruled out.

In their efforts to purify art, the De Stijl artists felt that they were completing a historical process. Step by step, the visual arts had moved along the road from the reproduction of reality to the presentation of essential, abstract truth; in the art of De Stijl the point had at last been reached when art had won full autonomy. Now art was free from alien influences, now it was no longer the handmaid of any other human activity, now it was free to become a way to the knowledge of absolute truth. For this art, strictly nonfigurative though it might be, was to present a subject in figures in the geometrical sense. These pictures, which carefully excluded all objects, were to portray, as objectively as possible, the subject that for the De Stijl artists was the essence of the art of all time: universal, absolute harmony. It would be quite mistaken to regard this art without any subject matter as an art without content; its content is its very center of gravity, the nucleus of its collective search and effort.

Universal harmony, the harmony that rules every part of the universe, was both the goal and the subject of the art of De Stijl. This harmony was to be revealed in all its pictures, sculptures, and buildings. It is a concept of the role of art that opens up limitless ethical and philosophical horizons for it. The fundamental creative theory, the conceptual form of this art, is closely related to Platonic philosophy, and its derivation from the Neoplatonist tradition and its theological variations is plain. The fact that this ambitious system of thought did not find its expression in words so much as in plastic images is, again, typically Dutch. Holland has no great philosophical tradition, but it has a great pictorial tradition. Truths and discoveries that other people would have expressed in the written word are transmitted here in pictures and images. De Stijl takes its most important steps in its pictures; the writings are *post factum* explanations.

The artists of De Stijl wanted to use their visual language to express their concept of reality and the laws governing reality. Their aim was to achieve a comprehensive view of this reality, one not restricted to a random fragment either by the choice of a single, random object as the subject of the picture, or by the arbitrary limitation of a random, individual point of view. For the artists of De Stijl it was of the utmost

importance to keep the whole in view; in this way every property, every value was valid only in its relationship to other values and properties, giving rise to an art of pure relationships, or, in Mondrian's words, "a true vision of reality." Above all, the De Stijl artists wanted to depict the way reality conformed to laws and to express this idea, this formula of universal harmony, in visual terms. It is in accordance with this plastic conception of nature—which can be related to Spinoza's *natura naturans*—that natural phenomena have the same relationship to the law as variations to a theme, and it is the theme that De Stijl tries to reveal.

It was in order to represent essential truth and to escape the chance nature of variations that the De Stijl artists rid their pictures of every kind of portrayal of things and restricted themselves to an expressive language so limited that their representation really was as objective as possible. This is yet another manifestation of Dutch absolutism and does much to explain the compelling, almost religious, power of these pictures: a work of De Stijl presents the viewer with an exemplary purity that has the effect of another "categorical imperative"; by its very purity and perfection it makes a demand on the beholder. The spiritual principles and ethical perspectives of De Stijl are contained in this demand for purity; anyone looking at the picture should purify his vision of reality in the same way as the picture does: it is intentionally a paradigm. The artists of De Stijl are on no account to be written off as agreeable manipulators of color and line, producing work of purely visual and decorative significance. Such a judgment would be a grave injustice, for it would be to apply to them norms that are valid for the decorative arts, and to such norms they were always violently opposed. Every De Stijl picture proceeds from the principle of harmony and thus expresses an ideal subject in visual terms. An art, ignorant of this subject, that used De Stijl's formal language could be assessed according to the norms of the decorative arts, but not the work of the De Stijl artists themselves, whose concern was always the plastic expression of this subject, and who therefore reached out beyond the realm of mere aesthetics.

It was Mondrian, above all, who defined the ethical implications of De Stijl, in his articles in the early volumes of *De Stijl* and later in his pamphlet *Art and Life*. His recurring theme is this: the life of modern man has not yet been able to attain the order and harmony that are the goal of life. Human individualism and unrestrained subjectivity have prevented the establishment of harmony, obscured the clarity of life,

thus giving rise to tragedy and leading humanity astray from its one, essential path. Art, on the other hand, has found this harmony and has been able to express it objectively and visually because it has now, at last, broken down the barriers raised by individualism. Now art has a new task: it precedes life and therefore must show life the way to the realization of universal harmony. The vision of art as pioneer and pilot was constantly before the De Stijl group and it was this principle that they expounded in their journal. This vision, it is true, is as utopian as it is revolutionary. But for Mondrian himself the utopia was the reality in which he breathed and created throughout his life. The earliest sign of his utopian and visionary view of reality is the dedication on the title page of his pamphlet *Le néoplasticisme* (1920): *aux hommes futurs.*

Painting was to be the forerunner of the life of the future and would even be able to hasten its approach and realization. The great purpose of De Stijl's painting was to bring to mankind the light of true purity. In formulating this belief Mondrian was fully conscious that its realization would inevitably lead to the end of painting, but he was not much troubled by this: as long as universal harmony was not yet established in everyday life, he wrote, painting would be needed to provide a temporary substitute for it. But in the future, when once harmony had permeated all areas of life, then painting would have fulfilled its task and become superfluous—so much the better for painting and for life. Mondrian had an unfaltering, precise conception of this harmonious future life. The order, equilibrium, and harmony that he had first established in his pictures would reign in every sphere of human life: in politics, architecture, music, and the theatre. He tried to envisage exactly how future forms in all these spheres would appear to onlookers. He was sure of one thing: never again would individualism, chance, and the tragedy resulting from them be able to rupture this harmony once it was established. In the future to which painting showed the way, mankind would have regained Paradise.

This magnificent utopian vision, a Nirvana of radiant purity and brilliant light, was Mondrian's contribution to De Stijl's world view. In his pictures the visions become visible signs, pointing the way not only to the purity of the future, but also to personal purification of the onlooker's view of reality. The same visions are the subject of his articles in *De Stijl,* the important, comprehensive essay published during the first year and the subsequent dialogues that define his conception of the ideal potentialities of this painting. All his later writings, including his pamphlet *Le néoplasticisme,* draw on these original articles or elabo-

rate particular points first mentioned in them. The first attempt to sum up his ideas was not written until 1931, in *Art and Life,* after *De Stijl* had ceased publication. Without Mondrian's utopian vision De Stijl would never have been able to develop the universal validity, the great power of conviction that it still radiates today. But if there had not been another force at work in the movement, if this sublime vision of the future had not evoked a response, De Stijl would probably never have progressed beyond the dream and, splendid vision though it was, we would hardly remember it today.

To make the dream come true called for a personality of a different order from Mondrian, the ascetic and visionary who created a model for the future in his paintings. To fix the dream in the contemporary world was a task for someone with the courage to attack and change reality as it was, and that person was Theo van Doesburg. For him it was not enough to be sure that the world of the future would be altered to conform with the principles of De Stijl; and inner compulsion drove him to alter and renew the world here and now. That is why this talented painter became an architect, that is why, from the very earliest days of De Stijl—of which he was the driving force and founder—he drew architects into the group: Oud, Van 't Hoff, Wils, and later, Rietveld, Van Eesteren, and Kiesler. His constant desire was to build solid realities, to see the structures of his imagination rise against the forms of the past as witnesses of the new age. Van Doesburg was an innovator, a pioneer, and his works are the proof of his vigor and energy: not his pictures alone, which from 1924 on show a new and extraordinary dynamism, but above all his architectural works—the models he made in 1923 with Van Eesteren and Rietveld, the Aubette in Strasbourg of 1928, now unhappily lost to us, and finally his own house in Meudon, started in 1930 but not completed till after his death, which is an authentic plastic expression of the spirit of the twentieth century. It was Van Doesburg who, over the years, made architecture, building, solid construction, of greater importance for the De Stijl movement than the utopianism of his painting.

This gradual change of emphasis is made clear in the articles printed in the journal. The issues published in Leiden during the first three years are dominated by the painters; the few contributions by architects are in tune with the general trend set by them. The volume for the third year contains the second manifesto, on literature, and Van Doesburg's first article on poetry (under the first of several pseudonyms,

I. K. Bonset). This shows the first signs of the influence of Dada, which did not affect all the members of De Stijl but was very strong on Van Doesburg himself. Then in the fourth volume, which was published in Weimar, with a new typographical makeup, a change in direction becomes apparent, due not so much to the influence of the Bauhaus*— on the contrary, De Stijl's influence on the Bauhaus was by far the stronger—as to the fact that Van Doesburg was writing far more and expounding his new ideas. The gradual development, which for example brought more and more illustrations of engineering work to the journal's pages, culminated in Van Doesburg's article in the sixth volume, "Von der neuen Aesthetik zur materiellen Verwirklichung" ("From the new aesthetic to its material realization").

For this was Van Doesburg's purpose: the realization of De Stijl's principles in material form, not just in the carefully sheltered world of painting, but in architecture, which played a tangible role in the modern, external world. De Stijl had been concerned with architecture from the very beginning, and its importance for the movement increased as time passed. To begin with it was Oud, Wils, and Van 't Hoff in particular who put the principles of De Stijl to work, in their designs rather than in actual buildings; after 1923 a new group came to the forefront, due largely to Léonce Rosenberg's commission for a private dwelling and an artist's studio: Van Doesburg himself began his architectural activities at this point, his colleagues on the project being Van Eesteren and Rietveld. They never carried out Rosenberg's commission, but the creative ideas worked out in studies and plans for it are evident in Rietveld's Schröder House (1924; figs. 92, 93) in a lapidary form that convinces by its very economy. Since 1924 this second generation of De Stijl architects has put up one milestone after another. The list includes Van Doesburg's Aubette in Strasbourg and the house in Meudon that he designed for himself and De Stijl in 1930, Van Eesteren's town-planning schemes—the redevelopment of Unter den Linden in Berlin and the Rokin in Amsterdam—Rietveld's last buildings—the Dutch pavilion at the Venice Biennale, the Zonnehof in Amersfoort—as well as the designs that, since his death, have not yet been carried out, for the School of Art in Amsterdam and the Van Gogh museum, and in another dimension Van Eesteren's magnificent plans for the redevelopment of

* Founded in 1919 at Weimar in Germany by Walter Gropius, the architect, the Bauhaus was a school of architecture, design, and craftsmanship. Klee and Kandinsky taught there. It was closed by the Nazis in 1933.—Eds.

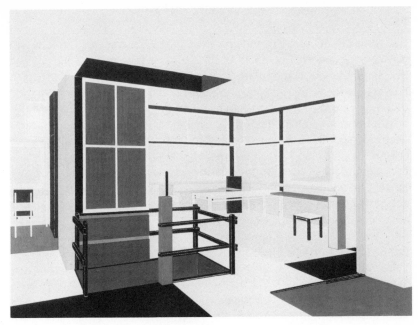

92. Gerrit Rietveld: Schröder House, Utrecht. 1924. Gouache and pencil on paper. 20½″ × 26″. Interior perspective executed for "De Stijl" exhibition, The Museum of Modern Art, New York, 1952. Collection The Museum of Modern Art, New York.

93. Gerrit Rietveld: Schröder House, Utrecht. 1924. Exterior. Photograph courtesy The Museum of Modern Art, New York.

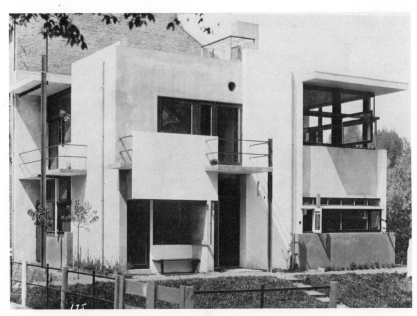

Amsterdam and the use and organization of land and space in Holland as a whole.

The first wave of De Stijl architects devoted their energies in the early years, from 1917 on, to combating the excrescences of a decorative architecture that had recently become fashionable again, particularly with the so-called Amsterdam school. Their reaction took them to where the dominant forces were technical sobriety and severe structural honesty, and so Berlage and Frank Lloyd Wright became the decisive influences on Van 't Hoff and Wils in particular, and to a lesser degree on Oud also. The influence of the great American, whose importance Van 't Hoff had seen for himself during a visit to the United States, is already very plain in the houses he built in Huis ter Heide before De Stijl was founded; but it is also unmistakable in Jan Wils's alterations to the hotel De dubbele Sleutel in Woerden, particularly in the emphasis given to the extended, horizontal eaves, so typical of Frank Lloyd Wright.

But in addition to the influence exercised by great contemporary architecture, an important part was played within the circle of De Stijl itself by the dominance of painting. The balance and harmony that were being achieved in the work of Mondrian, Van der Leck, and Van Doesburg became a goal for the architects to aim at; Oud's first designs that were published in De Stijl are a proof of this. His 1917 design for a seaside promenade is more reminiscent of Cubism, but the decisive step was taken by 1919 when Oud published the design for a factory for Purmerend, where he was born: the left wing, with the large, boldly framed door, still owes much to Berlage, while the right wing, with its predominantly horizontal lines, shows the unmistakable influence of Frank Lloyd Wright. The central block, between two large, smooth walls is pure De Stijl, a transposition of the principles of De Stijl painting into the third dimension, the language of architecture. The transposition is by no means a purely mechanical one of formal elements only; the principles of the visual language first formulated by the painters in the De Stijl movement are applied here with full regard to the requirements and meaning of architecture.

Rietveld's armchair of 1918 is also a quite independent product owing nothing to Mondrian's forms, but a totally original creation, closest if anything to Bart van der Leck's pictures of the same period—a relationship that can be explained by the fact that they both worked for some time with the same Utrecht architect, P. C. Klaarhamer. Oud's earlier designs and Rietveld's armchair are both characterized by the

deliberate purging of all alien influences and formal complexes—this idea of purgation, autonomy, and independence derives from the painters. Thus it was the principle rather than the forms of painting that exercised the most influence upon the De Stijl architects.

This first phase of De Stijl architecture, from 1918 to 1923, is most typically represented in the work of Oud (fig. 94). His earliest designs—the seaside promenade and the Purmerend factory—never got

94. J. J. P. Oud: Café de Unie, Rotterdam. 1925. Exterior. Photograph courtesy The Museum of Modern Art, New York.

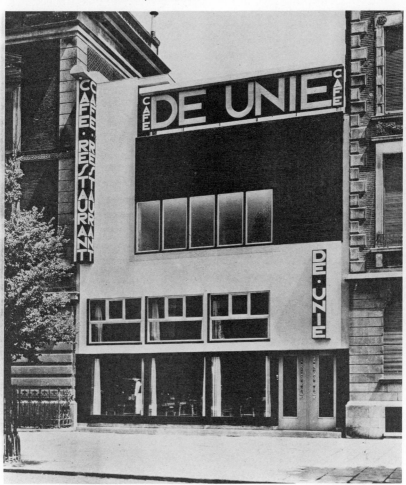

further than the drawing board, but he soon had the opportunity to put his ideas into practice on a really large scale and in a social context, in apartment blocks and housing estates in Rotterdam and at Hook of Holland; his point of departure in all of them is the tension between the house and the street's exterior walls. And, true to the spirit of all that De Stijl stood for, he laid the emphasis in this work on a totally new architectural phenomenon: the impersonal perfection that mechanical methods of production now made possible. The architect's work increasingly comes to mean composition with objects designed for a specific function: his blueprint becomes as complete a creation as a musician's score. And he will take care to restrict the opportunities for chance and human idiosyncrasy to a minimum by basing his design on the fundamental facts of building.

Oud's buildings of the early 1920s, and his principles, which reached their maximum of purity and architectural precision a few years later in the Kiefhoek estate in Rotterdam, are one of the acknowledged starting points of "functional architecture" in Europe. Above all else it was Oud's connections with the Weimar Bauhaus that caused the idea of logical functionalism, which owed its conception to De Stijl to become a generally accepted principle in European architecture. Firm roots in the human environment and the anonymous perfection of mechanization were the characteristic features of the new architecture, which was thus a typical expression of the principles of De Stijl: the defeat of subjectivity.

About a year before Oud began work on the Kiefhoek estate— probably his outstanding achievement within the framework of De Stijl—the second architectural phase of De Stijl got under way as the result of the commission from the Parisian art dealer Léonce Rosenberg, who first approached Oud himself. Oud refused—and the reason is typical of the practical architect he happened to be—because Rosenberg had not yet found a site and it would therefore be futile to take up so theoretical a commission; an architect could not possibly design a building without knowledge of its site.

Oud referred the commission to Van Doesburg, who took it up in collaboration with Van Eesteren and Rietveld, and used it, theoretical as it was, as a starting point for a thorough analysis of the principles of architecture, an analysis that gave rise to the fifth manifesto "Vers une construction collective" (1923; "Toward a Collective Construction"), published in the sixth volume of De Stijl. This manifesto, like all the earlier ones, was in every respect the result of creative application,

practice forming the basis for theory. Van Doesburg and his two friends and colleagues took the hypothetical commission as the starting point, not in order to design a house that would actually be built, but to investigate the basic principles of architecture and space down to their smallest details and so to produce a universal work in accordance with the aims of De Stijl, not a specific design modified by circumstances. They were not concerned with one particular house, which in De Stijl's terminology would be an arbitrary construction, subject to the vagaries of chance, on any one site chosen at random, but with the general problems of space for living in. The three artists solved these problems in a series of designs, drawings as well as models, in which they revealed the possibilities offered to architects by open planning, as opposed to the division of space into separate, boxlike units in traditional architecture. They demonstrated the attractions and good sense of using color as an integral part of the design, again in contrast to traditional practices, and in all these ways opened up new architectural horizons.

In 1924, the year following the completion of the designs for the Rosenberg houses, Rietveld and Madame Schröder-Schräder built a house on the Frederik Hendriklann in Utrecht (see figs. 92, 93). In it Rietveld put into practice all the architectural solutions that the three artists had together worked out on paper. In particular, the treatment of space as one continuous unit reveals an important progression beyond the first stage of De Stijl architecture; the interplay of interior and exterior, the tense, uncompromising form of the structural elements, unmistakably embody the immaculate, Puritan spirit of De Stijl. This house is the first building to reflect the ideas of the second generation of De Stijl architecture, and has become the monument to its belief in clarity, openness, and simplicity. It is one of the most significant and influential architectural works of our century. The new approach is shown in all kinds of details; for example, the use of color to give meaning and character to the spatial structure of the building anticipates the concepts that became current in painting in 1917, and in architecture a few years later. This early work by Rietveld was a harbinger of subsequent developments in architecture in Holland and elsewhere, and his later works are inspired by the same freedom, brilliance, and radiant happiness.

After Rietveld, it was Van Eesteren who made the most significant contribution to the second phase of De Stijl architecture in the work he did in Paris. His influence on the group's ideas about architecture and space, even on Van Doesburg, was of the greatest importance, particu-

larly in the opportunity he created for fundamental rethinking about the elements of architectonic construction and form. His 1923 design on the creation of the Paris architectural models for a house on a riverbank shows how advanced his ideas were in many respects. But his most important work was on a larger scale, in the field not of single buildings, but of town planning. In the early years of De Stijl the modern city was a major source of inspiration to the artists; now it was remade according to De Stijl's principles by one of the group's members. Van Eesteren applied De Stijl's ideas to the organization of space in large units—cities or whole provinces; his designs for areas within cities, such as Unter den Linden in Berlin and the Rokin in Amsterdam, were forerunners of the designs made many years later for the expansion of Amsterdam. In this Van Eesteren brought to fulfillment one of De Stijl's major concerns, the harmonious ordering of space embodied in the forms and structures of a city, equilibrium of function and form.

In this way De Stijl changed contemporary surroundings according to the principles that had come to the fore in the group over the years and made a lasting impression on many different areas of the human environment. This essentially moral influence of De Stijl proceeded in the first place from the untiring, dynamic activity of Theo van Doesburg, but all the members of the group played a part in its spread, and not least Mondrian, who in later life won over the United States. The influence was not restricted to isolated areas of the arts: it was felt in typography and in filmmaking, in architecture and in the design of everyday objects, and, in the most general sense, in the ambience of our life today. Nor did only minor artists succumb to it: it is at its most evident in the work of Le Corbusier and the Bauhaus.

The essential effect of De Stijl lies in a wider sphere: the artists worked for years in isolation, obscurity, even poverty without thinking of making a name for themselves. Only later did people discover that their ivory tower was a spiritual and intellectual beacon for a whole generation to steer by. The artists of the De Stijl group tried to redefine the role of art in the present and the future; they saw the need for a universal language of visual terms, and they based it on the elementary rules of balance and harmony. They drew up a grammar and a syntax for this language that expressed the human urge toward order and regularity. After 1917, while Holland was reclaiming land from the Zuider Zee and the ordering of new spaces was literal fact, they were winning new provinces for the old empire of art and setting out in the

new areas a model of human order, of the triumph of human laws over the random caprices of nature. In art, in design in general, in the human environment as a whole, in all the many fields embraced by the word *civilization* De Stijl put into practice the ideal it had expressed as "One serves mankind by enlightening it."

Mondrian and Theosophy*

ROBERT WELSH

Several artists were developing an art without representational imagery before World War I. Their sources and intentions varied. Piet Mondrian, like Wassily Kandinsky, evolves toward an art of complete abstraction gradually. As with several of their contemporaries, Franz Marc, Frank Kupka, and Ciurlionis, the path toward abstract art is intimately affected by a search for the spiritual. In this search, both Mondrian and Kandinsky were inspired by the Theosophical movement, widespread in Europe around the turn of the century. Mondrian was particularly interested in the cosmological system of Madame Blavatsky, as Welsh demonstrates in the following essay.

Welsh finds that this esoteric belief system had a profound impact on Mondrian's pre-Cubist paintings, for example, the *Evolution* tryptich of 1911. The artist's own writings in *Two Mondrian Sketchbooks, 1912–1914,* translated and introduced by Welsh (Amsterdam: Meulenhoff International, 1969), are used to support this argument. By establishing Theosophical sources for the artist's earlier representational work, Welsh suggests the importance of the spiritual for Mondrian's stark and elemental later paintings.

Robert Welsh is Professor of Fine Arts at the University of Toronto.

* Reprinted from the exhibition catalogue *Piet Mondrian Centennial Exhibition,* The Solomon R. Guggenheim Museum, New York, 1971.

Mondrian's membership in the Theosophic Society, although invariably cited in accounts of his career, in general has been treated merely as an intellectual interest that helped to clarify his thinking about art, especially during the period of World War I, which he spent in Holland. By 1917, along with other members of the De Stijl group, he had arrived at a form of geometrizing abstract art so radically novel that some theoretical justification seemed called for in printed form. Thus, in October 1917, he joined in founding, under the editorship of Theo van Doesburg, the periodical *De Stijl,* which immediately began to carry his own series of articles, "Die nieuwe Beelding in de Schilderkunst" ("The New Plasticism in Painting").[1] As an influence on these essays, most critics have singled out the Dutch "Christosoph," Dr. M. H. J. Schoenmaekers, whose books, *Het nieuwe Wereldbeeld* (1915) and *Beginselen der beeldende Wiskunde* (1916) Mondrian is known to have admired.[2] Indeed, although translated into English as *The New Image of the World* and *Principles of Plastic Mathematics,* like Mondrian's own Franco-Anglicized term *Neoplasticism,* these titles all rely upon the significance of the Dutch word *beelding.* This is best translated as "form-giving" and is closer in definition to the German *Gestaltung* than to the English "image" or "plasticism." In any case, both the art theory of Mondrian and the philosophical system of Schoenmaekers adopt the concept *beelding* as a fundamental principle in viewing the world, and there can be no doubt that the personal contact between the two men was a mutually fruitful one. Doubtless, too, Professor Hans L. C. Jaffé is correct in finding an affinity between the "abstract" thought patterns of Mondrian and Schoenmaekers, which, in turn, share in Dutch Calvinist traditions of precise and logical intellectual formulation.[3] Nonetheless, the general tendency to grant such emphasis in Mondrian's art-theory development to the role of Schoenmaekers has helped to obscure two essential facts; namely, the importance of Theosophy to Mondrian at a date previous to his contact with Schoenmaekers, and the incorporation of Theosophic ideas into his actual style of painting.

It was, in fact, as early as May 1909, that Mondrian officially joined the Dutch branch of the Theosophic Society. Shortly thereafter, an approving critic, the Amsterdam writer Israël Querido noted Mondrian's use of Theosophic terminology in a letter received from the painter that contained art-theoretical observations and that Querido published in lieu of comment by himself.[4] In exhibition reviews from both 1910 and 1911[5] another critic cited the artist's Theosophic interests, in the latter year with specific reference to the monumental *Evolu-*

tion triptych (1910–1911; figs. 95, 96, 97), a work that, as will be shown below, eminently deserved this special mention. By the winter of 1913/14, Mondrian's attachment to Theosophy was so well appreciated that, although then living in Paris, he was asked to write an article upon the subject "Art and Theosophy" for *Theosophia,* the leading organ of the Dutch spiritualist movement.[6] Although this essay remained unpublished, it very likely reflected the thoughts about art with which Mondrian annotated two sketchbooks from approximately the same period[7]

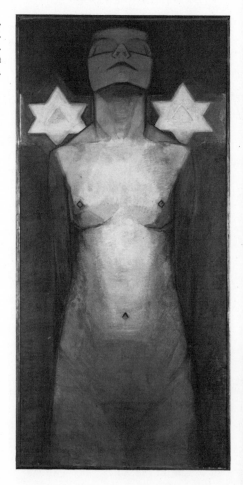

95. Piet Mondrian: *Evolution,* triptych. 1910–1911. Oil on canvas. Left panel. 70″ × 33″. 96. Middle panel. 71⅜″ × 34⅛″. 97. Right panel. 70″ × 33″. Collection Haags Gemeentemuseum, The Hague.

and which are also summarized in several extant letters from early 1914.[8] In sum, there is adequate documentation that Mondrian's involvement with the Theosophic movement predated his contact with Dr. Schoenmaekers and from the first related directly to his own activities as an artist.

Significantly, in none of his surviving texts from before the De Stijl period does the artist as yet advocate the exclusive use in painting of either straight vertical and horizontal lines, rectilinear planes, or the

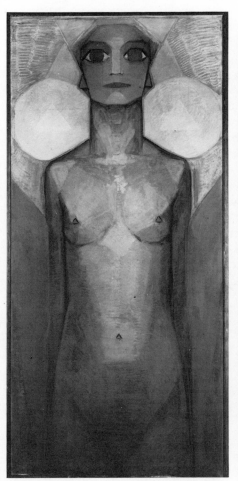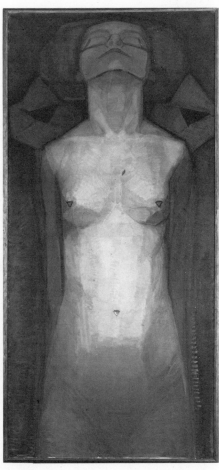

three primary colors: red, yellow, and blue. Nonetheless, whereas the basic color triad is mentioned by Dr. Schoenmaekers for the first time in his *Het nieuwe Wereldbeeld,* it is apparent that the combination of ochre (for yellow), blue and red/pink hues already occurs in a number of major paintings that Mondrian executed previous to his return from Paris to Holland in mid-1914 when the book in question was datelined. Similarly, in his *Mensch en Natuur* (1913; *Man and Nature*),[9] a work until now unnoticed in the literature on Mondrian, Schoenmaekers discusses such abstract geometric forms as vertical and horizontal lines, crosses, circles, and ovals in a manner that might seem to explain their occurrence in compositions by Mondrian. Indeed, the oval-shaped, so-called plus and minus grid, which is expressed overtly in the pier and ocean theme of 1914–1915 and a number of related compositions, embodies the same range of linear configurations emphasized in the three above-mentioned volumes by Schoenmaekers. Yet, a closely related grid conception occurs as the underlying structural basis for several tree and still life paintings executed by Mondrian as early as 1912.[10] These chronological considerations make clear that the structural character of Mondrian's painting during his Cubist and proto–De Stijl phases of 1912 to early 1917 was determined by precepts that antedate the occurrence of related formulations in the writings of Dr. Schoenmaekers. In fact, although the founder of Christosophy in particular was reluctant to acknowledge his intellectual dependence upon standard Theosophic doctrine, preferring to credit personal intuition and mystical insight instead, both he and Mondrian maintain a world view and employ a critical jargon patently derived from earlier texts fundamental to the international Theosophic movement. In Mondrian's case, the principal debts are to no lesser personages than Madame H. P. Blavatsky and Rudolf Steiner, whose writings appear to have influenced his painting most directly during the pre-Cubist or "coloristic" period of circa 1908 to 1911.

The gradually increasing and self-transforming debt to Theosophic belief found in the pre-Cubist work of Mondrian is summarized in, though scarcely encompassed by, an analysis of three figural compositions. The *Passion Flower* (fig. 98), a watercolor executed as early as circa 1901,[11] already manifests the basic iconographic format that would be used in all three works; namely, the combined image of a profoundly meditative female torso with upturned head and accompanying heraldic flower blossoms. The *Devotion* (1908; fig. 99)[12] summa-

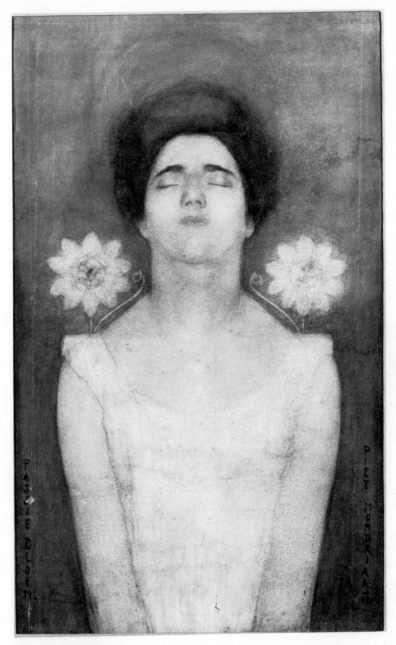

98. Piet Mondrian: *Passion Flower*. 1901. Watercolor. 28¼″ × 18½″.
Collection Haags Gemeentemuseum, The Hague.

rizes essentially the same iconographic nomenclature by means of a profile view of a girl seen contemplating a single chrysanthemum blossom. This latter work nonetheless adds a novel element by its bright blue and red coloration. Such hues are lacking in the dullish tones of the earlier example and doubtless are symptomatic of the artist's new appreciation for post-Impressionist and Fauve traditions. Finally, by late 1911, Mondrian had produced his *Evolution*,[13] (see figs. 95, 96, 97), a work that thrice employs a frontally posed figure with flanking "flower" attributes as found in *Passion Flower* and that yet surpasses the color intensity of even the *Devotion* through the use of a deeply resonant blue background and a radiant yellow ambience for the head of the central figure. The general debt to Symbolist and Art Nouveau tradition that informs all three of these works is indisputable and has been discussed in some depth already by Martin S. James.[14] Therefore one need only to emphasize here those aspects that differentiate Mondrian's approach from that contained in his presumed models and to elucidate where, if at all, Theosophic thinking performed an innovative function.

Such an influence, of course, is not very likely to have affected the *Passion Flower,* which was produced at least several years before the artist officially registered as a Theosophist. Moreover, the title alludes to the inherited Christian symbolism of a particular flower, since its three stamen and tendrils were popularly equated with, respectively, the three nails and the crown of thorns from the Crucifixion.[15] At the same time, Mondrian's female may be thought to suffer as much from the torments of her own earthly passions as from contemplation of her Savior's sacrifice on the cross. Hence, the artist's close friend and the watercolor's former owner, the late Mr. A. P. van den Briel, preferred to stress the mundane circumstances in which the work had its origin.[16] Having heard that his model might be infected with venereal disease and possessing some dubious medical advice that one symptom of such illness was a greenish discoloration of the throat, Mondrian incorporated this information in the pose of the upturned head with its suggestion of "longing for release" and the somber, earthen tonalities of his palette. Apart from providing an early instance of Mondrian's frequently recorded mistrust of the hue green as "too close to nature," this story illustrates the still basically ethical or Christian content with which his iconography was preoccupied. The *Passion Flower* thus remains closer in conception to the example of Jan Toorop and other Dutch fin-de-siècle Symbolists than to the teachings of an esoteric Theosophy that was little concerned with specific instances of terrestrial woe.

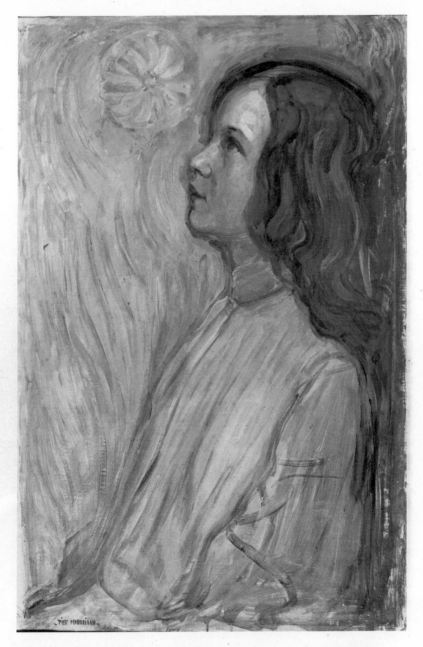

99. Piet Mondrian: *Devotion*. 1908. Oil on canvas. 37″ × 24″. Collection
Haags Gemeentemuseum, The Hague.

In a brief biographical sketch from 1907, Mondrian stated that in 1901 he had ceased doing "portraiture" in order to concentrate upon landscape painting.[17] But with the *Devotion* (1908) he once again employed figural content in a manner that attracted immediate critical attention. After seeing this painting, when exhibited in January 1909, Querido, believing himself to be reiterating the painter's own analysis, described it as representing a praying girl.[18] Yet Mondrian reacted immediately and insistently against this interpretation, stating in effect that the girl was not viewed in an act of prayer but as representing the concept *devotion*. The painter also explained his use of an unnatural red color as a means by which the viewer's attention was distracted from thoughts about the girl's material reality. In the same account he admitted his wish to obtain "knowledge of the occult spheres" and claimed that progress in this pursuit was accompanied by the attainment of greater clarity in his art, which nonetheless still was produced "in the normal way." While one may in fact understand the basis of Querido's traditional manner of interpretation, it is even more important to investigate the additional levels of meaning that were intended by Mondrian.

The most relevant explanation of the artist's own content can be found in the writings of Rudolf Steiner. Among the handful of books that Mondrian kept until death was a collection of lectures, paraphrased in Dutch, which the then German Secretary of the Theosophic Society had given in various Dutch cities during March 1908.[19] A number of passages in these *Dutch Lectures* were pencil-marked by Mondrian. In one such passage Steiner explains how certain occult ". . . impulses, which time and again must work themselves into the Etheric Body, can be awakened by devotional religious feelings, *true* art, music."[20] In numerous related texts,[21] Steiner elaborates on how an esoteric capacity for devotion can be developed in the Theosophic initiate through recourse to meditative exercises. For the attainment of this goal the "positive mystical" observation of various forms of mineral, animal, and, especially, plant life is particularly recommended and is described in great detail. In reference to Mondrian's paintings, it is noteworthy that Steiner mentions young girls as sometimes gifted with natural feelings of devotion and describes how the mystical experience of devotional feelings is to be sought with eyes open and in full mental alertness, rather than by turning away from the world of nature as had earlier practitioners of "negative mysticism."

Nonetheless, this devotional contemplation of natural objects is accompanied, whenever fruitful, by clairvoyant visions of the "higher

spheres" in which color manifestations not visible to the normal, untrained eye play a fundamental role. Such manifestations radiate from the objects viewed, constituting their "aural shells," and represent the supramundane "astral" or "etheric" levels of being. Although the exact meaning of specific hues and tints sometimes is disputed within Theosophic circles (and single hues may assume variant shades of both honorific and derogatory connotation), Steiner definitely associates the appearance of blue with the experience of devotion, and this sometimes in combination with certain forms of red that can be interpreted to signify deeply felt affection. It is important to note that these color auras are not to be thought of as symbols for something else—Theosophists in general disparage the word *symbol*—but as indications of spiritual states of being. This attitude in itself would explain why Mondrian objected to the conventional interpretation of his painting as a symbolic action.

Unfortunately, neither Mondrian's own references to *Devotion* nor any single Theosophic text adequately explains the exact relation of Mondrian as creative artist to the clairvoyant experience of devotion. One may wonder, for example, whether the artist either was attempting to reproduce in paint some form of remembered vision, had actually combined his working procedure with devotional meditative exercises, or otherwise sought through his activity as painter to gain a knowledge of the higher spheres. The question, as intriguing as it is, for lack of further evidence, is unanswerable. For, whatever attitude one maintains in reference to supra- or extrasensory perception and spiritualism in general, only a firsthand account by Mondrian could provide the basis for serious discussion of this complex issue. It can be stated, however, that, by 1908 when *Devotion* was executed, Mondrian was profoundly concerned with the possibility of clairvoyant experience in relation both to his creative and to his personal life.

A second aspect of the *Devotion* that can be illuminated by reference to the writings of Steiner is the significance of the flower blossom included in the upper left. In fact this blossom was meant to serve an iconographic function that may be extended equally to other major flower studies from the same period. These include several treatments of the sunflower theme and numerous depictions of chrysanthemums, particularly the well-known *Dying Chrysanthemum* (1908; fig. 100). Steiner's analysis of plant life depends heavily upon his esoteric reading of the scientific theories of Goethe and comprises in essence a Theosophic reinterpretation of German Romantic nature philosophy.[22] Like human and animal bodies, plant forms, especially flower blossoms,

100. Piet Mondrian: *Dying Chrysanthemum*. 1908. Oil on canvas.
33″ × 21″. Collection Haags Gemeentemuseum, The Hague.

radiate "auras" of color that can be perceived by all properly trained clairvoyants.[23] As part of the function that they serve in devotional exercises, flowers may be said to recapitulate in microcosm the eternal processes of birth, life, reproduction, decay, material death, and regeneration that Theosophy sees as the ruling principle of the universe, and that is summed up in the term *evolution*. For Steiner in particular, the flower illustrates this process with unmistakable clarity. Like the human or animal eye, the flower blossom stands as proof of the primal efficacy of light as a cosmic force. In reference to the evolution of animal organisms, Steiner considers it unthinkable that the material organ of the eye would have developed except for the omnipotence of light, which, as the purest manifestation of spirit, called the physical eye into being.[24] Steiner's favorite metaphor for spiritual awakening is the man born blind who suddenly is enabled to see. As does physical vision, so does the flower depend upon light for its very existence, not to mention the beauty of its color, which phenomenon is treated wholly as a function of light. The power of light is said to be directly operative in every phase of the life cycle of the plant, since from germination of the seed to withered decay the life of plants responds to the warmth and rays of the sun and to the "etheric" and "astral" principles that govern all organic growth. What is the significance of these theories for Mondrian's flower pieces?

First, the blossoms both of the chrysanthemum in *Devotion* and of numerous independent flower studies from a comparable date are embellished with a color halo that can be interpreted as an artistic re-creation of the flower's etheric or astral shell. Even as the material body of the plant decays, this astral phenomenon survives, which concept would seem to explain the vibrant ebb and flow of color surrounding the many dying blossoms produced by Mondrian during the years circa 1908 and 1909. Second, Steiner insists that the individual species of a flower is of little importance, since only the cosmic process in which *all* flowers participate provides a sound guide to esoteric knowledge. Here, too, the intellectual bias is anti-Symbolist, and associations of ethical virtues with specific flowers are notably absent from Steiner's analysis, except as historical illustration. By analogy, one should not casually associate the flowers chosen by Mondrian for his paintings with the various accretions of meaning inherited from Symbolist art. It is in this respect that the *Devotion*, iconographically interpreted, is furthest removed from the *Passion Flower*, in which such associations are paramount.

Third, even the contrast between healthy, upright flowers and withering alternative forms, so graphically illustrated within Mondrian's oeuvre by the *Upright* (1908) and the *Dying Sunflower,* participates in the fin-de-siècle fascination with life-death polarities, chiefly thanks to the power of tradition. In keeping with the basically utopian and transcendental optimism of the whole spiritualist movement, Steiner, for example, encourages the Theosophic initiate to discover in a dying blossom the expectation of regeneration and in the healthy flower the inevitability of decay. In this respect, Steiner's esoteric pedagogics reflects the adoption by Theosophy of oriental religious doctrines regarding transmigration of the soul. It is therefore very likely not by accident that in 1909 Mondrian exhibited a flower piece, probably the *Dying Chrysanthemum,* under the title "Metamorphosis."[25] Though usually described not only as indebted to Art Nouveau style, which it is, but also as containing a Symbolist allusion to death, this work was explained by Mondrian himself, when writing in 1915,[26] as limited merely by an excess of "human emotion." This limitation, moreover, was contrasted to a somewhat later flower painting, which was very likely the *Arum Lily* (1909–1910) and which, in its frontal, upright positioning, promised more of "the immobile." In all those works, Mondrian clearly was concerned more with thoughts of perpetual life than with premonitions of death. Of course, flowers, like other subjects based on nature, gradually would disappear behind the veil of Mondrian's adoption of the Cubist style during the winter of 1911/12. In this historical context, the adoption of Cubist style involved for Mondrian the abandonment of all residual attachment to particular instances of natural beauty. Thereafter, only in the stylistically *retardataire,* yet exquisitely subtle, flower pieces with which Mondrian, especially during the early 1920s, ensured his material survival, can one believe that he continued to practice a form of artistic "devotion" that related intimately to his Theosophic preoccupations of circa 1908.

If the *Devotion* comprised an attempt by Mondrian to give artistic expression to an esoteric, clairvoyant experience of "astral" colors appropriate to the preliminary stages of Theosophic initiation, then the *Evolution* triptych transports us to more exalted realms of occult knowledge. Above all, it is the title of this composition that betrays the "higher spheres" to which its content relates. Evolution is no less than the basic tenet in the cosmological system predicated by Madame Blavatsky and, as such, replaces the Christian story of Creation as an

explanation for how the world functions. This cosmology is analogous to Hindu and other mythologies that stress a perpetual cosmic cycle of creation, death, and regeneration. It also has much in common with the Darwinian scientific theory of evolution. Darwin's only essential mistake, in Blavatsky's opinion, was to substitute matter for spirit as the motivating force in the universe. In her own world view, matter, though constituting a necessary vehicle through which the world of spirit was to be approached, clearly stands second in importance to the latter phenomenon, from which, to be sure, matter is said to have been born. The resulting concept of spirit as the active and matter as the passive force in the world is, of course, deeply rooted in a wide range of mystical tradition reaching far back into the past, as the writings of Blavatsky profusely attempt to illustrate.[27] More to the point, this conceptual polarity was universally accepted as a cardinal doctrine throughout the Theosophic and other intellectually related late-nineteenth-century spiritualist movements and also is present within the subsequent Anthroposophy of Steiner and the Christosophy of Schoenmaekers. The same polar conception pervades the art-theoretical writings of Mondrian, beginning with his letter to Querido of 1909, and is epitomized in his *Sketchbooks* of circa 1912 to 1914. In the latter text he specifically alludes to the Theosophic Doctrine of Evolution as a determining factor in the history of art.[28] In short, Mondrian could not have chosen as the theme of his monumental triptych a doctrine that was more central to Theosophic teaching than this.

In terms of compositional format the *Evolution,* like the *Devotion,* derives from Symbolist precedent. Jan Toorop's *Three Brides* (1893), a work doubtless known to Mondrian, comprised an example of an hieratically tripartite composition based upon three frontally posed female figures that was inherently suggestive of sacerdotal tradition. As illustrated diagrammatically in a minor crayon drawing, the *Two Sylphs Ringing Bells* (c.1893), Toorop had anticipated essential features of the *Evolution* in his contrast between a nude with closed eyes seen against a blue background at left and the open-eyed girl with yellow background at right. Certainly the three figures of the *Evolution* to some extent embody the same distinction between sought-for and achieved enlightenment that Toorop makes evident by the question mark that accompanies his figure at left. Moreover, in both works this distinction is enhanced by an accompanying color contrast between the blue of night and a use of yellow that may be associated with daylight sun. The same opposition between a closed-eyed, seeking and an open-eyed, enlight-

ened female type is also contained in the progression from Mondrian's
Passion Flower to his *Devotion.* The retained inclusion in the *Evolution*
triptych of this principle testifies to the pervasiveness and legibility of
such naïve Symbolist usages within the Dutch artistic milieu to which
both Mondrian and Toorop belonged.

Nonetheless, one should not be satisfied to interpret Mondrian's
triptych merely as a late example of Dutch Symbolism. Toorop's *Three
Brides,* like comparably symbolic figures in the art of Edvard Munch
that are sometimes also said to have influenced Mondrian,[29] constitute
ethical and psychological archetypes that relate essentially to the mun-
dane world of human joy and woe. The physically undifferentiated
figures of the *Evolution,* in contrast, are expressively devoid of human
emotion and appear to participate in a transcendental ambience that
exists beyond any concrete earthly setting. Similarly, the crimson flower
forms that accompany the figure at left defy identification with any
particular species and hence with any well-established Symbolist flower
iconography. To the extent that a reference to another flower representa-
tion can be supposed, this image, because of its similar color and
triangulated petal shapes, relates to the artist's own *Amaryllis,* a water-
color quite close in date and style of execution to the *Evolution.*[30] The
six petals of the amaryllis, if viewed frontally, can be thought to form a
six-pointed star, which is the insignia of the Theosophic movement and
is to be found with the figure at right in the *Evolution.* The positive
meaning for Theosophy and Mondrian's triptych of these geometrizing
elements will be discussed in greater detail below. Here one merely
needs to note their negative function of obviating the kind of ortho-
dox Symbolist floral associations that inform the content of the *Three
Brides.*[31] In contrast to this work by Toorop, Mondrian has not pro-
vided his figures with attributes that are explicable exclusively in refer-
ence to any established iconographic tradition, Christian or otherwise.
Thus, while his imagery may bear a formal resemblance to his own
earlier *Passion Flower,* the intended content is substantially different.
On one level, his three starkly upright nudes further expand the idea of
clairvoyant visionary experience found in *Devotion.* Theosophic writings
couple supersensory perception with either open or closed eyes accord-
ing to specified conditions, and the blue and yellow colors used by
Mondrian in the *Evolution* can be interpreted as suggesting "astral"
shells or radiations of the figures.[32] However, the visionary spheres in
which these figures participate clearly relate to a stage of Theosophic
initiation considerably more advanced than that appropriate for the

cultivation of devotional feelings. Indeed, as a consequence of the exalted level of spiritual activity in which Theosophy conceives "evolution" to have its origin, the implied setting of the triptych may be described not only as supramundane, but as transcending the limits of particular time and space.

It is in reference to this occult metaphysical sphere that the three figures of Mondrian's triptych and their accompanying emblems must be analyzed. As the similar, somewhat androgynous physical appearance of the figures implies, one should view them not merely as personifications of three separate ideas, but as the same person viewed in three complementary aspects. Indeed, another Dutch artist who was a Theosophist wrote in 1906 that "For Theosophy man himself is a living temple of God,"[33] or, in other words, represents within himself a microcosmic instance of the universal principles that govern his existence. Thus, Madame Blavatsky, in paraphrasing a text from the mystic Paracelsus, explains:

> Three spirits live and actuate man, . . . three worlds pour their beams upon him; but all three only as the image and echo of one and the same all-constructing and uniting principle of production. The first is the spirit of the elements (terrestrial body and vital force in its brute condition); the second, the spirit of the stars (sidereal or astral body—the soul); the third is the *Divine* spirit . . .[34]

Of course, this statement permits an identification of the three figures as generalized personifications, since if read in the order left, right, and center, we have the classic mystic progression from matter through soul to spirit. To this extent the *Evolution* still reflects Symbolist thinking. Yet Blavatsky's writings also contain a more profoundly syncretic idea that is as relevant for Mondrian's background as for his figures. This idea is inclusively defined in another statement by Madame Blavatsky, which comprises one of her most essential pronouncements upon the nature of man:

> Man is a little world—a microcosm inside the great universe. Like a foetus, he is suspended, by all his *three* spirits, in the matrix of the macrocosmos; and while his terrestrial body is in sympathy with its parent earth, his astral soul lives in unison with the sidereal *anima mundi*. He is in it, as it is in him, for the world-pervading element fills all space, and *is* space itself, only shoreless and infinite. As to his third spirit, the divine, what is it but an infinitesimal ray, one of the countless radiations proceeding directly from the Highest

Cause—the Spiritual light of the world. This is the trinity of organic and inorganic nature—the spiritual and the physical, which are three in one. . . .[35]

According to this principle, not merely the figure at left but all three females participate as physical beings in the world of matter, while the astral colors in which each is shrouded suggest the "sidereal *anima mundi*," which as "the world-pervading element fills all space, and *is* space itself." Finally, at least the center figure may be considered representative of mankind's "third spirit, the divine," conceived as "one of the countless radiations proceeding directly from the Highest Cause —the Spiritual light of the world." As such, these figures embody what Blavatsky described as "the same all-constructing and uniting principle of production," which is no more than to say the idea of evolution as defined by Theosophy.

It is in this same exalted metaphysical context that one must analyze the various geometric figures, particularly triangles, that occur within the composition. These Mondrian attached to the navels and breast nipples of the figures (most probably through Theosophic identification of such body parts with the *anima mundi*), but also to the "flower" images that are placed with heraldic symmetry near the figures' heads. Here, too, a progression from matter to spirit is operative. At left the triangles, including that at the center of the flower image, point downward, at right overlapping downward- and upward-pointing triangles form a six-pointed star, the emblem of Theosophy,[36] and at center upward-pointing triangles are inscribed in circles. As any seriously interested student of Theosophy would know, the respectively downward- and upward-pointing triangles basically indicate the opposing principles of matter and spirit that sometimes interpenetrate and achieve balance in the "sacred hexagram." This abstract imagery thus derives from those same metaphysical principles with which Blavatsky described the nature of man. This philosophy is perhaps best described as a kind of "tripartite dualism," since even the triangle itself participates in a related dualist principle. As the founder of Theosophy writes:

The triangle played a prominent part in the religious symbolism of every great nation; for everywhere it represented the three great principles—spirit, force and matter; or the active (male), passive (female), and the dual or correlative principle which partakes of both and binds the two together.[37]

This latter "dual or correlative principle," incidentally, frequently is identified within Theosophic writings as androgynous, an idea that may help to explain the expressively masculine aspect of Mondrian's ostensibly female figures. In any case, in her exegesis of the Theosophic hexagram, Blavatsky identifies the significance of triangles with a basically dualist philosophy:

> In the great geometrical figure which has the double figure in it [i.e., a double hexagram, as that accompanying the figure at right in the *Evolution*] the central circle represents the world within the universe. . . . The triangle with its apex pointing upward indicates the male principle, downward the female; the two typifying, at the same time, spirit and matter.[38]

In reference to the *Evolution,* this text explains not only the presence and meaning of the Theosophic hexagram, but also why Mondrian chose to inscribe within circles the upward-pointing triangles that occur with the figure at center. For Blavatsky the circle, too, comprises a profoundly meaningful spiritual essence. Its use by Mondrian thus elevates the center figure to a mystical status identified with the "worlds within the universe," or with the force of cosmic creation and evolution itself. In fact, both her triangular emblems of spirit and the head of this center figure appear embedded in radiating auras of white and yellow light in striking similarity to the diagrams used by Blavatsky to explain the first principles of the cosmos. A variant use of this same abstract iconography can be found in a paradigmatic example of Dutch Symbolist art, a woodcut known as *The Marriage* (1894) by the architect and Theosophist K. P. C. de Bazel.[39] Although this minor illustration retains a descriptive Christian symbolism of monk, nun, and God the Father, the marriage (i.e., shunned by the monastic devotees but not by the kneeling couple at center) can also be interpreted as one between male spirit and female matter. Thus the triangle that radiates rays of divine light from behind the head of the God Father image above performs the same mystical functions of perpetual creation and the uniting of opposing male and female principles that may be assumed for the center figure in the *Evolution.* Whether known to Mondrian or not, the de Bazel woodcut illustrates the seriousness with which Dutch artistic and intellectual circles treated the esoteric theories exemplified in the writings of Madame Blavatsky. It is doubtless the widespread currency of this esoteric Symbolist tradition in Holland that explains why Mondrian could present the essential cosmological theories of Thesophy

in a form as iconographically sparse, if physically monumental, as the *Evolution* triptych, and nonetheless expect that his meaning would be understood.

However, it is not only as a refined distillation of Symbolist and Theosophic thinking that the *Evolution* was important in the career of Mondrian. The ideas it embodied proved of equal importance to his future stylistic development, especially during the Cubist and immediately post-Cubist periods of circa 1912 to 1917. During these years, as mentioned above, virtually all Mondrian's major compositions employed some form of underlying or overt grid of vertical and horizontal lines. Frequently the dispersion of linear elements was contained within a circular or oval perimeter, which nonetheless allowed for a varied play of curvi- and rectilinear forms. In fact, for Blavatsky, who introduced into Theosophic literature the alleged quotation from Plato "God geometrizes," all basic geometric shapes bear witness to the same doctrines that she discusses in reference to the triangle. The triangle, with its three-in-one character, comprises for her at the same time the "mystic four," which concept also is "summarized in the unity of one supreme Deity." In reference to the Greek cross, which she calls the Egyptian cross and places at the very center of her hexagram and inscribes within a circle,[40] this too embodies the same unitarian, dual, tripartite, and quadripartite concepts elsewhere associated with the triangle. As well as speaking of "the celestial perpendicular and the terrestrial horizontal base line," she observes that "the vertical line being the male principle, and the horizontal being the female, out of the union of the two at the intersection is formed the *cross*." Far transcending in significance its historical occurrence within any particular religion, the cross, like other geometric figures, expresses a single mystical concept of life and immortality. Blavatsky summarizes this concept conveniently in another and our final quotation:

> The philosophical cross, the two lines running in opposite directions, the horizontal and the perpendicular, the height and the breadth, which the geometrizing Deity divides at the intersecting point, and which forms the magical as well as the scientific quaternary, when it is inscribed within the perfect square, is the basis of the occultist. Within its mystical precinct lies the master-key which opens the door of every science, physical as well as spiritual. It symbolizes our human existence, for the circle of life circumscribes the four points of the cross, which represent in succession birth, life, death, and IMMORTALITY. Everything in this world

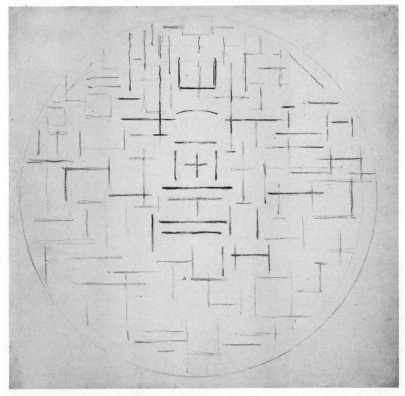

101. Piet Mondrian: *Circular Composition: Church Facade*. c. 1914. Charcoal on board. 43¾″ × 45″. Courtesy Sidney Janis Gallery, New York.

is a trinity completed by the quaternary, and every element is divisible on this same principle.[41]

Such was the weight of philosophical meaning borne by the mystical cross of Theosophy and by the other geometric forms that relate to it. Considering the importance of simple, two-dimensional geometric forms to Theosophic teaching, it is not surprising that shortly after completing the *Evolution* triptych, Mondrian introduced and increasingly emphasized a free play of often crossing vertical and horizontal lines as the basis for his evolving compositional experiment.[42] Indeed, since "the four points of the cross . . . represent in succession birth, life, death, and IMMORTALITY," the cross, too, may be thought emblematic of those cosmic processes that Theosophy sums up in the term *evolution*. In one large drawing from circa 1914, the *Circular Composition: Church Facade* (fig. 101), Mondrian apparently wished to express this

Theosophic content in a relatively direct and comprehensive manner. Although derived in terms of its natural subject from a circular window containing an inscribed Greek cross that decorates the facade of the Roman Catholic church Notre Dame des Champs in Paris,[43] this drawing can be interpreted iconographically as a tribute to all the abstract geometric configurations, the meaning of which is summarized in the philosophical cross of Blavatsky. Significantly, the artist inscribed upon a smaller drawing of this same subject the observation that, "If one does not represent things [i.e., natural objects as such], a place remains for the Divine."[44]

In similar fashion, although concomitantly inspired by models in the work of Braque and Picasso, Mondrian's adoption in such 1913 works as the *Oval Composition with Trees* of a well-defined oval compositional border also very likely carried with it an iconographic meaning derived from Theosophy. The oval is viewed within Theosophy as a variant form of the circle, and was identified by Madame Blavatsky and her followers[45] with the "world egg" of Hindu mythology, which concept, therefore, also relates directly to the theme of cosmic birth and evolution. Finally, even Mondrian's use beginning circa 1918 of the lozenge compositional format probably owes some carried-over debt to an esoteric interpretation of geometric form. His diamond-shaped canvases in fact comprise perfect squares turned to stand upon a corner point, which shape, as such, can be thought to circumscribe an imaginary upright Greek cross. At the same time, this format also may be read as an alternative form of the Theosophic double triangle, which is to say, as two triangles joined at a horizontal line bisecting the lozenge.[46] These are only a few salient possibilities, limited to the plastic or *beeldend* element "line," in which the artist's use of geometric elements of expression can be associated with the cosmological theories of Madame Blavatsky. In each instance, the Theosophic concept that justifies in iconographic terms the diagrammatic shapes found in the emerging abstract art of Mondian relates to the movement's cardinal Doctrine of Evolution. It is thus not by chance that the artist chose this doctrine to commemorate in his triptych of 1911, nor that it is cited specifically, indeed provides the underlying theme, in the two annotated sketchbooks that he produced during the Cubist years circa 1912 to 1914.

The early intrusion of Theosophic beliefs in Mondrian's art was of profound meaning to his development of a fully abstract style (see figs. 90, 91). Above all, his precipitate adoption of Cubist style during the

winter of 1911/12 and his immediate enthusiasm for the writings of Schoenmaekers may now be interpreted to have resulted from his previous deep involvement with Theosophic teachings. Not that this fact diminishes the importance of either the Cubists' or Schoenmaekers's influence upon the art of Mondrian. The writings of Blavatsky and Steiner by no means constituted an exclusive source of inspiration during his periods of transition to abstract art. Indeed, throughout the years 1908 to 1917, virtually every major painting within his numerically restricted oeuvre deserves special attention for the idiosyncratic fusion of natural subject, esoteric iconography, and employment of style that it contains. While typically unorthodox in approach, Mondrian's successive use of the Art Nouveau, pointillist, and Cubist styles was invariably inventive and aesthetically satisfying. Consequently, whereas many viewers of the present, unprecedentedly complete showing of his mature work will have little interest in Mondrian's Theosophic iconography, they readily will respond to the extraordinary quality of his handling of color, brushwork, and compositional structure.* In this respect, the *Evolution* and such related works as the *Church at Domburg* (1910–1911) and *The Red Mill* (1911)[47] may appeal to a present-day audience chiefly for the optical phenomena of intense color luminosity and irradiation that they contain and that so clearly anticipate contemporary artistic trends. Similarly, no one who seriously studies Mondrian's abstract work in the original will confuse his paintings—enlivened as they are by subtle tensions of line, color, implied movement, and generated space—with the theoretical preoccupations that inform his iconographic content. Nonetheless, it was with the aid of such preoccupations that Mondrian achieved the artistic results on view in the present exhibition. If for no other reason than this, one may feel grateful for the contribution made by Theosophic doctrine to the art of one of the major painters of the present century.

NOTES

1. I.e., *De Stijl*, 1–2, October 2, 1917–October 1918.
2. See Michel Seuphor, *Piet Mondrian, Life and Work* (New York: Harry N. Abrams, Inc., 1956), pp. 132–134.

* "Piet Mondrian: 1872–1944, Centennial Exhibition," The Solomon R. Guggenheim Museum, New York, 1971.—Eds.

3. See Hans L. C. Jaffé, *De Stijl 1917–31: Dutch Contribution to Modern Art* (London: Alec Tiranti, 1956), pp. 53–62. See also Mr. Wijsenbeek's article in the present catalogue. [Welsh refers here and in note 32 to essays that appeared in the *Piet Mondrian Centennial Exhibition* catalogue, The Solomon R. Guggenheim Museum, 1971.—Eds.]

4. Translated in *Two Mondrian Sketchbooks, 1912–14* (Amsterdam: Meulenhoff International, 1969). Robert Welsh, Introduction and English translation; Joop Joosten, ed., pp. 9–10.

5. M. D. Henkel, "St. Lucas-Ausstellung," *Kunstchroniek,* June 6, 1910, and "Ausstellung der Kubisten in dem 'Moderne Kunstkring' zu Amsterdam," *Kunstchroniek,* December 22, 1911.

6. "Documentatie over Mondrian, 1–3," *Museumjournaal voor Moderne Kunst,* 13, nos. 4–6, 1968, pp. 208–215, 267–270, 321–326; letters 7 and 10.

7. *Sketchbooks,* p. 13.

8. "Documentatie 1," especially letter 5.

9. Published in Bussum, Holland: C. A. J. van Dishoek.

10. See R. P. Welsh, "Mondrian," *Revue de l'Art,* no. 5, 1969, pp. 99–100.

11. The original owner, Mr. A. P. van den Briel, repeatedly advised the present writer that this watercolor was in his possession by 1904 at the latest and, according to his memory, had been executed several years earlier.

12. Exhibited Amsterdam, January 1909, at the Stedelijk Museum, no known catalogue.

13. Exhibited Amsterdam, October–November 1911, *Moderne Kunstkring,* no. 97.

14. In "Mondrian and the Dutch Symbolists," *The Art Journal,* 23, no. 2, Winter 1963–1964, pp. 103–111.

15. *Ibid.,* pp. 105–106.

16. In conversation with the present writer.

17. See F. M. Lurasco, ed., *Onze Moderne Meesters* (Amsterdam: C. L. G. Veldt, 1907), under "Piet Mondrian," n. p.

18. *Sketchbooks,* p. 10.

19. Known in the literature on Mondrian from the title of the first recorded lecture, "Mystiek en Esoterik," since the title page of the artist's copy is missing (hereafter cited as *Dutch Lectures*).

20. *Ibid.,* p. 32. Though unacknowledged, Steiner's concept of *devotion* owes much to the *Thought Forms* of A. Besant and C. W. Leadbeater (Dutch trans.: 1905) and, through these writers, to Madame H. P. Blavatsky, the founding spirit of modern Theosophy. The source of Mondrian's interpretation is therefore not necessarily limited to the writings of Steiner.

21. Especially in the popular introductory texts, *Theosophy* and *Knowledge of the Higher Worlds,* which Mondrian could have known in the original German versions (Dutch trans.: 1909 and 1911 respectively).

22. Steiner had begun his career by editing the scientific writings of Goethe.

23. Here, too, Steiner was reiterating standard Theosophic doctrine. For the general teachings of Theosophy and their relation to the development of abstract art, see Sixten Ringbom, "Art in the 'Epoch of the Great Spiritual,'" *Journal of the Warburg and Courtauld Institutes,* 29, 1966, pp. 386–418.

24. *Dutch Lectures,* p. 2. The following discussion of Steiner's theories is based on statements found in this same text.

25. *Sketchbooks,* p. 9 and note 10.

26. I.e., letter to Mrs. August de Meester-Obreen, "Documentatie 2," p. 267.

27. The ideas relevant to the present discussion were proliferated in numerous texts, lectures, and discussions undertaken by Madame Blavatsky and her followers. However, for the sake of convenience and because its role as a source for other quotations often has been overlooked, the monumental, two-volume *Isis Unveiled* (New York: J. W. Bouton, 1877), and especially its discussion of two cosmological diagrams (II, pp. 266–271), will provide the exclusive text upon which our discussion is based. In the original Dutch translation, vol. I is dated 1911 and vol II 1914, but, in fact, both volumes were available through serialized installments (published respectively, 1908–1910 and 1911–1914).

28. *Sketchbooks,* p. 64.

29. E.g. James, *op. cit.,* pp. 106–107. However, the present writer has found virtually no evidence that the work of Munch was either exhibited in Holland or illustrated in Dutch art journals by the date that the *Passion Flower* or even the *Evolution* was executed. In any case, such an influence would have been a formal one at most.

30. Either this or a second version (now private collection, France) was exhibited Amsterdam, April–June 1910, at St. Lucas, no. 490.

31. E.g. the virginal symbols of lilies at left and rose garden at center.

32. In *De Stijl,* 1, no. 3, p. 30, note 3 (1968 edition, p. 46) Mondrian rejects the "imitation of astral colours" as incompatible with his approach to painting, which he then described as "abstract-real." See Miss Charmion von Wiegand's remarks on this subject in the present catalogue, p. 81.

33. I.e., the Dutch architect and Theosophist, J. L. M. Lauweriks, writing on "Rembrandt and Theosophy," *Theosophia,* 15, July 1906, p. 136.

34. *Isis Unveiled,* I, p. 212. James, *op. cit.,* p. 107, was the first to discover in a similar quotation from Ed. Schurés, *Les Grand Initiés* (Dutch trans.: 1907) an essential iconographic aspect of Mondrian's triptych. However, apart from documenting the availability of Madame Blavatsky's ideas in this popularized secondary source (see note 27 above), the quotation does not prove equally applicable to the *Three Brides* according to the strict form of James's analysis.

35. *Ibid.*

36. As found, for example, on Mondrian's membership certificate, preserved by the artist's heir, Mr. Harry Holtzman.

37. *Isis Unveiled,* II, p. 269 (i.e., in reference to the "Chaldean" diagram that follows p. 264).

38. *Ibid.,* p. 270, in reference to the Hindu diagram placed adjacent to the "Chaldean."

39. I.e., no. 12 in *De Houtsneden van K. P. C. de Bazel* (Amsterdam: S. L. van Looy, 1925), whose editor, J. L. M. Lauweriks (see note 33) in his introduction refers to de Bazel's wish with his woodcuts "to make visible the supersensory world."

40. I.e., in her "Hindu" and "Chaldean" diagrams, *Isis Unveiled* (see notes 37 and 38), to which the shorter quotations given in the present text also allude.

41. *Isis Unveiled,* I, p. 508.

42. See note 10.

43. See Toronto, The Art Gallery of Toronto, *Piet Mondrian, 1872–1944,* February 12–March 20, 1966. Exhibition catalogue. Text by Robert Welsh. Catalogue nos. 76–78 and especially fig. 23. Elsewhere (see note 10), the present writer has connected the Notre Dame des Champs subject with the *Composition in Color A* and *Composition in Color B,* which relationship is also found in the related drawings (see catalogue nos. 81 and 82).

44. *Sketchbooks,* p. 67.

45. I.e., including by the Theosophist-Christosoph Dr. Schoenmaekers, beginning with his *Mensch en Natuur* (1913), which may be considered a personal interpretation of standard Theosophic doctrine.

46. This alternate usage is found in the hexagram and body emblems of the figure at right in the *Evolution,* and may already have been incorporated into the *Arum Lily* of the previous year.

47. These works also contain triangulated design elements that relate to the iconographic content found in the *Evolution,* as the present writer will discuss in greater detail in a book in preparation on the pre–De Stijl work of Mondrian.

Kandinsky and Abstraction:
The Role of the Hidden Image*

ROSE-CAROL WASHTON LONG

Long studies Wassily Kandinsky's paintings from the years 1909 to 1914 and uncovers traces of recognizable subject matter that the artist disguised by "stripping and hiding imagery." This occurred immediately before Kandinsky developed his abstract style. Further, Long establishes iconographic sources for Kandinsky's images in the Bible and, more specifically, in Theosophist Rudolf Steiner's reading of the book of The Revelation to John. By choosing themes such as "The Deluge" and "The Last Judgment," Kandinsky hoped to lead the viewer into a world of inner spiritual experience. In his major theoretical writing, *Concerning the Spiritual in Art* (1912), Kandinsky claims that painting will advance "the epoch of great spirituality." His messianic spirit parallels Mondrian.

This essay is part of the author's forthcoming book on Kandinsky. Rose-Carol Washton Long is assistant professor of Fine Arts at Queens College, New York.

* Reprinted from *Artforum,* 10, no. 10 (June 1972).

In an autobiographical statement published in 1919, Wassily Kandinsky claimed he painted his first abstract work in 1911.[1] However, in his essays written before World War I, he made no mention of abstract works before the middle of 1913.[2] No wonder then that one of Kandinsky's biographers, when faced with describing the paintings of the period 1911 to 1913, wrote in 1924: "One thinks one sees in the works from 1911–1913 vegetables, meteorological forms, remnants of trees, water, fog, but by careful concentration one is able to make these figments of our imagination disappear."[3] This expression of uneasiness about the seeming presence of images in Kandinsky's works betrays the conflict many have felt when seeking to establish a clear cutoff date for Kandinsky's excursion into abstraction. Kandinsky's remarks of 1919 have been used to support the misconception that the imagery, actually visible in his paintings from 1911 through 1914, does not really exist. This contradiction between what one sees in the paintings and what one frequently reads is partly due to the fact that Kandinsky's interpretation of abstraction changed between 1913 and 1919.

Before World War I, Kandinsky sought to develop an abstract style by increasingly veiling and stripping his imagery, which he retained to provide the spectator with a key to his apocalyptic visions of a coming utopia. In essays written in 1911, 1912, and 1913, he stressed the importance of this "hidden" imagery, stating that it gave expressive power to a painting and that it would be the first step toward the development of a "pure art." In the essay of 1919, however, Kandinsky no longer mentioned the importance of imagery or its transference into a "construction" as the key element in the creation of abstract painting. By this date, Kandinsky had left Munich and returned to his native land—Russia—where he was exposed to a number of abstract artists using geometric forms. The success of these abstractionists seems to have moved Kandinsky to emphasize an earlier date for his own excursions into abstraction, and to deny the importance of the hidden object in his own development.

Until recently[4] most studies of Kandinsky's work before World War I emphasize those paintings that appeared to use only pure form and color, and as a result they ignore the most interesting aspects of Kandinsky's development during this period: (1) his determination to communicate, (2) his stripping and hiding of imagery[5] to create an effect that moved more and more toward the subliminal, (3) his fears of abstraction becoming merely decorative, and (4) the influences that shaped his gradual resolution of these somewhat contradictory aims.

Kandinsky's determination to communicate a messianic vision led him to search for a "spiritual" form freed from representational elements, which he considered materialistic. Although he envisioned abstraction as having the most potential for the expression of his antimaterialistic values, he feared that neither artists nor spectators would be able to grasp its "meaning" and would see it as mere decoration. Consequently, he worked with veiled and stripped imagery as a means of developing an abstract style that would not lose its power to communicate its message to the uninitiated.

Reaching the spectator was a major goal for Kandinsky, for he believed that man stood at the threshold of a new spiritual realm and that the arts would, through the stimulation of the senses, lead mankind to this new age. In his major theoretical tract of the period, *Concerning the Spiritual in Art,* published in 1912, Kandinsky explained that art was "one of the most powerful agents of the spiritual life," a "complicated but definite movement forward and upward."[6] He viewed all of his efforts of this period as steps toward achieving this goal. In his autobiography of 1913, for example, he clearly stated that *Concerning the Spiritual in Art* and the almanac, *Der Blaue Reiter,* were conceived for the explicit purpose of awakening the "capacity, absolutely necessary in the future, for infinite experiences of the spiritual."[7] He repeatedly wrote that he wanted his works of art to *klingen,* to sound, so that they would send "vibrations" into the human soul and help to elevate the human spirit. Kandinsky's wish to use all the means at his disposal to communicate his ideas even led him to experiment with a stage composition during this period. He felt that a stage work incorporating music, poetry, painting, and dance, which he called the "monumental art work," would have a greater possibility of reaching the minds of his audience, since those who were only capable of responding to one of the arts would more easily become involved,[8] or, as Kandinsky would express it, "vibrated." However, he devoted his major efforts before World War I to painting, and he ended *Concerning the Spiritual* with the optimistic statement that the type of painting he envisioned would advance "the reconstruction already begun, of the new spiritual realm . . . the epoch of great spirituality."[9]

Although Kandinsky's interpretation of his era as one dominated by a struggle between the forces of good, or "the spiritual," and the forces of evil, or materialism, reflects many of the intellectual currents of the turn of the century, several historians have suggested that Kandinsky's "new spiritual realm" was a reference to a Theosophical

utopia.[10] Certainly, statements in *Concerning the Spiritual* that describe Theosophy as "one of the greatest spiritual movements" of his time and as a "strong agent in the spiritual atmosphere, offering redemption to despondent and gloomy hearts,"[11] indicate that Kandinsky viewed favorably the Theosophical search for universal hidden truths. Although Kandinsky never called himself a Theosophist and remained somewhat skeptical of this movement's optimism, he went so far as to include in *Concerning the Spiritual* the conclusion from one of the books written by the founder of the Theosophical Society, Madame Blavatsky, which proclaimed: "Earth will be a heaven in the twenty-first century in comparison with what it is at present."[12] While Kandinsky reserved praise for only a few individuals in this essay, he did give the most laudatory comments to Blavatsky and to Rudolf Steiner, another major leader of the Theosophical movement. Although Blavatsky was highly venerated, Steiner, who was the head of the German Theosophical Society and whose home base was Munich, appears to have been the dominant influence on Kandinsky. Steiner's physical presence in Munich during this period, his belief that artistic experiences were the strongest stimulant for the development of an understanding of the spiritual, plus his own artistic activities, undoubtedly contributed to Kandinsky's interest in this Theosophist. Moreover, Kandinsky, who often compared himself and his friends to the early Christians for trying to raise "the weakest to spiritual battle,"[13] and who frequently referred to his love for the Russian church, must have been attracted by Steiner's interpretation that Christianity incorporated the wisdom of all previous religions and cults and consequently offered the richest source for advancing the destiny of mankind. While Blavatsky emphasized the importance of Hinduism and Buddhism, Steiner used The Revelation to John as the major framework to express his belief in the inevitability of catastrophe before the emergence of a new epoch.[14]

Steiner's prophecies must have seemed a continuation of many of the apocalyptic notions prevalent in the early years of the twentieth century. Many of the French and Russian Symbolists, and those in their circle to whom Kandinsky had been exposed since the late 1890s,[15] had written of the need for a new spiritual era. For example, the Russian philosopher Vladimir Solov'ev, whom Steiner admired, prophesied before his death in 1900 that the apocalyptic expectations of Saint John would soon occur.[16] Moreover, since 1906, Steiner had been friendly with the French Theosophist Édouard Schuré, whose books, *Les grands initiés*

in particular, were studied by many of the painters and writers associated with French Symbolism. Schuré, in addition, had been involved in the 1890s with the theatrical experiments of the Rosicrucian group of Sar Peladan, whom Kandinsky praised in *Concerning the Spiritual.*

Kandinsky's contact with Steiner's Christian Theosophy and his interpretation of The Revelation to John[17] may be responsible for Kandinsky's increasing use of religious motifs from 1909 to 1914,[18] at a time when he was also becoming increasingly interested in abstraction. Beginning late in 1909, Kandinsky started to use apocalyptic images in paintings to which he frequently gave clear eschatological titles,[19] such as *Horsemen of the Apocalypse, Deluge, All Saints' Day, Last Judgment,* and *Resurrection.* He used the terms "Last Judgment" and "Resurrection," or awakening of the dead, interchangeably. These works contain a number of similar motifs, such as angels blowing trumpets, figures rising from their graves, cities falling, lightning, which correspond to the description of the Day of Judgment in The Revelation to John.[20] The number of works with these religious motifs and titles reached its height during 1911. During that year, Steiner was especially active in Munich forming an organization called Johannes-Bauverein to support his theatrical productions, and Kandinsky, working in Munich and Murnau, was involved with the collection of material for the almanac, *Der Blaue Reiter,* which he and Franz Marc were editing,[21] in addition to preparing the manuscript of *Concerning the Spiritual in Art* for publication. In both works Kandinsky indicated that his concept of the spiritual rested on a new interpretation of Christianity, one not tied to established religion, which he felt had abandoned its responsibility. The Christian emphasis, not dominant in Kandinsky's works before 1909, can easily be seen when one compares the cover of *Concerning the Spiritual in Art,* with its apocalyptic overtones, to a membership card Kandinsky designed earlier for an artists' association formed in 1909. In the card for the Neue Künstlervereinigung, a fairy-tale ambience, and not a religious one, dominates, whereas the cover of *Concerning the Spiritual in Art* (1912; fig. 102) derives from the center of a glass painting of 1911, which takes its title from the Russian words for Resurrection written on the preparatory sketch (1911; fig. 103). The motif on the cover is quite simplified, but the outline of a mountain topped by a city with falling towers and a horse and rider can be identified if one compares it to the motif in the center of the glass painting. The Christian overtones evident in *Concerning the Spiritual*

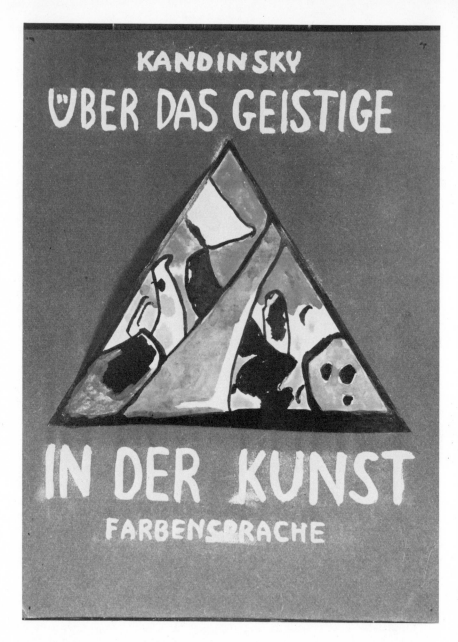

102. Wassily Kandinsky: Cover for *Concerning the Spiritual in Art*. 1912. Collection Städtische Galerie, Lenbachhaus, Munich.

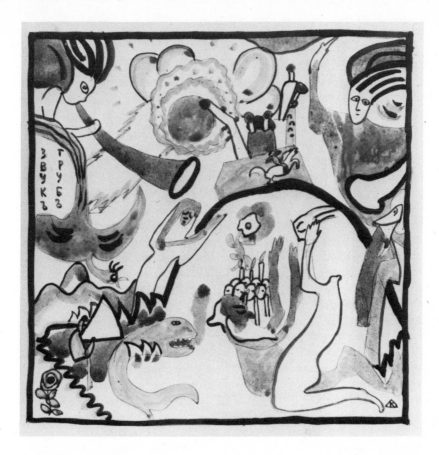

103. Wassily Kandinsky: Study for *Resurrection.* 1911. Watercolor. 12¾″ × 12¾″. Collection Städtische Galerie, Lenbachhaus, Munich.

are also apparent on the cover of the almanac, *Der Blaue Reiter,* which, like the essay, was compiled to "awaken the spiritual." The prophetic mood of religious conversion can be sensed when one analyzes the source from which the cover was derived. This cover, based on a glass painting derived from the Bavarian folk images of Saint George and Saint Martin,[22] who were associated with the conversion of heathens through their good deeds, reflected the similarity Kandinsky and Marc saw between their goals and those of the early Christians.

At times, Kandinsky's use of apocalyptic and Christian imagery has been attributed to an interest in fifteenth-century German Bible

illustration and in the Bavarian folk paintings on glass prevalent in Germany before World War I. Attributing Kandinsky's choice of motifs to a purely aesthetic interest in the formal aspects of such works ignores his overriding messianic outlook and his Russian background.[23] It seems more likely that folk art attracted him as a means of expressing his messianic intent, for he felt folk art was "purer" than Western art of the academic tradition. In some way he equated the artist's study of folk, primitive, and Gothic art with the Theosophical study of hypnosis and mesmerism, for both groups were seeking knowledge in areas not previously admired by the establishment. That Kandinsky's primary interest was not in the formalistic aspects of primitive art is reflected in his attempt to obscure the motifs that he borrowed from earlier styles. He felt that a style from another age could not transmit his message, for it had to be clothed in a form that grew out of his generation's experience. Believing that each period of culture produced its own art, Kandinsky maintained that if artists were to be effective, they should reflect the mood of their day, which he described as one of conflict, contradiction, dissonance, and confusion. But at the same time he felt artists should be able to point to the future with their works.[24] Consequently, Kandinsky could not be satisfied with imagery as clearly defined as that in *Resurrection,* where the bent tower and clouds of the central motif are derived, for example, from a fifteenth-century woodcut for the Nuremberg Bible.[25] For the cover of *Concerning the Spiritual,* Kandinsky hid the central motif from *Resurrection* to such a degree that the imagery and the theme are barely recognizable. Hiding the imagery, then, was a way in which Kandinsky could create a mood of confusion and yet also use the image to help lead one out of the initial confusion, thereby suggesting hope for the future. This is the logical basis for the remnants of imagery based on apocalyptic motifs that persisted in Kandinsky's work even as he moved ever closer to abstraction during this period.

We find that although Kandinsky gave only a few works religious titles after 1911, he still retained motifs, albeit largely hidden, that related to those in his titled religious paintings. In paintings such as *Composition V* (1911) or *Composition VI* (1913), he indicated in essays that the imagery of trumpets, angels, and boats, were not merely formal solutions but were included because the theme of *Composition V* had its origin in the Resurrection, or the awakening of the dead, and *Composition VI* had been suggested by the biblical flood.[26] In these

large oils the imagery is not easily perceived. However, usually one motif, such as the trumpet in *Composition V,* helps to bring the rest of the imagery into focus. Even those paintings with religious titles after 1911 seem to have no discernible imagery until one finds a key motif. For example, the glass painting, *Last Judgment* (1912), begins to come into focus only when one concentrates on the black-outlined trumpet in the upper right. When this work is compared to an earlier painting, such as *Resurrection* (1911), even more of the nondelineatory lines take on specific forms; the curved black lines in the upper center suddenly come into focus as the outline of a mountain topped by a walled city with falling towers. The themes of most of the paintings from 1912, 1913, and 1914, which had neither title nor written description, can be clarified when the works are compared to earlier paintings.

Although Kandinsky believed that color could have the same emotional intensity as music, could communicate thought, and that line could suggest dancelike motion, he maintained that color and line alone could not be the basis for the development of an abstract style. As he explained in *Concerning the Spiritual,* artists as well as spectators needed reference points from the external world; otherwise, the use of pure color and independent form would result in "geometric decoration, resembling something like a necktie or a carpet."[27] In his autobiography (1913) he wrote of the great demands that an abstract art would make on the spectator. Consequently, he urged artists to lead the spectator into the abstract sphere step by step, balancing abstract forms with barely perceptible signs. He suggested that objects could be transformed into these hidden signs and could become an additional means of causing a vibration. In *Concerning the Spiritual,* which contains the most extensive discussion of how the object could have an evocative power similar to that of pure color and form, Kandinsky explained that a combination of veiling the object with ambiguous shapes and colors and also stripping the object into a skeletonlike outline, or construction (as he did for the cover motifs), would create a "new possibility of leitmotivs for form composition."[28] He proclaimed: "It is not obvious (geometrical) constructions that will be richest in possibilities for expression but hidden ones, emerging unnoticed from the canvas and meant definitely for the soul rather than the eye."[29] Small wonder then that the 1924 biographer might have seen "trees, water, fog" and was genuinely bewildered by Kandinsky's insistence in 1919 that his first "abstract" work bore a date of 1911. Of course, even in 1919 Kandinsky did not claim that he painted only abstract works in 1911, but many critics nonetheless

refused to allow themselves to see imagery in Kandinsky's paintings after that date. As late as September 1913, in an essay called "Painting as Pure Art," Kandinsky continued to emphasize that the first step toward a "pure art" was the "replacement of the corporeal [object] with the construction."[30]

Kandinsky's concept of the hidden image as a means of achieving this first step has certain parallels with Steiner's ideas about how knowledge of the "higher worlds" should be communicated. Since Steiner believed that the uninitiated could not directly experience the "spiritual world" where colors and forms floated in space, he suggested that those who hoped to reach out to the layman must begin with something tangible, with physical matter. Although Steiner stressed that the artist or seer use myth, sagas, similes, and comparisons to begin his instructions, he advised that directions not be too clear. He believed that hidden and ambiguous suggestions would be the most powerful. He felt that if the student had to decipher the message, he would reach a new understanding in the process. In the preface to one of his books Steiner warned the reader that every page would have to be "worked out" if the reader wished to experience the message of the book.[31] Influenced by Symbolist theories, Steiner believed that the indirect rather than the direct would lead the way to the spiritual world.[32]

Although Steiner may have reinforced Kandinsky's antinaturalist orientation and although his emphasis on The Revelation to John may have offered Kandinsky a myth or saga upon which he could base his message of struggle and redemption, Steiner's own artistic efforts were rather heavy-handed and did not offer Kandinsky a model for solving the artistic problems he felt. Instead, Kandinsky drew upon the Symbolist aesthetic itself,[33] with its emphasis on the suggestive, the mysterious, and the indirect, for a solution to the conflict that grew out of his desire to reduce representational elements in his paintings without having the resulting shapes degenerate into meaningless geometric patterns. The Symbolist theory of language, which emphasized that words could create a strong emotional impact if their literal meanings were disguised, provided Kandinsky with a theoretical basis for hiding and veiling the objects in his paintings. A belief in synesthesia allowed Kandinsky to transfer a theory formulated for poetry and drama to the visual arts; it allowed him to believe that he could give to the visual object the evocative power the Symbolist poets and dramatists gave to words.

Although the Symbolist concept of language found coherent expression in many individuals, the Belgian dramatist Maurice Maeter-

linck is the only Symbolist to be discussed at length in the text of *Concerning the Spiritual*. Not only did Kandinsky cite three of Maeterlinck's plays and one essay, but he stated that his approach to language held "great possibilities for the future of literature."[34] Maeterlinck, who was praised by Kandinsky for expressing the transcendental through artistic means, was also highly regarded by Steiner, who described his work as one of the most "distinguished experiences of the modern soul."[35]

Maeterlinck, who had been attentive to the ideas of the French Symbolist poets in addition to the theories of numerous universalist cults, such as the Rosicrucians, Theosophists, and Swedenborgians, popular in the 1890s in France,[36] emphasized in his writings that a new language and a new type of theatre were needed to enable men to experience the transcendental in their daily lives. Kandinsky called Maeterlinck a clairvoyant and a prophet because he felt the dramatist's use of ambiguity and mystery in his plays and poems reflected the anxieties and turmoil of his age. In *Concerning the Spiritual* Kandinsky devoted considerable space to an analysis of Maeterlinck's use of words to manipulate moods "artistically." Maeterlinck, Kandinsky stressed, removed the external reference from words by constant repetition and by dislocation from the narrative. Kandinsky translated Maeterlinck's suggestions for the dematerialization of words into his own proposal for the dematerialization of objects, writing: "Just as each spoken word (tree, sky, man) has an inner vibration, so does each represented object."[37] He proposed to simplify the object to a residual, organic form that would have the same evocative effect as the symbolic word by placing the object in an unusual context, by hiding its external form beneath veils of color, or by stripping it to a construction. Just as the word could be used for its sound in addition to its notational value, so did Kandinsky believe that the residual object could be used to reinforce the effect of pure color and pure form. If the object were hidden, that is, if the object became indirect, the inner vibration would be stronger.

Painters connected with Maeterlinck and other Symbolists helped to reinforce Kandinsky's faith in the power of the hidden. He could study the paintings of Denis and Redon, both of whom he admired,[38] and examine how they used color and a loose brushstroke to dematerialize their images. Certainly in the actual development of Kandinsky's style, these painters, in addition to Matisse, are far more important than any of the Theosophical drawings of "thought forms" that have been

suggested as key influences in the evolution of Kandinsky's abstraction.[39]

While Theosophical drawings may not have had much influence on Kandinsky's stylistic development, Steiner's messianic program and his insistence on providing keys to the spectator through myth seems to have led Kandinsky to use images of an apocalyptic nature in his paintings. The Symbolist admiration for the mysterious and the ambiguous, in addition to Steiner's emphasis on the indirect, most likely moved Kandinsky to the use of barely perceptible images combined with nondelineatory colors and forms as a means of leading the observer into the spiritual realm.

The interaction of Symbolist and Theosophical ideas in Kandinsky's development before World War I is particularly evident in his experiments with stage compositions, which incorporated music, dance, painting, and poetry. Although none of his plays was performed and only one, Der gelbe Klang (The Yellow Sound), was published in Der Blaue Reiter almanac,[40] the theatre seemed to stand next to painting in Kandinsky's interests. While Kandinsky's fascination with the possibilities of a "total artwork" based on a stage composition may have originally developed from seeing and reading the work of Wagner[41]— the hero of many Symbolist groups—Steiner's adoption of Wagner's idea that the theatre should be the focus for the creation of a religious art[42] must have strengthened Kandinsky's desire to experiment with stage composition. Kandinsky could easily have seen one of the "mystery" dramas of Steiner and Schuré, which Steiner produced in Munich between 1907 and 1913. Indeed, one of Kandinsky's friends, Emy Dresler, worked on the set designs for these productions.[43] Both Steiner and Schuré used chorus, music, a rudimentary color symbolism, and a ritualized narrative in their theatrical productions.

Interestingly, certain motifs in Kandinsky's one published stage composition, The Yellow Sound, resemble motifs in Steiner's and Schuré's plays. The most striking similarity is the transformation, with the aid of lights, of one of the major characters, a giant, into an enormous cross at the conclusion of Kandinsky's stage composition. This is very similar to the conclusion of a Schuré play, performed in Munich in 1909, where a cross is placed in the center of a star, the basic Theosophical sign, thereby suggesting the absorption of all wisdom and religions into his Christianized version of Theosophy.[44]

While Kandinsky's experiments with a total artwork have numerous sources, all of those who influenced his productions seemed interested to some degree in the religious possibilities of the drama.

Maeterlinck is no exception. However, Maeterlinck's dramas with their abandonment of plot, narrative action, and conventional scenery were undoubtedly the primary inspiration for Kandinsky's avoidance of linear narrative and scenery, his use of indistinct words, and the erratic, puppetlike movements of the main characters in *The Yellow Sound*.[45]

Moreover, all those who influenced Kandinsky's experimentation with works combining the various arts were believers in theories of the correspondence of the senses. Such theories were popular at the end of the nineteenth century not only among the Symbolist groups in France and Russia, but also among psychologists and various occult groups such as the Theosophists. The belief that one means of stimulating the senses could be substituted for another, and that in certain persons the stimulation of one sense would set off the stimulation of all the others, was accepted by Maeterlinck as well as by Steiner and Schuré. Kandinsky, however, unlike many of the Symbolists and Theosophists and even those experimenters among his contemporaries such as Scriabin who related color to music, did not believe that his stage work combining the various arts should depend on parallel or reinforcing stimuli (bright colors supported by loud music). He felt a stronger expression of his ideas could be achieved if the various arts were used contrapuntally. For example, if in *The Yellow Sound* the colored lights were to be very intense, Kandinsky indicated that the music should subside. For Kandinsky, the repetition of parallel stimuli was in some sense like naturalism, a nineteenth-century device—it could in no way suggest the conflict and disharmony that he felt were present in the twentieth century. In this respect, the Austrian composer, Arnold Schönberg, who wrote an essay for *Der Blaue Reiter* on nonparallelism between text and musical accompaniment, exerted some influence on Kandinsky's movement away from a simple and harmonious use of parallel correspondence in his works.[46]

Kandinsky's paintings of this period, like his stage composition, are based on the principle of using as many different stimuli as possible to multiply the vibrations emanating from the canvas. Kandinsky often spoke about color as equivalent to music, of line as equivalent to dance, and of objects as equivalent to words. Here we find one more reason that Kandinsky would write that the object must be used in a painting: "To deprive oneself of this possibility of causing a vibration would be reducing one's arsenal of means of expression."[47]

Even in 1913 when Kandinsky began to feel he was closer to

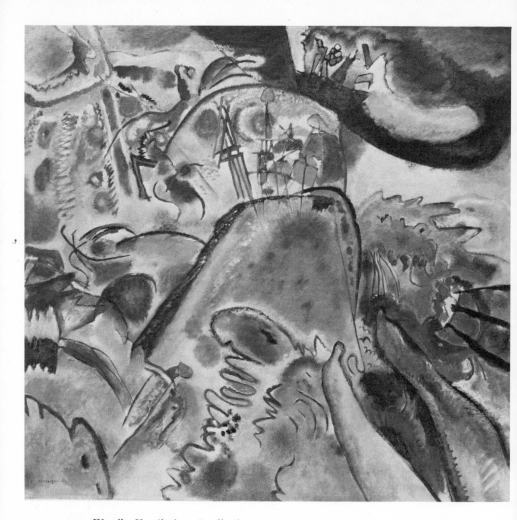

104. Wassily Kandinsky: *Small Pleasures*. 1913. Oil on canvas. 43¼″ × 47⅛″.
Collection The Solomon R. Guggenheim Museum, New York.

abstraction, the transformation of apocalyptic motifs into hidden con-
structions is quite evident in his paintings. In *Small Pleasures* (known
also as *Little Pleasures;* 1913; fig. 104), for example, whose title stands
in ironic counterpoint to its contents, the motifs and their arrangement
are similar, although much more veiled, to those in the clearly titled
religious works of 1911. Although at first glance *Small Pleasures* may
not appear to have religious signs, close examination of this painting and

the glass painting upon which it is based reveal a general scheme of a mountain, topped by a walled city, in the center of the work, and a boat tossed by stormy waves to one side of the mountain, a scheme that is similar to the arrangement of motifs in the glass painting, *Resurrection*. Moreover, the three horses and riders clearly outlined in black in the glass paintings of *Small Pleasures* (c. 1912; fig. 105), but simplified to a few incomplete lines veiled by layers of color in the oil, are derived from a glass painting that Kandinsky called *Horsemen of the Apocalypse I* (c. 1910; fig. 106). In both he included only three of the four riders described in The Revelation to John, an interpretation preferred by Steiner.

105. Wassily Kandinsky: *Small Pleasures.* c. 1912. Glass painting. 12″ × 5⅞″. Collection Städtische Galerie, Lenbachhaus, Munich.

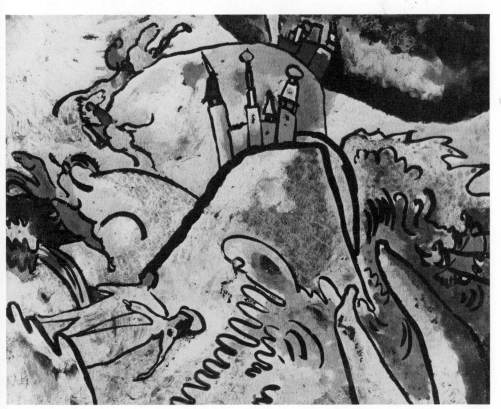

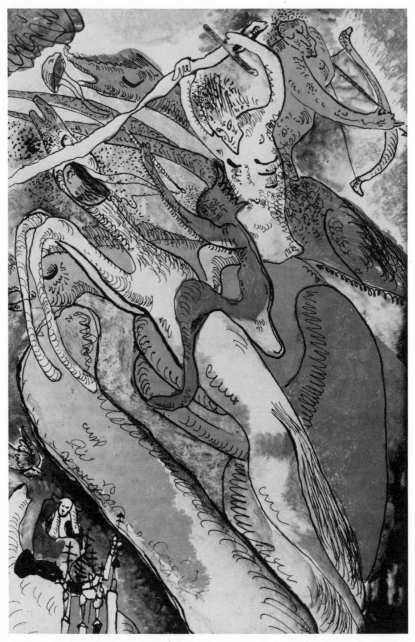

106. Wassily Kandinsky: *Horsemen of the Apocalypse I.* c. 1910. Glass painting. 11⅝″ × 8″. Collection Städtische Galerie, Lenbachhaus, Munich.

Despite the apocalyptic motifs, the imagery has been referred to as the " 'small pleasures' . . . rowing, loving, riding."[48] This would seem to ignore not only the relationship of the imagery to earlier apocalyptically titled works, but also the relationship of the imagery in the painting to vivid metaphors found in Kandinsky's essays, particularly in *Concerning the Spiritual*. Although Kandinsky did not write a specific essay about *Small Pleasures*, many of his verbal images in *Concerning the Spiritual* correspond to motifs in the paintings. The central image of the walled city on top of a mountain threatened by dark clouds frequently appears. In one section of *Concerning the Spiritual* Kandinsky wrote:

> Humanity is living in such a spiritual city, subject to sudden disturbances for which neither architects nor mathematicians have made allowance. In one place lies a great wall fallen down like a house of cards, in another are the ruins of a huge tower which once stretched to the sky. . . . Spots appear on the sun, and the sun grows dark; and what power is left against the dark?[49]

In another section Kandinsky seemed to be describing the purpose of the storm-tossed boat in *Small Pleasures* when he equated the anxiety and fear of his age as similar to the "nervousness, a sense of insecurity" of those at sea, when "the continent left behind in mist, dark clouds gather, and the winds raise the water into black mountains."[50] In addition, Kandinsky's frequent use of light as a metaphor for awareness and knowledge and his feeling that the color blue could express the spiritual suggest that the sun in the upper left of *Small Pleasures*, which in the first version was painted blue, is meant to represent the higher planes of the spiritual world.

Kandinsky's use of certain of the motifs, moreover, seems directly related to Steiner's attempt to put a more positive cast on apocalyptic symbols. In this lecture on The Revelation to John, Steiner stressed, for example, that the fourth horseman, traditionally indicating death, should be eliminated.[51] Indeed, in one of Steiner's drawings of the apocalypse, the fourth horseman is barely visible.[52] Kandinsky may have been following Steiner's injunction when he eliminated the fourth horseman from all of his versions, even from those called *Horsemen of the Apocalypse*. Kandinsky's choice of the sun motif as a sign of the spiritual may reflect Steiner's characterization of the sun as the essence of Christianity. Then the three apocalyptic horsemen leaping from the stormy sea toward the sun could be understood as a visual metaphor, not of the pestilence coming on the Day of Judgment, but of the struggle

to attain the light—enlightenment. Kandinsky often equated the horse and rider to the artist and his talent[53] and stated that the artist was to lead the way to the future. The theme of regeneration emerging from this more positive interpretation of the apocalypse is reflected in Kandinsky's statement of 1913 that "out of the most effective destruction sounds a living praise, like a hymn to the new creation, which follows the destruction."[54]

While *Small Pleasures* may indeed reflect Steiner's messianic views that the next epoch would only emerge after great destruction, little besides the theme and the motifs used to transmit the message can be attributed to Steiner. The means he used to transform the image into a hidden construction reflect other sources. Redon, Denis, and Matisse contributed much to Kandinsky's use of color and blurred edges to make his imagery ambiguous. And the Symbolist theory of correspondences strengthened his belief in the power of multiple stimuli in the form of residual motifs and layers of colors, related to the themes of the motifs, to reinforce his message. The motifs of storm and turmoil, such as the boat tossed by waves, on the right side of *Small Pleasures,* are reinforced by the darker colors of the black-brown cloud formation in the upper right. The more optimistic motifs of the sun, the couple, and the three apocalyptic riders on the left side of the painting are supported by warmer and brighter colors. However, the multiple stimuli are not always parallel. The title, for example, is clearly ironic and serves as a disguise for the deeper meaning of the painting, which could only be grasped, according to Kandinsky's intention, after much study and meditation. Although there is some general correspondence of color to motifs, the difference in color between the right and left sides of the painting is not striking. Indeed, at first glance the color division from bright to dark might not even be noticed. Through these devices of ambiguous multiple stimuli based on residual images of an apocalyptic nature overlaid with color, Kandinsky sought to communicate a tension and an uncertainty in his paintings that would express the dissonance of his age in juxtaposition with his hope for a better future.

Kandinsky was not alone in finding the step to abstraction a difficult one to take during this period. One thinks of the "hermetic" paintings of Picasso and Braque in 1911, where the objects are so dissected as to be virtually unrecognizable. But then, their use of more visible objects in paintings of the very next year indicates their resistance

to abstraction. Gleizes and Metzinger verbally testified to this dilemma in their short essay on Cubism, stating: "Nevertheless let us admit that the reminiscence of natural forms cannot be absolutely banished; as yet, at all events. An art cannot be raised all at once to the level of pure effusion."[55] Although Kandinsky had contact with the various Cubist groups, his hidden object bears little visual relation to the Cubist fragmentation of the object into geometric components. Nonetheless, many of the Cubists, as well as Kandinsky, would use one motif to bring the rest of the painting into focus.[56] In Picasso's *Man with Pipe* (1911), for example, once we fixate on the pipe, easily identified by the white color in the upper center, the simplified and fragmented forms of the man come into focus. Picasso's signs don't have the messianic implications of Kandinsky's, yet the efforts of both artists were frequently viewed in a similar context before World War I. Their movement away from representationalism was considered so radical at that time that both men were called "expressionists." By 1914, they were clearly moving in different directions and while Picasso's signs became more readable, Kandinsky's became almost incomprehensible.

By the end of 1913 Kandinsky had grown increasingly discouraged that his art could reach the uninitiated. The constant criticism of his paintings as meaningless and decorative had taken its toll. In 1914 Kandinsky began to make notations for changes in *Concerning the Spiritual* that indicated that he felt a few artists could venture into the sphere of abstraction. Even though the process for most of his works of late 1913 and 1914 was the same as the past several years, in some paintings the hidden images became so thoroughly veiled or stripped as to be virtually unrecognizable. Unlike *Small Pleasures,* where even without studies some sort of imagery can be recognized, a few paintings such as *Light Picture* (c. 1913; fig. 107) appear to have dispensed with apocalyptic imagery and to have susbstituted what Kandinsky would later call a sensation of the cosmos of infinity. At this point, the outbreak of World War I separated him from his friends and sources in Germany. When Kandinsky finally returned to Germany in 1921 after a lengthy stay in his native Russia, his solutions to the problems of abstraction had been radically altered.

107. Wassily Kandinsky: *Light Picture*. c. 1913. Oil on canvas. 30⅝″ × 39⅜″. Collection The Solomon R. Guggenheim Museum, New York.

NOTES

1. V. Kandinsky, "W. Kandinsky: Selbstcharakteristik," *Das Kunstblatt,* 3, no. 6, 1919, p. 173.

2. Kandinsky began to state in his essays of 1913 that he had made a major step in the creation of abstract forms. In his autobiography, "Rückblicke," first published in the catalogue *Kandinsky, 1909–1913,* Berlin, 1913, he described those paintings as closest to abstraction where the forms grew "out of the artist" rather than originating from nature, a separation that he felt he was just beginning to achieve in that year. See p. xxv. See also his lecture read at the gallery Kreis der

Kunst in Cologne on January 30, 1914, in J. Eichner, *Kandinsky und Gabriele Münter* (Munich, 1957), pp. 109–116.

3. W. Grohmann, "Wassily Kandinsky," *Der Cicerone,* 16, no. 9, 1924, p. 895.

4. See K. Lindsay's review of W. Grohmann's monograph on Kandinsky in *The Art Bulletin,* 41, no. 4, 1959, p. 350, which challenged the accuracy of the 1910 date for the work called the "first abstract watercolor." See also L. Eitner, "Kandinsky in Munich," *The Burlington Magazine,* 99, no. 651, 1957, pp. 192–197, and D. Robins, "Vasily Kandinsky: Abstraction and Image," *The Art Journal,* 22, no. 3, 1963, pp. 145–147.

5. K. Brisch in his unpublished Ph.D. dissertation, "Wassily Kandinsky (1866–1944), Untersuchungen zur Entstehung der gegenstandslosen Malerei an seinem Werk von 1900–1921," (University of Bonn, 1955), was the first scholar to explore the apocalyptic motifs in Kandinsky's pre–World War I paintings. See also H. K. Röthel, "Kandinsky: "Improvisation Klamm, Vorstufen einer Deutung," *Eberhard Hanfstaengl zum 75. Geburtstag* (Munich, 1961), pp. 186–192, where the imagery in a painting of 1914 is identified.

6. Many of the quotations from *Concerning the Spiritual in Art* are my translations from the German text of 1912, *Über das Geistige in der Kunst,* 7th ed. (which follows the 2d ed. of 1912), Bern-Bümpliz, 1963, p. 26 (hereafter cited as *U.D.G.*) The best English translation, by I. Golffing, M. Harrison, and F. Ostertag (New York: Wittenborn, Schultz, 1947), is based on additions of 1914 and will be used (hereafter cited as *C.T.S.*) when the translation does not conflict with the German version.

7. See Kandinsky, "Rückblicke," p. xxvii or its English translation, "Reminiscences," *Modern Artists on Art,* ed. R. Herbert (Englewood Cliffs, N.J.: Prentice-Hall, 1964), p. 42.

8. *U.D.G.,* pp. 107–108.

9. *Ibid.,* p. 143.

10. Although Theosophy has been connected with Kandinsky's name since 1912, the relationship has not been taken seriously until recently. See L. D. Ettlinger, *Kandinsky's "At Rest"* (London, 1961); S. Ringbom, "Art in 'the Epoch of the Great Spiritual,' Occult Elements in the Early Theory of Abstract Painting," *Journal of the Warburg and Courtauld Institutes,* 29, 1966, pp. 386–418; L. Sidhare, "Oriental Influences on Wassily Kandinsky and Piet Mondrian, 1909–1917," unpublished Ph.D. dissertation (New York University, 1967); and my unpublished Ph.D. dissertation, listed under my maiden name, R.-C. Washton, "Vasily Kandinsky, 1909–1913: Painting and Theory" (Yale University, 1968).

11. *U.D.G.,* pp. 42–43.

12. *Ibid.,* p. 43.

13. *Ibid.,* p. 107.

14. Between 1906 and 1914, Steiner devoted the majority of his lecture programs to an elucidation of the Gospels. See J. Hemleben, *Rudolf Steiner* (Reinbek bei Hamburg, 1963), p. 162. As early as 1902, Steiner revealed his Christian orientation in *Das Christentum als mystische Thatsache* (Berlin, 1902). Because of increasing differences with the international Theosophical Society, Steiner founded his own group in 1913, which he defined as Anthroposophical.

15. Between 1896 and 1911, Kandinsky had been exposed to a variety of Symbolist concepts. Although Symbolism reached its height as a literary movement in France in the mid-1890s, its impact was of a longer duration in Germany and Russia. In fact, in Russia, Symbolism continued to be a dominant influence in intellectual circles as late as 1911. Kandinsky was the Munich correspondent for the Russian Symbolist periodical *Apollon* in 1909 and 1910.

16. Solov'ev's vision of the cleansing effect of the Apocalypse is reflected in the works of the Russian Symbolist poets Blok and Belyj, both of whom described in their writings of the era before World War I the power of Symbolism to create a religious art, not merely an aesthetic. It is noteworthy that Belyj also became interested in Steiner and went in 1914 to stay with Steiner at his Goetheanum in Dornach, Switzerland. Kandinsky mentions neither Solov'ev nor Belyj nor Blok, but his friend Marianne von Werefkin, with whom he spent the summers in Murnau during 1909 and 1910, is reported to have been in contact with a number of the Russin Symbolists. See J. Hahl-Koch, *Marianne Werefkin und der russische Symbolismus* (Munich, 1967).

17. C. Weiler, who holds the diary of Marianne von Werefkin, reported in his biography of her companion, Jawlensky, that both artists had introduced Kandinsky to the ideas of Steiner, perhaps during the summer of 1909. Weiler stated that Jawlensky had spoken with Steiner and had seen one of his plays. See *Alexej Jawlensky* (Cologne, 1959), pp. 68, 70–73. According to Weiler, Kandinsky had attended a lecture by Steiner on Goethe's *Faust* in Berlin during April 1908 and had been inspired to illustrate the Ariel scene. See W. Grohmann, *Wassily Kandinsky* (New York: Harry N. Abrams, 1958), p. 41. One of Kandinsky's pupils, Maria Strakosch-Geisler, is reported to have attended a lecture of Steiner's in Berlin during 1908. See A. Strakosch, *Lebenswege mit Rudolf Steiner* (Strasbourg, 1947), pp. 22–24.

18. For an analysis of this development see Washton, "Vasily Kandinsky, 1909–1913: Painting and Theory." In *The Sounding Cosmos, A Study in the Spiritualism of Kandinsky and the Genesis of Abstract Painting* (Åbo, 1970), Ringbom also describes Kandinsky's interest in apocalyptic motifs, which he had not dealt with in his essay of 1966. However, he sees this interest primarily as a reflection of the fascination with the apocalypse, widely evident at the turn of the century, especially among the Russian Symbolists.

19. The earliest, *Paradise,* is listed as the last work of 1909 in the house catalogue Kandinsky kept of his paintings. The first of the paintings called *Last Judgment* is listed in 1910.

20. *All Saints' Day* also refers to another aspect of the Judgment Day, the gathering of all the saints. While the clearest examples of apocalyptic imagery occur in the small glass paintings of 1910, 1911, and 1912, which were modeled after Bavarian folk paintings on glass, a number of oils also contain these apocalyptic titles and motifs. The arrangement of these motifs became the basis for many of his compositions before World War I.

21. Kandinsky wrote in a letter of September 1, 1911, to Marc that the almanac had to mention Theosophy "concisely and strongly (if possible statistically)." See *Der Blaue Reiter,* reprint of the 1912 ed. with notes by K. Lankheit (Munich, 1965), p. 261.

22. See E. Roters, "Wassily Kandinsky und die Gestalt des Blauen Reiters," *Jahrbuch der Berliner Museen*, 5, no. 2, 1963, pp. 201–226; also H. Nishida, "Genèse du cavalier bleu," *XXe Siècle*, 27, 1966, pp. 18–24.

23. It also ignores the prevalence of Christian references in Kandinsky's essays and poems. See *Klänge* (Munich, 1913).

24. *C.T.S.*, pp. 23, 65–66.

25. It is reproduced in *Der Blaue Reiter*, Lankheit ed., p. 215. Other elements of this motif, such as the walled city and the leaping horse and rider, can be traced to Kandinsky's own works of 1902 and 1903.

26. See Kandinsky, lecture, January 30, 1914, in Eichner, *Kandinsky und Gabriele Münter*, pp. 114–115.

27. *U.D.G.*, p. 115.

28. *Ibid.*, p. 78.

29. *Ibid.*, p. 129.

30. Kandinsky, "Malerei als reine Kunst," *Der Sturm*, 4, nos. 178/179, 1913, p. 99.

31. R. Steiner, *Theosophie* (5th ed.; Leipzig, 1910), pp. iv, 79, 116. Kandinsky cited this book in *Concerning the Spiritual*, p. 32, in addition to mentioning articles by Steiner in the magazine *Lucifer-Gnosis*.

32. The Symbolists and various occult groups shared an interest in the mysterious and the hidden. During the 1880s and 1890s in France many of those who were to be called Symbolists were interested in Rosicrucian and Theosophical groups. See J. Senior, *The Way Down and Out: The Occult in Symbolist Literature* (Ithaca, N.Y.: Cornell University Press, 1959); G. Mauner, "The Nature of Nabis Symbolism," *The Art Journal*, 23, no. 2, 1963–64, pp. 96–103; R. Pincus-Witten, *Les Salons de la Rose + Croix*, 1892–1897 (London, 1968). Similarly Theosophists such as Schuré and the Rosicrucian Peladan adopted ideas from Wagner and the French Symbolists. See G. Wooley, *Richard Wagner et le symbolisme Français* (Paris, 1931).

33. Symbolism through its visual branches, Art Nouveau and Jugendstil, had a direct effect on the subject matter, style, and medium of Kandinsky's works from 1900 to 1906.

34. *U.D.G.*, p. 46.

35. Steiner, "Maeterlinck, der 'Frei Geist,'" 1899, reprinted in *Dr. Rudolf Steiner, Veröffentlichungen aus dem literarischen Frühwerk*, XXIV (Dornach, Switzerland, 1958), pp. 22–24.

36. See W. Halls, *Maurice Maeterlinck, A Study of His Life and Thought* (London: Oxford University Press, 1960), p. 48.

37. *U.D.G.*, p. 76.

38. Kandinsky had had contact with Denis and other Nabis since 1903 when works by Denis and others were displayed in the 1903 Phalanx exhibition organized by Kandinsky. As late as 1912, D. Burliuk wrote in an article, "Die 'Wilden' Russlands," for *Der Blaue Reiter* that Denis's opinion was highly regarded. See Lankheit ed., p. 47. Redon contributed an essay for the second exhibition catalogue of the Neue Künstlervereinigung Munich, 1910/11.

39. The importance of these drawings was stressed by Ringbom in "Art in 'the Epoch of the Great Spiritual,'" p. 405.

40. See Kandinsky, "Der gelbe Klang," *Der Blaue Reiter,* Lankheit ed., pp. 210–229, or English trans.: V. Miesel in *Voices of German Expressionism* (Englewood Cliffs, N.J.: Prentice-Hall, 1970), pp. 137–145. The music for this stage composition was written by Thomas von Hartmann, a Russian composer living in Munich who later became a follower of the mystic Gurdjieff.

41. See Kandinsky, "Über Bühnenkomposition," *Der Blaue Reiter,* Lankheit ed., pp. 195–200. Kandinsky adopted the Wagnerian term *leitmotiv* to describe his concept of the hidden object.

42. See E. Schuré, Le théâtre de l'âme (Paris, 1900), I, pp. xiii–xiv, and Schuré, *Les grands initiés* (Paris, 1909), pp. 438–439. Steiner was much indebted to Schuré's understanding of Wagner.

43. Emy Dresler was a pupil of Kandinsky who exhibited with the Neue Künstlervereinigung; see *Sammlungskatalog I, Der Blaue Reiter* (2d ed.; Munich, 1966), p. 12.

44. See Schuré, "Les enfants de Lucifer," *Le théâtre de l'âme,* I.

45. Maeterlinck used marionettes in his one-act plays and fairy-tale figures as the main characters in his larger works to reinforce his departure from the traditional theatre. Kandinsky's use of a chorus offstage may derive from Peladan's placement of the chorus in his religious dramas.

46. See Kandinsky, "Über Bühnenkomposition," and *C.T.S.,* p. 35.

47. *C.T.S.,* p. 50.

48. See H. K. Röthel, *Vasily Kandinsky, Paintings on Glass* (New York, 1966), no. 19.

49. *C.T.S.,* p. 31.

50. *Ibid.,* p. 30.

51. Steiner, "Die Theosophie an der Hand der Apokalypse," 1908, p. 90; copy of the manuscript of this 1908 lecture is located in the Anthroposophical Society, New York.

52. See Steiner, *Die Apokalypse des Johannes* (5th ed.; Dornach, 1963), no. 3.

53. See Kandinsky, "Reminiscences," pp. 32–33.

54. Kandinsky, "Notizen—*Komposition 6," Kandinsky,* 1901–1913, p. xxxviii.

55. A. Gleizes and J. Metzinger, "Cubism," in Herbert, *Modern Artists on Art,* p. 7.

56. In *The Rise of Cubism,* H. D. Kahnweiler described the Cubist use of signs as means of stimulating one's memory image in order to bring the whole object into mind; see H. Aronson's translation from the 1920 German ed. (New York: Wittenborn, Schultz, 1949), pp. 11–13.

Artists of the World, Disunite!*

JOHN BOWLT

Modern Russian art is relatively unexplored. Bowlt's essay introduces the first comprehensive exhibition in America of Russian art of the avant-garde. He gives a glimpse of the fervid artistic climate from 1909 until the October Revolution of 1917. It was then that modern art emerged in Russia. By 1921 the Russians were announcing the death of art. Neoprimitivism, Cubo-Futurism, Rayonnism, Suprematism, and the exhibition groups that sponsored these styles are set in historical perspective.

Scholarship in this field during the past decade builds upon Camilla Gray's pioneering survey. *The Russian Experiment in Art: 1863–1922* (New York: Harry N. Abrams, 1962).

John Bowlt recently translated major documents of Russian art, *Russian Art of the Avant-Garde* (New York; The Viking Press, 1976). He is assistant professor of Slavic languages at the University of Texas at Austin.

* Reprinted from the exhibition catalogue *Russian Avant-Garde, 1908–1922,* Leonard Hutton Galleries, New York, 1971.

ARTISTS OF THE WORLD, DISUNITE![1]

The works that constitute this exhibition represent one of the most dynamic periods in the history of the Russian visual arts: the first quarter of the twentieth century witnessed a cultural regeneration that affected literature, poetry, music, painting, and sculpture in Russia and that produced not only innumerable masterpieces, but also new art directions, journals, manifestos, and societies. It was a time, however, that despite its sudden ebullience owed much to indigenous traditions of the preceding fifty years—and in any appraisal of the so-called avant-garde in Russia, this must be borne in mind. The revolt of the artists in 1863 against the pedantic and conservative principles of the Imperial Academy, the establishment of the Society of Wandering Exhibitions in 1870 with its initially progressive credo of realism, the formation of art colonies such as Abramtsevo and Talashkino after 1870, and the emergence of the World of Art movement in the late 1890s headed by A. Benois and S. Diaghilev—all these factors contributed to the artistic boom of the period circa 1895 to circa 1922. In addition, the expansion of Russia's cultural experience was brought about by the activity of certain individuals, artists, critics, and Maecenases, whose efforts to combat cultural stagnation inspired many members of the first and second generations of the Russian avant-garde: in this respect, mention must be made of Vrubel, who exerted a profound influence on artists of the 1890s and early 1900s and whose distinctive, "cubistic"[2] pictorial approach presaged that visual fragmentation which we associate with Russian art after circa 1904; the delicate and allusive forms of Borisov-Musatov also contributed a great deal to this development, specifially through the Symbolist Blue Rose group, who "substitute emotion for everything—thought, form and even reason itself";[3] on a rather different level the achievements of leading art patrons should also be recognized, for without the enthusiasm and financial support that such figures as S. Mamontov (owner of Abramtsevo), Princess M. Tenisheva (owner of

Talashkino), and, later, N. Ryabushinsky (sponsor of the *Golden Fleece* magazine and its exhibitions) and the "crazy doctor," N. Kulbin, gave to the new art, the Russian avant-garde would not have made the impact that it did.

Although there were many cultural innovations in St. Petersburg and the provinces during the 1890s and early 1900s, it would be justifiable to regard the beginning of Russia's avant-garde as the year 1908, if, by the term *avant-garde,* we understand the dismissal of naturalism, realism, and Symbolism as viable, creative principles. Nineteen hundred and eight was the year in which the first extremist exhibitions shocked both the public and the critics—from the "Wreath" "dirtied by the works of Lyudmilla, Vladimir, and David Burliuk"[4] to the sensational "Link" at which "there's one canvas which is the crudest monstrosity—a portrait of a noseless man which V. Burliuk has called 'Summer Landscape.' ";[5] these shows were paralleled by Ryabushinsky's "Salon of the 'Golden Fleece' " and Kulbin's first "Impressionist" exhibition, which pointed the way to a tentative movement of Russian Expressionism led by P. Filonov and B. Grigoriev. With the exception of the last, all these exhibitions demonstrated a tendency toward what came to be called Neoprimitivism,[6] in the evident concern with such "unaesthetic" art forms as the "lubok,"[7] signboard painting, peasant wood carving, and children's drawing—a concern that was to culminate in the grand Neoprimitivist shows of the first "Knave of Diamonds" exhibition and that of the "Donkey's Tail." The lack of respect that the new artists felt for the popular professional realism of the Wanderers and the stylized graphics of the World of Art was summarized convincingly by one of the first manifestos of the Russian avant-garde, written by D. Burliuk and issued at the "Link" exhibition: "The priests of art go off in their automobiles, carrying away their gold. . . . Complacent bourgeois, your faces shine with the joy of understanding. . . . Bitter lard, fumes, and stench are in the works of those whom the crowd has loved, whom they fed so long with sweet praises that they ceased to resemble living creatures. The art of the past is all that painting in which time has passed by with a delicate net of wrinkles."[8] With this the battle was declared between the modernist avant-garde and the establishment, a rift that led to the fiery Futurist debates of 1910 to 1914 and the publication of vociferous polemics between reactionary critics and leftist artists.

One of the first of the radical artists to turn to peasant art as a source of inspiration was Mikhail Larionov, whose coarse, naïve canvases of 1908 to 1912 betrayed his attempts to transfer the devices of peasant art to easel painting (see figs. 108, 109, 110). The same aspi-

108. Mikhail Larionov: *Head of a Soldier.* 1910. Oil on canvas. 27½″ × 19⅝″. Collection Leonard Hutton Galleries, New York.

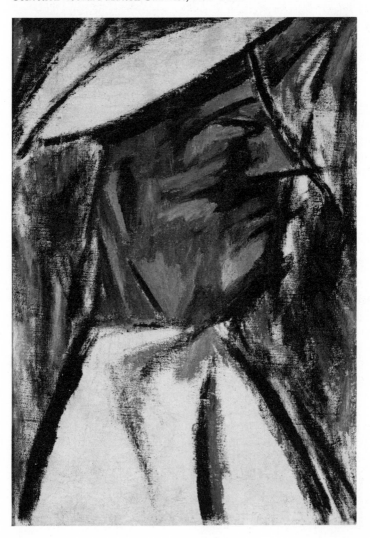

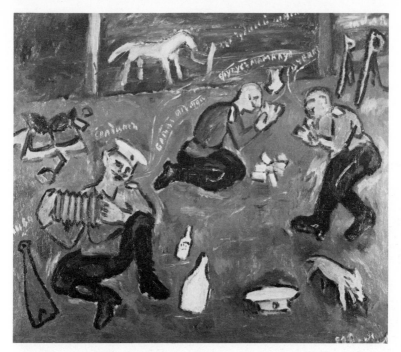

109. Mikhail Larionov: *Soldiers.* 1909. Oil on canvas. 34⅝″ × 40¼″.
Collection Leonard Hutton Galleries, New York.

110. Mikhail Larionov: *Street with Lanterns.* 1913. Oil on burlap. 13⅝″ ×
20″. Collection Leonard Hutton Galleries, New York.

ration was noticeable in the contemporaneous work of Natalia Goncharova (figs. III, II2), the Burliuks, and, a little later, Kasimir Malevich and Vladimir Tatlin; in fact, most members of the Russian avant-garde experienced some influence of Neoprimitivism. Yet while such artists appeared to be breaking with the traditions of Russian easel painting, specifically with the "idealist" concept of art favored by the Academy, they were, in fact, maintaining a tradition of "primitivism" that went back at least as far as the 1880s, when artists such as V. Vasnetsov and Vrubel had worked at Abramtsevo incorporating peasant motifs and pictorial methods into their easel and decorative work. In this respect it is dangerous to overemphasize the debt that Russian art, allegedly, owed to French models, although, undoubtedly, a certain influence was felt: it would be erroneous to assume that the occasional trips by Russian artists to Paris and the presence of canvases by Matisse, Rouault, Rousseau, *et alii,* in the collections of I. Morozov and S. Shchukin were the dominant factors in the formation of Russian Neoprimitivism, the more so since, contrary to general opinion, the above private collections were not readily accessible to the public, at least before 1908. The inclination toward vivid, oriental colors to be found in the work of such divergent artists as D. Burliuk, Goncharova, and Jawlensky was a distinctive feature rather foreign to their French contemporaries; and it was this quality, in particular, that struck Western connoisseurs at such expositions as Diaghilev's ballet presentations, Roger Fry's "Second Post-Impressionist Exhibition" in 1912 and the 1912 show of "Der Blaue Reiter." Russian Neoprimitivism, then, was very much a domestic, organic movement, a fact that received emphasis in 1913 when Goncharova, Larionov *et alii* rejected Western stimuli publicly and pledged their allegiance to Russian and Eastern art forms: "Hitherto I have studied all that the West could give me, but, in fact, my country has created everything that derives from the West. Now I shake the dust from my feet and leave the West, considering its vulgarizing significance trivial and unimportant—my path is towards the source of all arts—the East. The art of my country is incomparably more profound and important than anything I know in the West."[9]

The concentration of the Neoprimitivists on specific painterly elements—color, texture, mass—accelerated the process of formal disintegration and reduction identifiable with Russian Cubo-Futurism and Suprematism. The assimilation of Cubism by the more academic faction of the Knave of Diamonds—which included Exter, Falk, Konchalovsky, and, later Altman and Popova, Larionov's formulation of Rayonnism

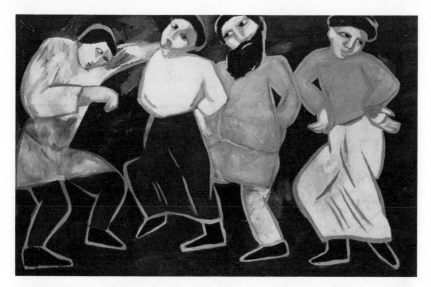

111. Natalia Goncharova: *Dancing Peasants*. 1910. Oil on canvas. 36″ × 56¾″.
Courtesy Leonard Hutton Galleries, New York.

112. Natalia Goncharova: *Railway Station*. 1912. Oil on canvas. 28⅜″ × 36⅝″.
Courtesy Leonard Hutton Galleries, New York.

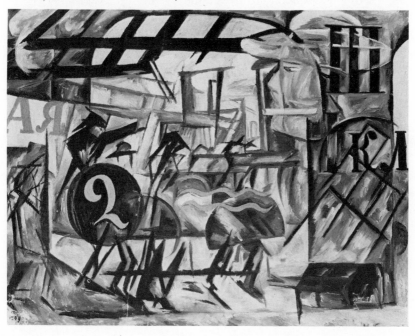

and Malevich's "geometricity" contributed further to this development and culminated in Malevich's Suprematist canvas, *Black on White* (1915), "with which painting committed suicide."[10] This attention to individual elements and the neglect of the conventional laws of perspective, delineation, and color combination made painting "easier" and more widely accessible, so that the ranks of the progressive artists were joined by charlatans, although such artists as Malevich, Puni, Rozanova, and Tatlin worked according to definite systems and did not resort to unnecessary caprice. For them the period in question was a time of frantic search for a cohesive artistic discipline, a search prompted, in part, by the concurrent disintegration of their own society. To a marked extent, the occasion for the emergency of Russian Neoprimitivism was this quest for a fresh, barbaric vigor that would replace the exhausted aesthetics of realism and Symbolism. In turn, the trend toward artistic synthesism, i.e., the unification of various art media under the umbrella of a single art, was stimulated by a common acknowledgment of an aesthetic vacuum: the many booklets of Futurist verse illustrated by Goncharova, Larionov, Malevich, Rozanova, *et alii,* the musical experiments by Baranoff-Rossiné, the color analyses of Scriabin, and even the Theosophic explorations by Kandinsky (see figs. 104, 105) can be seen as part of this aspiration toward artistic wholism. It is significant, therefore, that Malevich's advocation of Suprematism, the "New Painterly Realism," in 1915, should have been presaged by his decorative contributions to an opera, of all art forms the most synthetic: part of his decor to the Matiushin/Kruchenykh *Victory over the Sun* contained an abstract backdrop divided diagonally into black and white sections, and it may be argued that this formed a prototype of his abstractionist, Suprematist canvases of after 1914. His own realization that a new artistic credo, a style, was essential to the subsequent development of Russian art was expressed in his program of 1915, "From Cubism to Suprematism. The New Painterly Realism":

> Only when the conscious habit disappears of seeing Nature's little nooks, Madonnas and Venuses in pictures, will we witness a purely painterly work of art. . . . Hitherto there has been realism of objects, but not of painterly, coloured units, which are constructed so that they depend neither on form, nor on colour, nor on their position vis-à-vis each other. . . . Hurry up and take off the hardened skin of centuries, so that you can catch us up more easily. . . . We Suprematists throw open the way to you.[11]

It was not until 1915, in fact, that a complete break was made with representational painting in Russia. It may be argued, of course, that such titles as Tatlin's *Compositional Analysis,* Rozanova's *Dissonance,* and Malevich's series of exercises in Transrational Realism, all of which were shown at the fourth exhibition of the "Union of Youth," were abstract, but, in fact, they were still thematic and were certainly not Suprematist. Despite even Larionov's assertion in 1913 that "Painting is self-sufficient, it has its own forms, colour and timbre,"[12] practically all of his and Goncharova's contributions to current exhibitions were representational. However, by the spring of 1915 when the comprehensive "Exhibition of Painting" was opened in Moscow, it seemed that art had lost all reason, as Lentulov, one of the participators recalled: ". . . there were relief combinations hastily put together by Larionov and Goncharova in one night . . . the Burliuks hung up a pair of trousers and stuck a bottle to them in the middle . . . Tatlin exhibited his counter reliefs . . . the poet, Kamensky, asked the jury to allow him to exhibit a live mouse in a mouse-trap."[13] A more serious approach to art was observed at the parallel exhibition, "Tramway V," at which the foremost members of the avant-garde were well represented, including Exter, Klyun, Popova, Udaltsova, as well as Malevich, Puni, and Tatlin. But it was only in the winter of 1915, at the famous "0.10" exhibition, that Suprematism as interpreted by Malevich (fig. 113) and

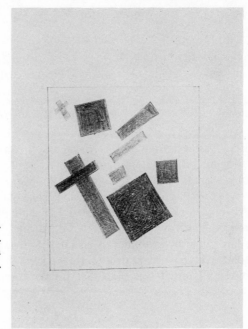

113. Kasimir Malevich:
Suprematist Composition. 1914–1915.
Pencil on paper. 10″ × 7¾″.
Photograph courtesy Annely Juda
Fine Art, London.

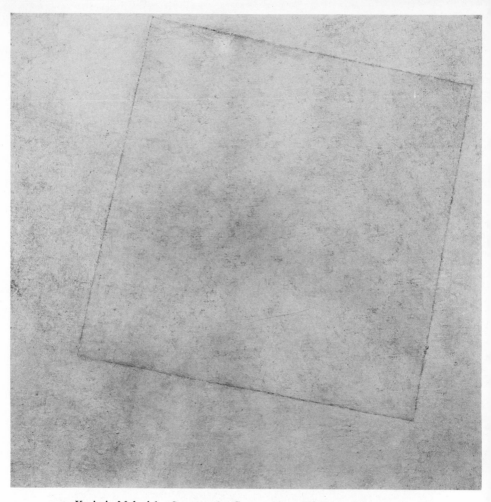

114. Kasimir Malevich: *Suprematist Composition: White on White*. 1918. Oil on canvas. 31¼″ × 31¼″. Collection The Museum of Modern Art, New York.

Puni was presented both in visual and in verbal terms: a handout signed by Puni and his wife, Boguslavskaya, proclaimed: "An object is the sum of real units, a sum which has a utilitarian purpose. . . . A picture is a new conception of abstracted real elements, deprived of meaning . . . An object (a world) freed from meaning disintegrates into real elements—the foundation of art."[14] At the same exhibition Tatlin was represented by examples of his latest abstract reliefs, and he emphasized sculptural abstractionism at his own exhibition, the "Shop," a few months later; it was here that his own reliefs were complemented by

those of his pupil, S. Tolstaya, and by two triplanar reliefs of L. Bruni, as well as by thematic pictures of Exter, Malevich, Popova, Rodchenko, and Udaltsova.

The ostensible impasse that Russian art had reached by 1916 in the Suprematist painting of Malevich and in the self-sufficient reliefs of Tatlin cast serious doubt on the subsequent development of the Russian visual arts. Malevich's canvas, *White on White* (1918; fig. 114), both acted as the requiem to a dead society and anticipated the Constructivists' slogan "Death to art"[15] of the early 1920s. The social and political Revolution of October 1917 suddenly confronted art with new tasks and provided it with a new sense of direction; and if, ultimately, this proved to be pernicious and retrograde, then, at least Russian art was given that cohesive style for which it had been searching over the preceding years.

NOTES

1. V. K[aratygin], "M. Reger," *Zolotoe runo,* no. 2, 1906, p. 97.

2. The question of Vrubel's Cubism is discussed by S. Makovsky in *Siluety russkikh khudozhnikov* (Prague, 1922), pp. 120–121.

3. From the review of the "Blue Rose" exhibition by A. S[kalon] in *Russkie vedomosti,* no. 69, March 25, 1907.

4. P. Muratov, "Staroe i molodoe na poslednikh vystavkakh," *Zolotoe runo,* no. 1, 1908, p. 89.

5. I. Chuzhanov, "Vystavki": "Zveno," *V mire iskusstv,* nos. 14/16, 1908.

6. The first and only Neoprimitivist manifesto was written by A. Shevchenko; it was published as "Neo primitivism," Moscow, 1913.

7. The "lubok" or "lubochnaya kartina" was a cheap popular print or woodcut similar to the English broadsheets of the eighteenth and nineteenth centuries.

8. D. Burliuk, "Golos Impressionista—v zashchitu zhivopisi" in catalogue of the "Link" exhibition, Kiev, 1908.

9. N. Goncharova, Preface to catalogue of personal exhibition, Moscow, 1913, p. 1.

10. A Fedorov-Davydov, *Russkoe iskusstvo promyshlennogo kapitalizma* (Moscow, 1929), p. 62.

11. K. Malevich, *Ot kubizma i futurizma k suprematizmu. Novyi zhivopisnyi realizm* (Moscow, 1916), pp. 2, 28, 32.

12. M. Larionov, Part of epigraph to: "Luchistskaya zhivopis," *Oslinyi khvost i mishen* (Moscow, 1913), p. 83.

13. A. Lentulov, "Avtobiografiya," *Sovetskie khudozhniki,* vol. 1 (Moscow, 1937).

14. I. Puni and K. Boguslavskaya, "Manifest suprematizma," Petrograd, 1915.

15. A. Gan, *Konstruktivizm* (Tver, 1922), p. 18.

"Dada": A Code for Saints?*

JOHN ELDERFIELD

Dada is "everything" and "nothing," rebellious, spirited, and paradoxical, an artistic revolt against art. John Elderfield probes for clues concerning the chance discovery of the name itself. He sets the scene at the Cabaret Voltaire in Zurich and allows the original collaborators to speak in their own language, filled with insult, contradiction, and wordplay.

Dada grew up in New York, Zurich, Berlin, Cologne, Hanover, and finally, Paris in 1919. Everywhere, Dada painters and poets rebelled against modernist developments—Fauvism, Cubism, and Futurism—and bequeathed to the Surrealists some of their most powerful impulses. More a state of mind than an artistic movement, Dada does not easily lend itself to art-historical analysis. Any comprehensive history necessarily depends upon the writings of the participants, which are as confusing and entertaining as the brief detective story that follows.

John Elderfield, an English art critic, is Curator at The Museum of Modern Art, New York.

* Reprinted from *Artforum,* 12, no. 6 (February 1974).

A word was born, no one knows how.

—Tristan Tzara

I

There is no stronger link between the respectable world of professional scholarship and the far more glamorous world of fictional intrigue than in the case of disputed inventions. What follows is concerned with the word *Dada,* with the conditions of its discovery, and with the kinds of meaning that were attached to it.

A disputed invention in Dada is unlikely to produce a definite solution. It is as well to say this from the start. Much of the evidence is either hearsay or circumstantial; the witnesses change their stories; and all of the suspects are only too keen to confess.

Perhaps the topic itself is not all that important to our understanding of the Dada movement. Hans Arp thought so. "Only imbeciles and Spanish professors can take an interest in dates," he wrote on this very subject. "What interests us is the Dada spirit and we were all Dada before Dada came into existence."[1] In Zurich itself, Hans Richter adds, "no one cared in the least how or by whom [the word *Dada*] had been invented."[2] This is borne out by what remains from that period: the circumstances of the "invention" are not mentioned at all in any known Zurich document.

But once the Zurich episode was ended, a very different picture begins to emerge. This word, which "ne signifie rien" (as Tzara had put it),[3] became meaningful after all, and did so because Dada itself came to signify many different things as the years passed. In France and in Germany, Tzara and Huelsenbeck, the two principal couriers of the Zurich word, each wished to affirm that his interpretation of Dada was consistent with its original meaning. Whoever had discovered Dada, it seemed, had title to the movement as well. In consequence, they "set out, a posteriori, to cut off each other's supplies of vital fluid even, as it were, in the womb."[4] The controversy still remains.

Now, the discovery of the word *Dada* did not make the original activities of the Cabaret Voltaire into a movement. It represents, rather,

the first moment at which its members—or, at least, some of them—began to think of what they were doing in this light. The Cabaret Voltaire was founded on February 5, 1916, on the initiative of Hugo Ball and with the collaboration of Tristan Tzara, Marcel Janco, and Hans Arp. Richard Huelsenbeck, whom Ball had known in Germany since 1912, arrived approximately a week later, and these five, together with Ball's mistress, Emmy Hennings, and some others, formed the core of the group. The Cabaret Voltaire lasted only a short period—until the end of June 1916—but just before it closed, the anthology *Cabaret Voltaire* was published on June 4. Ball was the editor. His foreword to the volume, dated May 15, 1916, advertised a forthcoming journal, to be called *Dada*. This was the first appearance in print of the word *Dada* and provides the starting point for our investigation. It was discovered somewhere in the preceding six weeks. But when? And by whom? And what does it mean, if anything?

Despite the many and contrasting statements by the Dadaists and their apologists, there are in fact two basic versions of what happened: one deriving from Tzara and Arp (and supporting Tzara); the other from Huelsenbeck and Ball (and supporting Huelsenbeck). The Tzara-Arp version is better considered first since it was the one that became most common in Dada histories. As Dada itself declined, Parisian Surrealism most evidently extended its initiative. The plurality of immediately post-Dada histories are, therefore, French, and tend to rely on evidence close at hand.

II

In George Ribemont-Dessaignes' "Histoire de dada," there is directly quoted Arp's famous and humorous deposition that dates the discovery of the word *Dada*—by Tzara—to "February 8, 1916, at six o'clock in the afternoon: I was present with my twelve children when Tzara for the first time uttered this word which filled us with justified enthusiasm. This occurred at the Café de la Terrasse in Zürich and I was wearing a brioche in my left nostril. . . ."[5] Arp's account, widely repeated elsewhere,[6] was originally published in Paris in September 1921, in the journal *Dada Intirol,* on the basis of a statement that Arp had read out to André Breton, Max Ernst, and Tzara when they were holidaying in

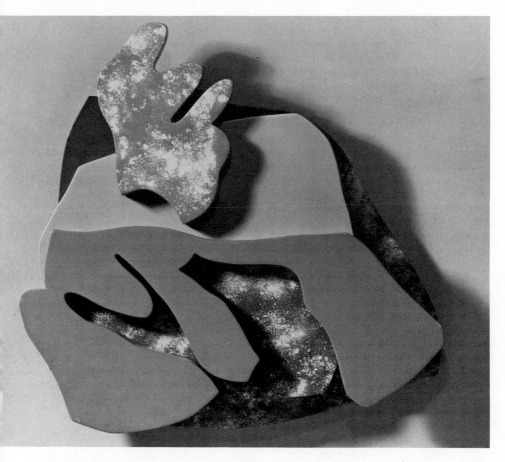

115. Hans Arp: *Head of Tzara.* 1916. Wood relief. 9⅜″ × 7¼″ × 4″. Collection Madame Jean Arp. Photograph courtesy Musée d'Art et Histoire, Geneva.

the Tirol in the summer of that year. This assembly formed an important part of the Paris Dada circle, initiated when Tzara arrived from Zurich at the end of 1919 and made contact with what is usually called the *Littérature* group (led by Breton) and with Francis Picabia (who from November 1919 published in Paris his review *391*). By 1921, however, when Arp's statement was made, Paris Dada was beginning to break at the seams. Both Breton and Picabia were questioning Tzara's importance to Zurich Dada as a way of discrediting him in Paris. And

their way of doing this was to say that Tzara had nothing to do with the discovery of Dada, movement or word. Rumors were circulating in Paris that it was, in fact, Arp who had discovered the word. It seems more than likely, therefore, that Arp's deposition was made at the instigation of Tzara, who was wishing to recover his prestige.[7] Much later (in 1949), Arp confessed that it should be evident from its fantastic tone that his public declaration had been a Dada joke.[8] Moreover, he put his name (with those of Duchamp, Ernst, Hausmann, Huelsenbeck, and Richter) to a document, prepared by Huelsenbeck, confirming Huelsenbeck's claim that he and Hugo Ball were the ones who had discovered Dada.[9] Tzara replied by saying that "except for Arp, how can the other signatories testify that description given by Huelsenbeck . . . since they were not in Zürich in 1916?" and that "Arp has forgotten his contradictory declaration."[10] In the end, they all withdrew their signatures, leaving Huelsenbeck and Tzara alone in their opposition.

Given his almost frantic inisistence upon his own authorship, it is then surprising that Tzara's "Chronique Zurichoise, 1915–1919" (1920),[11] a series of dated entries covering the Zurich period, says on this point only: "A word was born, no one knows how. . . ." This is an entry headed "1916. June" noting the appearance of *Cabaret Voltaire,* which, we remember, advertised *Dada* (the journal) for the first time. But Tzara's first dated mention of "Dada" in the chronicle is in an entry for February 26, 1916. Headed "HUELSENBECK ARRIVES [in Zurich]," it states "DADA! latest novelty!!!" That Tzara chose the word at the time of Huelsenbeck's arrival is suggested by Georges Hugnet in his "L'Ésprit dada dans le peinture." He writes: "Tristan Tzara gave a name to this delicious malaise: Dada," and then describes the circumstances:

> . . . On February 8, 1916, a paper-knife was pointed at a page in a French dictionary opened at random, and a home was found for the manifestation of the new spirit—Dada. And a Dada celebration was arranged for Richard Huelsenbeck, a German writer who had just come from Berlin.[12]

But according to Tzara, Huelsenbeck did not arrive in Zurich until the 26th. So clearly Hugnet's date derives from the Arp version of the story. And, just as clearly, the dictionary part coincides with Huelsenbeck's own account.

In "Dada Lives" (1936),[13] Huelsenbeck's most detailed description of the discovery of Dada, he wrote that they needed a slogan to affirm group solidarity and as the title for a proposed publication. He was, he said, with Hugo Ball in Ball's room in a Zurich tenement flat. This is what supposedly occurred:

> Besides his wife, I was the only person present. We were discussing the question of a name for our idea, we needed a slogan which might epitomize for a larger public the whole complex of our direction. This was all the more necessary since we were about to launch a publication in which all of us wanted to set forth our ideas about the new art. . . .
>
> Hugo Ball sat in an armchair holding a German-French dictionary on his knees. He was busy with the preliminary work for a long book in which he wanted to show the deleterious changes German civilization has undergone as a result of Luther's influence. Consequently, he was studying countless German and French books on history.
>
> I was standing behind Ball looking into the dictionary. Ball's finger pointed to the first letter of each word descending the page. Suddenly I cried halt. I was struck by a word I had never heard before, the word Dada.
>
> "Dada," Ball read, and added: "It is a children's word meaning hobby-horse." At that moment I understood what advantages the word held for us.
>
> "Let's take the word dada," I said. "It's just made for our purpose. The child's first sound expresses the primitiveness, the beginning at zero, the new in our art. We could not find a better word." Emmy Hennings . . . too, thought that Dada was an excellent word. "Then we'll take Dada as the slogan for our new artistic direction," said Ball. That was the hour of the birth of Dadaism. The following day we told our friends, Tristan Tzara, Marcel Janco and Hans Arp what we had found and decided on. They were enthusiastic about the word Dada.
>
> And so it happened that it was I who pronounced the word Dada for the first time . . . it is perhaps important to re-state the authorship of Dada since today Dadaism assumes once more a very special importance. My idea of Dada was always different from that of Tristan Tzara who, after the dissolution of the Cabaret Voltaire, founded and became the leader of Dadaism in Paris.

This is worth quoting at such length for the rare detail it possesses. No other version presents the same amount of specific incident. It was written, however, some twenty years after the events it describes. Is it to be believed?

The last quoted paragraph shows just how partisan was Huelsenbeck's intent in recounting the story, and just how ideological his motive. He is thinking of the situation in Germany in 1936 and of his political-revolutionary interpretation of Dadaism. He goes on to particularize this, saying that Tzara's transformation of Dada into an artistic movement was opposite to his own—and, he says, original—interpretation of the word. And yet, he has himself talking of "new art" and his wish to set forth his ideas on it. Although Huelsenbeck's political understanding of Dada does have its origins in his Zurich period, it was only fully defined after he moved back to Berlin. But if his interpretation of Dada is a matter of considerable hindsight, what of the conditions of the discovery?

In 1916 Ball was beginning to research post-Lutheran history for his book, *Zur Kritik der deutschen Intelligenz*.[14] Moreover, he would, as a German national, be looking at French entries in his dictionary. *Dada* would not have appeared in the entries on the German side, nor would other than a French entry produce the definition "hobby-horse," which Huelsenbeck notes. Moreover, we have seen from other evidence that the Cabaret Voltaire members were consciously searching for a name for "a publication . . . to set forth our ideas about the new art." Further, although Huelsenbeck's claims are in principle as partisan as Tzara's, they have some kind of contemporary backing, which Tzara's do not have, namely Hugo Ball's diaries.[15]

Let us first note that Ball makes no mention of "Dada" around February 8 (Arp's date for Tzara's discovery). He has Huelsenbeck arriving in Zurich on the 11th. If "a Dada celebration" was arranged for Huelsenbeck's arrival (as Hugnet claims), it is strange that Ball does not mention it by this name. If Huelsenbeck arrived not on the 11th, but on the 26th, as Tzara claims, and it was then that Dada was the "latest novelty," why is it that in his diary entry for that very same day Ball talks of the cabaret being "about to come apart at the seams?" Hardly the moment for group solidarity. If Ball's diaries are to be believed, such solidarity was not evident for another two months.

In a diary entry for April 11, Ball notes: "There are plans for a 'Voltaire Society' and an international exhibition. The proceeds of the soirées will go towards an anthology to be published soon." Although he was at that time opposed to turning the Cabaret Voltaire, his "whim," into "an artistic school" (and recorded Huelsenbeck's opposition as well), it seems inconceivable that he would have used the phrase "Voltaire Society" had "Dada" existed on that date. April 11, rather, is

surely the approximate date by which the idea of a group name, to be used also for a publication title, was aired. A week later (April 18), Ball wrote: "Tzara keeps on worrying about the periodical. My proposal to call it Dada is accepted."

"My proposal": is this the same as my invention? Given the loudness of Huelsenbeck's claims, most commentators have preferred to think not. Further, an explanation for Ball's role as middleman would tie in the possibility that Huelsenbeck felt a proposal from Ball would be better accepted by Tzara, with whom his own relations had never been ideal. Thus, a collaborative Ball-Huelsenbeck discovery somewhere in the week April 11 to 17 seems a reasonable conclusion. But there is one more piece of evidence to consider, which supports Ball's individual claim to the discovery and which suggests that the word *Dada* may have actually had a specific meaning.

III

Our next question, therefore, is this: Is there anything to suggest that when the word *Dada* was first chosen, it was taken to mean anything? Huelsenbeck, we remember, after saying it was important "to re-state the authorship of Dada," claimed that his interpretation of the word was *always* different from that of Tzara. Further, no sooner had the word *Dada* been discovered than instead of bonding and solidifying the group, it broke it apart. Was there, in fact, immediate disagreement as to what *Dada* meant?

On April 18, 1916, it was agreed that the new periodical should be called *Dada*. The anthology *Cabaret Voltaire* was then in preparation, Ball having taken time away from the cabaret to do the editing. It appeared on June 4, 1916, and was the first publication of the Zurich group: the first time, that is, the activities of the Cabaret Voltaire were presented to a wider audience than that which attended the soirees. It advertised the forthcoming periodical, *Dada*. On July 14, the group presented a lecture and recitation evening at the Waag Hall in Zurich. (The Cabaret Voltaire had closed at the end of June.) This was the first properly public event in Zurich Dada. Ball read a manifesto.[16] It was, he said, "a thinly disguised break with friends. They felt so too. Has the first manifesto of a newly founded cause ever been known to refute the cause itself to its supporters' face? And yet this is what happened"

(6.VIII.1916). Ball, in fact, was opposed to Dada going public, to it becoming a "cause" at all. As the Cabaret Voltaire closed down, Ball left Zurich for the village of Vira-Magadino in the Swiss countryside and severed—at least for the moment—his links with Dada. While he was away, Tzara took on the initiative. It was through Tzara's efforts that Dada became a cause. In August, Ball learned that Tzara had initiated a publishing program under the Dada imprint. First to appear was Tzara's own *La première aventure céleste de Monsieur Antipyrine.* "The celestial adventure for me," Ball noted, ". . . is apathy" (4.VIII.1916). In October, however, there were urgent letters from Tzara, Arp, and Janco begging him to return to Zurich. His presence was "urgently desired" (3.X.1916). A few days later he learned the cause of the trouble. Huelsenbeck wrote to him: "I decided weeks ago to return to Germany." Huelsenbeck was suffering from a stomach complaint. "Perhaps the punishment," he said, "for the Dada hubris that you now think you have recognized. I too have always been greatly opposed to this art" (6.X.1916).

It is evident what had happened. Ball had been the initiator and the leader of the Cabaret Voltaire. His leaving had brought on a crisis between the interpretations of Tzara and Huelsenbeck as to how Dada should be developed. Tzara's "art" interpretation had won the day. Once Dada had a name, the original Zurich group began to dissolve. If by Dada, then, we mean the Dada movement, Tzara's claim to its paternity is incontestable. It was he who created the movement, and it was his keen sense of publicity that fostered it. If, however, we see the Cabaret Voltaire as also part of Dada, we need to acknowledge Ball's leadership in 1916, and his close affiliation with Huelsenbeck. For them, Dada was not an art movement at all, but an attitude. For Tzara, the word that "ne signifie rien" was no more than a convenient slogan for the movement he was creating. Huelsenbeck and Ball, however, do seem to imply that the word itself tells something about the nature of their attitude. Ball describes what "Dada" means in each of the languages of the Dadaists: "Dada is Yes, Yes in Roumanian, rocking-horse and hobby-horse in French. For Germans, it is a sign of foolish naïveté, joy in procreation and preoccupation with the baby carriage" (18.IV.1916). The "infantile" meaning became the most popular one. According to Arp, the Zurich group wanted "an international word free from any political or partisan color, and even from any exact meaning.[17] Huelsenbeck came across the word *Dada,* whose childishness seemed to meet all the requirements. Huelsenbeck himself talked of

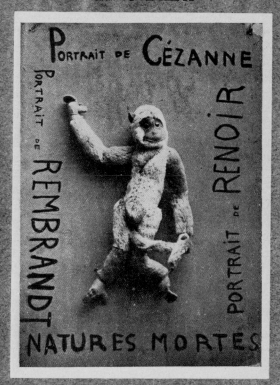

116. Francis Picabia: *Portrait of Cézanne*. 1920 (no longer extant). Reproduced from *Canibale*, Paris, April 25, 1920. Photograph courtesy The Museum of Modern Art, New York.

Dada as "the child's first sound," but for him it was not "childishness" itself but the fact that: "the child's first sound expresses the primitiveness, the beginning at zero, the new in our art."[18]

"Primitiveness" was an important feature of Cabaret Voltaire activity. Janco's stylized masks, the interest in child and African art, the so-called Negro chants and sound poems—all speak of an obsession with the "uncivilized" arts. Especially relevant here are the poems. The word *Dada* was discovered at the very same time that Ball was preparing his sound poems for their Cabaret Voltaire premiere. These were not abstract (nonsignifying) poems as is sometimes claimed, but a poetry of meanings: pseudomagical incantations deriving most immediately from Wassily Kandinsky's concept of the "inner sound" (*innerer Klang*) of words.[19] Kandinsky (whom Ball had known in Munich) had written in *Über das Geistige in der Kunst* of the *innerer Klang,* which "partly (perhaps mainly) corresponds to the object for which the word serves as a name." By this he meant that there were spiritual archetypes for all objects in the world, that objects have an outer and an inner effect upon us, and that the *Klang* is the expression of the inner archetype. This notion of a two-part system of inner meaning hidden by an outer form from which it can be freed by spiritual exercise is, of course, a commonplace in the history of mysticism. Kandinsky was interested in "mystical books and lives of the saints." Ball was too. Arriving in Switzerland in 1915, he immersed himself in mysticism (as well as in political theory), studies that eventually produced a "fantastic" novel (*Tenderenda der Phantast*)[20] and *Byzantinisches Christentum,*[21] a study of three early saints (Johannes Klimax, Dionysius the Areopagite, and Simon Stylites). The sound poems he was preparing in the spring of 1916 were close in spirit to Catholic chants. He talked of the "power" of words and of their possession of an "innermost alchemy" (24.VI.1916). "We have loaded the word with strengths and energies," he wrote, "that helped us to rediscover the evangelical concept of the 'word' (logos) as a magical complex image" (18.VI.1916). Given, then, Ball's obsession with the potency of words and with the power of their meanings, it seems inconceivable that he would have lightly accepted as a group title a word that "ne signifie rien."

Huelsenbeck confirms that a "nonsense" interpretation of the word *Dada* was not what they intended:

> To be sure, the choice of the word Dada in the Carbaret Voltaire was selective-metaphysical, predetermined by all the idea-energies

with which it was now acting upon the world—but no one had thought of Dada as babies' prattle.[22]

That is to say, it was not so much an infantile word as a primitive one: "The child's first sound expresses the primitiveness, the beginning at zero . . ." Its archetypal implication was a part of its attraction. But was there another one? "All living art," Ball wrote, "will be irrational, primitive and complex; it will speak a secret language and will leave behind documents not of edification but of paradox" (25.XI.1915). What we have considered is certainly paradoxical; but does Dada itself "speak a secret language?"

In Munich, Ball had coauthored poems with a young German writer called Hans Leybold.[23] They had signed these works "Ha Hu Baley": a simple kind of code using similar and repeated forms. On March 29, 1916, Ball signed a letter "Da Da."[24] This was, of course, around two weeks after the word *Dada* had been discovered; but the two-syllable division seems interesting. Could it have been that the word sparked off for Ball a special kind of association when he and Huelsenbeck alighted upon it in the dictionary? "Dadaism . . . was really my creation," Ball wrote on July 23, 1920. He could, however, have been meaning the idea. Far more interesting is a diary entry from around a year later:

> When I came across the word "Dada" I was called upon twice by Dionysius. D.A.—D.A. (H[uelsenbec]k wrote about this mystical birth; I did too in earlier notes. At that time I was interested in the alchemy of letters and words) (18.VI.1921).[25]

"D.A.," of course, is Dionysius the Areopagite, one of the three subjects of Ball's *Byzantinisches Christentum*. Is Ball's diary entry no more than hindsight fantasizing in the light of his more developed interest in early Christian theology, or had he, in fact, five years earlier, made this connection? Had he seen in Dada a double echo of the sixth-century Neoplatonist who was to obsess him in his later life? For Ball, Dionysius's lesson was of an ascetic rebellion against a demonic and dissolute world—escaping (and reforming) this world in a new "mystical birth." This is also Ball's own understanding of Dada. He was, as he says, "at that time . . . interested in the alchemy of letters and words." Beyond that, however, the issue is unlikely to be decided. But it would be strange indeed if hidden in the alchemy of letters that denotes the most scurrilous of modern movements lies a saint who dreamed of a hierarchy of angels.

NOTES

1. *Dada Intirol Augrandair Der Sängerkrieg* (Paris, 1921).
2. Hans Richter, *Dada: Art and Anti-Art* (New York: McGraw-Hill Book Co., 1965), p. 31.
3. "Dada manifeste 1918," in his *Sept manifestes dada* (Paris, 1924).
4. Hans Richter, *Dada: Art and Anti-Art*, p. 32.
5. *La Nouvelle Revue Française*, 36, no. 213, June 1931, p. 868, quoting from *Dada Intirol*, 1921.
6. For examples see William Rubin's account of the evidence in his *Dada, Surrealism and Their Heritage* (New York: The Museum of Modern Art, 1968), pp. 189–190. A slightly different version appears in his *Dada and Surrealist Art* (New York: Harry N. Abrams, 1969), p. 64.
7. Ribemont-Dessaignes thinks so. According to his account, once Arp was outside the room where his statement was made, he issued a disclaimer, saying he had found himself "under an obligation to make this declaration," but it was indeed he himself who had chosen the word (*Déjà Jadis,* Paris, 1958, p. 12). This, however, is hearsay, for Ribemont-Dessaignes was not among those in the Tirol. His informant was presumably Breton, of those present the one most anxious to discredit Tzara. But whether Ribemont-Dessaignes's report is authentic, and whether Breton's—if it was his—is genuine are matters not easily decided.

There are further complications. If Arp did repudiate his statement as soon as it was made, why did it appear in print that autumn? There may be an explanation. While the group was meeting in the Tirol, Picabia published, in July 1921, a supplement to his magazine *391* called *Le Pilhaou-Thibaou,* and there wrote that he, Picabia, together with Marcel Duchamp had "invented" Dada, and that Huelsenbeck was as likely to have chosen the word itself as was Tzara. In Arp's printed statement are mentioned the "imbeciles and Spanish professors" who are the only ones interested in dates. Is this a dig at Picabia, who was Spanish? And was Arp's statement directed not principally against Breton (after all, he apparently had told Breton it was untrue) but against Picabia, who was continuing to attack Tzara's claims to the invention. Is this why it appeared in print after the disclaimer had been made? It seems likely, for in a tract Picabia distributed at the Paris Salon d'Automne of 1921—and dealing mainly with his attitudes to Arp—he had ironically referred to himself as "an imbecilic Spanish professor."
8. Robert Motherwell, ed., *The Dada Painters and Poets* (New York: Wittenborn, Schultz, 1951), p. xxxi.
9. The document was Huelsenbeck's *Dada Manifesto, 1949,* published as a separate pamphlet in Motherwell. For details of the controversy see Motherwell, p. xxx.
10. Letter of September 26, 1949, in Motherwell, p. xxxi.
11. In Richard Huelsenbeck, ed., *Dada Almanach* (Berlin, 1920), pp. 10–29.

A "Chronique Zurich" also appeared in *Dada,* nos. 4–5 ("Anthologie Dada"), Zurich, May 15, 1919.

12. Originally published in *Cahiers d'Art,* 7, 1932; 9, 1934; and widely reprinted. See Motherwell, pp. 126–127.

Another version of the invention linking "Dada" to a specific cabaret performance is worth noting here. In a diary entry for February 7, 1916, Hugo Ball notes the premiere at the Cabaret Voltaire of a singer he calls "Madame Leconte." In 1920, Huelsenbeck wrote that "the word Dada was accidentally discovered by name as Lurois, but since the article is based on a lecture, the spelling may be a name for Madame le Roy, the chanteuse at our cabaret" ("En Avant Dada," 1920, in Motherwell, p. 24). Presumably "Leconte" and "le Roy" are one and the same. (A recent article by Huelsenbeck in *Studio International,* January 1972, has her name as Lurois, but since the article is based on a lecture, the spelling may be a transcription error.) Since she began working at the cabaret on February 7, had Tzara mentioned her in his claims to have discovered "Dada" the day after—or had Arp mentioned her in his deposition—things would be a lot clearer. But she does not appear in any of the versions supporting Tzara—and, in fact, disappears from Huelsenbeck's later accounts, when he insists that "Dada" was intended for the Dadaists alone. Of course, if "Dada" had been chosen for this enigmatic lady, Huelsenbeck could not have had anything to do with it, since the earliest date given for his arrival in Zurich is the 11th. Perhaps this is why she so conveniently disappears. To complicate matters further, however, Ball has a variant date for her Cabaret Voltaire premiere: the very first performance of the 5th (Preface to *Cabaret Voltaire,* dated May 15, 1916). We are forced to conclude that the Leconte-le Roy story is probably a red herring.

13. *Transition,* 25, Fall 1936, pp. 77–80.

14. Bern, 1919.

15. *Die Flucht aus der Zeit* (Munich and Leipzig, 1927). Further references to Ball's diaries are given by date of entry. (English trans.: *Flight Out of Time,* Ann Raimes, trans., and John Elderfield, ed., New York: The Viking Press, 1974).

16. The first complete version of the manifesto is printed in *Flight Out of Time.*

17. Quoted in Gabrielle Buffet-Picabia, "Some Memories of Pre-Dada: Picabia and Duchamp," in Motherwell, p. 265.

18. See note 13.

19. See Sixten Ringbom, *The Sounding Cosmos, A Study in the Spiritualism of Kandinsky and the Genesis of Abstract Painting* (Åbo, 1970), pp. 118–119, 152–153.

20. Posthumously published, Zurich, 1967.

21. Munich, 1923.

22. Huelsenbeck, "En Avant Dada," in Motherwell, p. 31.

23. They appeared in *Die Aktion* in March, May, June, and August 1914.

24. Hugo Ball, *Briefe 1911–1927* (Einsiedeln, 1957), pp. 52–53. The letter is simply dated "Zurich, 29th," but on internal evidence the editor of the *Briefe* (Annemaire Schutt-Hennings) presumes a date in March 1916.

25. We do not know, for example, when Ball was first interested in "D.A." He began systematic study for *Byzantinisches Christentum* in 1919, but is likely to have known about its subjects earlier, if not from childhood, at least from his renewed interests in mysticism from 1915. For a linguistic study of the word *Dada,* but one that suggests no meanings: Jean-Claude Chevalier, "Dada, étude linguistique de la fonction d'un terme qui 'ne signifie rien,' " *Cahiers Dada Surrealisme,* 1, September 1966. It may also be relevant that *être sur son dada* means to indulge in one's hobby.

Introduction to Surrealists on Art*

LUCY LIPPARD

In her concise introduction to *Surrealists on Art,* Lucy Lippard touches the movement's core consciousness. She describes essentials—the collage aesthetic, the pun, automatism, chance, the dream, and politics. She shows how the Surrealists juggled opposites. They were in search of revolution and the dream, of social action and the unconscious, of the marvelous and the absurd.

The Surrealists rejected conventional criticism. Only two major studies exist on the plastic arts: Surrealist Marcel Jean's *The History of Surrealist Painting* (New York: Grove Press, 1960) and William Rubin's *Dada and Surrealism* (New York: Harry N. Abrams, 1969). An important general history of the movement is Maurice Nadeau's *The History of Surrealism* (New York: Collier Books, 1967).

Lucy Lippard is a well-known author and critic of modern art.

* Reprinted from *Surrealists on Art* (Englewood Cliffs, N.J.: Prentice-Hall, 1970).

The Surrealists had nightmares because they couldn't paint too well.

—Sidney Tillim (1966)

Do you still remember that time when painting was considered an end in itself? We have passed the period of individual exercises.

—Paul Éluard (1933)

Surrealism was officially baptized in 1924, though its birth cries were audible by 1922, when Dada, "the Virgin Microbe," disintegrated into influential particles. The official Surrealist movement continued into its senility until the death, in 1964, of André Breton, but most visual artists of any note had left the fold by 1945, when Surrealism's last direct influence (on the New York School) was absorbed, and the last international Surrealist exhibition that can be called important in any sense at all took place in Paris in 1947. In most opinions, the truly heroic years lasted only until 1929; certainly they were over by 1935.

Underlying all Surrealist art is the collage aesthetic, or the "reconciliation of two distant realities" on a new and unexpected plane. Its

117. Max Ernst: *The Blind Swimmer.* 1934. Oil on canvas. 36¼″ × 28⅞″. Photograph courtesy Pierre Matisse Gallery, New York.

prime literary source was Isidore Ducasse (alias Comte de Lautréamont), a nineteenth-century poet virtually unknown until Breton exhumed him, whose famous image—"the fortuitous encounter of an umbrella and a sewing machine on a dissecting table"—triggered endless Surrealist variations in all media. Its pictorial inventor (aside from such historical figures as Hieronymus Bosch and Odilon Redon) was Giorgio de Chirico, and its immediate animator was the Dada-Surrealist Max Ernst, in 1919. In Ernst's collages of 1921 it is possible to see an illustration of the gradually diverging strains of Dada and Surrealism. His Dada work, founded on the harsh conjunction of opposing realities, was essentially destructive and dissective in its approach to accepted meanings, styles, and pictorial references. By 1921, however, the artist began to connect dissimilar objects by association; the result was no longer a single new image but a new *situation,* narrative, or drama comprised of recognizable images integrated into a novel context that was closer to the now standard idea of Surrealist "dream pictures" (see figs. 117, 118). The unity of this carefully constructed oneiric realism

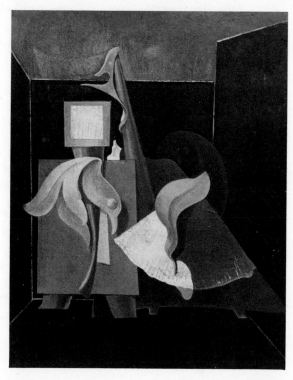

118. Max Ernst:
Two Anthropomorphic Figures. 1930.
Oil on canvas. 26 ″ × 21¼ ″.
Photograph courtesy
Pierre Matisse Gallery, New York.

was assured by such smooth passage between images. Many of these collages seem like individual frames from films or comic strips, dislocated parts of strange tales. The Surrealists hoped eventually to draw from the juxtaposition of thus dislocated fragments a new, superreality, rather than mere destruction of the old.

> One thing is certain, that I hate simplicity in all its forms.
> —Salvador Dali

The basis of this collage aesthetic is the pun, a word originating in the Italian *puntiglio* and implying a "fine point." In modern literature, the pun is inextricably bound to the "stream-of-consciousness" technique of James Joyce (who was not adopted by the Surrealists, but must have been aware of them in Paris in the 1930s). Joyce's magnificent and often outrageous use of puns transcended specific translation when the multiple meanings of a phrase were expanded into innuendos based on several ancient and modern languages. He used them in such a way that their rhythms and general allusions were available and tantalizing, even to the less-than-erudite reader, for no linguistic (and now pictorial) form has deeper roots in the play between conscious and unconscious responses to life than the pun.

Similarly, the Surrealist image of a hybrid reality wrenched from its accustomed context is recognizable on several levels, the lowest of which is mere grotesquerie or whimsical fantasy and the highest, the sheer density of associations that can be accumulated in a nearly abstract image. A psychologist's definition of adult fantasy is illusion, a mental image taken as reality by a disturbed mind. It was this aspect of the fantastic that most interested the Surrealists. The intermingling of writing and drawing that is typical of schizophrenic art, explored only formally by the Cubists, was one source of the Dadas' efforts to fathom the contents of the alienated or extraordinary mind, efforts that were further systematized by the Surrealists. By 1919 both Ernst and Breton had worked with or studied the insane. From their experiences came the seeds of automatism, the technique of allowing a passive hand to record the "dictations" of the subconscious.

> Everybody knows there is no such thing as Surrealist painting: neither pencil lines made as a result of accidental gesturing, nor images tracing dream figures, nor imaginative fantasies can qualify as such.
> —Pierre Naville (1925)

> Surrealism is within the compass of every consciousness.
> —Surrealist tract

The artists and the poets who wrote the [Surrealist] texts were more or less, at one time or another, adherents of the constantly revolving platforms upon which André Breton—the "Pope of Surrealism"—took his stand (the exceptions are Giorgio de Chirico, Pablo Picasso, and Joseph Cornell). While most of the men were excommunicated at one time or another, their work was generally untouched by Breton's theoretical vicissitudes. In fact, the visual arts had no place in the original blueprint for the movement, which was conceived not in order to achieve aesthetic "progress" but to revolutionize society at every level. Surrealist writers, such as Breton, Louis Aragon, or Paul Éluard, justified the inclusion of visual art by proclaiming that what they liked was not painting but "beyond painting" or a "challenge to painting." Surrealism intended to initiate a new humanism, in which "talent" did not exist, in which there were no artists and nonartists, but a broad new consciousness that would sweep the old concept of art along with it.

These two ideas—everyman an artist and the artist as medium—developed and changed from Marcel Duchamp to Max Ernst to Jean Dubuffet to Andy Warhol. An early Surrealist tract announced that "every true adept of the Surrealist revolution is obliged to believe that the Surrealist movement is not a movement in the abstract, and particularly in a certain poetic abstract that is utterly detestable, but is really capable of changing something in the minds of men." Through the 1940s second-generation Surrealists could say, as did Matta: "I always defended Breton's definition of Surrealism, which has to do with the total emancipation of man. Surrealism is 'more reality.' There is always the need for man to grasp 'more reality'; for only in this way can we create a truly *human* condition." It is indicative of Surrealism's failure to effect this change that its art is now its best-known product. Even Breton eventually fell back on art when his disillusionment with revolution became complete; Nadeau dates the failure of Surrealism from the moment in 1935 when Breton "classifies himself, whether willingly or not, in the category of the *artists.*"

By the mid-1930s most of the artists, having exhausted the superficial benefits of automatic techniques, found their pictorial vocabularies impoverished and their styles becoming increasingly illusionistic. In the wake of Salvador Dali's introduction of the "dream photograph" and "paranoic criticism" came a resurgence of interest in the object, the illusionist phase of the collage aesthetic. The Surrealist objects of the 1930s differed from Duchamp's Dada "readymades" and other Dada and early Surrealist objects in their complexity and self-consciousness.

Where the earlier works had seemed either spontaneous or basically restricted to a single shape, pun, or idea, the later stage brought forth the most esoteric and visually elaborate images, some of which were perishable or impermanent in form, others of which differed from sculpture only in that they were assembled entirely from non-art materials. Dummies and mannequins played an important part (the influence of de Chirico was stronger than it had been since Dada). In the "International Surrealist Exhibition" of 1938, full-sized mannequins played leading roles in the theatrical installation. An interest in primitive art, important to Surrealism since its inception, but now particularly valued for its fetishistic qualities and occult implications, also increased.

> The Surrealist dimension of film is . . . most strikingly communicated in the first sequence of [Feuillade's 1915] *Vampires*. On a bedroom wall hangs a painted landscape; in the landscape is a Sphinx, painted against a deep, receding (painted) space. The picture is shifted to one side, revealing a deep, dark recess in the screened wall. Musidora, pale and dark-eyed, emerges, and the game begins, War—and it is Surrealism's war—is declared on a world of surfaces.
>
> —Annette Michelson

> Perfection
> is laziness.
> —André Breton and Paul Éluard

> Criticism can only exist as a form of love.
> —André Breton

In the film, the Surrealists found the ideal medium in which to combine verbal and visual collage, and it is in the contemporary film that the Surrealist contribution is most conspicuous, despite Dali's contention in 1932 that "contrary to current opinion, the cinema is infinitely poorer and more limited for the expression of the real function of thought than writing, painting, sculpture and architecture. There is hardly anything below it except music, whose spiritual value is, as everyone knows, just about nil." Not only was the film, like the dream, experienced in the dark by an audience detached from itself, but its photographic realism offered the possibility of a still more credible (and physically enveloping) disruption of ordinary events, behavior, and time sequence. It also reached more people, and was therefore a more potent revolutionary and evangelical weapon. Around 1930 the Surrealist film was considered a real threat to public decency (as in the *L'Age d'or* affair). Its effectiveness can be judged by comparison with any of the

saccharine "dream sequences" found in Hollywood musicals. Today, the sight gag (or visual pun) is found as frequently in television commercials as it is in over- or underground movies.

The Surrealist antipathy to logical and reasoned explanation is partially responsible for the absence of what we call criticism. Poetry was considered an appropriate and complementary analogue for painting, while scholarly or "intellectual" criticism was bypassed because, as Éluard put it, "poetry is the opposite of literature . . . a poem must be a debacle of the intellect." The Surrealists' interest in science, scientific techniques, and scientific metaphor might be seen as a contradiction of this attitude, but in fact the Surrealists saw science as an indicator of the unknown similar to their own art. There were "laws of the unconscious." Modern science's incorporation of flux and disorder was understood by Breton and the others as a confirmation of Surrealism's "will to

119. René Magritte: *Usage of the Word I.* 1928–1929. Oil on canvas. 21½" × 28½". Photograph courtesy Sidney Janis Gallery, New York. Private collection.

objectification." "Objective chance" was the "geometric locus" of coincidences, the expression of a hidden order. The collective procedures used by the Surrealists to "force inspiration"—the collaborative drawing (Exquisite Corpse), the collaborative novel or poem—simulated the product of a scientific "team" and reflected scorn for *mere* art, opium of the individualist. The "enquiry" was one of their favorite methods of systematizing the products of the subconscious, and a Bureau of Surrealist Enquiries, engaged in collecting from the public "communications relative to diverse forms which the unconscious activity of the mind is likely to take," actually existed on the rue de Grenelle in Paris for a few months in 1924 and 1925. Automatic writing was presented as research, experiment; and the review *La Révolution Surréaliste* had an austere format modeled after the scientific journal *La Nature*. In the 1930s

120. René Magritte: *The Key of Dreams.* 1930. Oil on canvas. 14″ × 23″. Courtesy Sidney Janis Gallery, New York.

scientific jargon and lengthy pseudoscientific speculations crept into Surrealist theory. A Hegelian orientation was compatible with these perorations, and Robert Shattuck has noted that Breton's three favorite Surrealist metaphors all derive from physics: *"interference,* the reinforcement and canceling out that results from crossing different wavelengths; the *short circuit,* the dangerous and dramatic breaching of a current of energy; and *communicating vessels* that register barely visible or magnified responses among tenuously connected containers."[1] The cosmic references of later Surrealism were the basis of another attempt at a new humanism. All along, the scientific principle of discovering a suspected but unknown order, of exposing and embodying the invisible, was obviously attractive to visual artists who were by nature accustomed to making visible the invisible.

121. Salvador Dali: *The Persistence of Memory.* 1931. Oil on canvas. 9½″ × 13″. Collection The Museum of Modern Art, New York. Given anonymously.

The Poet of the future will surmount the depressing notion of the
irreparable divorce of action and dream.

—André Breton

Surrealism is not concerned with what is produced around it on the
pretext of art, or even anti-art or philosophy, in a word all that does
not have as its purpose the annihilation of being in a blind and
inward splendor, is no more the soul of ice than fire . . .

—André Breton

. . . the radical denial of the Establishment and the communica-
tion of the new consciousness depend more and more fatefully on
a language of their own, as all communication is monopolized and
validated by the one-dimensional society.

—Herbert Marcuse

By 1929 Breton was disgusted with the artists' and poets' use of
automatism for personal and aesthetic ends alone; "The Second Sur-
realist Manifesto" marks the beginning of the movement's political
phase, during which most of the artists went their own ways. The above
quotation from Marcuse is not necessary to point up the similarities
between at least the goals of Surrealism's revolution and that cultural
and social revolution projected by young people in 1970. Forty years
has emphasized rather than dimmed the pertinence and urgency of many
Surrealist programs, though their methods may now seem hopelessly
impractical. Parallels are found under the blanket of revolution—in
proposals for free love, destruction of capitalism, equality of all men
including the "normal" and the "abnormal," and a utopian reconcilia-
tion between the "masses" and the "elite," to be accomplished, accord-
ing to the Surrealists, through total freedom from social repression and
destruction of barriers between conscious and unconscious, admissible
and inadmissible behavior.

The materiality, the presence of the work of sculpture in the world,
essentially independent of any single individual, but rather a residue
of the experience of many individuals, and the dream, the experi-
ence of the sea, the trees, and the stones—I'm interested in that kind
of essential thing.

—Carl Andre (1969)

In view of the similarity between the broad goals of the Surrealists
and those of today's youth, it is not surprising that interest in the
multilateral Surrealist enigma has proved stronger than ever in recent
years, and that of all the twentieth-century movements in art, Surreal-

122. André Masson: *Battle of Fishes.* 1927. Sand, gesso, oil, pencil, and charcoal on canvas. 14¼″ × 28¾″. Collection The Museum of Modern Art, New York. Purchase.

ism, along with Dada, has more vibrant connections with contemporary art than any other. These influences, appropriately enough, have been exerted largely unconsciously, in the various ways new art has plugged into the network of ideas evolved by the Surrealists. If much Surrealist painting now appears dated and retrograde, its successors have found new ways to utilize its main tenets: the collage aesthetic, concreteness or "materialism," automatic techniques, chance or random order, black humor, and biomorphic morphology—though Surrealist art per se holds little attraction for most advanced artists today. Traces of these tenets have filtered into the most unexpected areas, among them modernist abstraction—which the Surrealists abhorred as "unreal" and "escapist" art for art's sake—and, to mention only a few, Pop art, funk art, "antiform," Happenings, even areas of "primary structure," Conceptual art, technological art (particularly in its collaborative, anonymous aspect), and intermedia environment. Reconciling such stylistically diverse sensibilities is the Surrealist emphasis on direct experience: physiological (unconscious as well as intellectual) identification, direct confrontation and communion between artist and viewer, with the work as the "communicating vessel."

NOTE

1. Roger Shattuck, "Love and Laughter: Surrealism Reappraised," in Maurice Nadeau, *The History of Surrealism* (New York: Collier Books, 1967), p. 23.

Stripping Down to Cosmos*

DORE ASHTON

Dore Ashton evokes rather than explicates the way Joan Miró saw the world: one of tiny creatures and prolific detail in closeup vision. At the same time, she describes his creation of vast spaces.

Miró's metaphysical concerns and the visual language he found to express them are the focus of this essay. This visual language involves a "stripping down," a reduction of means that Ashton sees as central to Miró and to twentieth-century art. According to the author, Miró, like Matisse, belongs to a family of "organic" artists for whom stripping is the result of a purifying process largely governed by intuition.

Dore Ashton, a well-known author and critic, is Professor of Art History at Cooper Union, New York.

When Matisse was painting *Dance* (1910), Miró was seventeen years old. Two years later he saw his first Impressionist and Fauve paintings and began a painstaking examination of modern art. He maintained a

* Reprinted from *A Reading of Modern Art* (rev. ed.; Cleveland: The Press of Case Western University, 1971, in connection with Harper and Row, New York).

singularly open spirit throughout his life, eagerly examining every conceivable avenue of expression and testing his own observations against those of others. Certain assumptions posited at the turn of the century were accepted by him without question and remained with him always. The Symbolist emphasis on the indefinable function of "spirit" seems never to have left him. In 1917 he wrote to a friend, "I believe our 'school' will grasp the essentials of the painting of the future. It will be stripped of all concern for pictorial problems, it will vibrate in harmony with the pulse of the Spirit." He stated his belief that after all the modern movements, including that of the Analytical Cubist and Futurist tendencies, there would be "a free art, all interest in which will focus on the vibration of the creative spirit. These modern analytical movements will ultimately carry the spirit to the light of freedom."[1] Miró wrote this as a very young man, not long after Kandinsky had published his own similar convictions, which Miró could not have known, but which also stemmed from nineteenth-century Symbolist tenets.

Miró's ready acceptance of the exalted ambitions for art—an art of the spirit—was not unusual for the moment in which he was maturing, but his preparations in terms of working methods were. Although he was already well informed about what was happening in advanced literary and painting circles in Paris, Miró followed his own course. In the letter cited, he asserted that "everything is contained in reality and it is by digging deep that we succeed in producing good painting." His confidence that a realistic approach would release the "spirit" led him to paint a number of exceptionally detailed landscapes that sound the first note of his individual genius. At this same time, he and several other painters in Barcelona were aggressively establishing their antiromantic viewpoint in the Group Courbet (a name that makes significant allusion to a vigorous realist tradition of the past). In these landscapes the dry, even sunlight of Catalonia etches each tiny detail. Miró's vision of a world teeming with living form—a cosmos containing abundant and ordered vitality—is at this time explicitly expressed, although later he was to rephrase his paean to the world of prolific detail in more or less abstract terms.

As early as 1916 Miró expressed his conception of the harmony of nature when he wrote from Montroig, "I have come here for a few days to live with the landscape, to commune with this blue and golden light of the wheat fields and to ennoble myself at this sight. . . . I love every tiny creature, every blade of grass."[2]

In 1918 he pursued his microcosmic exploration of nature, writing to Rafols,

> What happiness to manage to comprehend a single blade of grass in the landscape—why scorn a blade of grass?—that blade of grass is as beautiful as any tree or mountain. Except for the primitives and the Japanese, nobody has ever taken a good look at this thing which is so divine. Artists are always looking for great masses of trees or mountains to paint, never attuning their ears to the music that emanates from tiny flowers, blades of grass and little pebbles in a gully.[3]

Here again, we have the Symbolist's poetic concern with the "music" that emanates from nature, the binding harmony that can be discerned when the world of phenomena is examined in intimate focus.

This closeup vision of the universe was to occur to many artists in the twentieth century, finding their way individually to an almost oriental concept of detail. Mark Tobey literally discovered the small world underfoot in Japan ("While in Japan sitting on the floor of a room looking over an intimate garden with flowers blooming with dragonflies hovering in space, I sensed that this small world almost underfoot had a validity all its own, but must be realized and appreciated from its own level in space").[4] And James Johnson Sweeney reported that Arshile Gorky decided in 1943 to "look into the grass," producing a series of beautiful drawings in which the miniature world of small insects, grains of earth, and tiny grasses was characterized.

Miró had explicitly elected to ignore not only the principles of Cubism, but all pictorial conventions, when he set about painting his landscapes of 1918 and 1919. "What I am interested in most of all is the calligraphy of a tree or the tiles of a roof, leaf by leaf, twig by twig, blade by blade of grass."[5] Leaf by leaf, he did build up the essence of each particular tree, but he worked always toward the total harmony, the "spirit" of his subject. His paintings, even with their most meticulously handled small details, are still organized on the principle of the arabesque, that curving line that always returns, always closes off the cosmos from the chaos. Musicality and the idea of the arabesque—even the most spiritualized idea of the arabesque as expressed by Mallarmé in poetry and Moreau in his aesthetic writings—are implicit in these landscapes.

A view of the cosmos as an abundant, proliferating but harmonized world, a world of myriad tiny details, is, in a sense, one side of a

symmetrical dialectic, while the great wide world of infinite spaces—desert, sky, sea—is its symmetrical concomitant. Instinctively, Miró moved from the external realism of a Courbet toward that metaphysical realism described so accurately by Paul Klee. He was undoubtedly helped to find his way to his own poetic synthesis by his extensive reading. In 1916, for instance, he was reading French avant-garde magazines and was familiar with the poetry of Apollinaire and probably with his art criticism, as well as with that of Pierre Reverdy. By the time he left for his first trip to Paris in 1919, Miró was already steeped in the spirit of the avant-garde.

The principal twentieth-century drive toward the reduction of means, the elimination of all unnecessary flourish in painting, was conveyed to him early. Miró's statements in French abound with the word *dépouiller* (to strip, to eliminate, to render bare, and, significantly, to reap or harvest). Miró had written as a youth that the Group Courbet must "sweep away all the rotting and fossilized corpses," and had frequently referred to the process of simplification he wished to pursue. He was undoubtedly helped toward his goal by his exposure to the group of avant-garde poets and painters he met on the rue Blomet during his first long sojourn in Paris. Michel Leiris, Robert Desnos, Georges Limbour were regulars. Their exuberance, their espousal of Dada, were not lost on Miró. Yet, through all the feverishly imaginative activities he witnessed and all the queer and original ideas he absorbed, Miró continued to work in his own way toward his own already established ideals. Around 1923, he wrote, "I have managed to escape into the absolute of nature. . . . I know that I am travelling a perilous route, and I confess that I am often seized with panic, the panic of following unexplored paths to an unknown destination."[6]

"A perilous route": from the world of microcosmic exactitude to the world of the infinite, in which the groundline gives way and the spaces are no longer divided by habit and convention, but by feeling. Symbolist principles still influence him. In speaking of *The Hunter* (*Catalan Landscape*) (1923–1924; fig. 123), he writes to his friend Rafols, "Monstrous animals and angelic animals. Trees with ears and eyes and a peasant in a Catalan cap, holding a shotgun and smoking a pipe. All pictorial problems solved. To express with precision all the golden sparks the soul gives off."[7] These golden sparks, not palpable but felt keenly by Miró as reality, are his entrée into the world of the absolute,

that same world of fantasy, essentially, that Matisse entered when he erased the walls and took in the sky on the same terms as a small Moroccan pot.

In *The Hunter* Miró literally works with golden sparks; his forms glide in a yellow sky over a pink area suggesting the landscape. Shapes wander freely in various levels in space. Small and large are handled with great caprice, their relative sizes underplayed. Large circles and small circles, large arabesques and small share the infinite space. The world in little is symbolized with the greatest economy—sometimes in the flourish of a dotted line alone—and each figure is stripped to its essential identity. Echoes of Picabia's machine parodies are to be found, but the real experience in *The Hunter* is of a space that knows no artificial boundaries and of forms that navigate that space illumined by what Miró called "the light of freedom."

Shortly after, Miró embarked on his characterization of the "large"

123. Joan Miró: *The Hunter (Catalan Landscape)*. 1923–1924. Oil on canvas. 25½″ × 39½″. Collection The Museum of Modern Art, New York. Purchase.

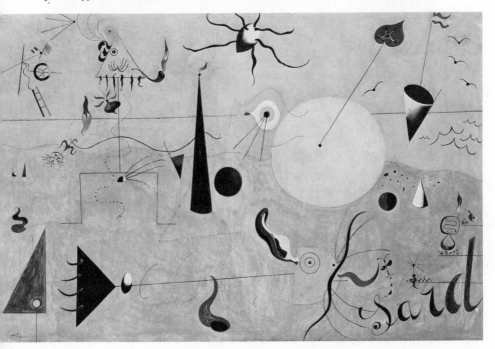

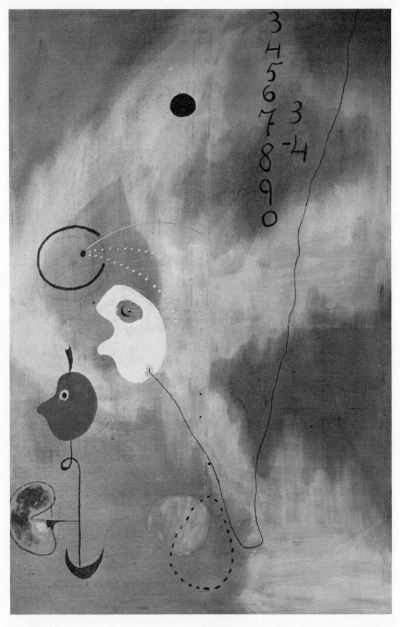

124. Joan Miró: *The Check*. 1925. Oil on canvas. 76¾″ × 51⅛″. Photograph courtesy Pierre Matisse Gallery, New York.

vision of the cosmos. (He had just encountered the name of Paul Klee, and was moved by some of Klee's watercolors that he had seen in André Masson's studio. Their common assumptions apparently were immediately noticed by Miró; see figs. 34, 35.) Although Jacques Dupin, his biographer, insists that the so-called dream paintings of 1925 to 1927 had no metaphysical intentions, and that they are the expression of "the void," these paintings are expressed in the metaphysical language of the modern painter and can mean nothing other than their profound expression of things that exist in the human imagination virtually; things that fulfill the function of the unreal (figs. 124, 125).

This was the moment of Surrealism, a moment Miró lived along

125. Joan Miró: *Dog Barking at the Moon*. 1926. Oil on canvas. 29″ × 36¼″. The Philadelphia Museum of Art. A. E. Gallatin Collection.

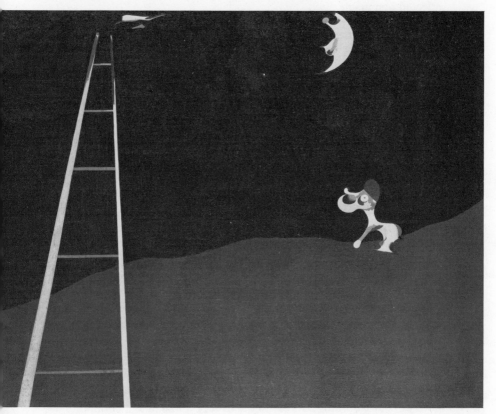

with its most ardent proponents. It was a moment in which Miró himself according to Dupin, was devouring the great rebels of poetry—Novalis, Lautréamont, Rimbaud, Jarry. Since it was neither the bizarre nor the fashionable in Surrealism that appealed to Miró (he never fully exercised the proper automatistic ritual), it was most probably the metaphysical reverberations, particularly in Novalis and Rimbaud, that spoke to him in their work.

It is worth examining the tone of Novalis. Both Miró and Klee read him. (Klee is said to have read his *Hymns to the Night* many times, and many of Klee's thoughts echo Novalis.) As Miró is a serious and assiduous reader, we may assume that Novalis's various insights reached him in full. We may assume, in Novalis's own words, that the poetry affected him magically,

> for it is not the mere hearing of words that really affects us in this magic art. Everything happens inside . . . the inner sanctuary of the mind. . . . He—the poet—can arouse these magic powers in us at his pleasure, and through the medium of words enables us to experience an unknown, glorious world. Out of their cavernous depths times gone by and times yet to come rise up before us— innumerable people, strange regions and the most fantastic happenings—and make use of the familiar present.[8]

Novalis's poetic vision is rooted in metaphysical questions. "How little one has applied physics to the human spirt and the spirit to the external world," he wrote.

> Reason, imagination, intelligence—these are the bare framework of the universe operating in us. No word of their wonderful blendings, new forms and transitions. No one has thought of seeking out a new unknown force, to follow out their cooperative relationships. Who knows what wonderful new unities, what wonderful new developments still lie ahead of us within ourselves.[9]

Certainly the program of the twentieth-century painters was consonant with Novalis's vision of new relationships, and it is precisely in the effort to express the possibility of "wonderful blendings, new forms and transitions" that modern art announces itself as "modern."

Novalis's tone is exalted, and oneiric, as Dupin says Miró's paintings were in 1925, but, far from expressing a mystical "void," Novalis's poetry posits a cosmos familiar to the history of the imagination:

What spirited being, endowed with senses, does not love, above all, the other miraculous phenomena of space that surround him, the all cheering light, with its colors, its rays and billows, its mild omnipresence, as when day is breaking? Like life's innermost soul, the titanic world of the restless stars breathes it and swims dancing in its blue tide—the sparkling eternally tranquil stone, the meditative, sucking plant, and the wild, burning, multiform animals breathe it— . . .

But I turn down toward the sacred, inexpressible, mysterious night. . . . Far-aching memory, desires of youth, dreams of childhood, the brief joys and vain hopes of an entire long life come gray-clad, like evening mist after sundown . . .—o ardor of night, o slumber of heaven, you it was came over me—the landscape rose softly; and above it soared my delivered, newborn spirit. . . .[10]

His *Hymns to the Night* could serve as descriptions of certain paintings of both Miró and Klee. What is important is not so much the visionary aspect as the opening out; within these paintings, which are tough, self-searching statements of both the tangible and the intangible, of both aspects of human life, are elements of widely differing character from which later generations were amply nourished.

The vision of large spaces that persists in the human imagination is recurrently expressed in Miró's oeuvre. The paintings of 1925 expressing extension ad infinitum are intimately related to the paintings of 1961—sublime statements of Miró's career.

In *Head of a Catalan Peasant* (1924–1925), for instance, Miró's various fantasies of the peasant are sublimated, and the poetic surge of feeling for a cosmos very like Novalis's is the content. The Catalan becomes a simple scheme—two intersecting threads against the infinite sky, fine and fragile but written with confidence, with the head symbolized only by the Catalan beret. A moving star, and yet another, three small planets, and the red baton, a God-like finger that floats downward or upward, depending on interpretation: a simple statement of the wide world of fantasy—as real to the painter as to the poet, as real as the world of small things.

In this painting and others of the 1920s, Miró has moved through the metamorphosis of form toward what he called the "absolute of nature." Dupin states:

The problem of the genesis of forms has now been solved as far as he is concerned. Like nature herself, he works from the embryo, from the mother cells which grow and develop, split up, take on various fixed forms, but always according to a continuous process in obedience to laws of organic development.[11]

Even in these free cosmos paintings, the function of the form—or rather, the forms as entities functioning in spaces—are felt as conditioned dynamically by the whole. So slender a thread as the Catalan peasant rides the ether because the ether is as it is. The enlarged dots, or planets, are formed as much by the pressure of the blue density (under-scored by the brush marks) as by the "idea" of them. A dynamic view of form changes the relationships of things in space:

> Les pointes rouges da ma cravate
> piquaient le ciel . . .

wrote Miró in his "Jeux Poétiques."[12] A poetic game, a fantasy, yet a summary of a point of view which in substance is much the same as Matisse's; here, the artist can imagine myriad relationships between the solid that he is himself and the invisible concept that is space, or sky, or cosmos.

Nothing reveals his attitude better, though, than the group of paintings titled *Blue* (1961; fig. 126). In all of these paintings, the "point" is crucial, the point that Klee called the primordial, cosmic element. "Every seed is cosmic." One aspect of Miró's work, particularly in these recent paintings, is his "cosmicizing." They are invocations of vastness (a conception we *know* rather than experience directly), of sensations such as flying, gazing, daydreaming, hurtling, invocations of the function of unreality and its absolute necessity. It is the vastness understood by Coleridge who, in a letter concerning his youth, wrote: "From my early reading of fairy tales . . . my mind has been *habitu-ated to the Vast* and I never regarded my *senses* in any way as the criteria of my belief."[13] Like Coleridge, Miró is habituated to the vast. In these paintings it is given on the canvas as a great, modulated field of blue—the chaos from which will emerge cosmos.

What is cosmos in *Blue II*? It is the black irregular trail of rounded shapes and the nearly vertical bar of earth-and-blood red (the same finger of destiny as in *Head of a Catalan Peasant*). The vivid black shapes, rounded like stones or seeds, stroll across the blueness, as would a living being who must decide each of his next steps. They are the marks of man's presence and they cosmicize the vastness. The completed painting is the concrete result of a prior ritual, or the conclusion of an unconscious metamorphosis.

In an interview Miró expalined that the large Blue canvases took

him a great deal of time, not in the painting, but in meditation. The first step, he said, was of an intellectual order. But then, in a surprising confirmation of the metaphysical, the "cosmicizing" aspect, he stated:

> It cost me an enormous effort, a very great interior tension, to arrive at a desired stripping-down [*dépouillement*] . . . It was as before the celebration of a religious rite, yes, like the entrance into religious orders. You know how the Japanese archers prepare themselves for competitions? They begin by putting themselves in a state, exhaling, inhaling, exhaling—it was the same for me. I knew I risked

126. Joan Miró: *Blue II*. 1961. Oil on canvas. 106" × 140". Photograph courtesy Pierre Matisse Gallery, New York.

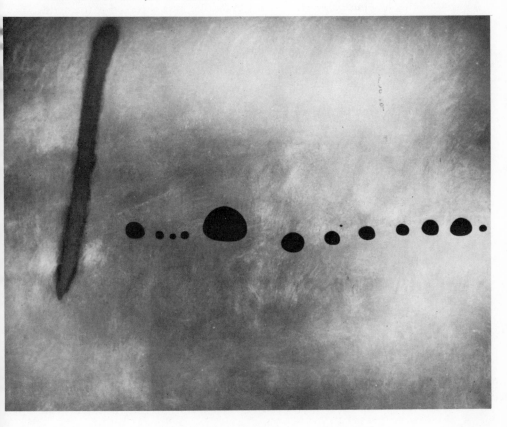

everything, a weakness, an error, and everything would have fallen to earth.

Finally, when asked what his painting orientation would be, he answered: "De plus en plus dépouillée" (More and more stripped down).[14]

In cosmicizing the uncultivated zone (in Eliade's phrase) Miró asserts his stature as a man, nothing more, but certainly nothing less. He is never given to sentimental fantasies that go beyond the bounds of his own experience, his own emotion. Miró began as a realist, an aggressive, programmatic realist, willing to ally himself with the Group Courbet and to reject all the academic motifs considered acceptable at the time. He has said in a hundred different ways that his source is always nature. Dupin points out that the symbol of the foot throughout Miró's work is probably an allusion to Miró's conviction that man is rooted in the earth via his feet and everything that grows springs from this contact with terra firma. Miró is quoted somewhere as saying a man must brace his feet against the earth in order to spring upward (see fig. 127).

(It is this deep commitment to earthly experience and the concrete world that has led Miró to protest strongly that he is not an abstract artist. "Have you ever heard of greater nonsense than the aims of the abstractionist group?" he exclaimed to Sweeney. "And they invite me to share their deserted house as if the signs that I transcribe on canvas at the moment when they correspond to a concrete representation of my mind were not profoundly real and did not belong essentially to the world of reality." Again: "For me, a form is never something abstract; it is always the sign of something. It is always a man, a bird, or something else.")[15]

To "cosmicize" is to make the unknown habitable. The familiar experiences of the concrete world are indispensable. Miró's great arcs from the earth to the infinite blue skies of fantasy and back constitute a vision of a whole world. Miró is one of the artists who have made certain twentieth-century assumptions—of prelogical concerns, of new spaces, of dynamic form—into a healthy vision. He has joined the function of the real to the function of the unreal in healthy wholeness. That "other" world of myth, archaism, and nonhistory that Miró understands with perfectly intuitive responses is always there. But so is the real world, with its linear history and its describable activities. The "other" world can only be expressed metaphorically (as Miró once

pointed out, he wanted to go beyond form to poetry), and its proofs must lie in the realm of the sensible and common sense.

For instance, even if we were to resist the extravagant theories of modern philosophers and ethnographers concerning the role of myth in the collective psyche, we should have to admit that there are surges of emotion that seem utterly unprepared by an occasion. We should have to admit that colossal fury exists, that deep depressions exist, that many extremes of imaginative behavior exist without "real" explanation. When a man says, "I acted with a strength I never knew I had," or "I

127. Joan Miró: *Composition*. 1933. Oil on canvas. 51″ × 63¾″. Courtesy Perls Galleries, New York.

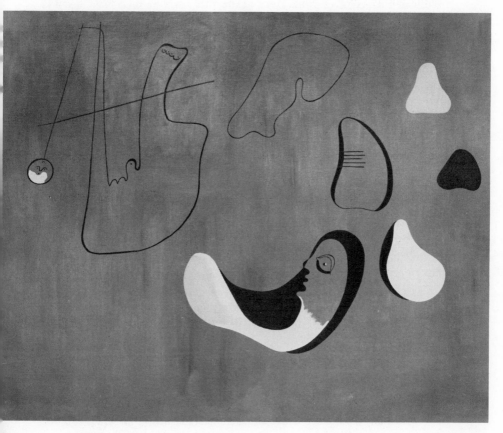

don't know what came over me," he is acknowledging the occurrence of a personal experience that cannot be demonstrated to others, but only understood through the imagination.

When Miró says that he wants to "rediscover the sources of human feeling," he is already taking a metaphysical position, or, rather, he is speaking of his language of signs as an instrument toward greater understanding. His language, with all its magical overtones, and probably its cultivation in knowledge of actual magic, is his philosophy made visible for all to ponder. His friends, such as Michel Leiris, probably stimulated him. Leiris, a poet and anthropologist, has made significant studies of rituals and magic all over the world as a scientist, and his conclusions invariably underline the serious sources and purposes of non-Western European custom. Here again, Miró is a man of his time, and the late nineteenth- and twentieth-century willingness to "see" beyond Western European culture is expressed in him. The organic imagination moves in a world of creative evolution, a world eloquently described by Bergson, whose intuitions are supported by another great twentieth-century anthropologist, Claude Lévi-Strauss, who quotes a metaphysical philosophy common to all the Sioux Indians, according to which things and beings are nothing but materialized forms of creative continuity:

> Everything as it moves, now and then, here and there, makes stops. The bird as it flies stops in one place to make its nest, and in another to rest on its flight. A man when he goes forth stops when he wills. So the god has stopped. The sun, which is so bright and beautiful, is one place where he has stopped. The moon, the stars, the winds, he has been with. The trees, the animals, are all where he has stopped, and the Indian thinks of these places and sends his prayers there to reach the place where the god has stopped and win help and a blessing.[16]

(If a text were to serve as a parallel to Miró, what better text than this, for Miró has "stopped" in all of these places?)

Bergson's metaphysics, which conditioned Miró's generation to a great extent, are very similar as Lévi-Strauss proves in his choice of a Bergson text for comparison:

> A great current of creative energy gushes forth through matter, to obtain from it what it can. At most points it is stopped; these stops are transmuted, in our eyes, into the appearance of so many living species, i.e. of organisms in which our perception, being essentially analytical and synthetic, distinguishes a multitude of

elements combining to fulfill a multitude of functions, but the process of organization was only the stop itself, a simple act analogous to the impress of a foot which instantaneously causes thousands of grains of sand to contrive to form a pattern.[17]

I have said that Miró joins the function of the real to the function of the unreal in a wholesome way. Lévi-Strauss, in commenting on the two texts, the Sioux and Bergson, makes a similar point with terms of discourse that are significantly scientific. What have the Indian wise man and Bergson in common, he asks.

It seems that the relationship results from one and the same desire to apprehend in a total fashion the two aspects of reality which the philosopher terms *continuous* and *discontinuous*; from the same refusal to choose between the two; and from the same effort to see them as complementary perspectives giving on to the same truth.[18]

The need to apprehend "in a total fashion" the two worlds that are continuous and discontinuous is probably the central philosophical question of our time. Miró has consistently woven back and forth between the two realms, knowing instinctively that they exist as two aspects of reality. But Miró is a painter, and his language is the language of a painter. Forms, no matter how many times he has questioned their importance, are the flesh and blood of his paintings—forms, or, in a different sense, symbols. Vegetables, hats, feet, skies, winds, seas, hair, and blood symbolize both worlds in a poetic reminder of their ineffable capacity to stir emotion at levels we hardly discern in our everyday existence. The moon, stars, the ladder inevitably resound poetically.

NOTES

1. Jacques Dupin, *Joan Miró: Life and Work* (New York: Harry N. Abrams, 1962), p. 81.
2. *Ibid.*, p. 65.
3. *Ibid.*, p. 83.
4. Mark Tobey, letter dated October 28, 1954, in *Art Institute of Chicago Quarterly*, February 1, 1955, p. 9.
5. Dupin, *Miró*, p. 84.
6. *Ibid.*, p. 139.
7. *Ibid.*, p. 140.

8. Cited in Max Brod, *Heine: The Artist in Revolt* (New York: Collier Books, 1962), p. 213.

9. Lancelot Law Whyte, *The Unconscious Before Freud* (New York: Doubleday & Co., 1962), p. 113.

10. Novalis, *Hymns to the Night,* trans. Eugene Jolas, *Transition Workshop* (New York: The Vanguard Press, 1949).

11. Dupin, *Miró,* p. 179.

12. Joan Miró, "Jeux Poétiques," *Cahiers d'Art,* 20–21, 1945–1946, pp. 269–272.

13. I. A. Richards, ed., *The Portable Coleridge* (New York: The Viking Press, 1950), p. 225.

14. Rosamond Bernier, "Propos de Joan Miró," *L'Oeil,* nos. 79–80, July–August 1961.

15. James Johnson Sweeney, *Miró* (New York: The Museum of Modern Art, 1941).

16. Claude Lévi-Strauss, *Totemism* (Boston: Beacon Press, 1962), p. 28.

17. *Ibid.*

18. *Ibid.*

Marcel Duchamp, Or, the Castle of Purity*

OCTAVIO PAZ

Paz's complex study relies upon paradox, a mode congenial to Duchamp and to the author. This affinity is not surprising. Paz was involved with the Surrealist movement, sympathetic to its alogic, and Duchamp among twentieth-century figures is *the* master of irony and contradiction. His art is a criticism and his criticism is art, the first of many paradoxes that Paz unravels in his discussion of that most enigmatic work of art, *The Bride Stripped Bare by Her Bachelors, Even,* also known as the *Large Glass.* The work was begun in 1912, about the time Duchamp "gave up painting," and was left in its present "unfinished" state in 1923. Paz discusses the *Large Glass* in terms of ideas relating to myth and criticism.

The interpretation of the *Large Glass* is tied to Paz's treatment of Duchamp's "readymades." These are anonymous objects converted into works of art by the artist's simple act of choosing them. Paz explains how they function as criticisms of taste and of art itself.

* Reprinted in its entirety: Octavio Paz, *Marcel Duchamp, Or, the Castle of Purity,* trans. Donald Gardner (New York and London: Golliard Press, Grossman Publishers, 1970).

Duchamp directly challenged his critics to interpret his work by stating "the spectator makes the picture." The interdependence of the two, artist and viewer-critic, makes for a special situation, which is reflected in the vast literature on Duchamp that has appeared since 1959. The most complete, current bibliography on Marcel Duchamp appears in the exhibition catalogue *Marcel Duchamp,* The Museum of Modern Art, New York, 1973.

Octavio Paz is Mexico's foremost poet and essayist. He is author of many books including one on Duchamp and Claude Lévi-Strauss, translated into French as *Deux Transparents.*

> Sens: on peut voir regarder.
> Peut-on entendre écouter, sentir?
>
> —M. D.

Perhaps the two painters who have had the greatest influence on our century are Pablo Picasso and Marcel Duchamp. The former by his works; the latter by a single work which is nothing less than the negation of *work* in the modern sense of the word. The transformations that Picasso's painting has gone through—*metamorphoses* would be a more accurate word—have astonished us consistently over a period of more than fifty years; Duchamp's inactivity is no less astonishing and, in its way, no less fruitful. The creations of the great Spanish artist have been incarnations and, at the same time, prophecies of the mutations which our age has suffered between the end of Impressionism and World War II. Incarnations: in his canvases and his objects the modern spirit becomes visible and palpable; prophecies: the transformations in his painting reveal our time as one which affirms itself only by negating itself and which negates itself only in order to invent and transcend itself. Not a precipitate of pure time, not the crystallizations of Klee, Kandinsky, or Braque, but time itself, its brutal urgency, the immediate imminence of the present moment. Right from the start Duchamp set up a vertigo of delay in opposition to the vertigo of acceleration. In one of the notes in the celebrated *Green Box* he writes: "use *delay* instead of 'picture' or 'painting'; 'picture on glass' becomes 'delay in glass . . .'" This sentence gives us a glimpse into the meaning of his activity: painting is a criticism of movement but movement is the criticism of

painting. Picasso is what is going to happen and what is happening, he is posterity and archaic time, the distant ancestor and our next-door neighbor. Speed permits him to be two places at once, to belong to all the centuries without letting go of the here and now. He is not the movements of painting in the twentieth century; rather, he is movement become painting. He paints out of urgency and, above all, it is urgency that he paints: he is the painter of time. Duchamp's pictures are the presentation of movement: the analysis, the decomposition, the reverse of speed. Picasso's drawings move rapidly across the motionless space of the canvas; in the works of Duchamp space begins to walk and take on form; it becomes a machine that spins arguments and philosophizes; it resists movement with delay, and delay with irony. The pictures of the former are images; those of the latter are a meditation on the image.

Picasso is an artist of an inexhaustible and uninterrupted fertility; Duchamp painted less than fifty canvases and these were done in under ten years: Duchamp abandoned painting in the proper sense of the term when he was hardly twenty-five years old. To be sure, he went on "painting" for another ten years but everything which he did from 1913 onward is a part of his attempt to substitute "painting-idea" for "paint-ing-painting." This negation of painting, which he calls "olfactory" (because of its smell of turpentine) and "retinal" (purely visual), was the beginning of his true *work*. A work without works: there are no pictures except the *Large Glass* (the great delay) (1915–1923; fig. 128), the "readymades," a few *gestures,* and a long silence. Picasso's work reminds one of that of his compatriot Lope de Vega and in speaking of it one should in fact use the plural: the works. Everything which Duchamp has done is summed up in the *Large Glass,* which was *finally unfinished* in 1923. Picasso has rendered our century visible to us; Duchamp has shown us that all the arts, including the visual, are born and come to an end in an area which is invisible. Against the lucidity of instinct he opposed the instinct for lucidity: the invisible is not obscure, or mysterious, it is transparent . . . The rapid parallel I have drawn is not an invidious comparison. Both of them, like all real artists, and not excluding the so-called minor artists, are incomparable. I have linked their names because it seems to me that each of them has in his own way succeeded in defining our age: the former by what he affirms, by his discoveries; the latter by what he negates, by his explora-tions. I don't know if they are the "greatest" painters of the first half of the century. I don't know what the word *greatest* means when applied to

128. Marcel Duchamp: *The Bride Stripped Bare by Her Bachelors, Even* (*Large Glass*). 1915–1923. Oil and lead wire on glass. 109¼″ × 45¼″. The Philadelphia Museum of Art, The Louise and Walter Arensberg Collection.

an artist. The case of Duchamp—like that of Max Ernst, Klee, de Chirico, Kandinsky, and a few others—fascinates me not because he is the *greatest* but because he is *unique*. This is the word that is appropriate to him and defines him.

The first pictures of Duchamp show a precocious mastery. They are the ones, however, which some critics describe as "fine painting." A short time afterward under the influence of his elder brothers, Jacques Villon and the sculptor Raymond Duchamp-Villon, he passed from Fauvism to a restrained and Analytical Cubism. Early in 1911 he made the acquaintance of Francis Picabia and Guillaume Apollinaire. It was undoubtedly his friendship with these two men that precipitated an evolution which had until then seemed normal. His desire to go beyond Cubism can already be seen in a canvas of this period; it is the portrait of a woman passing by: a girl glimpsed once, loved, and never seen again. The canvas shows a figure which unfolds into (or fuses with) five female silhouettes. As a representation of movement or, to be more precise, a decomposing and superimposing of the positions of a moving body it anticipates the *Nude Descending a Staircase* (1912; fig. 129). The picture is called *Portrait or Dulcinea*. I mention this detail because by means of the title Duchamp introduces a psychological element, in this case affectionate and ironic, into the composition. It is the beginning of his rebellion against visual and tactile painting, against "retinal" art. Later he will assert that the title is an *essential* element of painting, like color and drawing. In the same year he painted a few other canvases, all of them striking in their execution and some of them ferocious in their pitiless vision of reality: Analytical Cubism is transformed into mental surgery. This period closes with a noteworthy oil painting: *Coffee Mill*. The illustrations to three poems of Laforgue also come from this time. These drawings are interesting for two reasons: on the one hand, one of them anticipates the *Nude Descending a Staircase;* on the other, they reveal that Duchamp was a painter of *ideas* right from the start and that he never yielded to the fallacy of thinking of painting as a purely manual and visual art.

In a conversation which he had in 1946 with the critic James Johnson Sweeney,[1] Duchamp hints at the influence of Laforgue on his painting: "The idea for the *Nude* . . . came from a drawing which I had made in 1911 to illustrate Jules Laforgue's poem *Encore à cet astre* . . . Rimbaud and Lautréamont seemed too old to me at the

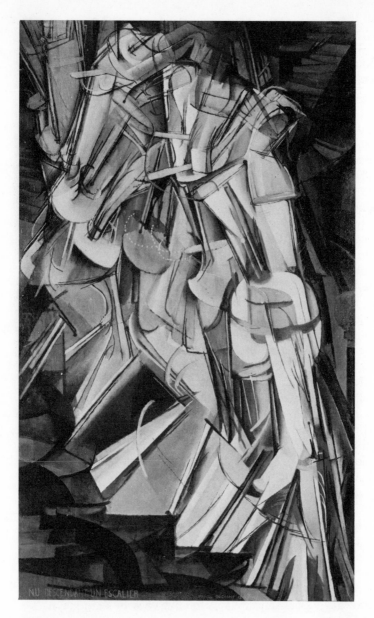

129. Marcel Duchamp: *Nude Descending a Staircase, No. 2.* 1912. Oil on canvas. 58″ × 35″. The Philadelphia Museum of Art, The Louise and Walter Arensberg Collection.

time. I wanted something younger. Mallarmé and Laforgue were closer
to my taste . . ." In the same conversation Duchamp emphasizes that
it was not so much the poetry of Laforgue that interested him as his
titles ("Comice agricole," for example). This confession throws some
light on the *verbal* origin of his creative activity as a painter. His
fascination with language is of an intellectual order; it is the most
perfect instrument for producing meanings and at the same time for
destroying them. The pun is a miraculous device because in one and the
same phrase we exalt the power of the language to convey meaning only
in order, a moment later, to abolish it the more completely. Art for
Duchamp, all the arts, obey the same law: meta-irony is inherent in
their very spirit. It is an irony which destroys its own negation and,
hence, returns in the affirmative. His mention of Mallarmé is no less
fortuitous. Between the *Nude* and *Igitur* there is a disturbing analogy:
the descent of the staircase. How can one fail to see in the slow
movement of the woman-machine an echo or an answer to that solemn
moment in which *Igitur* abandons his room forever and goes step by
step down the stairs which lead him to the crypt of his ancestors? In
both cases there is a rupture and a descent into a zone of silence. There
the solitary spirit will be confronted with the absolute and its mask:
chance.

Almost without realizing it, as if drawn by a magnet, I have passed
over in a page and a half the ten years which separate his early works
from the *Nude* . . . I must pause here. This picture is one of the
pivotal works of modern painting: it marks the end of Cubism and the
beginning of a development which hasn't yet been exhausted. Superfi-
cially—though his work is constant proof that no one is less concerned
with the superficial than Duchamp—the *Nude* . . . would seem to
draw its inspiration from preoccupations similar to those of the Futurists:
the desire to represent movement, the disintegrated vision of space, the
cult of the machine. Chronology excludes the possibility of an influence:
the first Futurist exhibition in Paris was held in 1912, and already, a
year before, Duchamp had painted a sketch in oils for the *Nude* . . .
The similarity, moreover, is only an apparent one: the Futurists
wanted to suggest movement by means of a dynamic painting; Duchamp
applies the notion of delay—or, rather, of analysis—to movement. His
aim is more objective and goes closer to the bone: he doesn't claim to
give the illusion of movement—a Baroque or Mannerist idea which the

Futurists inherited—but to decompose it and offer a static representation of a changing object. It is true that Futurism also rejects the Cubist conception of the motionless object but Duchamp goes beyond stasis and movement: he fuses them in order to dissolve them the more easily. Futurism is obsessed by sensation; Duchamp by ideas. Their use of color is also different: the Futurists revel in a painting which is brilliant, passionate, and almost always explosive; Duchamp came from Cubism and his colors are less lyrical; they are denser and more restrained: it is not energy that he is after but a rigorous accuracy.

The differences are even greater if we turn from the external features of the painting to considering its real significance, that is to say, if we really penetrate the vision of the artist. (Vision is not only what we see; it is a stance taken, an idea, a geometry—a *point of view* in both senses of the phrase.) Above all, it is one's attitude toward the machine. Duchamp is not an adept of its cult; on the contrary, unlike the Futurists, he was one of the first to denounce the ruinous character of modern mechanical activity. Machines are great producers of waste and the refuse they leave increases in geometric proportion to their productive capacity. To prove the point, all one needs to do is to walk through any of our cities and breathe its polluted atmosphere. Machines are agents of destruction, and it follows from this that the only mechanical devices that inspire Duchamp are those which function in an unpredictable manner—the anti-machines. Their relation to utility is the same as that of delay to movement; they are without sense or meaning. They are machines which distill criticism of themselves.

The *Nude* . . . is an anti-machine. The first irony consists in the fact that we don't even know if there is a nude in the picture. Encased in a metal corset or coat of mail, it is invisible. This suit of iron reminds us not so much of a piece of medieval armor as of the carriage work of an automobile or a fuselage. Another stroke which distinguishes it from Futurism is the fact that it is a fuselage caught in the act not of flight but of a slow fall. It is a mixture of pessimism and humor: a feminine myth, the nude woman, is turned into a far more gloomy and threatening apparatus. I shall mention, as a last point, a factor which was already present in his earlier works: the rational violence, so much more ruthless than the physical violence which attracts Picasso. Robert Lebel says that in Duchamp's painting "the nude plays exactly the same role as the old drawings of the human skeleton in the anatomy books: it

is an object for internal investigation."[2] For my part I would emphasize that the word *internal* should be understood in two senses: it is a reflection on the internal organs of an object and it is interior reflection, self-analysis. The object is a metaphor, an image of Duchamp; his reflection on the object is at the same time a meditation on himself. To a certain extent each one of his paintings is a symbolic self-portrait. Hence the plurality of meanings and points of view of a work like the *Nude* . . . : it is pure plastic creation and meditation on painting and movement; it is the criticism and culminating point of Cubism; it is the beginning of another kind of painting and the end of the career of Duchamp as a pictorial artist; it is the myth of the nude woman and the destruction of this myth; it is machine and irony, symbol and autobiography.

After the *Nude* . . . Duchamp painted a few extraordinary pictures: *The King and the Queen, The Passage from the Virgin to the Bride, The Bride.* In these canvases the human figure has disappeared completely. Its place is taken not by abstract forms but by transmutations of the human being into delirious pieces of mechanism. The object is reduced to its most simple elements: volume becomes line; the line, a series of dots. Painting is converted into symbolic cartography; the object into idea. This implacable reduction is not really a system of painting but a method of internal investigation. It is not the philosophy of painting but painting as philosophy. Moreover, it is a philosophy of plastic signs that is ceaselessly destroyed, as philosophy, by a sense of humor. The appearance of human machines might make one think of the automatons of de Chirico. It would be quite absurd to compare the two artists. The poetic value of the figures of the Italian painter comes from the juxtaposition of modernity with antiquity; the four wings of his lyricism are melancholy and invention, nostalgia and prophecy. I mention de Chirico not because there is any similarity between him and Duchamp but because he is one more example of the disturbing invasion of modern painting by machines and "robots." Antiquity and the Middle Ages thought of the automaton as a magical entity; from the Renaissance onward, especially in the seventeenth and eighteenth centuries, it was a pretext for philosophical speculation; Romanticism converted it into erotic obsession; today, because of science, it is a real possibility. The female machines of Duchamp remind us less of de Chirico and other modern painters than of the Eve Future of Villiers de

l'Isle-Adam. Like her, they are daughters of satire and eroticism, although, unlike the invention of the Symbolist poet, their form doesn't imitate the human body. Their beauty, if it is possible to use the word of them, is not anthropomorphic. The only harmony that Duchamp is interested in is the harmony of "indifference": a beauty free at last from the notion of beauty, equidistant from the romanticism of Villiers and from contemporary cybernetics. The figures of Kafka, de Chirico, and others take their inspiration from the human body; those of Duchamp are mechanical devices and their humanity is not corporeal. They are machines without vestiges of humanity and, yet, their function is more sexual than mechanical, more symbolic than sexual. They are ideas or, better still, *relations*—in the physical sense, and also in the sexual and linguistic: they are propositions and, by virtue of the law of meta-irony, counter-propositions. They are symbol-machines.

There is no need to seek further than this for the origins of Duchamp's delirious machines. The union of these two words—*machine* and *delirium,* method and madness—brings to mind the figure of Raymond Roussel. Duchamp himself has on various occasions referred to that memorable night in 1911 when—together with Apollinaire, Picabia, and Gabrielle Buffet—he went to a performance of *Impressions d'Afrique.* To his discovery of Roussel must be added that of Jean-Pierre Brisset: "a sort of Douanier Rousseau of philology."[3] But "it was fundamentally Roussel who was responsible for my glass, *La Mariée mise à nu par ses célibataires, même* . . . This play of his which I saw with Apollinaire helped me greatly on one side of my expression. I saw at once that I could use Roussel as an influence. I felt that as a painter it was much better to be influenced by a writer than by another painter. And Roussel showed me the way . . ." *The Bride* . . . is a *transposition,* in the sense that Mallarmé gave the word, of the literary method of Roussel to painting. Although at that time the strange text in which Roussel explains his no less strange method, *Comment j'ai écrit certains de mes livres,* had not yet been published, Duchamp intuited the process: juxtaposing two words with similar sounds but different meanings and finding a verbal bridge between them. It is the carefully reasoned and delirious development of the principle which inspires the pun. What is more, it is the conception of language as a structure in movement, this discovery of modern linguistics which has had so much influence on the anthropology of Lévi-Strauss and, later, on the new French criticism. For Roussel, of course, the method was not a philos-

ophy but a literary method; equally, for Duchamp, it is the strongest and most effective form of meta-irony. The game that Duchamp is playing is more complex because the combination is not only verbal but plastic and mental. At the same time it contains an element which is absent in Roussel: criticism and irony. Duchamp *knows* that it is insane. Roussel's influence is not limited to the method of delirium. In the *Impressions d'Afrique* there is a painting machine; although Duchamp did not fall into the trap of naïvely repeating the device literally, he resolved to suppress the hand, the brushstrokes, and all personal traces from his painting. In their place he used ruler and compasses. His intention wasn't to paint like a machine but to make use of machines for painting. His attitude does not, however, show any affinity for the religion of the machine: every mechanism must produce its own antidote, meta-irony. The element of laughter doesn't make the machines more human, but it does "connect" them with their center, which is man, with the source of their energy, which is hesitancy and contradiction.

In the summer of 1912 Marcel Duchamp went to Munich for a time. He had finished painting the *Nude* . . . It was then that he conceived the idea for what would be his "magnum opus," if it is permissible to use the terms of alchemy to describe the *Large Glass.* This project was on his mind from 1912 to 1923. Despite this central preoccupation, he was possessed by a will to contradiction which nothing and no one escaped, not even himself and his work, and there were long periods in which he almost totally lost interest in his idea. His attitude oscillating between whether to realize or abandon the work found a solution which contained all the possibilities that he could adopt toward it: to contradict it. This is, in my opinion, the meaning of his activity over all these years, from the invention of the *readymades* and the puns which he distributed under the androgynous pseudonym of Rrose Selavy to the optical machines, the short *Anaemic Cinema* (in collaboration with Man Ray), and his intermittent but central participation first in the Dadaist movement and later in Surrealism. It is impossible in an article of this length to enumerate all of Duchamp's activities, gestures, and inventions after his return from Germany.[4] I will only mention a few of them. The first was his journey to Zone, a community in the Juras, again in the company of Apollinaire, Picabia, and Gabrielle Buffet. This excursion, to which we owe the title of the poem by Apollinaire which opens *Alcools,* already foretells the future explosion

of Dadaism. In the personal evolution of Duchamp it has a significance analogous to his discovery of Roussel: it confirms his decision to break not only with "retinal" painting but with the traditional conception of art and the common use of language (communication). In 1913 the first exhibition of modern art (the Armory Show) was held in New York and the *Nude Descending a Staircase,* which was shown there, obtained an immediate and literally scandalous renown. It is significant—exemplary, I should say—that in the same year Duchamp gave up "painting" and looked for employment which would allow him to dedicate himself freely to his investigations.

Many notes, drawings, and calculations have been preserved from this period, almost all of them relating to the long-delayed execution of the *Large Glass.* Duchamp calls these notes: *physique amusante.* They could also be called *comic calculations.* Here is an example: "a straight thread one meter long falls from a height of one meter onto a horizontal plane and, twisting *as it pleases,* gives us a new model for the unit of length." Duchamp carried out the experiment three times, so that we have three units, all three of them equally valid, and not just one, as we have in our poor everyday geometry. The three threads are preserved in the position in which they fell, in a croquet box: they are "canned chance." Another example: "By *condescension* this weight is denser going down than going up." All these formulas have the aim of rendering useless our notions of left and right, here and there, East and West. If the center is in a state of permanent schism, if the ancient notions of solid matter and clear and distinct reason disappear and give place to irresolution, the result is general *disorientation.* Duchamp's intention is to get rid forever of "the possibility of recognizing or identifying any two things as being like each other": the only laws which interest him are the laws of exception, which prevail only by chance and for one occasion only. His attitude to language is no different: "The search for *prime words,"* says one of the notes in the *Green Box,* "divisible only by themselves and by unity." He also imagines an alphabet of signs to denote only the words which we call abstract ("which have no concrete reference") and concludes: "this alphabet very probably is only suitable for the description of this picture." Painting is writing and the *Large Glass* is a text which we have to decipher.

In 1913 the first "readymade" appears: *Bicycle Wheel* (fig. 130). The "original" has been lost but an American collector possesses a "version" of 1951. Little by little others arrive: *Comb, With Hidden*

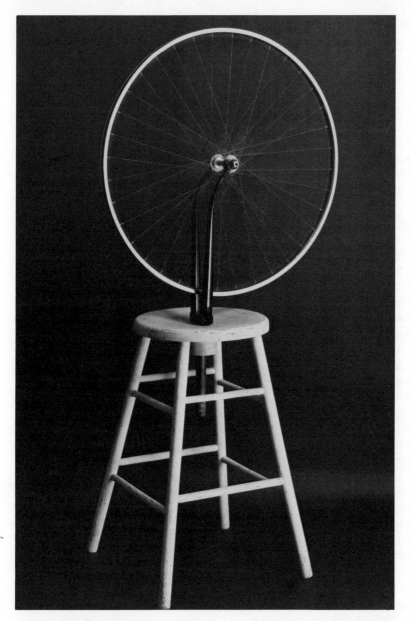

130. Marcel Duchamp: *Bicycle Wheel No. 2.* 1951 (original 1913). Wheel on wood stool. H. 52″. Collection The Museum of Modern Art, Sidney and Harriet Janis Collection.

Noise, Corkscrew, Pharmacy (a chromolithograph), *Eau et gaz à tous les étages, Apolinère enameled* (an advertisement for Sapolin enamel), *Pocket Chess Set,* and a few others. There aren't many of them; Duchamp exalts the *gesture* without ever falling, like so many modern artists, into gesticulation. In some cases the readymades are pure, that is, they pass without modification from the state of being a normal object to that of being a "work of anti-art"; on other occasions they are altered or rectified, generally in an ironic or tendentious manner to prevent any confusion between them and artistic objects. The most famous of them are *Fountain,* a urinal sent to the "Independents" exhibition in New York, and rejected by the selection committee; *L.H.O.O.Q.* (1919; fig. 131) (a whimsical pun), a reproduction of the *Mona Lisa* provided with a beard and moustache; *Air de Paris,* a 50-c.c. glass ampoule which contains a sample of the atmosphere of that city; *Bottle Rack; Why Not Sneeze?,* a birdcage which holds pieces of marble shaped like sugar cubes and a wooden thermometer . . . In 1915, to avoid the war and encouraged by the expectations that the *Nude* . . . had aroused, he went to New York for a long period. He founded two pre-Dadaist reviews there and, with his friend Picabia and a handful of artists of various nationalities, he went about his work of stimulating, shocking, and bewildering people. In 1918 Duchamp lived for a few months in Buenos Aires. He told me that he spent the nights playing chess and slept during the day. His arrival coincided with a coup d'etat and other disturbances, which "made movement difficult." He made very few acquaintances—no one who was an artist, a poet, or a thinking individual. It is a pity: I don't know of anybody with a temperament closer to his own than Macedonio Fernàndez.

In the same year (1918) he returned to Paris. Tangential but decisive activity in the Dadaist movement. Return to New York. Preparatory work on the *Large Glass,* including the incredible "dust raising" which we can see today thanks to an admirable photograph by Man Ray. Explorations in the domain of optical art, static or in movement: *Roto-relief, Rotary Glass Plate* (precision optics), *Rotary Demi-Sphere* and other experiments which are among the antecedents of Op art. Continuation and final abandonment of the *Large Glass.* Growing interest in chess and publication of a treatise on a game. Monte Carlo and an abortive attempt to discover a formula which would enable him always to win at roulette. Participates in various exhibitions and manifestations of the Surrealists. During World War II settles finally in New York.

131. Marcel Duchamp: *L.H.O.O.Q.* 1919. Rectified readymade. Pencil on a repro-
duction. 7″ × 4″. Photograph courtesy The Sidney Janis Gallery, New York.
Private collection.

Marriage to Teeny Sattler. Interviews, fame, influence on the new painting of England and America (Jasper Johns, Robert Rauschenberg), and even on music (John Cage) and dance (Merce Cunningham). And always the same attitude to good fortune or bad—meta-irony. Last summer, when I heard that they were soon going to hold a retrospective exhibition of his work in London, I asked him: "when will they have one in Paris?" He answered me with an indefinable gesture, and added: "No one is a prophet in his own country." He is liberty in person; he is not even afraid of the commonplace which is the bogey of most modern artists . . . This summary of his life leaves out many things, many encounters, various names of illustrious poets and artists and others of women whom he found enchanting or were enchanted by him. It is impossible, however, not to mention the *Box in a Valise* (1941) and the *Green Box* (1934). The first contains reproductions in miniature of almost all his works. The second holds ninety-three documents: photos, sketches, calculations, and notes from 1911 to 1915 and also a color plate of *The Bride* . . . These documents are the key, though incomplete, to the *Large Glass:* "I wanted to make a book, or rather, a catalogue which would explain every detail of my picture."[5]

The readymades are anonymous objects which the gratuitous gesture of the artist, by the simple act of choosing them, converts into "works of art." At the same time this gesture dissolves the notion of work. Contradiction is the essence of the act; it is the plastic equivalent of the pun: the latter destroys meaning, the former the idea of value. The readymades are not anti-art, like so many of the creations of expressionism; they are *an-artistic*. The wealth of commentaries on their meaning—some of them would no doubt have made Duchamp laugh—reveals that their interest is not plastic but critical or philosophical. It would be stupid to discuss them in terms of their beauty or ugliness, as much because they transcend beauty and ugliness as because they are not works but rather question marks or signs of negation that oppose the idea of works. The readymade doesn't postulate a new set of values: it is a spanner in the works of what we call "valuable." It is active criticism, a contemptuous dismissal of the work of art seated on its pedestal of adjectives. The critical action unfolds in two stages. The first serves the purpose of hygiene, an intellectual cleanliness: the readymade is a criticism of taste; the second is an attack on the notion of the work of art.

For Duchamp good taste is no less harmful than bad. We all know that there is no essential difference between them—yesterday's bad taste is the good taste of today—but what is taste? It is what we call pretty, beautiful, ugly, stupendous, marvelous without having any clear understanding of its raison d'être; it is execution, construction, style, quality— the distinguishing characteristics of a work. Primitive people don't have any idea of taste; they rely on instinct and tradition, that is to say, they repeat almost instinctively certain archetypes. Although the Middle Ages and antiquity formulated aesthetic canons, they had no knowledge of taste either. The same is true of the East and of pre-Columbian America. Taste was probably born in the Renaissance and didn't become self-conscious until the Baroque period. In the eighteenth century it was the courtier's mark of distinction and later, in the nineteenth, the sign of the parvenu. Today, since popular art is extinct, it tends to propagate itself among the masses. Its birth coincides with the disappearance of religious art and its development and supremacy are due, as much as anything, to the open market for artistic objects and to the bourgeois revolution. (A similar phenomenon, though it is not identical, can be seen in certain epochs of the history of China and Japan.) "There's no law about tastes," says the Spanish proverb. In fact, taste evades both examination and judgment: it is a matter for samplers. It oscillates between instinct and fashion, style, and prescription. As a notion of art it is skin-deep both in the sensuous and in the social meaning of the term: it titivates and is a mark of distinction. In the first case it reduces art to sensation; in the second it introduces a social hierarchy which is founded on a reality as mysterious and arbitrary as purity of blood or the color of one's skin. The process has become accentuated in our time; since Impressionism painting has been converted into materials, color, drawing, texture, sensibility, sensuality— ideas are reduced to a tube of paint, and contemplation to sensation.[6] The readymade is a criticism of "retinal" and manual art; after he had proved to himself that "it was the craft that dominated," Duchamp denounced the superstition of craft. The artist is not someone who makes things; his works are not pieces of workmanship—they are acts. There is a possibly unconscious echo in this attitude of the repugnance Rimbaud felt for the pen: Quel siècle a mains!

In its second stage the readymade passes from hygiene to the criticism of art itself. In criticizing the idea of execution, Duchamp doesn't claim to dissociate form from content. In art the only thing

which counts is form. Or, to be more precise, forms are the transmitters of what they signify. Form projects meaning, it is an apparatus for signifying. Now, the equipment that "retinal" painting uses to signify is insignificant: it consists of impressions, sensations, secretions, ejaculations. The readymade confronts this insignificance with its neutrality, its nonsignificance. For this reason it cannot be a beautiful object, or agreeable, repulsive, or even interesting. Nothing is more difficult than to find an object that is really neutral: "anything can become very beautiful if the gesture is repeated often enough; this is why the number of my 'readymades' is very limited . . ." The repetition of the act brings with it an immediate degradation, a relapse into taste—a fact which Duchamp's imitators frequently forget. Detached from its original context—usefulness, propaganda, or ornament—the readymade suddenly loses all significance and is converted into an object existing in a vacuum, into a thing without any embellishment. Only for a moment: everything that man has handled has the fatal tendency to secrete meaning. Hardly have they been installed in their new hierarchy, than the nail and the flatiron suffer an invisible transformation and become objects for contemplation, study, or irritation. Hence the need to "rectify" the readymade: injecting it with irony helps to preserve its anonymity and neutrality. A labor of Tantalus since, when significance and its appendages, admiration and reprobation, have been deflected from the object, how can one prevent them from being directed toward the author? If the object is anonymous, the man who chose it is not. And one could even add that the readymade is not a work but a gesture, and a gesture which only an artist could realize, and not just any artist but inevitably Marcel Duchamp. It is not surprising that the critic and the discerning public find the gesture "significant," although they are usually unable to say what it is significant of. The transition from worshiping the object to worshiping the gesture is imperceptible and instantaneous: the circle is closed. But it is a circle which binds us to ourselves: Duchamp has leaped it with agility; while I am writing these notes he is playing chess.*

One stone is like another and a corkscrew is like another corkscrew. The resemblance between stones is natural and involuntary; between manufactured objects it is artificial and deliberate. The fact that all corkscrews are the same is a consequence of their significance: they

* Duchamp died October 1, 1968.—Eds.

are objects that have been manufactured for the purpose of drawing corks; the similarity between stones has no inherent significance. At least this is the modern attitude to nature. It hasn't always been the case. Roger Caillois points out that certain Chinese artists selected stones because they found them fascinating and turned them into works of art by the simple act of engraving or painting their name on them. The Japanese also collected stones and, as they were more ascetic, preferred them not to be too beautiful, strange, or unusual: they chose ordinary round stones. To look for stones for their difference and to look for them for their similarity are not separate acts, they both affirm that nature is the creator. To select one stone among a thousand is equivalent to giving it a name. Guided by the principle of analogy, man gives names to nature: Rocky Mountains, Red Sea, Hell Canyon, Eagles' Nest. The name—or the signature of the artist—causes the place—or the stone—to enter the world of names, or, in other words, into the sphere of significances. The act of Duchamp uproots the object from its significance and makes an empty skin of the name: a bottle rack without bottles. The Chinese artist affirms his identity with nature; Duchamp, his irreducible separation from it. The act of the former is one of elevation or praise, that of the latter, a criticism. For the Chinese, the Greeks, the Mayans, or the Egyptians nature was a living totality, a creative being. For this reason art, according to Aristotle, is imitation: the poet imitates the creative gesture of nature. The Chinese artist follows this idea to its ultimate conclusion: he selects a stone and signs it. He inscribes his name on a piece of creation and his signature is an act of recognition; Duchamp selects a manufactured object; he inscribes his name as an act of negation and his gesture is a challenge.

The comparison between the gesture of the Chinese artist and that of Duchamp demonstrates the negative nature of the manufactured object. It is worth looking at the point a bit more closely. For the ancient world nature was a goddess and, what is more, a creator of gods—manifestations in their turn of vital energy in its three stages: birth, copulation, and death. The gods are born and their birth is that of the universe itself; they fall in love (sometimes with our own women) and the earth is peopled with demigods, monsters, and giants; they die and their death is the end and the resurrection of time. Objects are not born: we make them; they have no sex; nor do they die: they wear out or become unserviceable. Their tomb is the dustbin or the recasting furnace. Technology is neutral and sterile. Now, technology is the nature

of modern man; it is our environment and our horizon. Of course, every work of man is a negation of nature, but at the same time it is a bridge between nature and us. Technology changes nature in a more radical and decisive manner: it throws it out. The familiar concept of the return to nature is proof that the world of technology comes between us and it: it is not a bridge but a wall. Heidegger says that technology is nihilistic because it is the most perfect and active expression of the will to power. Seen in this light, the readymade is a double negation: not only the gesture but the object itself is negative. Although Duchamp doesn't have the least nostalgia for the paradises or infernos of nature, he is still less a worshiper of technology. The injection of irony is a negation of technology because the manufactured object is turned into a readymade, a useless article.

The readymade is a two-edged weapon: if it is transformed into a work of art, it spoils the gesture by desecrating it; if it preserves its neutrality, it converts the gesture into a work. This is the trap that the majority of Duchamp's followers have fallen into: it is not easy to juggle with knives. There is another condition: the practice of the readymade demands an absolute disinterest. Duchamp has earned derisory sums from his pictures—he has given most of them away—and he has always lived modestly, especially if one thinks of the fortunes which a painter accumulates today as soon as he enjoys a certain reputation. Harder than despising money is resisting the temptation to make works or to turn oneself into a work. I believe that, thanks to irony, Duchamp has succeeded; the readymade has been his Diogenes's barrel. Because, in the end, his gesture is a philosophical or, rather, dialectical game more than an artistic operation; it is a negation which, through humor, becomes affirmation. Suspended by irony, in a state of perpetual oscillation, this affirmation is always provisional. It is a contradiction which denies all significance to object and gesture alike; it is a pure action—in the moral sense and also in the sense of a game—his hands are clean, the execution is rapid and perfect. Purity requires that the gesture should be realized in such a way that it seems as little like a *choice* as possible:

> The great problem was the act of selection. I had to pick an object without it impressing me and, as far as possible, without the least intervention of any idea or suggestion of aesthetic pleasure. It was necessary to reduce my personal taste to zero. It is very difficult to select an object that has absolutely no interest for us not only on the

day we pick it but which never will and which, finally, can never have the possibility of becoming beautiful, pretty, agreeable or ugly . . .

The act of selection bears a certain resemblance to making a rendezvous and, for this reason, it contains an element of eroticism—a desperate eroticism without any illusions: "To decide that at a point in the future (such and such a day, hour and minute) I am going to pick a 'readymade' . . . What is important then is chronometry, the empty moment . . . it is a sort of rendez-vous." I should add that it is a rendezvous without any element of surprise, an encounter in a time that is arid with indifference. The "readymade is not only a dialectical game: it is also an ascetic exercise, a means of purgation. Unlike the practices of the mystics, its end is not union with the divinity and the contemplation of the highest truth: it is a rendezvous with nobody and its ultimate goal is noncontemplation. The readymade occupies an area of the spirit that is null: "this bottle-rack which still has no bottles, turned into a thing which one doesn't even look at, although we know that it exists— which we only look at by *turning our heads* and whose existence was decided by a gesture I made one day . . ." A nihilism which gyrates on itself and refutes itself; it is the enthroning of a nothing and, once it is on its throne, denying it and denying oneself. It is not an artistic act, this invention of an art of interior liberation. In the *Large Sutra on Perfect Wisdom*[7] we are told that each one of us has to endeavor to reach the blessed state of being a Bodhisattva while knowing that Bodhisattva is a non-entity, an empty name. This is what Duchamp calls the *beauty of indifference*. Or, to put it another way: freedom.

The Bride Stripped Bare by Her Bachelors, Even, is one of the most impenetrable works of our century. It is different from most modern texts—because this painting is a text—in that the author has given us a key: the notes of the *Green Box*. I have already said that, like the *Large Glass* itself, it is an incomplete key; moreover the notes have no order except a chronological one and they are, in their own way, additional brainteasers, scattered signs which we have to regroup and decipher. *The Bride . . .* and the *Green Box* constitute a system of mirrors which interchange reflections; each one of them illuminates and *rectifies* the others. There are numerous interpretations of this enigmatic work. Some of them are penetrating.[8] I shall not repeat them or offer a new one. My purpose is descriptive: preliminary notes for a future

translation into Spanish.[9] I shall begin with the titles: *La mariée mise à nu par ses célibataires, même.* It is not easy to translate this sentence that twists and oscillates. The first term, *mise à nu,* doesn't exactly mean undressed or unclothed; it is a much more energetic expression, the implications are, rather, of stripping naked or exposing. The obvious associations are with a public ceremony or ritual such as the theatre (mise-en-scène) or execution (mise-à-mort). The use of the word bachelor (*célibataire*) instead of what would seem to be the more normal term, *fiancé* or *suitor,* suggests an insurmountable separation between the male and the female: the bachelor is not even a suitor, and the bride will never be married. The plural, bachelors, and the possessive adjective go to stress the inferiority of the males: one thinks of a herd rather than of polyandry. The adverb *même*—even, not excluding, right down to—underlines the action and converts it into a veritable exposition, in the liturgical as well as the ordinary sense of the word. Almost all the elements of the work are already present in the title: the mythic or religious, the barrack-room joke, the erotic and the pseudo-technical or ironic.

The names of each of the parts also have a significance—sometimes more than one—which completes the meaning of the plastic composition. In fact they are *signposts.* The names of the Bride are Motor-Desire, Queen Bee, and Hanged Woman (which we could in turn, to continue the game, call Pendant: *pendu* and *pendule*). For H. P. Roché the Bride is a mixture of dragonfly and praying mantis; Carrouges has discovered, for his part, that *Mariée* is the popular name in France for an insect: the *noctuelle.* The group of bachelors has a repertory of somber names: Bachelor Apparatus, Eros Machine, Nine Malic Molds (*Neuf Moules Malic*), and, finally, Cemetery of liveries and uniforms. In fact there are nine males and they are only molds, empty suits inflated by the fluid or gas which the Bride emits. They represent nine families or tribes of men: gendarme, cuirassier, policeman, priest, busboy, stationmaster, department-store delivery boy, flunky, and undertaker's assistant. The list couldn't be more gloomy. The other parts have names which indicate their functions: Top Inscription, Slide (Sleigh or Chariot), Water Mill, Scissors, Sieve, Chocolate Grinder (composed of Bayonet, Necktie, Rollers, and Louis XV Chassis), and Oculist Witnesses. There are four others which I shall mention later. I should point out in passing the aggressively virile character of the Chocolate Grinder—although it doesn't have a head.

The Bride Stripped Bare by Her Bachelors, Even, is a double glass, two meters, seventy centimeters high and one meter, seventy centimeters wide, painted in oil and divided horizontally into two identical parts by a lead wire. A cloud of grayish color floats through the upper part of the top half, the domain of the Bride. It is the Milky Way. According to Carrouges it is also a chrysalis, the previous form of the Bride-dragonfly; Roché, on the other hand, sees a sort of gaseous crocodile in the cloud. The Milky Way contains three boards, like those which are used in stadia to mark up the score of the teams or, in airports, to announce the arrival and departure of the planes. These boards are the Top Inscription; their function is to inform the bachelors of the unloading of the Bride—her commands. Roché thinks of them as the "Original Mystery, the Cause of Causes, a Trinity of empty boxes." The Bride appears on the extreme left, a little below the Top Inscription. She is a machine (an agricultural machine, Duchamp informs us—perhaps an allusion to Ceres). She is also a skeleton, a motor, a body that oscillates in space, a terrible insect, a mechanical incarnation of Kali, and an allegory of the Assumption of the Virgin. Duchamp has said that she is the two-dimensional shadow of a three-dimensional object which, in its turn, is the projection of an unknown object of four dimensions: the shadow, the copy of a copy of an Idea. Contiguous to this Platonic vision there is another: Lebel thinks that the fourth dimension is the moment of copulation, when the lovers fuse all the realities into one—the erotic dimension. I won't bother to describe the complicated morphology of the organs which compose the Bride, such as the receiving and transmitting set which is aimed at the group of her bachelors. In the extreme right of the upper part there is an area of dots: they are the discharges of the bachelors. Duchamp left two other parts unpainted: the equipment of the Bride above the lead wire and, toward the right and center, the Handler or Tender of Gravity.

In the lower half, to the left, one finds the group of the Nine Malic Molds or the Cemetery of liveries and uniforms. They are "the architectonic base of the Bride-Apotheosis." The nine puppets stand "as if enveloped . . . by a mirror reflecting back to them their own complexity to the point of their being hallucinated." Are they men who are driven mad by desire or by the vanity of desire? To the right of the Nine, there is a little cart with runners: it is the Slide. This apparatus contains a Water Mill, which propels it. Thanks to an ingenious piece of mechanism which includes, among other things, the spilling of some bottles of

Benedictine (not painted), the Mill animates the Slide with a seesaw movement. As it goes to and fro, the Slide recites interminable litanies: "slow life, vicious circle. Onanism. Horizontal. Junk of life . . ." The Sieve, which is made of seven cones, is to the right of the Slide. It is connected with the Malic Molds by a system of capillary tubes—which are none other than the "capricious units of metrical length," obtained by the method I described earlier. Between the cones of the Sieve and the Chocolate Grinder, the Scissors open and close. The Chocolate Grinder occupies the central part of the lower half of the Glass. An *adage of spontaneity* defines its purpose: "the bachelor grinds his chocolate himself," a formula which to some extent condenses the litanies of the ambulating Cart. The Oculist Witnesses are on the right-hand side; they are geometrical figures which remind one of those of optics. They suggest, moreover, the witnesses who are present at the miracles of religious paintings and the "voyeur" of pornography. Below them, on the extreme right, is one of the areas which are not painted: the region of splashes.

I should complete this catalogue with a very brief description of the function of the Machine. The Bride transmits to her bachelors a magnetic or electric fluid by means of the Top Inscription. Aroused by the discharge, the molds inflate and emit in their turn a gas which, after various vicissitudes, passes through the seven cones of the Sieve, while the ambulating Cart recites its monotonous litanies. The fluid, after it has been filtered through the cones and converted into a liquid, arrives at the Scissors, which scatter it as they open and close: one part falls into the "region of the splashes" and the other, which is explosive, shoots up and perforates the glass (area of the cannon shots). At this moment the Bride takes her clothes off (imaginarily). End of performance. The origin of all this eroticomechanical movement is one of the organs of the Virgin: the Motor-Desire. Duchamp emphasizes that the Motor is "separated from the Bride by a water cooler." The cooler "expresses the fact that the Bride, instead of being merely an a-sensual icicle, warmly rejects (not chastely) the bachelors' brusque offer." So, between the Bride and the bachelors there is no direct contact save at a distance and it is a contact that is at times imaginary and at other times electric. This new ambiguity reflects, I suppose, another verbal analogy: thought is electric and matter is thought. The operation ends when the Bride, stripped bare at last, experiences a threefold sensation of expansion or pleasure: a physical sensation (the result of the act of being

stripped by her bachelors), another which is imaginary, and a third which incorporates the other two, the eroticomechanical, that is, and the mental reality. It is a circular operation: it begins and ends with the Motor-Desire of the Bride. A self-sufficient world. Nor is there any need of spectators because the work itself includes them: the Oculist Witnesses. Inevitably we are reminded of Velázquez and las Meniñas.

The *Large Glass* is the design for a piece of machinery and the *Green Box* is something like one of those instruction manuals for the upkeep and running of a machine. The former is a static illustration of a moment of the operation and to understand it in its entirety, we must refer to the notes of the *Green Box*. In actual fact the composition should have three parts: one plastic, another literary, and a third sonic. Duchamp has made a few fragmentary notes for the last: the litanies of the Chariot, the proverb of the Chocolate Grinder, the shots or explosions, the noise of an automobile engine as it changes gear and goes uphill, etc. It is a transposition into the world of machines of the moans and sighs of lovemaking. On the other hand, the *Large Glass* is also a portable mural which represents the Apotheosis of the Bride, a picture of the Assumption of the Virgin, a satire on the world of machines, an artistic experiment (painting on glass), a vision of love, etc. Of all the interpretations, the psychoanalytical is the easiest and the most tempting: onanism, destruction (or glorification) of the Virgin Mother, castration (the Scissors), narcissism, retention (anal symptoms), aggression, self-destruction, etc. A well-known psychiatrist concludes his study, which is not without its brilliance, with the predictable diagnosis: autism and schizophrenia. The weakness of this kind of hypothesis lies in the fact that its advocates tend to treat works of art simply as symptoms or expressions of certain psychic tendencies; the psychological explanation converts the reality (the picture) into a shadow and the shadow (the sickness) into the reality. One only needs to talk to Duchamp to see that his schizophrenia must be of a very unusual nature since it doesn't get in the way of his dealings with other people or prevent him from being one of the most open-minded people I know. Moreover, the reality of the *Large Glass* is in no way modified by the truth or falsity of the diagnosis. The realities of psychology and of art occupy different levels of meaning: Freud gives us a key to the understanding of Oedipus but the Greek tragedy cannot be limited to the interpretations of psychoanalysis. Lévi-Strauss says that Freud's inter-

pretation of the myth is nothing more than *another* version of it: in other words, Freud tells us, in the language that is appropriate to an age which has substituted logical thought for mythological analogy, the same story as Sophocles told us. Something similar could be said of the *Large Glass:* it is a version of the ancient myth of the great Goddess, Virgin, Mother, Giver, and Exterminator of life. It is not a modern myth: it is the modern version—or vision—of the Myth.

Apollinaire said that Duchamp would be the modern artist who would reconcile art and the people. It is a prophecy that cannot be realized: what the French poet called "the people" has long since ceased to exist; today, instead of "the people," we have "the public," "the masses," "consumers," etc. But there is an element of truth in this bold affirmation: Duchamp does reconcile art with the spirit of the age. I shall try and clarify this idea at the end of my essay. For the time being I shall point out that there are three levels of meaning in the *Large Glass:* the popular, the mythic, and the critical. In an interview with Jean Schuster, Duchamp tells us this story of the origin of his picture: "the fairground stalls of those days (1921) gave me the inspiration for the theme of the bride. They used to display dolls in the sideshows which frequently represented the partners of a marriage. The spectators threw balls at them and, if they hit the mark, they beheaded them and won a prize." The Bride is a doll; the people who threw the balls are her bachelors; the Oculist Witnesses are the public; the Top Inscription is the Scoreboard. The idea of representing the males as bachelors in uniform also has a popular origin. The bachelor keeps his virility intact, while the husband disperses it and so becomes feminine. The husband, Tomás Segovia says, breaks the closed circle of the adolescents and, until he is redeemed by becoming a father, he is seen by his former comrades as a traitor to his own sex. This attitude expresses the adolescent's terror of woman and the fascinated revulsion which he feels for his own secret sexual organs. The uniform preserves his masculinity for two reasons: it belongs by right to men, is a sign which proclaims the separation between the two sexes in such a way that women who put it on look like men; second, the uniform makes a group of the men, it turns them into a separate collectivity bearing some resemblance to the ancient guilds and other secret male societies. So then, behind the modern masquerade another reality appears, archaic and fundamental: the separation between men and the Woman, the ambiguous cult which the former profess and the dominion of the latter over them. We are

moving from farce to sacred mystery, from popular art to the religious mural, from folk tale to allegory.

The *Large Glass* is a scene from a myth or, rather, from a family of myths related to the theme of the Virgin and the closed society of men. It would be curious to attempt a systematic comparison between the other versions of the myth and that of Duchamp. It is a task, however, beyond my ability and my purpose as translator of the text. I shall limit myself to isolating certain elements. The first is the insurmountable separation between the males and the Bride and the dependency on her of the former; not only does the appeal of the Virgin wake the life in them but all their activity, a mixture of adoration and aggression, is a reflex action aroused by the energy which the woman emits and which is directed by her and toward herself. The spatial division into two halves is also significant: the here-below of the males—a messy and monotonous hell as the litanies of the Chariot tell us—and the solitary above-and-beyond of the Virgin, who is not even touched by the shots—the supplications of her bachelors. The meaning of this division is plain; energy and decision are above, below there is passivity in its most contemptible form: the illusion of movement, self-deception (the males are led to believe that they exist only by way of a mirror which prevents them from seeing themselves in their comic unreality). The most noteworthy feature is the circular and illusory character of the operation: everything is born from the Virgin and returns to her. There is a paradox here: the Bride is condemned to remain a Virgin. The erotic machinery which sets things in motion is entirely imaginary, as much because her males have no reality of their own as because the only reality which she knows and by which she is known is reflex: the projection of her Motor-Desire. The emanations which she receives, at a distance, are her own, filtered through a meaningless piece of machinery. At no moment of the process does the Bride enter into any relation with the true masculine reality or with the real reality: the imaginary machine which her Motor projects comes between her and the world. In the version of the myth which Duchamp offers us there is no hero (the lover) who, by breaking the circle of males, setting fire to his livery or uniform, crossing the zone of gravity, conquering the Bride, and liberating her from her prison, will open her and break her virginity. It is not surprising that some critics, influenced by psychoanalysis, have seen in the *Large Glass* a castration myth, an allegory of onanism, or the expression of a pessimistic vision of love in which a true union is

impossible. This interpretation is inadequate. I hope to demonstrate that the theme of the *Large Glass* is another myth; in other words, that the myth of the Virgin and her bachelors is the projection or translation of another myth. For the moment I shall limit myself to emphasizing the circular nature of the operation: the Motor-Desire causes the Bride to rise out of herself and thus desire encloses her all the more completely in her own being. The world is her representation of herself.

The Tantric imagery of Bengal represents Kali dancing in frenzy over two bodies that are as white as corpses. They are not dead: they are two ascetics covered with ashes. In one of her hands Kali grasps a sword, in another, a pair of shears, in the third she holds a lotus, and in the last, a cup. By her side are two little female figures, who hold a sword in one hand and also hold a cup in the other. Around the five figures there is profusion of bones and broken human limbs. A number of dogs are gnawing and licking them. The two white bodies are placed on top of each other and represent Siva, the husband of Kali. The first of them has his eyes closed; he is fast asleep and unaware of what is happening; according to the traditional interpretation he is the absolute unconscious of itself. The other figure, a sort of emanation of the former, has his eyes half-open and his body is hardly formed; he is the absolute already in a state of awareness or consciousness. The Goddess is a manifestation of Siva and the three figures represent the stages of the manifestation: the unconscious passivity of the absolute, the phase of consciousness that is still passive, and the emergence of activity and energy. Kali is the world of phenomena, the incessant energy of this world, which is shown as destruction—sword and shears—as nourishment—the cup full of blood—and as contemplation: the lotus of the interior life. Kali is carnage, sexuality, propagation, and spiritual contemplation. It is obvious that both the image and its philosophical explanation offer more than one parallel with the *Large Glass* and the *Green Box:* Kali and the Bride, the Oculist Witness and the two attendants, masculine passivity and feminine activity. The most obvious resemblance is that in both cases we are present at the representation of a circular operation which unveils the phenomenal reality of the world (strips it bare: ex-poses it) and simultaneously denies it all true reality. This parallel is not external but constitutes the essence or fundamental theme of both representations.

The undeniable similarities between the Hindu image and the *Large Glass* and my explanation of the Tantric tradition do not mean, of

course, that there is a direct relation between them. Nor is the parallel a chance coincidence. They are two distinct and independent versions of the same idea—perhaps of a myth which refers to the cyclic character of time. Of course, it is not necessary to know either the Hindu tradition or Duchamp to understand this myth: the two versions are responses to the traditional images that both civilizations have made of the phenomenon of creation and destruction, woman and reality. But my purpose is not anthropological and the only thing which interests me in comparing these two images is to get somewhat deeper into the work of Duchamp . . . There is another image of Kali which helps to clarify the resemblance. The Goddess is again dancing on the two pale Sivas. Seized by her delirium, she has decapitated herself; instead of the lotus, she is holding her own head in one of her hands; the mouth is half-open and its tongue is hanging out. Three streams of blood gush from her neck: two of them into the cups of her attendants and the central one into her own mouth. The Goddess feeds the world and herself with her own blood in exactly the same way as the Bride sets her bachelors in motion simply by gratifying herself and stripping herself bare. In the first case the operation is related to us in terms of myth and sacrifice; in the second, in pseudomechanical terms which, however, do not exclude the idea of sacrifice. The separation of the female body into two is equally striking: the Goddess and her head, the Bride and her Motor. This last point calls for further comment: the subdivision of the Goddess and the Bride into two parts—one active and the other receptive—is in its turn the consequence of another division; the Goddess and the Bride are projections or manifestations of something which Hindu imagery represents in the mode of myth—Siva in his double form—and which Duchamp preserves invisibly: the fourth or archetypal dimension. Kali and the Bride are representations, and the real world is another representation, the shadow of a shadow. The circular movement is the reintegration of the energy dispersed by the dance or by desire, without any extraneous element enriching or changing it. Everything is imaginary. It is time to pass from myth to criticism.

Neither the Hindu myth nor that of Duchamp is self-sufficient. To understand them we have to resort to the methods of traditional exegesis and, in the case of the *Large Glass,* to the *Green Box.* The enigma of the two images consists in this: if Kali and the Bride are projections, or representations, what do they represent, what is the energy or entity that they are projecting? The Hindu myth gives a clear account of the origin

of the Goddess: a frightful demon threatens the universe with destruction; the gods go in terror to the great divinities, Siva and Vishnu, to seek refuge; Siva and Vishnu, on being informed of what is happening, become angry and swell with rage; the other gods imitate them, the assembly of divine angers fuses into a single image: the black Goddess with eight arms. Male power abdicates in favor of a female deity who will destroy the monster.[10] Philosophical commentary translates this story into metaphysical and ethical terms: energy and the world of phenomena are representations or manifestations of the absolute (unconscious and conscious, asleep and half-awake). Energy is feminine for two reasons: woman is creation and destruction; the world of phenomena is *maya,* illusion (la illusión). Duchamp's version of the myth is different from that of the Hindu commentator in that he rejects the metaphysical explanation and keeps silent. The Bride is a projection of the fourth dimension, but the fourth is, by definition, the unknown dimension. Michel Carrouges concludes from this silence that he is an atheist. From the point of view of Christian tradition his verdict is correct. But our believers and our atheists belong to one and the same family: the former affirm the existence of a single God, a personal Creator; the latter deny it. The negation of the latter only makes sense in the context of the Judeo-Christian monotheistic concept of God. As soon as it abandons these grounds, the discussion loses interest and turns into a quarrel inside a sect. In reality our atheism is antitheism. For a Buddhist atheist, occidental atheism is only a negative and exasperated form of our monotheism. Duchamp has declared quite rightly on a number of occasions that "the genesis of the Glass is exterior to any religious or antireligious preoccupation." (In this context the word *religion* refers to Christianity. The rites and beliefs of the East, for the most part, don't constitute what we would call a *religion;* this term should be applied only to the West.) Duchamp expresses himself even more clearly in a letter to Breton: "I don't accept discussions about the existence of God on the terms of *popular metaphysics,* which means that the word "atheist," as opposed to "believer," doesn't even interest me . . . For me there is something else which is different from *yes, no* or from *indifferent*—for example: *absence of investigation in this area."* Duchamp hasn't represented the Motor of the Motor-Desire because this would have meant dealing with a reality about which, as he himself honorably says, he knows nothing. Silence is more valid than dubious metaphysics or than error.

In Duchamp's silence we find the first and most notable difference between the traditional method of interpretation and the modern. The one affirms the myth and gives it a metaphysical or rational support; the other places it between parentheses. All the same, Duchamp's silence does have something to tell us: it is not an affirmation (the metaphysical attitude) or a negation (atheism), nor is it indifference (skeptical agnosticism). His version of the myth is not metaphysical or negative but ironic: it is criticism. On the one hand, it makes fun of the traditional myth: it reduces the worship of the Goddess, both in its religious and in its modern form, cult of the Virgin or romantic love, to a grotesque mechanism in which desire becomes an internal-combustion engine, love becomes petrol, and semen is gunpowder. On the other hand the criticism also makes fun of the positivist conception of love and, in general, of everything which we call *modern* in the common use of the word: "scientism," positivism, technology, and so on. The *Large Glass* is a comic and infernal portrayal of modern love or, to be more precise, of what modern man has made of love. To convert the human body into a machine, even if it is a machine that produces symbols like a computer, is worse than degradation. Eroticism lives on the frontiers between the sacred and the blasphemous. The body is erotic because it is sacred. The two categories are inseparable: if the body is mere sex and animal impulse, eroticism is transformed into a monotonous process of reproduction; if religion is separated from eroticism, it tends to become a system of arid moral precepts. This is what has happened to Christianity, above all to Protestantism, which is its modern version.

Despite the fact that they are made of materials more lasting than our bodies, machines grow older more rapidly than we do. They are inventions and manufactured objects; our bodies are re-productions, re-creations. Machines wear out, and after a time one model replaces another; bodies grow old and die but the body has been the same from the appearance of man on the earth until now. The body is immortal because it is mortal; this is the secret of its permanent fascination—the secret of sexuality as much as of eroticism. The humorous element of *The Bride* . . . does not lie only in the circular operation of her desire but also in the fact that Duchamp, instead of painting brilliant and perishable bodies, painted opaque and creaking machines. The skeleton is comical because it is pathetic; the machine, because it is icy. The first makes us laugh or weep; the second produces in us what I would call, following Duchamp, a *horror of indifference* . . . In short, Duchamp's

criticism is two-edged: it is criticism of myth and criticism of criticism. The *Large Glass* is the culminating point of the tendency toward irony of affirmation which inspires the readymades. It is a critical myth and a criticism of criticism which takes the form of comic myth. In the first stage of the process, he translates the mythical elements into mechanical terms and in this way denies them; in the second, he carries the mechanical elements over into a mythical context and denies them again. He uses the myth to deny the criticism and the criticism to deny the myth. This double negation produces an affirmation which is never conclusive and which exists in perpetual equilibrium over the void. Or as he has said: Et-qui-libre? Equilibre.

Some critics have found a theological significance in the division of the *Large Glass* into two halves—the realm of the Bride above and the fief of her bachelors below—and have pointed out that this duality corresponds to the ancient idea of a world above and a world below. Harriet and Sidney Janis have gone further: the lower part is a sort of hell, governed by the laws of matter and gravity, while the upper part is the region of the air and of levitation; the Bride is nothing other than an allegory of purified matter or, in Christian terms, of the Ascension of the Virgin. The interpretation contains a grain of truth, but it is incomplete and based, moreover, on guesswork. Robert Lebel sees in the *Large Glass* an antiworld, the equivalent of the antimatter of contemporary physics, which reflects all Duchamp's fears and obsessions, especially those which are infantile or unconscious. Or to put it in mythical terms: it is the manifestation of what the painter fears and hates, just as the Goddess is the manifestation of the fear and anger of the gods. This antiworld is the "vomit, the monstrous and repulsive form of a Bachelor Apparatus which is nothing other than an incestuous and masculine hell." It hardly seems necessary to observe that the *Large Glass* is *not* the representation of male desire but the projection of the desire of the Bride, which is in its turn the projection of an unknown dimension or Idea . . . Lebel adds that Duchamp's picture belongs to the same family as the *Garden of Delights* of Hieronymus Bosch. Although the comparison is correct, it has the same defect as the hypothesis of Harriet and Sidney Janis: it is incomplete. Christian religious painting is Trinitarian or tripartite: it consists of the world, of heaven, and of hell. The opposition of dualities is not Christian but Manichaean. Moreover, the division of the *Large Glass* into two halves is not exactly a division into heaven and hell: both parts are hell. The line of division doesn't allude

to a theological separation ("the Bride is chaste with a touch of malice," the *Green Box* tells us), but one of power. The division is, if you like, of an onotological nature: the males have no existence in their own right; the Bride, on the other hand, enjoys a certain autonomy thanks to her Motor-Desire. But, as we have seen, the dual division is illusory like the whole painting; there comes a point when we have to reckon that, like the Bride and her bachelors, we have been victims of an illusion. Duchamp has good reasons for painting images on glass: everything has been a representation, and the characters in the drama and their circular actions are a projection, the dream of a dream.

The remarks I have made above do not mean that these critics haven't seen with some shrewdness a central feature of the *Large Glass:* this composition continues, in its own way, the great tradition of Western painting and, for this reason, it stands in violent opposition to what we have called painting since Impressionism. Duchamp has frequently referred to the aims which have inspired him:

> It was my intention not to make a painting for *the eyes but* a painting in which the tubes of colour were a means and not an end in themselves. The fact that this kind of painting is called literary doesn't bother me; the word *literature* has a very vague meaning and I don't think it is adequate . . . There is a great difference between a painting which is only directed towards the retina and a painting which goes beyond the retinal impression—a painting which uses the tubes of colour as a springboard to go further. This was the case with the religious painters of the Renaissance. The tubes of colour didn't interest them. What they were interested in was to express their idea of divinity, in one form or another. With a different intention and for other ends, I took the same concept: pure painting doesn't interest me either in itself or as a goal to pursue. My goal is different, is a combination or, at any rate, an expression which only grey matter can produce.[11]

This long quotation spares me the need of any commentary: the *Large Glass* continues the tradition not because it shares the same ideals or exalts the same mythology but because, like it, it refuses to turn aesthetic sensation into an end in itself. It continues it, moreover, by being monumental—not only because of its proportions but because the *Large Glass* is a *monument*. The divinity in whose honor Duchamp has raised this ambiguous monument is not the Bride, or the Virgin, or the Christian God, but an invisible and possibly nonexistent being: the Idea.

Duchamp's enterprise was contradictory and he saw it as such from the outset. For this reason irony is an essential element in his work. Irony is the antidote that counteracts any element that is "too serious such as eroticism" or too sublime like the Idea. Irony is the Handler of Gravity, the question-mark of *et-qui-libre?* The enterprise is contradictory for the following reason: how can one attempt a painting of ideas in a world which is impoverished of ideas? The Renaissance marked the beginning of the dissolution of the great Greco-Christian Idea of divinity, the last universal faith (in the limited sense of the term: *universal* meaning the community of European and Slavic peoples, the churches of East and West). It is true that the mediaeval faith was replaced by the imposing constructions of Western metaphysics but, from the time of Kant, all these edifices have begun to crumble, and from then on thought has been critical and not metaphysical. Today we have criticism instead of ideas, methods instead of systems.Our only idea, in the proper sense of the term, is Criticism. The *Large Glass* is a painting of ideas because, as I think I have shown, it is a critical myth. But if it was only this, it would merely be one work more and the enterprise would be partially abortive. I should underline the fact that it is also and above all the Myth of Criticism: it is the painting of the *only modern idea.* Critical myth: criticism of the religious and erotic myth of the Bride-Virgin in terms of modern, mechanical development and, simultaneously, a myth that burlesques our idea of science and technology. Myth of Criticism: monumental painting which relates one moment of the incarnations of Criticism in the world of objects and erotic relationships. Now, in the same way as religious painting implies that the artist, even if he is not religious, believes in some way in what he is painting, the painting of Criticism requires that the painting itself and its author be critics or that they participate in the critical spirit. As Myth of Criticism the *Large Glass* is a painting of Criticism and criticism of Painting. It is a work that turns in upon itself, that persists in destroying the very thing that it creates. The function of irony now appears with greater clarity: its negative purpose is to be the critical substance that impregnates the work; its positive purpose, as criticism of criticism, is to deny it and so to tip the balance onto the side of myth. Irony is the element which turns criticism into myth.

It would not be mistaken to call the *Large Glass* the Myth of Criticism. It is a picture which makes one think of certain works which prophesy and reveal the ambiguity of the modern world and its oscilla-

tion between myth and criticism. I am reminded of Ariosto's mock epic and of Don Quixote, which is an epic novel and a criticism of the epic. It is with these creations that modern irony is born; with Duchamp and other poets of the twentieth century, such as Joyce and Kafka, the irony turns against itself. The circle closes: it is the end of one epoch and the beginning of another. The *Large Glass* is on the borders of two worlds, that of "modernity," which is in its death throes and the beginnings of a new world, which hasn't yet taken shape. Hence its paradoxical position, similar to that of Ariosto's poem and Cervantes's novel. *The Bride . . .* continues the great tradition of Western painting which was interrupted by the appearance of the bourgeoisie, the open market for works of art, and the predominance of taste. This painting, like the works of the religious artists, is sign and Idea. At the same time, Duchamp breaks with this tradition. Impressionism and the other modern and contemporary schools continue the tradition of the craft of painting, although they eradicate the *idea* from the art of painting; Duchamp applies his criticism not only to the Idea but also to the very act of painting: the rift is total. It is a strange situation: he is the only modern painter who continues the tradition of the West and he is one of the first to break with what we have traditionally called the art or craft of painting. It could be argued that many artists of the present age have been painters of ideas: the Surrealists, Mondrian, Kandinsky, Klee, and many others. This is certainly true but their ideas are subjective; their worlds, almost always fascinating, are private worlds, personal myths. Duchamp is, as Apollinaire conjectured, a *public* painter. No doubt someone will point out that other artists have also been painters of social ideas: the Mexican mural painters, for example. In its intentions the work of these painters belongs to the nineteenth century: it is program painting, at times an art of propaganda and at other times a vehicle of simplistic ideas about history and society. (Mexican mural painting is interesting because of its character and other values, as I have shown in another essay.[12]) The art of Duchamp is intellectual and what it gives us is the *spirit of the age:* Method, the critical Idea at the moment when it is meditating on itself—at the moment when it reflects itself in the transparent nothingness of a pane of glass.

The direct antecedent of Duchamp is not to be found in painting but in poetry: Mallarmé. The work that most closely resembles the *Large Glass* is "Un coup de dès." It is not surprising: despite what the

insular critics of painting think, it is almost always poetry that antici-
pates and prefigures the forms that the other arts adopt later. The
affected piety of modern times which surrounds painting and often
prevents us from *seeing* it, is nothing other than idolatry for the object,
adoration of a magic object which we can touch and which, like other
objects, can be bought and sold. It is the elevation of the object in a
civilization dedicated to producing and consuming objects. Duchamp
refuses to put up with this superstitious blindness and has frequently
emphasized the *verbal* or poetic origin of his work. When he talks about
Mallarmé, he couldn't be more explicit: "A great figure. Modern art
must return to the direction traced by Mallarmé: it must be an intellec-
tual, and not merely an animal, expression . . ." The similarity between
the two artists springs not from the fact that they both show intellectual
preoccupations in their work but from their radical nature: one is the
poet and the other the painter of the Idea. Both of them come face to
face with the same difficulty: there are no ideas in the modern world,
only criticism. But neither of them takes refuge in skepticism and
negation. For the poet, chance absorbs the absurd; it is a shot aimed at
the absolute and which, in its changes and combinations, manifests or
projects the absolute itself. It is the number which, in a state of per-
petual motion, rolls from the beginning of the poem to the end and
which resolves itself in what may or may not be a constellation, the
unobtainable *sum total in formation.* The role which chance plays in the
universe of Mallarmé is the same as that which is assumed by humor
and meta-irony in Duchamp's. The theme of the picture and of the poem
is criticism, the Idea which ceaselessly destroys and renews itself.

In *Los Signos en Rotación*[13] (it is bad to quote oneself but worse
to paraphrase) I endeavored to show how "Un coup de dès" is "a
critical poem" and that "not only does it contain its own negation but
this negation is its point of departure and its substance . . . the critical
poem resolves itself in a conditional affirmation—an affirmation that
feeds on its own negation." Duchamp also turned criticism into myth
and negation into an affirmation that is no less provisional than Mal-
larmé's. The poem and the picture are two distant versions of the Myth
of Criticism, one in the solemn mode of a hymn and the other in the
mode of the comic poem. The resemblance can be seen more strikingly
if we pass on from analogies of an intellectual order to the *form* of these
two works. Mallarmé inaugurated in "Un coup de dès" a poetic form

which contains a plurality of readings—something very different from ambiguity or plurality of meanings, which is a property common to all language. It is an open form which "in its very movement, in its double rhythm of contraction and expansion, of negation which annuls itself and turns itself into an uncertain affirmation of itself, engenders its own interpretations, its successive readings . . . Sum total in perpetual formation: there is no final interpretation of "Un coup de dès" because the last word of the poem is not the final word." The incomplete state of the *Large Glass* is similar to the last word which is never final of "Un coup de dès": it is an open space which provokes new interpretations and which evokes, in its incomplete state, the void on which the work depends. This void is *the absence of the Idea.* Myths of Criticism: if the poem is a ritual of absence, the painting is its burlesque representation. Metaphors of the void. The hymn and the mural painting are open works which initiate a new type of creation: they are texts in which speculation, the idea of "gray matter," is the only character. An elusive character: Mallarmé's text is a poem in movement and Duchamp's painting is in a state of continual change. *The sum total in formation* of the poet is never complete; each one of its moments is definitive in relation to those which precede it and relative to those which come after: the reader himself is only one *reading* more, another instant in this never-ending tale, this constellation that is shaped by whatever is uncertain in each reading. Duchamp's painting is a transparent glass pane: as a genuine monument it is inseparable from the place it occupies and the space which surrounds it: it is an incomplete painting which is perpetually completing itself. Because it is an image which reflects the image of whoever contemplates it, we are never able to look at it without seeing ourselves. To sum up, the poem and the painting affirm simultaneously the absence of meaning and the necessity of meaning and it is here that the meaning of both works resides. If the universe is a language, Mallarmé and Duchamp show us the reverse of language: the other side, the empty face of the universe. They are works in search of a meaning.

The influence of Duchamp's work and of his personality is part of the history of modern painting. If we omit the numerous and persistent offspring of that part of his work which is painting in the strict sense of the word, above all of the *Nude* . . . and exclude also the equally numerous and not always successful readymades, this influence is con-

centrated at three points: Dada, Surrealism, and contemporary Anglo-American painting. Picabia and Duchamp, as is well known, foresaw, prepared, and inspired the explosion of Dada; at the same time, they gave it elements and tendencies that were lacking in the work of the orthodox representatives of the movement. It is best to quote Duchamp on this point:

> While Dada was a movement of negation and, by the very fact of its negation, turned itself into an appendage of the exact thing that it was negating, Picabia and I wanted to open up a corridor of humour which at once led into dream-imagery and, consequently, into Surrealism. Dada was purely negative and accusatory . . . For example, my idea of a capricious metrical unit of length. I could have chosen a metre of wood instead of a thread and broken it in two: this would have been Dada.

Duchamp's position in the Surrealist movement follows the same dialectic: in the full frenzy of Surrealism he returned to certain Dadaist gestures and keeps alive a tradition of humor and negation which the movement, dominated as it was by the passionate and logical genius of Breton, would perhaps have discarded. His action was, in both cases, that of a precursor or contradictor.

The influence of Duchamp on Anglo-American painting has a different character: it is not a direct though distant activity, as in the epoch of Dada and militant Surrealism; it is an example. Contemporary American painting has gone through two distinct periods. In the first, the painters were influenced by the Mexican mural artists and, a little later and more decisively, by the Surrealists: Ernst, Miró, Masson, Matta, Lam, and Tanguy. Among these names the most important were, in my opinion, Masson, Ernst, and Matta. This stage owed little to Duchamp; Abstract Expressionism was too olfactory and retinal to be the kind of painting he cared for. The second group, that of the young painters, would be unthinkable without his friendship, presence, and influence. It is necessary at this point to make a distinction between Pop art in the proper sense of the term and the work of other young artists such as Jasper Johns and Robert Rauschenberg.

Pop art bears only a superficial resemblance to the *gesture* of Duchamp or, for that matter, to the attitude of Picabia, although it is closer to the second. Pop humor lacks aggression and its profanities are not inspired by negation or sacrilege but by what Nicolas Calas defines as the *why not?* Nor is it a metaphysical revolt; fundamentally it is

passive and conformist. It is not a search for innocence or the "previous life," like the movement of the beat poets, although like them, and with greater frequency, it falls into sentimentality. Its brusque recourse to brutality is just this—a way of countering this sentimentality. It is a typical national reaction: the Anglo-Americans swing between these two extremes with the same facility as the Spanish turn from anger to apathy and the Mexicans from the shout to silence. No one is less sentimental than Duchamp: his temperament is fastidious; he is a *neutral* artist. Picabia was exuberant and could laugh or weep copiously, but he never groaned or smirked before the public-as-mirror as the Pop artist does. The common denominator of Duchamp and Picabia is their lucid desperation. The great master of the Pop painters is, in fact, Kurt Schwitters. It is hardly necessary to remind oneself that he called his art of refuse and garbage *Merz,* an allusion to *Kommerz* (commerce), *Ausmerzen* (garbage), *Herz* (heart), and *Schmerz* (grief). It is an art of anguish saved by humor and fantasy but not exempt from self-pity. Finally, Duchamp and Picabia, like all the Dadaists and the Surrealists after them, lived in perpetual conflict with the mass and with the minority; Pop art, on the other hand, is a populism for the comfortably-off. In the case of Rauschenberg, Johns, and a few other artists there is a difference. These two artists are extremely talented and their mental gifts are as great as their pictorial. Jasper Johns is, I think, the more concentrated and profound; his painting is rigorous: it is target practice and the target is metaphysical. Rauschenberg's sensibility is more on the surface and he has a great painterly instinct which he could turn into the beginnings of something important or which could relapse into good taste. Both of them have preoccupations similar to those of Duchamp, though in speaking of influence I mean affinity rather than exact derivation. They are two intrepid artists and their work is a continual exploration. Admittedly I don't see either in them or in the others the prospect of that *total* work which the United States has been promising us for a century and a half. I am thinking as I write this not only of painting but equally of poetry. What Whitman prophesied neither Pound nor Williams, neither Stevens nor cummings, neither Lowell nor Ginsberg have fulfilled. Lucid or visionary, almost always original and at times extraordinary, they are not the poets of midday but of twilight. Perhaps it is better so.

Being a public painter is not the same as being popular. Art, for Duchamp, is a secret and should be shared and passed on like a message

between conspirators. Let us listen to him: "To-day painting has become vulgarized to the utmost degree . . . While no-one has the nerve to intervene in a conversation between mathematicians, we listen every day to after-dinner dissertations on the value of this painter or that. . . . The production of an epoch is always its mediocrity. That which is not produced is always better than that which is." In another interview he confided to the poet Jouffroy: "The painter has already become completely integrated with actual society, he is no longer a pariah . . ." Duchamp doesn't want to end up either in the Academy or among the mendicants but it is obvious that he would prefer the lot of the pariah to that of the "assimilated artist." His attitude to the current situation in art is not different from that which inspired the readymades and the *Large Glass:* it is one of total criticism and, therefore, over and above all, criticism of modernity. The history of modern painting, from the Renaissance to our own times, could be described as the gradual transformation of the work of art into an artistic object: a transition from *vision* to the *perceptible thing.* The readymades were a criticism both of taste and of the object. The *Large Glass* is the last genuinely meaningful work of the West; it is meaningful because by assuming the traditional meaning of painting, which is absent from retinal art, it dissolves it in a circular process and in this way affirms it. With it our tradition comes to an end. Or, rather, the painting of the future will have to begin with it and by confronting it, if painting has a future, or the future a painting. Meanwhile, imitations of the readymades pile up in our museums and galleries: the isolated gesture is degraded into a dreary collective rite, a blasphemous game becomes passive acceptance and the "objet-dard" turns into an inoffensive artifact. Since World War II the process has accelerated and painting and sculpture have been converted, like the other products of industrial society, into consumer goods. We are witnessing the end of the "perceptible thing," of retinal painting reduced to optical manipulation. What distinguished modern from classical art was—from Romantic irony to the humor of Dada and the Surrealists—the alliance of criticism and creation; the eradication of the critical element from works of art is equivalent to a veritable castration and the abolition of meaning confronts us with a production no less insignificant, although much more numerous, than that of the retinal period. Finally, our epoch has replaced the old notion of *recognition* with the idea of publicity, but publicity dissipates into general anonymity. It is the revenge of criticism.

One of Duchamp's most disturbing ideas is crystallized in a sentence which has often been quoted: "the spectator makes the picture." Expressed with such insolent concision, it would seem to deny the existence of works of art and to proclaim an ingenuous nihilism. In a short text published in 1957 ("The Creative Act"[14]), he clarifies his idea a little. He explains here that the artist is never fully aware of his work: between his intention and the realization, between what he *wants* to say and what the work actually *says,* there is a difference. This "difference" is, in fact, the work. Now, the spectator doesn't judge the picture by the intentions of its originator but by what he actually sees; this vision is never objective: the spectator interprets and "distills" what he sees. The "difference" is transformed into another difference, the work into another work. In my opinion Duchamp's explanation does not account for the creative act or process in its entirety. It is true that the spectator creates a work which is different from the one imagined by the artist, but between the two works, between what the artist *wanted* to do and what the spectator *thinks* he sees, there is a *reality:* the work. Without it the re-creation of the spectator is impossible. The work makes the eye which sees it—or, at least it is a point of departure: out of it and by means of it the spectator invents another work. The value of a picture, a poem or any other artistic creation is in proportion to the number of signs or meanings which we can see in it and the possibilities which it contains for combining them. A work is a machine for *producing meanings.* In this sense Duchamp's idea is not entirely false: the picture depends on the spectator because only he can set in motion the apparatus of signs which comprises the whole work. This is the secret of the fascination of the *Large Glass* and the readymades. Both of them demand an active contemplation, a creative participation. They make us and we make them. In the case of the readymades the relation is not one of fusion but of opposition: they are objects made against the public, against ourselves. By one means or another Duchamp affirms that the work is not a museum piece; it is not an object of adoration, nor is it useful; it is an object to be invented and created. His interest in—indeed, his admiration and nostalgia for—the religious painters of the Renaissance has the same origin. Duchamp is against the museum, not against the cathedral; against the "collection," not against an art which is founded on life. Once more Apollinaire has hit the mark: Duchamp's purpose is to reconcile art and life, work and spectator. But the experience of other epochs cannot be repeated and Duchamp knows it. Art which is

founded in life is socialized art, not social or socialist art; and still less is it an activity dedicated to the production of beautiful or purely decorative objects. Art founded in life means a poem by Mallarmé or a novel by Joyce; it is the most difficult art. An art which *obliges* the spectator or the reader to become himself an artist and a poet.

In 1923 Duchamp abandoned definitely the painting of the *Large Glass*. From then on his activity has been isolated and discontinuous. His only permanent occupation has been chess. There are some people who consider this attitude a desertion and, inevitably, there are others who judge it as a sign of "artistic" impotence." These people never stop to take note of the fact that Duchamp has placed in parentheses not so much art as the modern idea of the work of art. His inactivity is the natural prolongation of his criticism; it is meta-irony. I emphasize the distinction between art and the idea of the work because what the readymades and Duchamp's other gestures denounce is the concept of art as an object—the "objet d'art"—which we can separate from its context in life and keep in museums and other safe-deposits. The very expression "priceless work of art" reveals the passive and lucrative character—there is no contradiction in the terms—of our notion of the work. For the ancients as for Duchamp and the Surrealists, art is a means of liberation, contemplation or knowledge, an adventure or a passion. Art is not a category separate from life . . . André Breton once compared his abandonment of painting with Rimbaud's break with poetry: chess would be in these terms a sort of Harrar in New York, even more "execrable" than that of the poet. But Duchamp's inactivity is of a different order from Rimbaud's silence. The adolescent poet opposes a total negation to poetry and reneges on his work; his silence is a wall and we don't know what lies behind this refusal to speak: wisdom, desperation, or a psychic change which converted a great poet into a mediocre adventurer. Duchamp's silence is open; he affirms that art is one of the highest forms of existence, on condition that the artist escapes a double trap: the illusion of the work of art and the temptation to wear the mask of the artist. Both of these petrify us: the first makes a prison of a passion, and the second, a profession of freedom. To think that Duchamp is a vulgar nihilist is sheer stupidity: "I love the word 'believe.' Normally when people say *I know,* they don't know what they are saying: they believe that they know. I believe that art is the only activity by which man shows himself as an individual. By this activity he

can transcend his animal nature: art opens onto regions which are not bound by time or space. To live is to believe—at least this is what *I believe.*" Is it not strange that the author of the readymades and the *Large Glass* should express himself in such a way and proclaim the supremacy of passion? Duchamp is intensely human, and it is contradiction that distinguishes men from angels, animals, and machines. Moreover, his "irony of affirmation" is a dialectical process which has the precise intention of undermining the authority of reason. He is not an irrationalist, he applies rational criticism to reason; his crazy and carefully reasoned humor is a shot aimed at the buttocks of reason. Duchamp is the creator of the Myth of Criticism, he is not a professor who makes criticism of the myth.

His friend Roché has compared him with Diogenes, and the comparison is correct: like the Cynic philosopher and like all of the very limited number of men who have dared to be free, Duchamp is a clown. Freedom is not knowledge but what one has become after knowledge. It is a state of mind which not only admits contradiction but which seeks it out for its nourishment and as a foundation. The saints do not laugh nor do they make us laugh but the truly wise men have no other mission than to make us laugh with their thoughts and make us think with their buffoonery. I don't know if Plato had a sense of humor, but Socrates did and so did Chuang Tsu and few others. Thanks to humor Duchamp protects himself from his work and from us who contemplate, admire, and write about it. His attitude teaches us—although he has never undertaken to teach us anything—that the end of artistic activity is not the finished work but freedom. The work is the road and nothing more. This freedom is ambiguous or, rather, it is conditional: we can lose it at any moment, above all if we take ourselves or our work too seriously. Perhaps it was to underline the provisional character of all freedom that he didn't finish the *Large Glass;* in this way he did not become its slave. The relation of Duchamp to his creations is contradictory and cannot be pinned down; they are his own and they belong to those who contemplate them. For this reason he has frequently given them away: they are instruments of liberation. In his abandonment of painting there is no romantic self-pity or the pride of a titan; it is wisdom, *insane wisdom.* It is not a knowledge of this thing or that, it is neither affirmation nor negation, it is the void, the knowledge of indifference. Wisdom and freedom, void and indifference resolve themselves into a key word: purity. Something which cannot be sought after but which gushes forth

spontaneously after one has traversed certain experiences. Purity is what remains after all the accounts have been made. Igitur finishes with these words: Le Néant parti, reste le château de la pureté.

NOTES

1. Quoted in *Marchand du sel,* écrits de Marcel Duchamp. Introduction by Michel Sanouillet. (Paris: La Terrain Vague, 1958).

2. Robert Lebel, *Sur Marcel Duchamp* (Paris, 1959).

3. For Brisset see André Breton, *Anthologie de l'Humour Noir* (Paris: Édition du Sagittaire, 1940).

4. Robert Lebel's book, quoted above, is the most complete and lucid study of the life and work of Marcel Duchamp. For Rrose Selavy and the puns, see *Marchand du sel,* ed. Michel Sanouillet (Paris: La Terrain Vague, 1958).

5. "Conversation avec Marcel Duchamp," Alain Jouffroy, *Une révolution du regard* (Paris, 1964).

6. According to Duchamp all modern art is "retinal"—from Impressionism, Fauvism and Cubism to abstract art and Op art, with the exception of Surrealism and a few isolated instances such as Seurat and Mondrian.

7. Translated by Edward Conze (London, 1961).

8. Among others, Michel Carrouges, *Les Machines Célibataires* (Paris, 1954) is worth mentioning. The best description of the painting can be found in André Breton, *Phare de la Mariée* (1945).

9. Translator's note: I have given an English rendering of Paz's "notes for a future translation into Spanish."

10. Heinrich Zimmer, *Myths and Symbols in Indian Art and Civilization* (New York: Pantheon Books, 1946).

11. "Conversation avec Marcel Duchamp," in *Une révolution du regard.*

12. "Las peras del olmo" (Mexico City, 1957), pp. 244–264.

13. *Los Signos en Rotación* (Buenos Aires, 1965).

14. *Art News,* 56, no. 4. New York, 1957.